Paper-craft 2

Design and Art with Paper

gestalten

Preface

As a species, we love to test our limits. In life and love, science and engineering, art and architecture, the boldest among us enjoy nothing better than flexing our — real or cerebral — muscles to see where daring, tenacity, and ingenuity might take us. And what better place to start than with a blank sheet of paper?

To some no more than a pragmatic means to an end, to others an infinitely fascinating and versatile material, paper has long ceased to be a mere medium for conveying thoughts and ideas. Liberated from its prime task as information carrier and receptacle, the humble page soon became the first point of call for all those who decided to give their graphics program or modelling software a break in favor of tangible, physical experimentation. Nevertheless, the relatively recent resurgence of DIY applications in art, design, and beyond often treats paper as no more than a temporary proxy for "real" works, a cheap prototyping stand-in and experimental base to be replaced by "worthier," more lasting choices once the outcome is right.

A true waste, considering paper's not-so-hidden assets. Far more flexible than it appears, this particular raw material can be delicate, gossamer, and brittle, but also strong and weight-bearing when corrugated or folded just right. It excels at both sharp folds and amorphous molds (in the guise of papier mâché), it tears and burns — and even dissolves under the right conditions. Cheap and cheerful in its basic incarnation, paper also comes in a broad range of types, weights, structures, and surface treatments. So why not promote this makeshift intermediate stage to a glorious and self-confident end in itself?

After all, both cost and properties have already made paper and cardboard the go-to material of set builders, window designers, and even select haute couture designers who glory in the glaring dichotomy between precious gown and mundane packing material. Here, cheap and disposable meets high-end glam, lightweight paper appears strong to the core — and we delight in the obvious deception, in the brief illusion and resulting double-take that toys with our expectations.

In this spirit, artists from all disciplines set out to (re-)discover the tricks of the trade, to teach themselves scalpel cuts, origami folds and pop-up and animation techniques in a realm where failure comes cheap: all it takes is time, dedication, and an open eye for novel and unexpected techniques.

Although a fascinating field of study in itself, this publication will not focus on those resolute souls who have dedicated their lives to a single idea, to the almost autistic recreation of a landscape fashioned from paper Lego bricks or faithful renditions of St. Paul's Cathedral, but instead aims to retrace the accelerating evolution of paper-based art and design beyond mere monothematic skill or deranged dedication.

And there is plenty to be discovered: emerging from the playful bedroom industry of early experimentation, the artists assembled in this book have left the inside-joke-riddled playground of simplistic sets, scenes, physical doodles, and papercraft toys behind to concentrate on more elaborate motifs and encompassing installations. The resulting explosion of expertise not only manifests in the visible works, but also in a more professional approach: no longer reduced to the one bright spark or great idea, these particular protagonists place equal emphasis on related aspects: technique, craft — and final documentation.

Chopping and snipping with the steadiest of hands, some of the featured scissor-fiends might take inspiration from Peter Callesen's economical yet ingenious cuts to create alternate realities from image and negative space, from removal, not addition, to explore the natural restrictions of paper cuts and silhouettes. Graduating from monochrome simplicity to often colorful, multi-layered, and even backlit landscapes or staggered dioramas, these miniature sets serve to tell a

story, adding a narrative twist to the art. And this is a recurring theme: from chunky, almost solid translations of an illustrator's signature style to entire villages emerging from pages, as if by magic, many of these works not only venture all the way into space and back to see how far they can stretch our sense of wonder and paper's properties, but also aim to convey a message. Exploring the realm of romance and mystery, of childhood favorites, school staples, and late 19th century classics, we are invited to get up close and personal with Jules Verne's retro-futurist adventures, Alice's wild ramblings in alternative, pre-LSD dreamscapes, or Captain Ahab's heroic and desperate crusades against his inner and outer demons.

On a similar note, and following in Brian Dettmer's eminently capable footsteps and knife slashes, even the relatively young discipline of book carving has turned over a new leaf to whittle sculptures rich in textured meaning and reveal a reshaped story of their own making. From eviscerated tomes to pop-up notes, the resulting works become compact homes of self-contained tales — multi-layered, beautiful, and riddled with hidden messages. Naturally, this element of reverential recycling also extends to other, non-book works that thrive on the deliberate, decipherable inclusion of pre-existing subtext; from political statement to timeless classic, secret love poem or tax statement (to some, the most intimate of them all).

Meanwhile, those with a more mathematical mind push paper's boundaries into worlds of jutting spikes, stealth bomber folds, or complex geometries, all set to invade space with abstract calm or near military aggression. As part of their ambitious undertakings, the medium itself can become something of an afterthought, hardly more than a neutral necessity. While some still indulge in its obviously ephemeral qualities — construct painstaking illustrations, installations, or scenes for stop-motion masterpieces, only to watch them go up in flames or delight in their dissolution, a sizeable section of works on display hardly betrays its paper origins.

Satisfyingly solid, even towering, these sculptures and objects transcend paper's implied limits in a stunning metamorphosis of its perceived properties. Illustrating paper's relatively recent, almost alchemic and unrecognizable transformation from simple building block or perhaps flimsy attire into a whole gammut of nevel textures, into something radically and fascinatingly different, these works turn pulp and paper into glittering jewels, coarse knitting yarn, delicate faux ceramics, or even the semblance of gleaming plastic grids.

As part of this sheer proliferation and professionalization of paper art and its countless permutations, the discipline has now attracted the attention of those with a more mundane goal and message: faced with society's universal yearning for authenticity, for personal touches among mass-produced perfection, big brands welcome paper-based communication measures as an ingenious means to differentiate their own product from the almost indistinguishable competition. From hand-crafted set to three-dimensional poster, from endearing stop-frame animation to cinema-quality trailer, paper adds instant depth, personality, and emotional reach. No longer the work of a sole tinkerer or idealistic bedroom artist, the respective commercials, portfolios, or image campaigns require the interplay of entire sets, scenes, and teams, choreographed by seasoned art directors and producers who take the new medium in their stride.

And this is where we come full circle: driving the limits ever further — with increasing intricacy, larger sets, bigger budgets, proliferating ramifications, and novel paper properties — the genre's original reject, the computer itself, is slowly starting to regain its status: as a welcome, if additional, tool for modeling and prepping all those brain-frazzling complexities and abstract algorithms required to realize tomorrow's visions.

01

Reality, Reimagined

Evolving in leaps and bounds, paper-based illustrations and collages have come a long way since the era of enthusiastic slash and churn punk publications. Right about now, an immaculate grasp of technique and technology is almost taken for granted — it's what you make of it that counts, beyond your skill with scissors or scalpel.

From the tentative portraits and silhouettes of yore, the artists assembled in this chapter have graduated to encompassing worlds, whorls, and layers shaped from their favorite material. With a self-confidence that emancipates artist and art alike from conventional notions of the material, paper has become a valid stepping stone and stage for entire intricate microcosms.

Take Megan Brain's Endo-period Japanese silhouettes and paper cuts, based on the origami patterns of precious paper, on delicate leaves and sheets saved for special occasions. From lady of leisure to cheerful and perfectly poised Female Ninja, her strong, if misguided, female protagonists embrace the traditional background and backdrop while they find themselves in decidedly more contemporary situations.

And while paper-based illustrators translate the line of an imaginary pen to the drapes and folds of tissue paper, shiny sheets, or coarse cardboard, those of a more disjointed mind add a secondary layer of meaning and intent to the humble collage — a meaning conveyed by the chosen material and its overt or inherent message.

To anchor their subject in a period or theme, they reach for what is already there, for pre-existing products — from simple sheet and brown paper bag to humble toilet roll or corrugated cardboard boxes — to serve as starting points for new revelations and paper-based exercises. Nick Georgiou, for example, adds a touch of history to his evocative works with salvaged books and paper artifacts, while Mark Langan's stern sculptures take on an almost metallic solidity in a deliberate denial of their flimsy origins.

In this, they are not alone: plenty of artists toy with textures, slipping and sliding multiple layers of construction paper to achieve a level of perceived solidity that boosts the immediacy of perception. By lending paper entirely novel qualities — think the feathery thickness of Carlos Meira's Brazilian carnival dress, Play-Doh like panorama or faux Plaster-of-Paris ballerina (a technique taken to ever-increasing extremes by paper sculpture veteran Jeff Nishinaka) — they leave its implied restrictions and symbolism behind and glory in its versatility.

But let's take a step back and return to the overall picture: from Meira's satisfyingly thick and almost diorama-like landscapes and panoramas to the deep-set "take a look inside" displays by the likes of Jayme McGowan or Andrea Dezsö, these stunning collages and illustrations add drama and depth to what used to be a decidedly two-dimensional discipline: a welcome development that keeps us guessing — and wanting more.

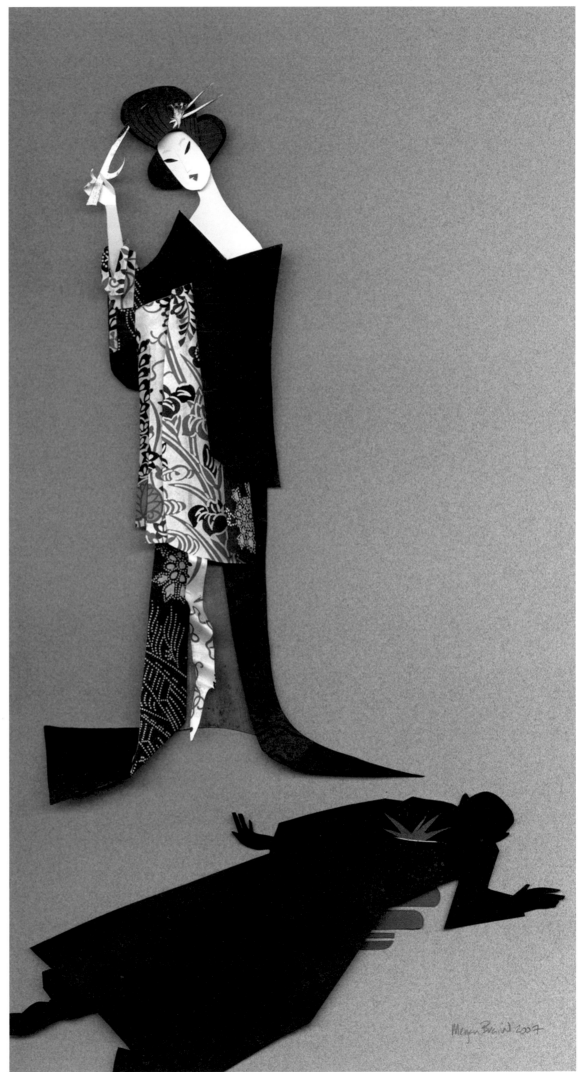

Megan Brain
Kunoichi – Female Ninja
Created for the "Ninja Show"
at Gallery Nucleus in Alhambra,
California.

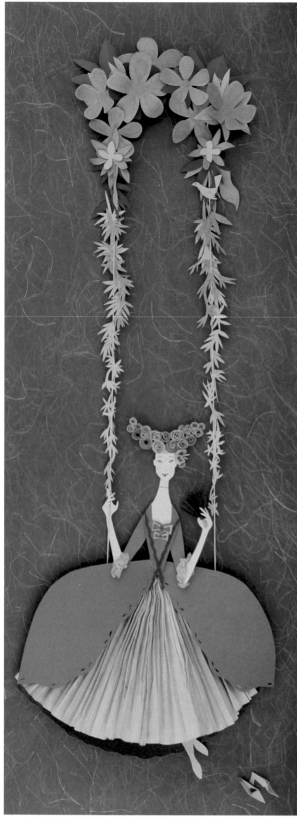

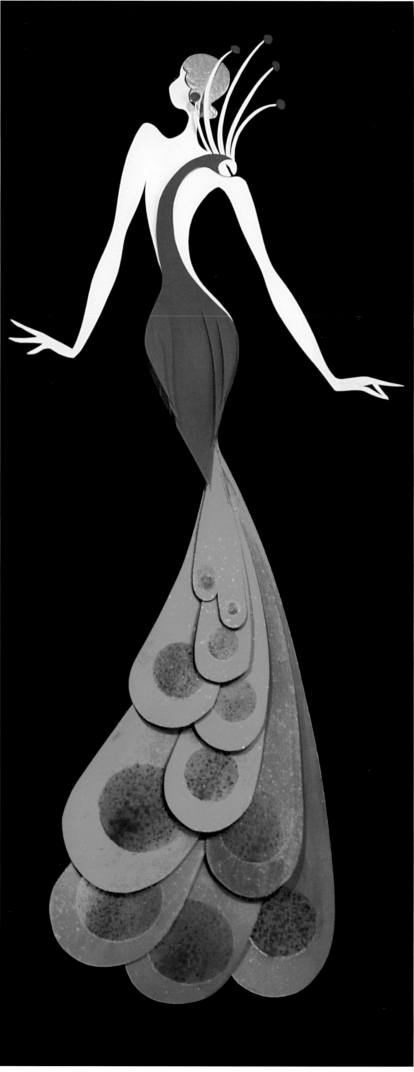

Megan Brain
01 Marie Antoinette
02 Peacock Dress

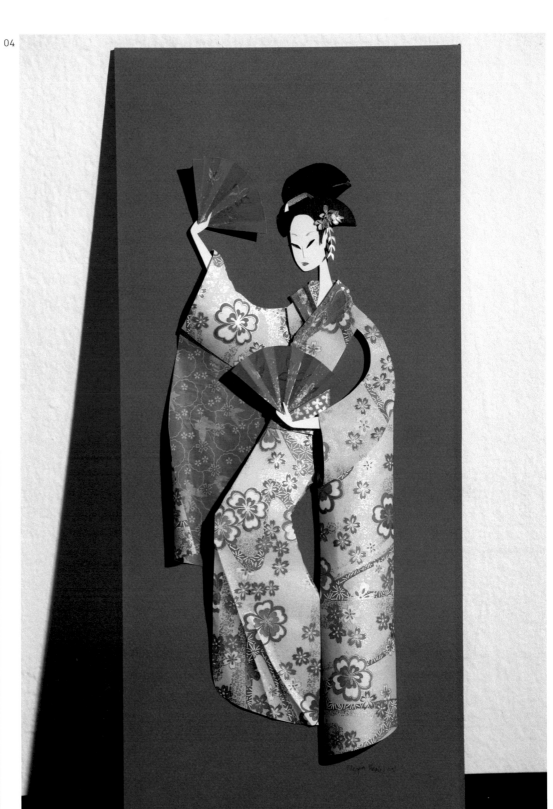

03

Megan Brain
03 Vintage Fashion
04 Geisha

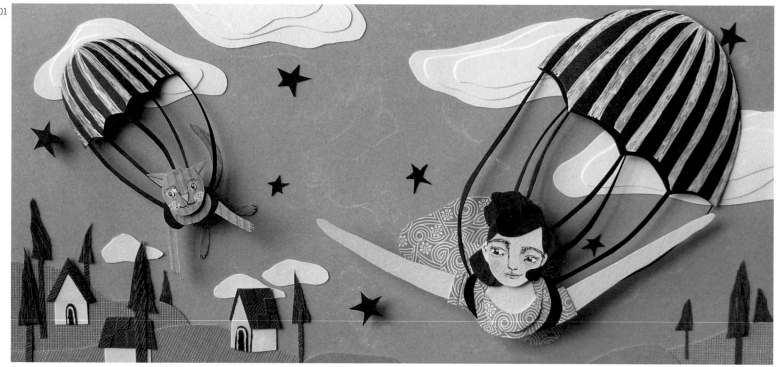

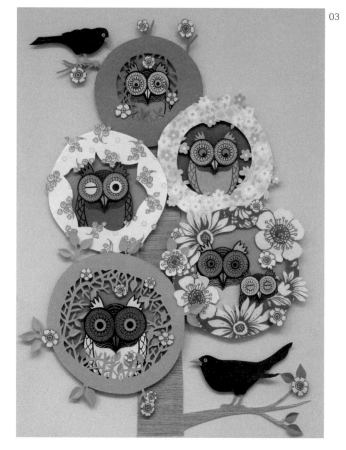

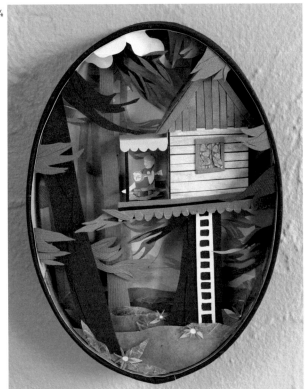

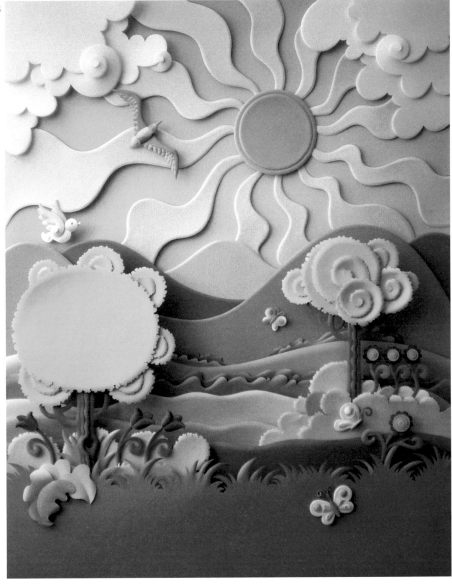

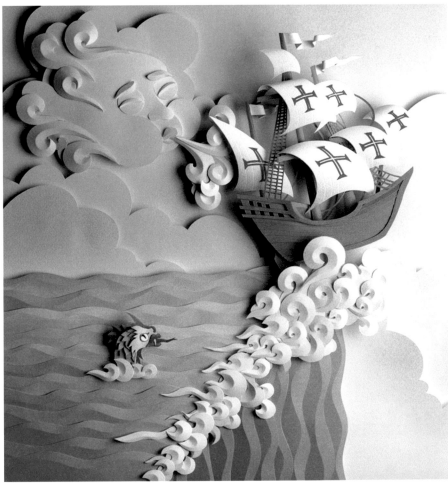

Jayme McGowan
01 Aerial Adventurers
Wallet illustration for Poketo.
02 Deeper Impact
Illustration for a *New Scientist* maga-
zine article about the effect meteors
have on Earth's volcanic activity.

Helen Musselwhite
03 Birds of a Feather

Jayme McGowan
04 In the Trees

Carlos Meira
05 Springtime
Illustration created for the advertising
campaign of a shopping mall.
06 Abysm

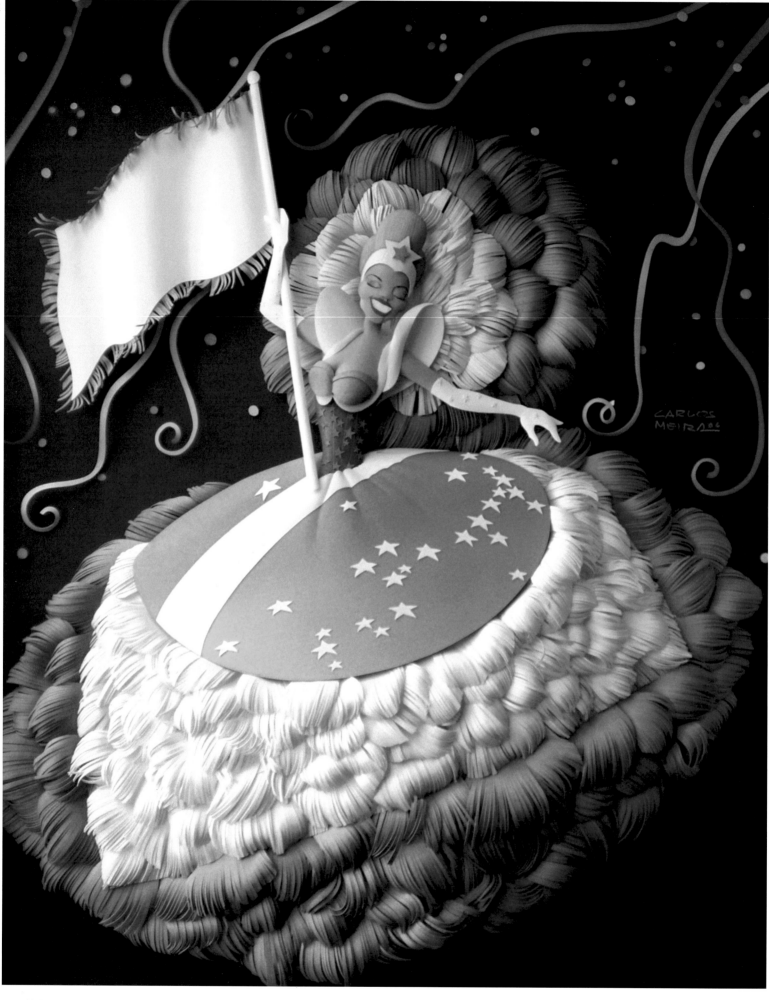

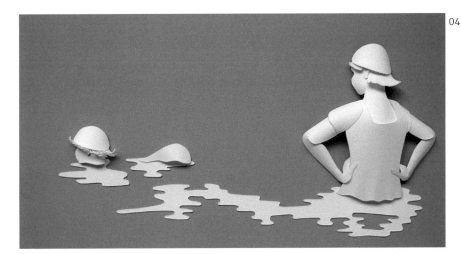

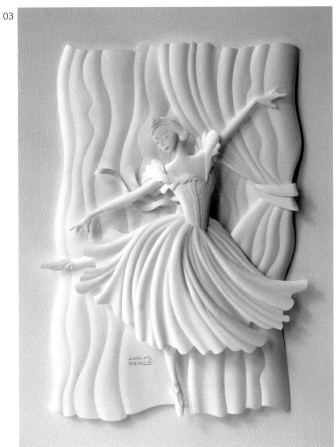

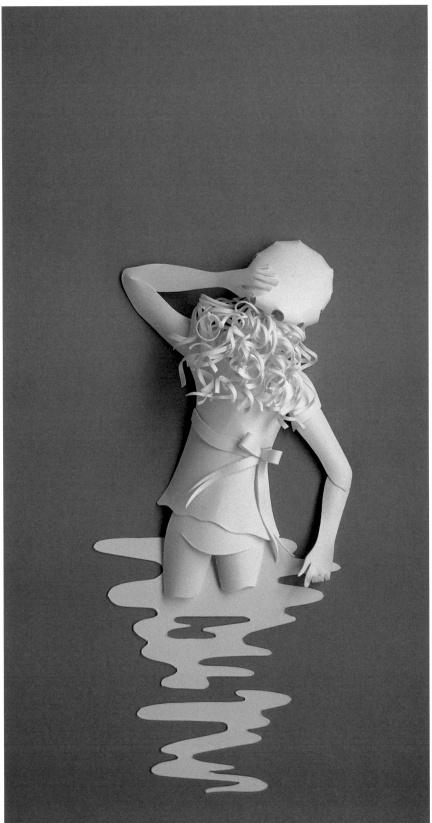

Carlos Meira

01 <u>Porta-bandeira – Carnival Paper</u>
Work created for "Carnival Paper,"
an exhibition dedicated to the
members of the samba schools of
Rio de Janeiro.
02 <u>Green Shiva</u>
03 <u>Ballerina</u>

Sher Christopher

04 <u>Bathers No. 3, Bathers No. 2</u>
Relief sculptures for "Bathers,"
a series based on photographs
of Victorian bathers. Created for
the "Pulp Fiction" exhibition at
Artsreach in Dorchester, U.K.

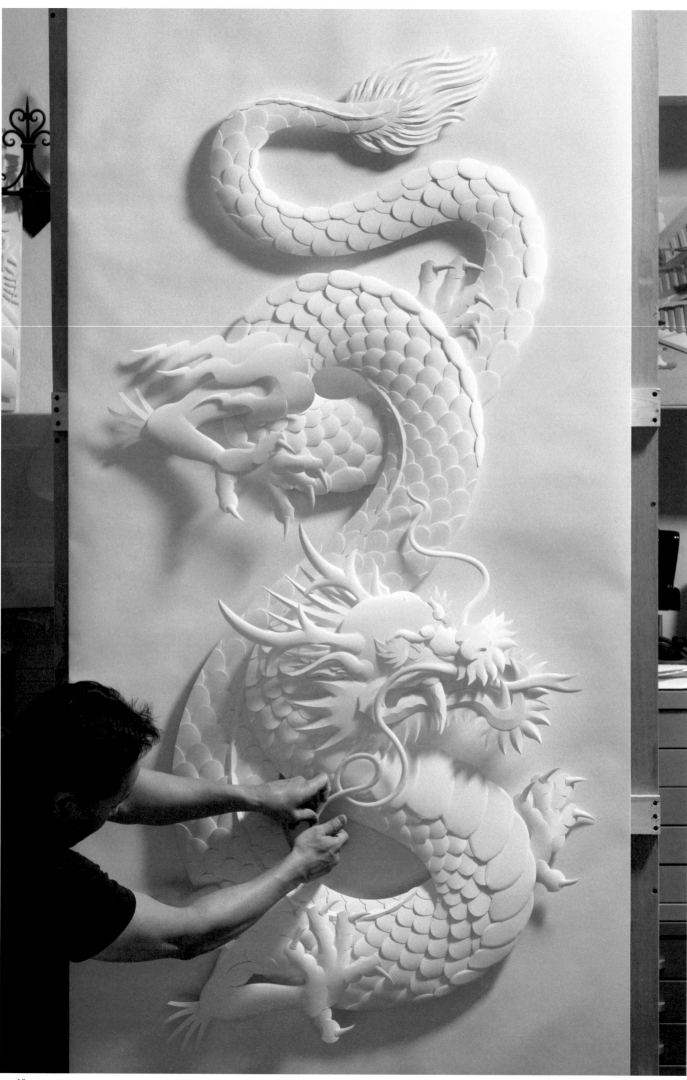

Jeff Nishinaka
Peninsula Hotel Dragon
A paper sculpture commissioned for the interior of the Peninsula Hotel in Shanghai, China. The piece leads to the restaurant's entrance.

02

Jeff Nishinaka

01 Novae: Courthouse, Marine & Agriculture
Paper sculpture series for the new visual identity of Novae, a London-based insurance company.

02 My Chic Grande Epicerie
Illustration of the Grande Epicerie de Paris for retailer Le Bon Marché's Christmas 2010 catalog.

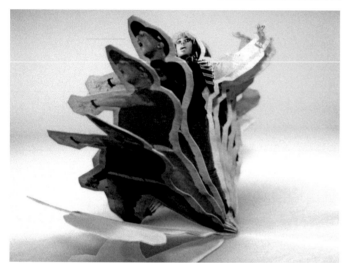

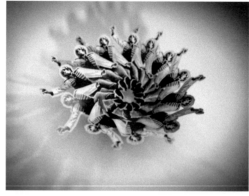

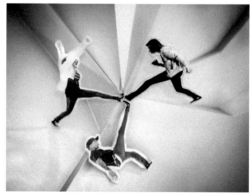

Psyop

01 Converse "My Drive-Thru"
Video about the concept of connectivity. Using 9,580 paper dolls, 30 animators created a world out of paper that tricks the viewer's perception of perspective. Instead of cutting actions together in the video, the camera is thrown around to find the next moment in time, while music and personality create a sense of energy through the camera moves.

Javan Ivey & Jamie Edwards

02 W+K: 12.6
Advertising agency W+K commissioned this animated piece to profile the 13 participants in its Wieden+Kennedy 12 program. It was created using the Stratastencil technique devised by Ivey, which adds a layer of paper to each frame while continuing to show the layers of the previous frames.

02

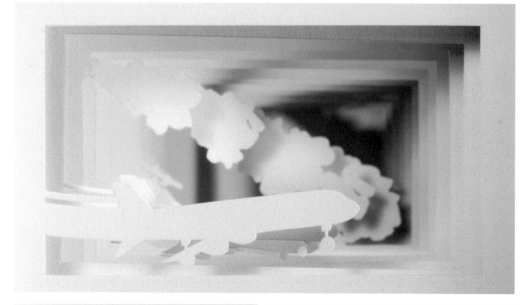

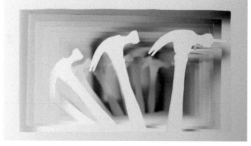

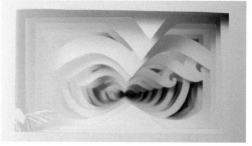

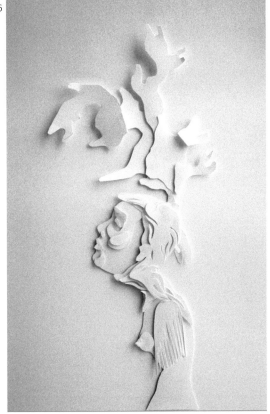

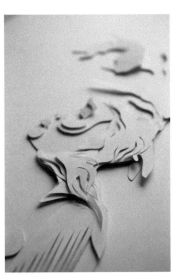

César Del Valle
03 Portraits III 7
04 Portraits II 7
05 Portraits III 5

Sveta Shubina
06 Deer

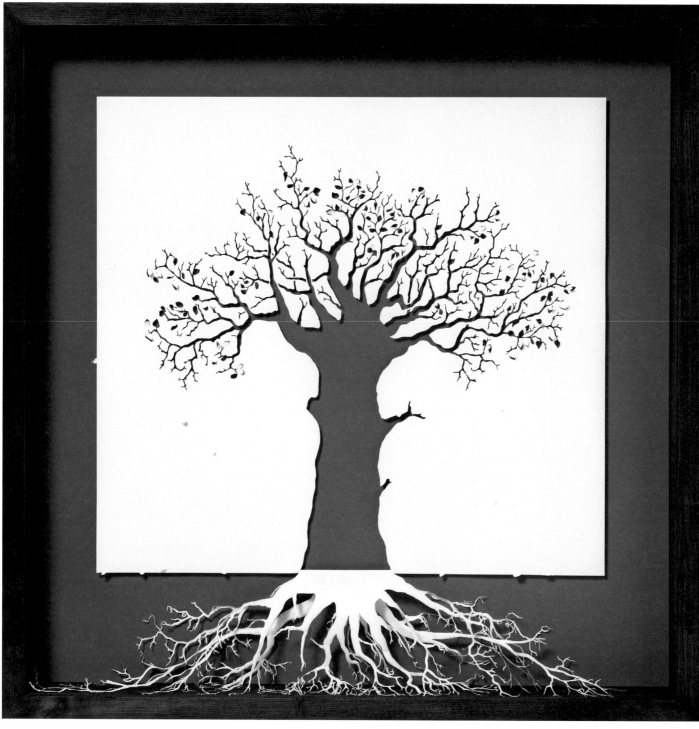

Peter Callesen
01 The Roots of Heaven
02 Boat II
03 Running Fire II

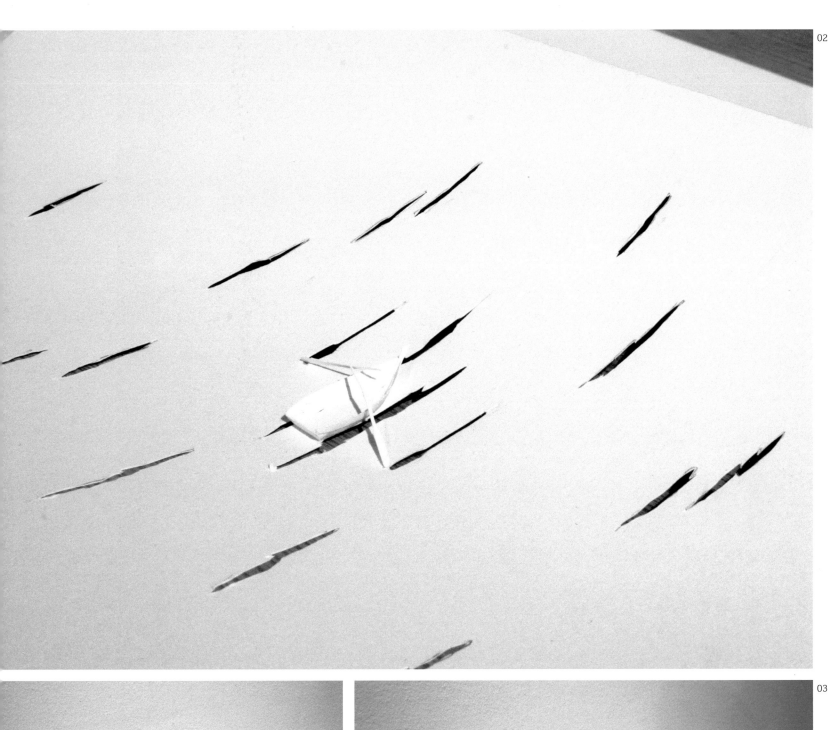

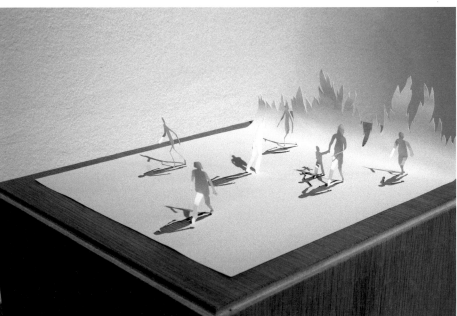

Yuken Teruya

A sculpture of a tree that is cut out of a copy of Shel Silverstein's book, *The Giving Tree*.

Economical to a fault in his recycled creations, Okinawa-born Yuken Teruya takes a closer look at everyday helpers—and offers them a new lease of life. True to the adage "waste not, want not," each of his cutouts becomes an exercise in negative space and, at the same time, serves as raw material for related creations.

Here, Teruya snips the most delicate of microcosms from mundane, almost shameful staples like toilet tissue rolls or brown paper bags. Already fragile and coarse-fibered, he turns the latter into sheltered ecosystems for organic growth and impossibly flimsy trees.

In his quest to "awaken the paper's ability to come to life," the artist meticulously teases the filigree ramifications from his material. Once finished, the source of his harvested work becomes an overhead clearing for the fresh new growth inside. Incidentally, each tree is modeled on a real-life specimen—a portrait of the flora encountered by the artist during his travels.

01
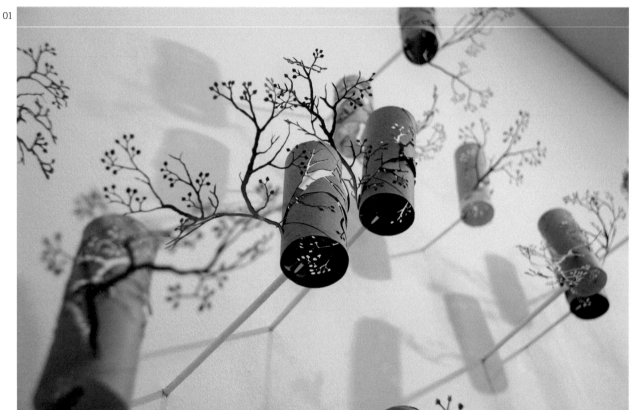

02
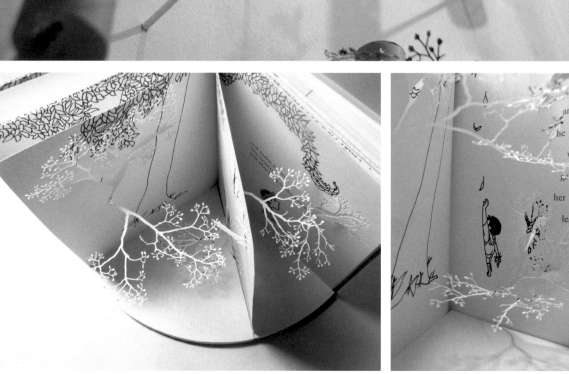

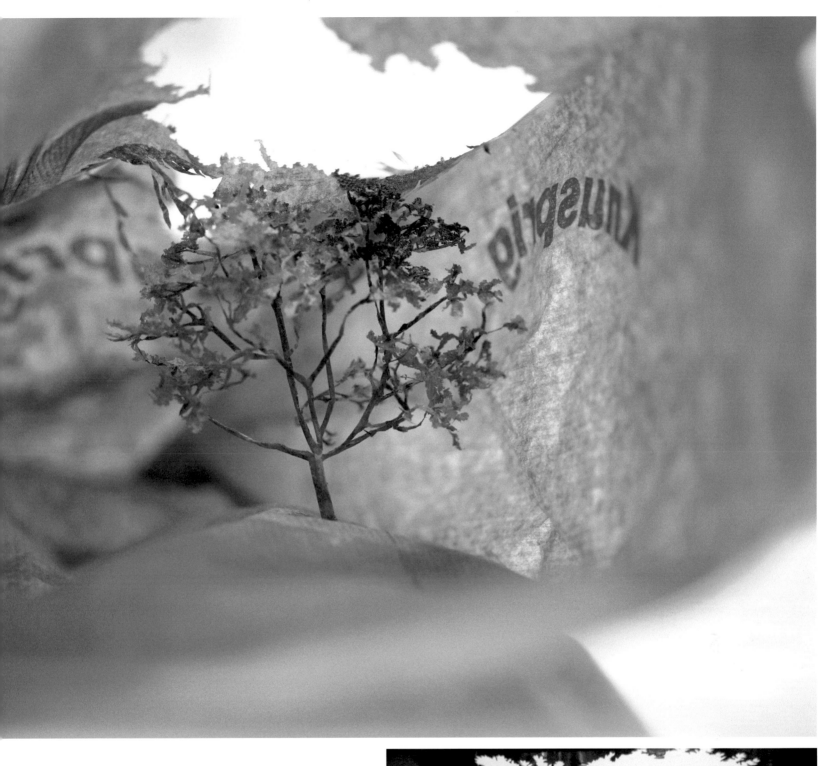

Yuken Teruya
Notice – Forest
Trees are sculpted from the paper
of a disposable paper bag, then
placed inside the bag.

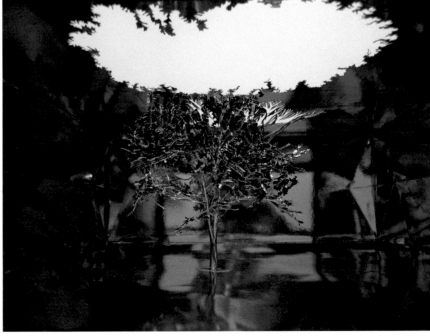

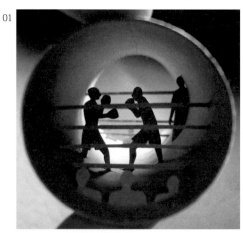

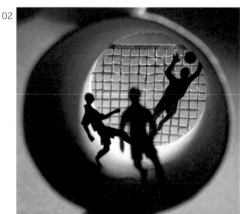

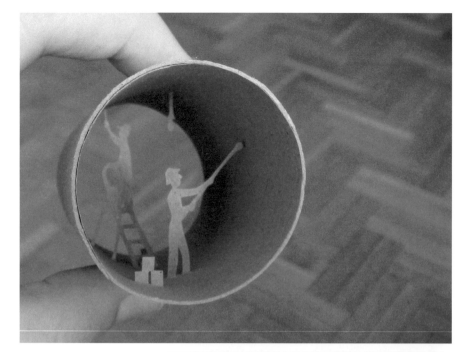

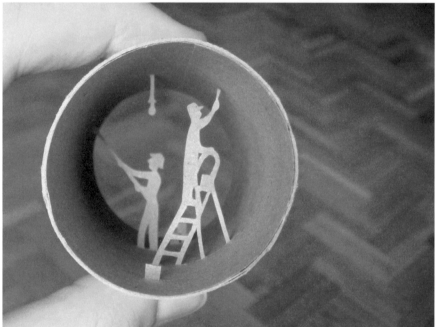

Anastassia Elias
01 Boxing
02 Football
03 Renovation

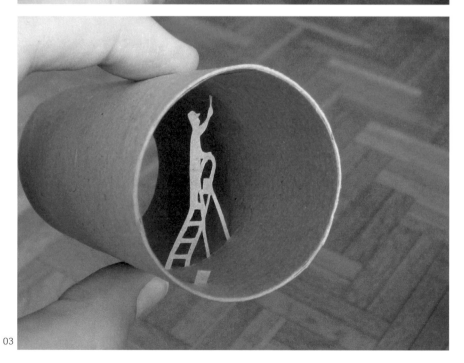

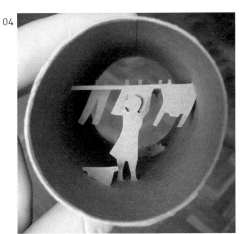

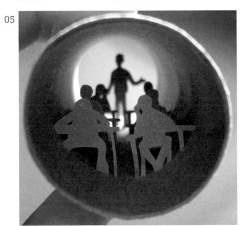

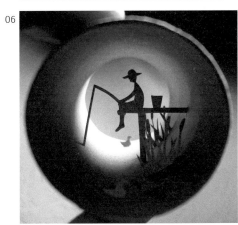

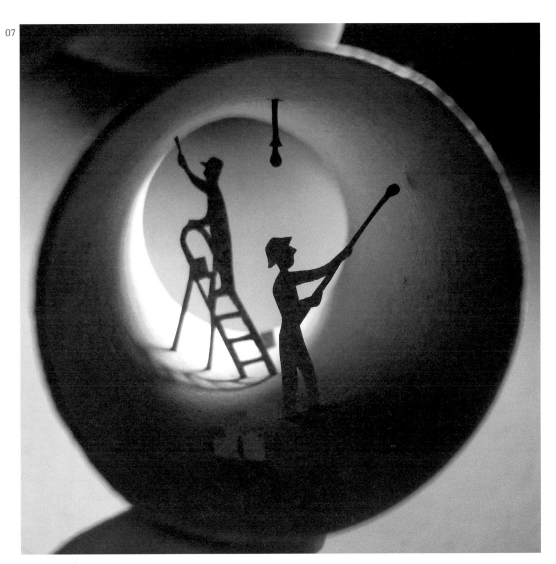

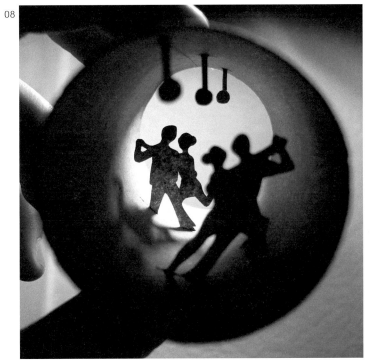

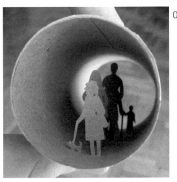

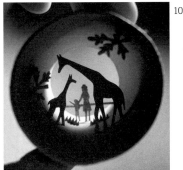

Anastassia Elias

01

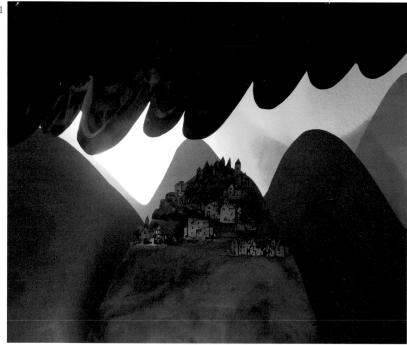

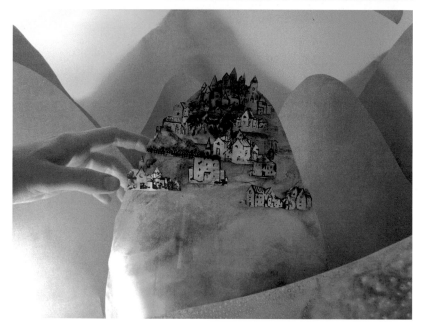

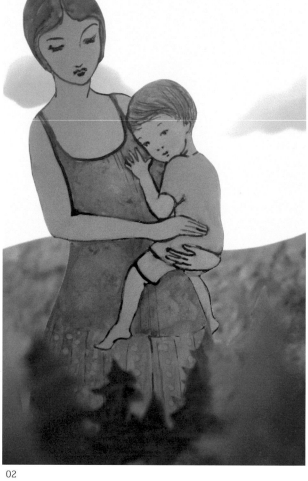

02

03

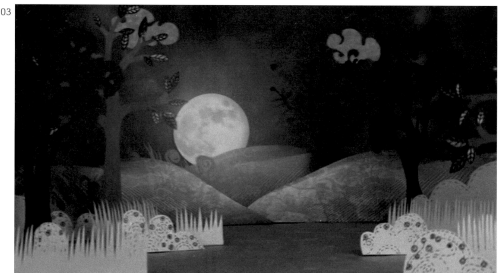

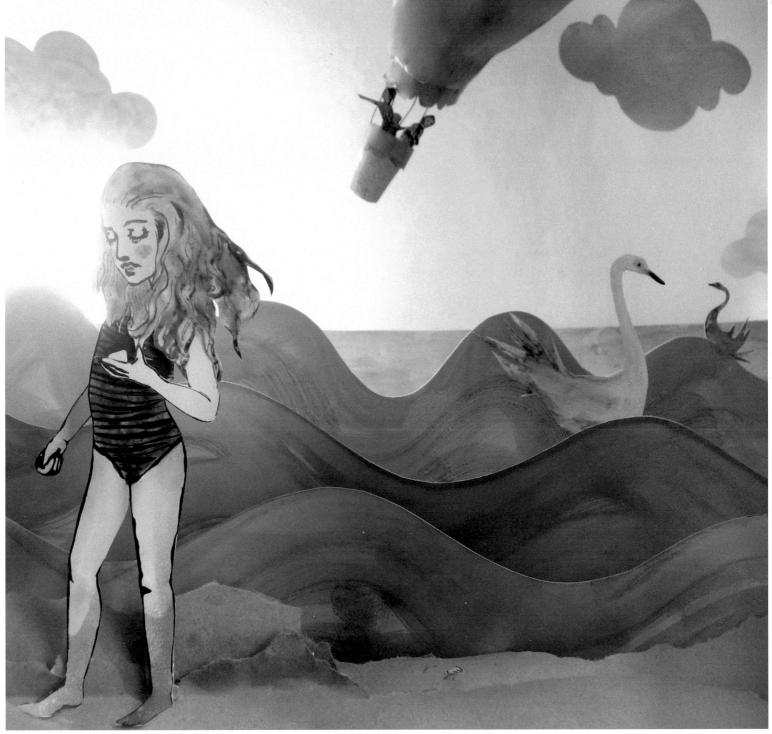

Elly MacKay

01 Haunted Averdale

02 When She Held Her Child, She Could Walk through the Forest, Eyes High above the Treetops.
Yupo, a durable and flexible plastic paper, is the base material for the scenes created and photographed by Elly MacKay. After painting illustrations of the characters and settings, she cuts them into layers and proceeds to set up scenes in a miniature theater. Her photographs of this paper theater are given a distinct atmosphere through lighting techniques that use a combination of filters, parchment, and colored tissue paper.

**Yvonne Perez Emerson /
Cre8tivegirl**

03 From Flat to Flight: A Curious Dream
A promotional piece for the Curiosity Group in Portland, Oregon, the film was created along with a papercraft elephant, which could be downloaded and assembled with just a few basic materials.

Elly MacKay

04 She Found a Shell in the Morning Light

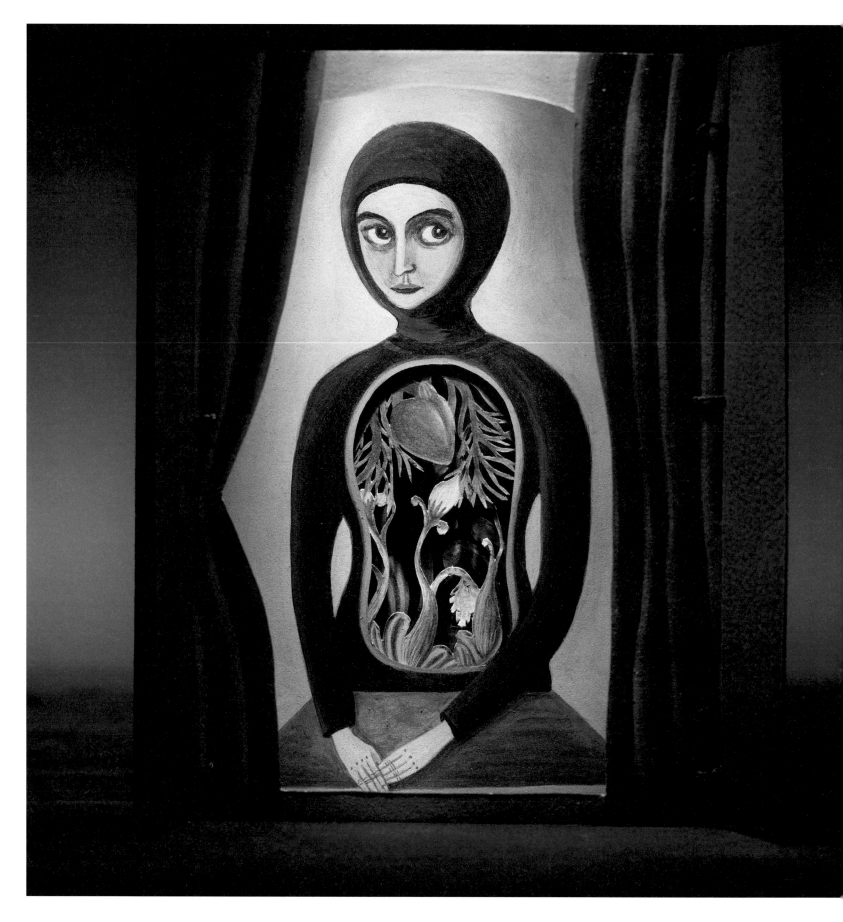

Andrea Dezsö
30 Tunnel Books

With a steady hand and eagle-sharp eye, a masterful command of the scalpel, and a superb sense of proportion, Andrea Dezsö's *Tunnel Books* explore the apparent oxymoron of "opaque transparency," of chopped up and reassembled memories, desires, and the most fleeting of dreams.

Rendered in receding layers of richly detailed, hand-cut, and painted paper, her dissections invite us all the way into her muted, eerie worlds of patina-tinged color schemes, nocturnal woods, fleeting ghosts, and the inner workings of our own bodies.

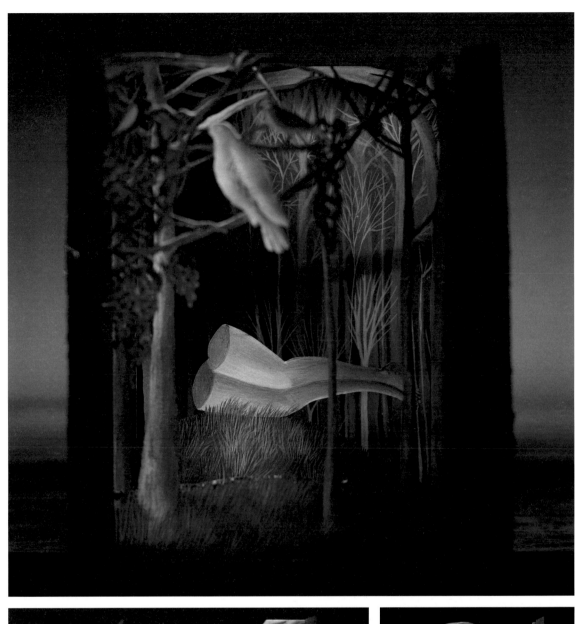
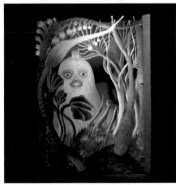
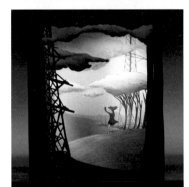

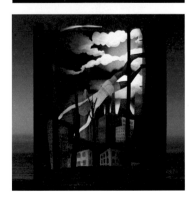
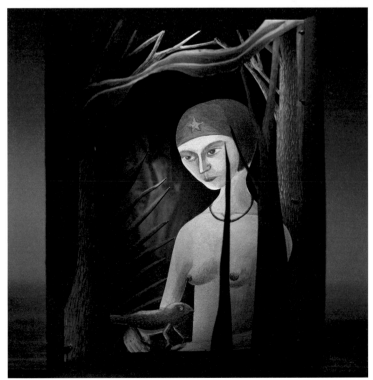

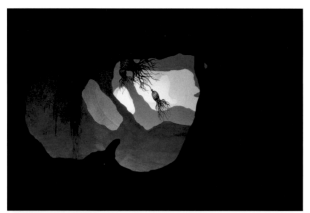

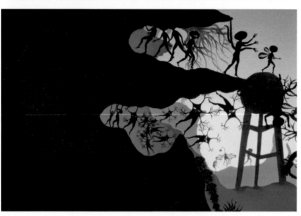

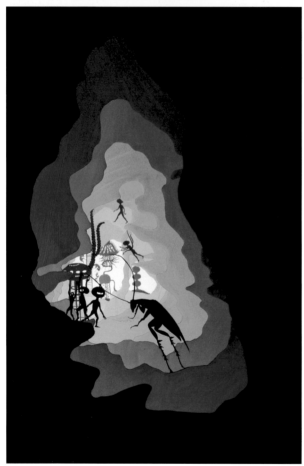

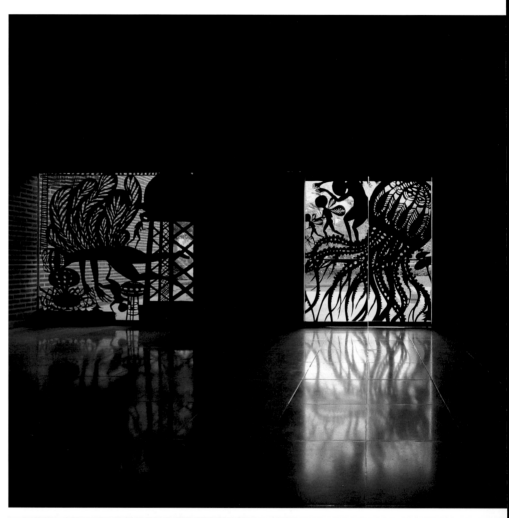

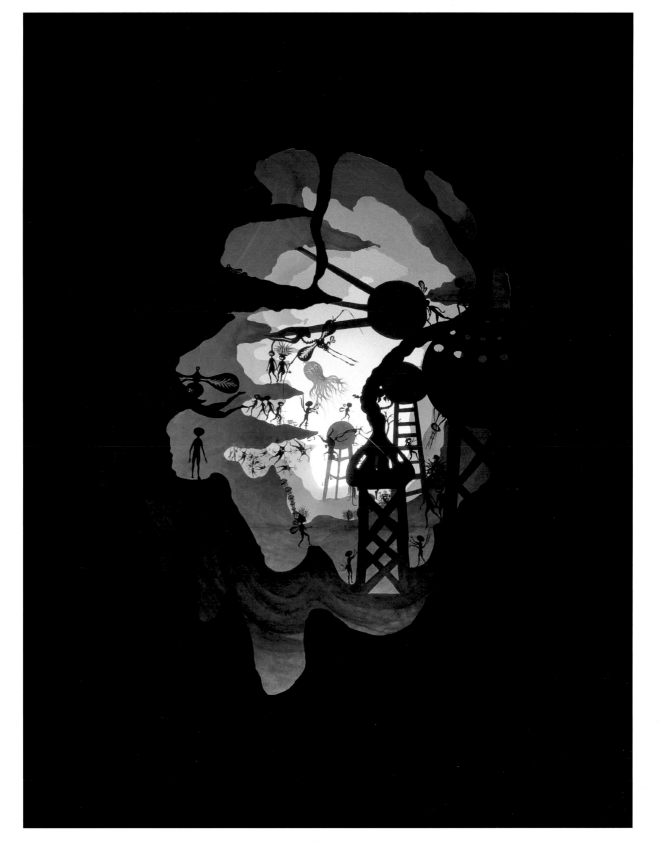

Andrea Dezsö
Sometimes in My Dreams I Fly

Escaping classic book dimensions, Andrea Dezsö's exhibit "Sometimes In My Dreams I Fly" expands on the visions of her *Tunnel Books* by several orders of magnitude. Inspired by an imaginary journey to the moon, the monumental, 14-meter installation at Houston's Rice Gallery required the artist to switch scissors for power tools and a laser cutter to prepare hundreds of individual elements in her hometown of New York for final shipment to the far-off gallery.

Assembled step by step, layer by layer, the resulting silhouettes and shadows take us back to Dezsö's childhood in Cold War period Romania, where most, if not all, travel took place in people's imagination. Fascinated by the ongoing space race, Dezsö decided to create an alternate ending for the ill-fated Apollo 13 mission. In her mind, instead of having to return to Earth due to technical problems, the spaceship's heroes successfully land on the moon and discover a richly populated lunar world.

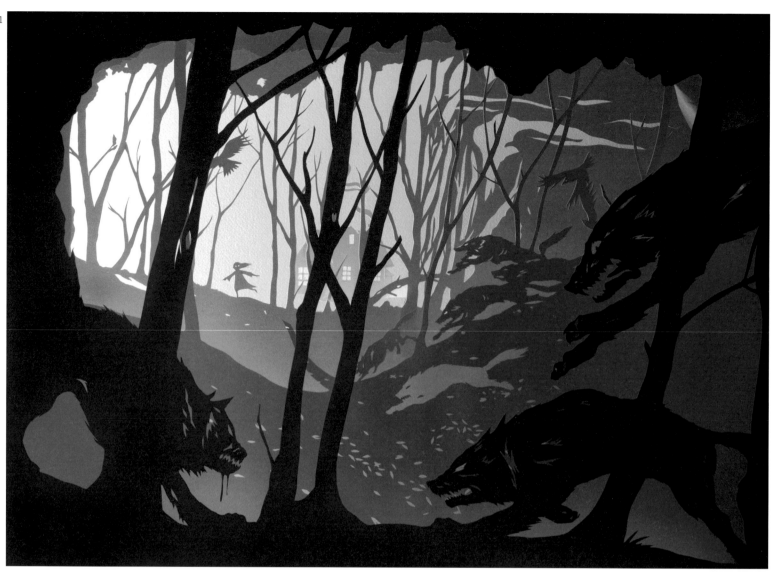

01

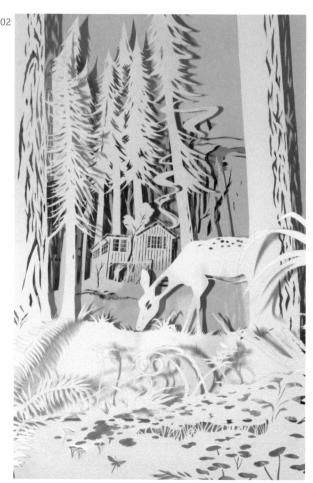

02

03

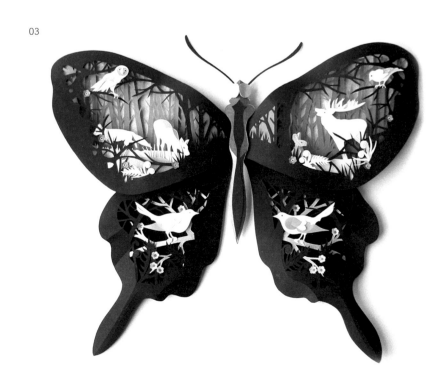

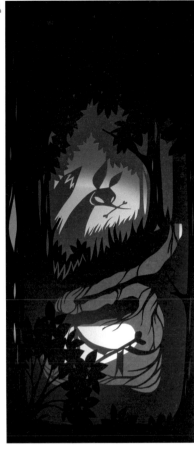

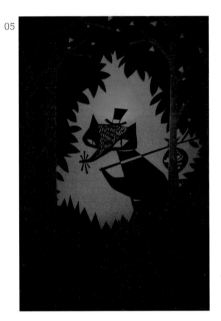

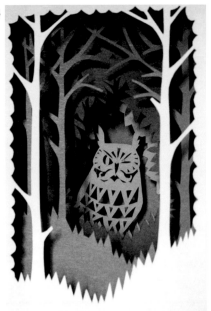

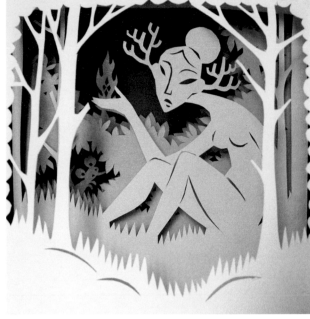

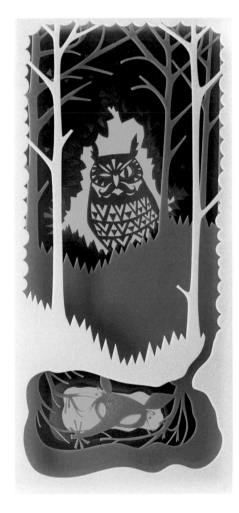

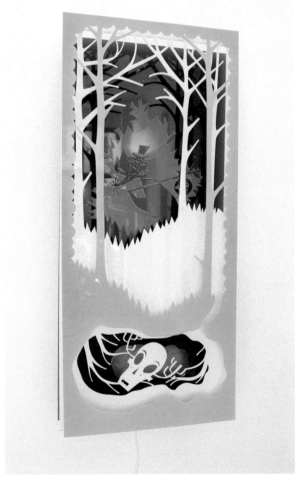

Stuart McLachlan

01 The Hunter's Daughter
 Based on a story written by
 the artist.

02 The Cabin
 Inspired by a cabin located in
 the outskirts of San Francisco,
 California. The project was commis-
 sioned by a client as a present for
 his mother, who grew up in the rus-
 tic log house that is still inhabited
 by his grandmother – and is now
 threatened by encroaching urban
 development.

Helen Musselwhite

03 Beauties Butterfly
 One in a series of paper sculptures
 inspired by the woodlands that
 feature in the fairy tale *Sleeping
 Beauty*.

Cecilie Ellefsen

04 The Bone Collector
 Personal work.

05 Mr. Fox, The Secret
 A diorama for the exhibition "In the
 Forest Deep." The work is made from
 a paper sketch and extruded acrylic
 sheets. The acrylic sheets are laser
 cut, which allows for the detailed
 cutting necessary to achieve the
 intricate shapes in the work.

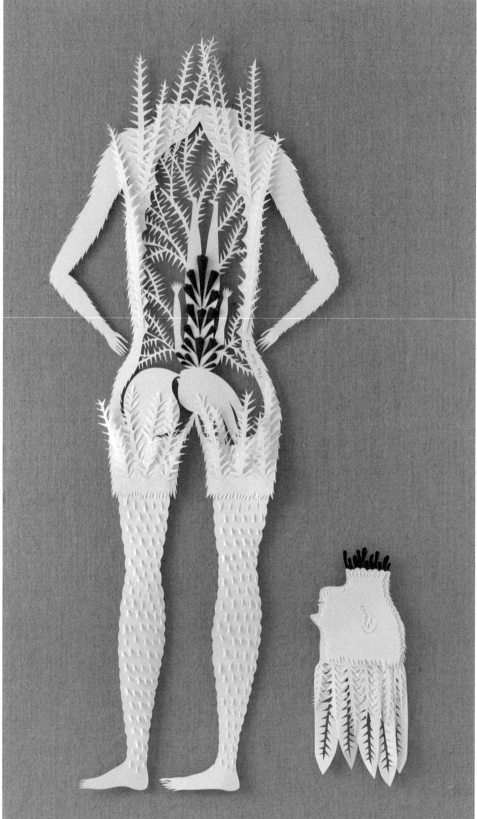

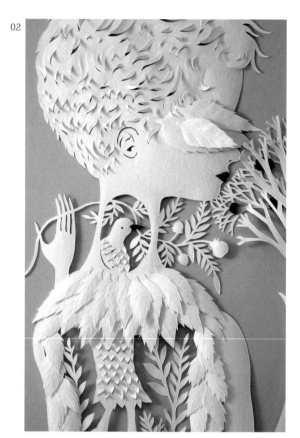

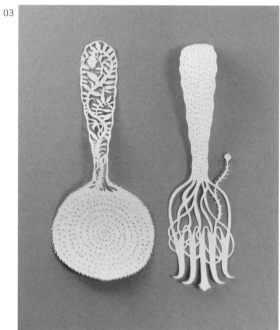

Elsa Mora

01 <u>Missing Thoughts</u>
02 <u>Por Dentro (Within)</u>
 A piece about emotional growth
 and introspection.
03 <u>Utensils</u>
04 <u>Open Head</u>
 A person's ideas have just started
 to grow into something real.

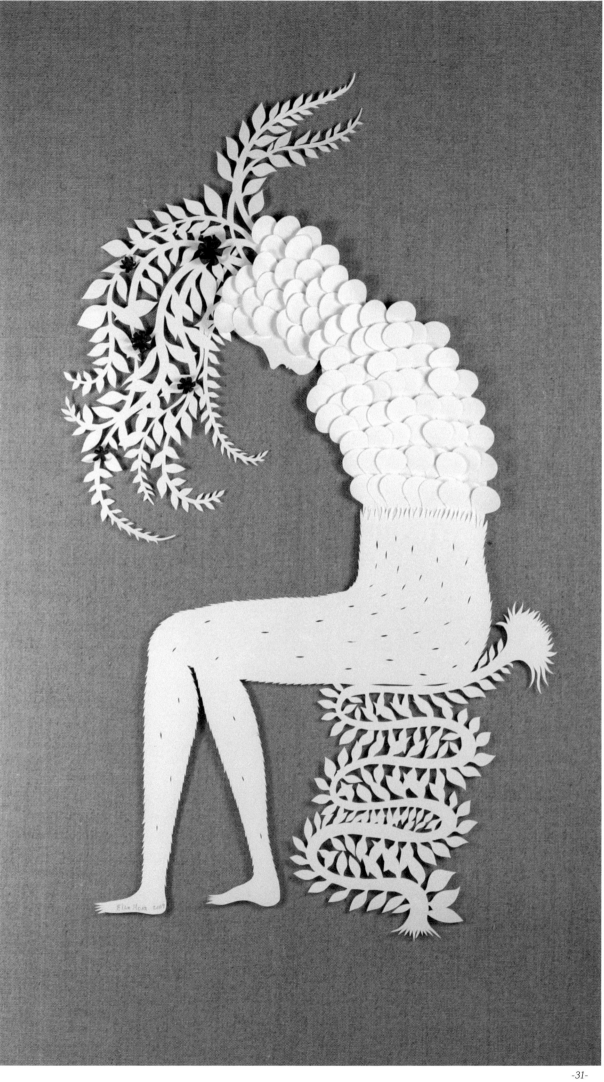

Lena Wolff

01 Meeting Place
02 Circle Study, 2
03 Pair
04 Circular Path

San Francisco General Hospital commissioned this paper collage as a part of its Acute Care Unit Public Art Program. The piece, one of three in a series, will be fabricated as a tile mosaic by Mosaika, a Montreal-based studio that specializes in creating mosaics for public art projects. It will be installed as a permanent mural on the hospital's campus in San Francisco, California.

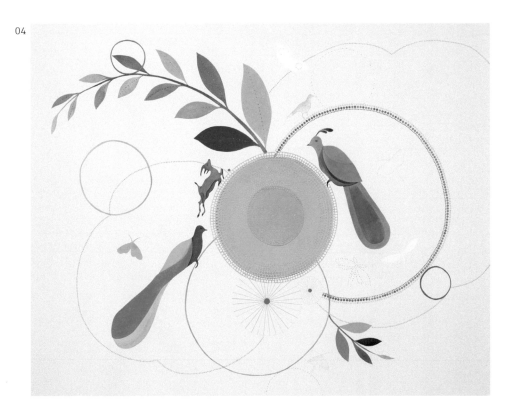

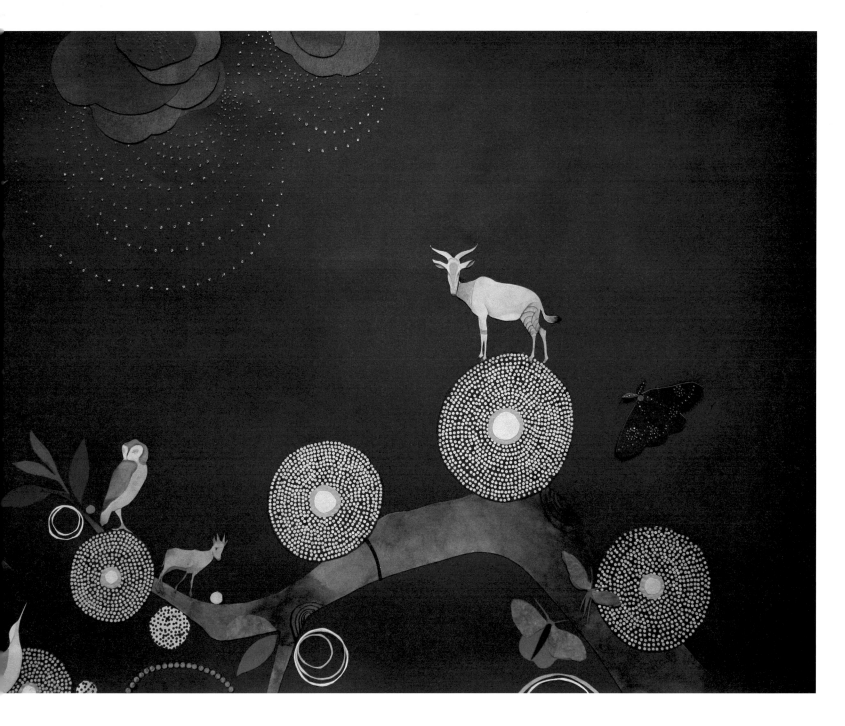

Lena Wolff

Taking a leaf or two out of the Olaf Hajek school of naïve two-dimensional illustration with plenty of graphic elements and burgeoning nature, Lena Wolff repurposes strands liberated from folk art, anthropomorphic fables, allegory, and organic abstraction for her visual tales of wildlife and wonder.

In this, she references several narrative textile techniques with a long tradition of symbolic stories and encoded messages: individually glued hole-punched dots, pinpricks, and hand-painted collage elements combine to make otherworldly and fantastic tableaux with textured, almost sculptural surfaces. Her painstaking, hypnotic process of assembly borrows from the repetitive movements of needlepoint, juxtaposed with techniques purloined from drawing and painting. Working on both sides of the paper, Wolff's surfaces are transformed into the fabric of her imagination, often joining multiple, possibly disjointed, panels into paper quilts of exquisitely distorted reality and shifted perception.

Finally, and beyond a careful sprinkling of hole-punched orbs, fine pinpricks on darker surfaces—attained by a gradual build-up of gray paint rubbed with powdered graphite—help to catch the light and blur the boundaries between heaven and earth, dream and reality, that little bit further.

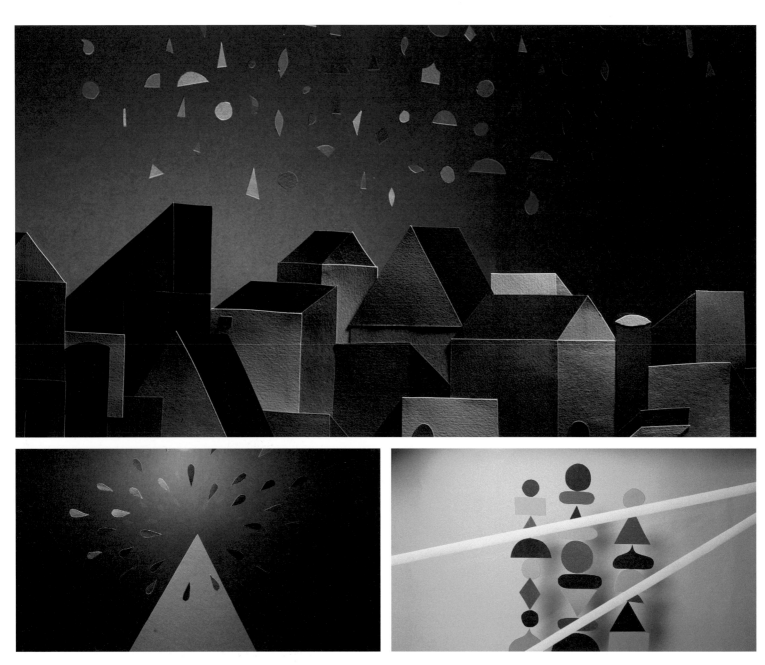

Jesse Brown & Christian Hansen
Grieves & Budo "Cloud Man"
A video for the single "Cloud Man"
by hip-hop artists Grieves & Budo.
It was produced using hand-cut
paper and stop-motion animation.

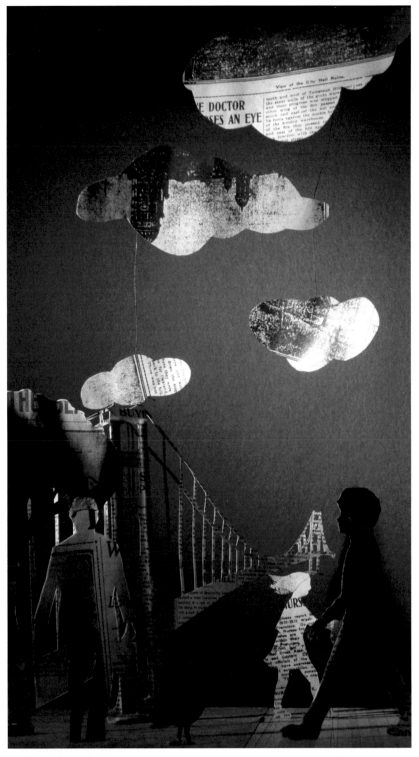

Andrea Dezsö
Editorial Illustration for *Harper's*
Magazine
Illustration for the article "Twilight
of the American Newspaper" by
Richard Rodriguez.

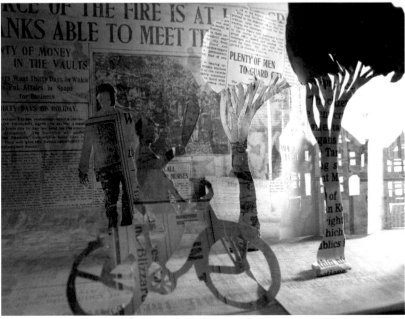

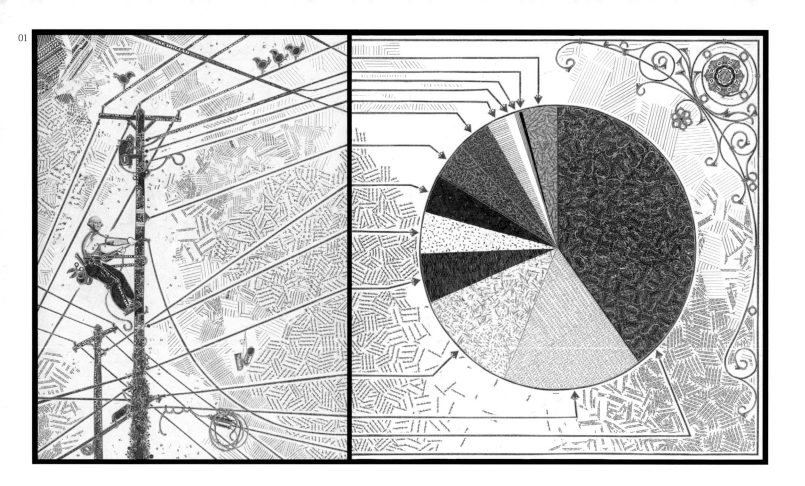

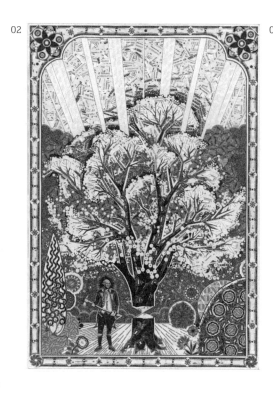

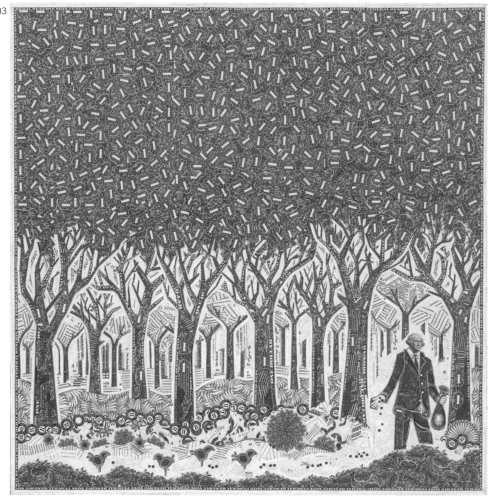

Mark Wagner

01 Power Lines Converge /
Statistics Show
02 The Alleged Cherry Tree Incident
03 Lost in the Woods

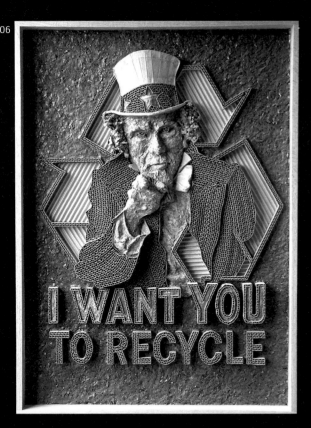

Mark Langan

Using simple tools, Mark Langan creates detailed sculptures from re-claimed corrugated cardboard boxes.

04 Untitled

One of three commissioned sculptures for Mid-States Packaging in Lewistown, Ohio.

05 Interpretive Star of David

Star of David commissioned to commemorate the completion of a Bar Mitzvah.

06 I Want You...

A reinterpretation of the vintage army recruitment poster featuring the American icon Uncle Sam.

07 Homage to Roy Lichtenstein

Corrugated boxes were used in this commission to create a three-dimensional version of an artwork

Ryuta Iida

01 I See, I Can't See – Color Book Cards
Sculptural object made from the book *Color Book Series*.

02 I See, I Can't See – Abe
Sculptural object made from a book by Abe Kobo.

03 I See, I Can't See – Ôgai
Sculptural object made from a book by Mori Ôgai.

04 Ornament of Book – Part
Sculptural object made from a collection of English poetry.

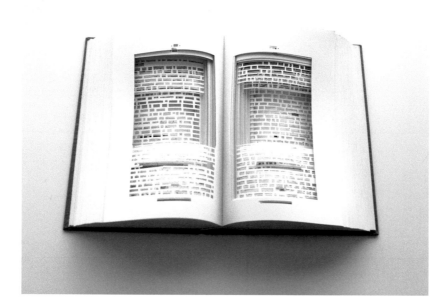

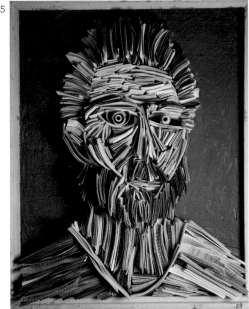

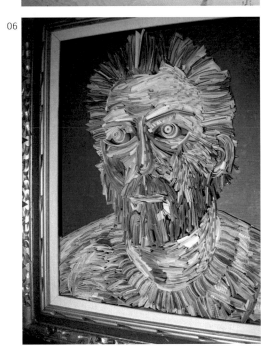

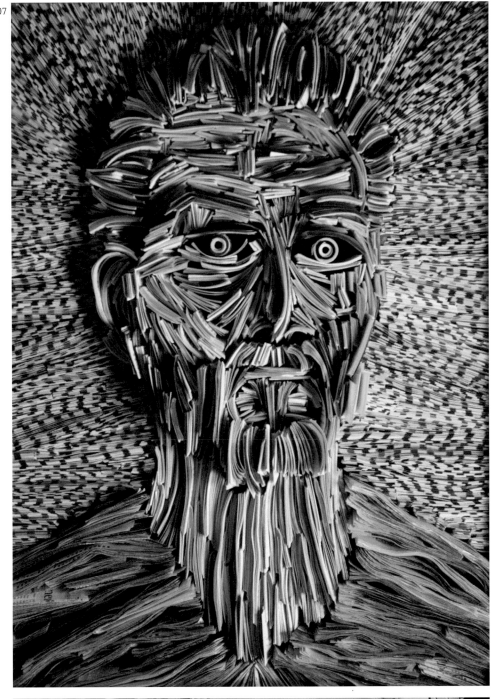

Nick Georgiou

Amongst Nick Georgiou's artistic influences are salvaged family artifacts: old books, frayed sepia photographs, and half-scorched icons. Now that traditional publications are threatened with extinction, it could be argued that all printed material will soon be an artifact. Instead of letting the printed material fade into the past, Georgiou chooses to give it a new use by turning it into art.

05 Massachusetts Man
Portrait made from archival books and acrylic paint.

06 Green Me
Portrait made from discarded books.

07 The Author's Description
Portrait made from the *Financial Times* and discarded books.

08 Titus (detail)
Portrait made from newspaper including the *Financial Times, Arizona Daily Star,* and discarded books.

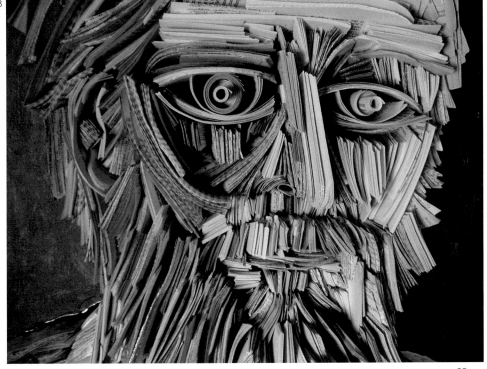

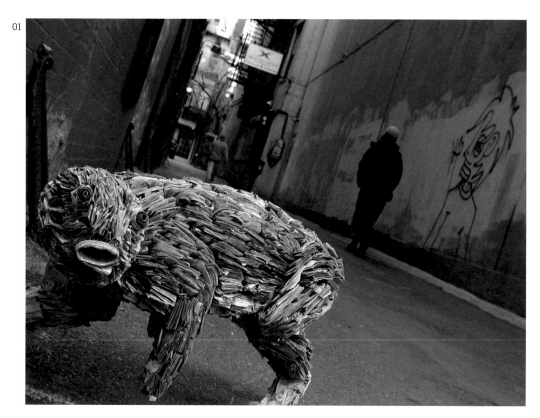

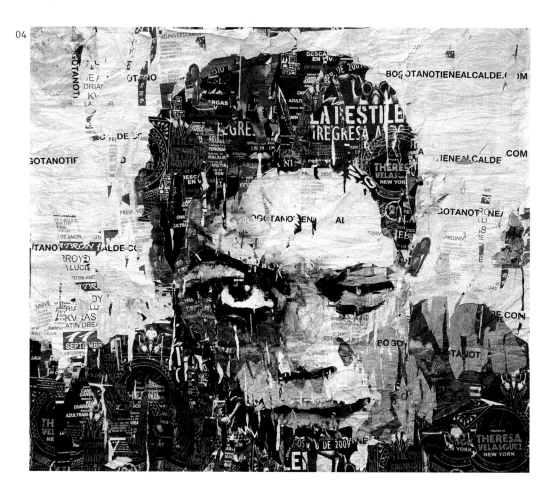

Nick Georgiou

01 Freeman's Alley
02 Android
03 Daily Reader
The newspaper sculptures created by Nick Georgiou are a product of their environment; by using local newspapers, Georgiou attempts to reflect the personality of a city and a personal connection to that city in each piece.

Nathalia Azuero

04 Poster Boy
Created as a street poster décollage, the piece references the deconstructed images of the urban aesthetic, which are created through the process of pasting, layering, and tearing down old posters.

05

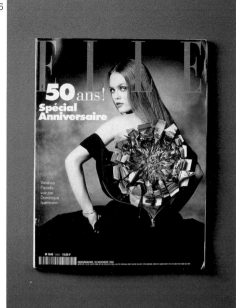

06

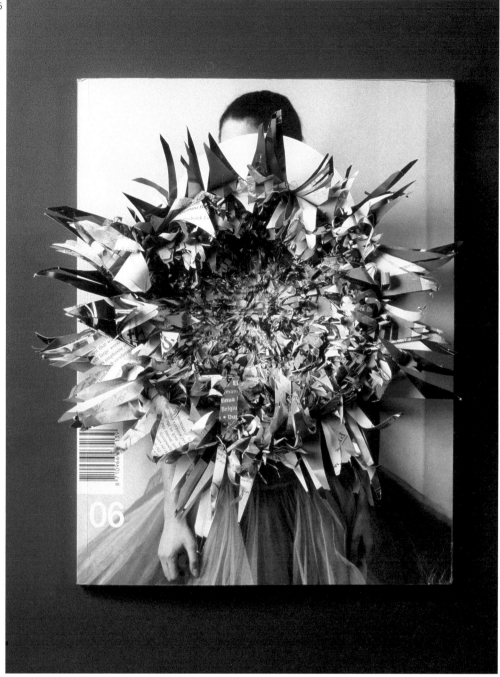

Christopher Coppers

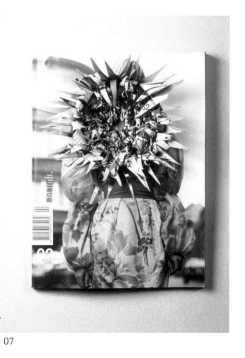

07

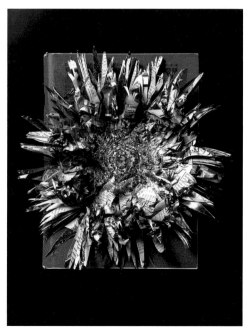

08

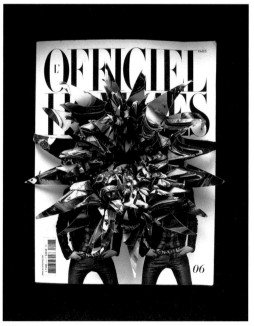

09

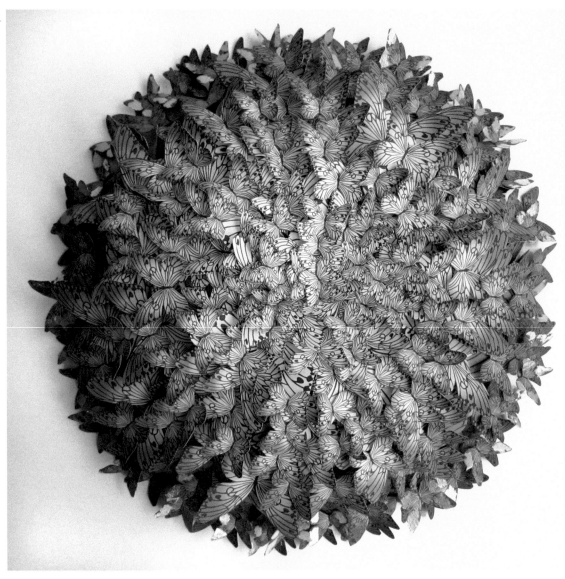

01

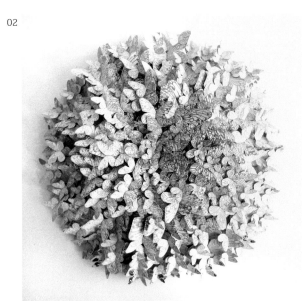

02

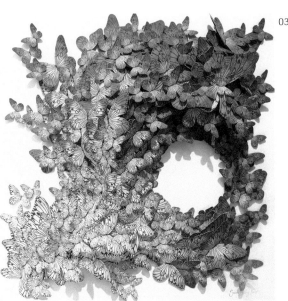

03

Susila Bailey-Bond
01 Flowerbomb
02 We Live in a Beautiful World
03 Firefly

right page
Natasha Bowdoin
Untitled (Alice)
Organic paper sculpture installation
at CTRL Gallery in Houston, Texas,
incorporating layered and interwo-
ven texts from *Alice's Adventures in
Wonderland*.

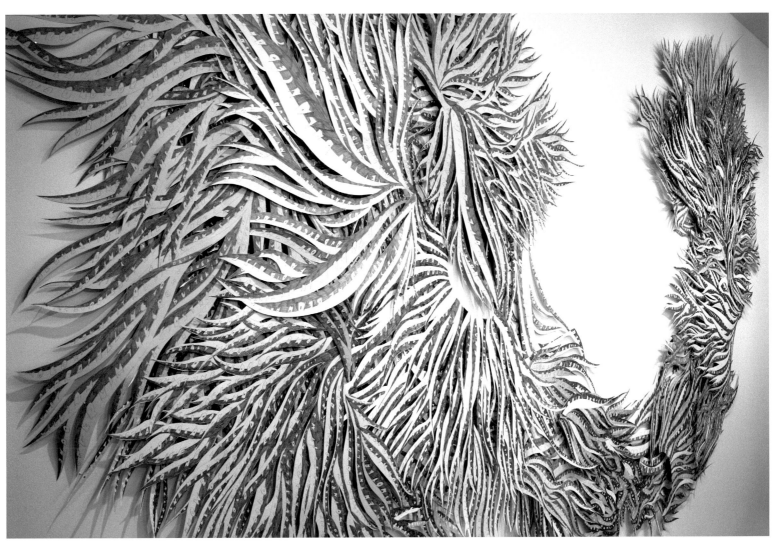

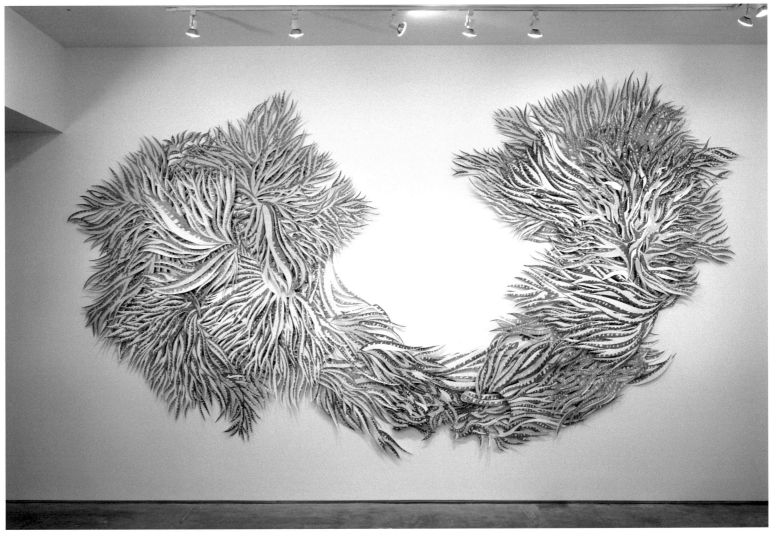

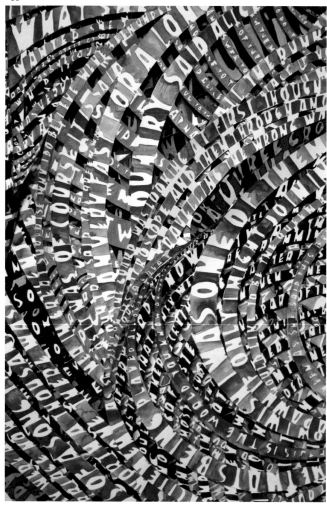

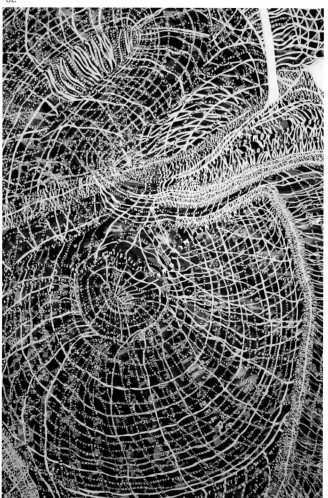

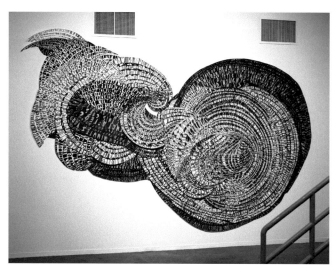

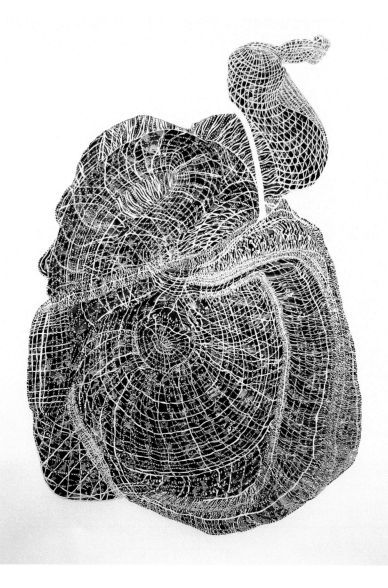

Natasha Bowdoin

01 <u>Tulgey Wood</u>
Thirty-five different drawing pieces referencing Lewis Carroll's *Through the Looking Glass*. Words were laid out, washed with color, and assembled to form segmented circles. Seeking to make a piece that is liberated from language's structural expectations, the translation is a visual process; these drawings are pictures of words, not visualizations of the content or the meaning.

02 <u>Of His Wondrous Tun</u>
Paper sculpture constructed from sections of *Moby Dick* that were transformed into drawn patterns, then cut, reformed, and reassembled.

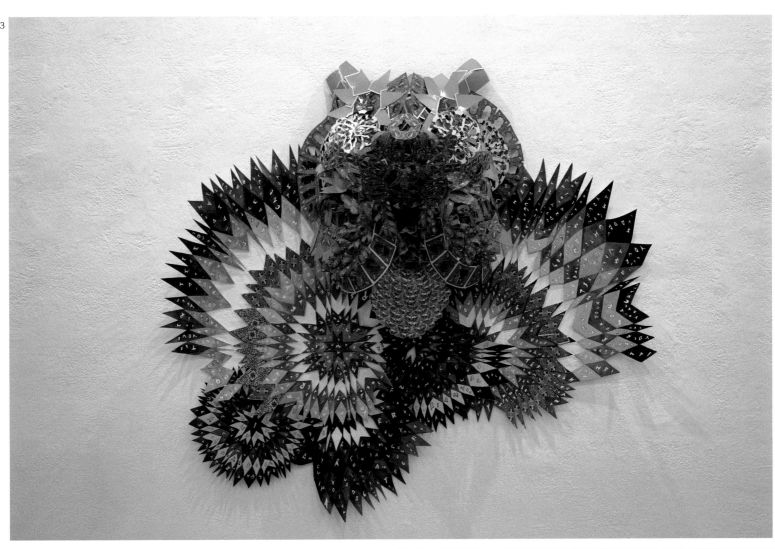

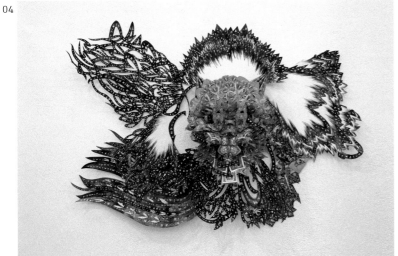

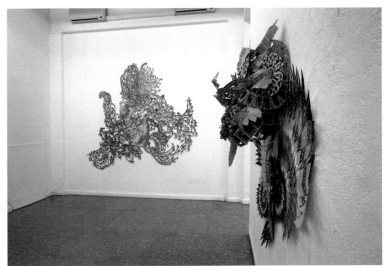

Natasha Bowdoin's paper sculptures and installations take us all the way down the rabbit hole and into the abstract yet organic ramifications of the delightfully surreal narrative of Alice and her assorted peers. Interlaced fronds from afar, interlocking narratives up close, Bowdoin's hypnotic swirls appear to be wafting and moving in front of our eyes, like a mature coral colony. And this motif of interlocking stories and organic paper convolutions re-emerges in most of her works — some jutting all the way into space to reel us back into the reconfigured narrative.

Pulled from several iconic sources, Bowdoin redefines her literary citations through thorough deconstruction of plot, words, and subtext. Other references — old botany illustrations, fables, masks, deep-sea life, her studio floor — occasionally join this maelstrom of volatile patterns. Thus broken up and reconfigured into loose, free flowing rhythms, her works thoroughly transform our perception of language by blurring the line between looking and reading.

Natasha Bowdoin

03 Paper Tiger

04 I Am the Sun in the Morning, I Am a Dog at Night
Multiple decks of playing cards were hand-cut, layered, and reassembled to arrive at this final mask-like creation.

05 Signs (installation view)
Installation view of "Signs," Bowdoin's solo show at Temple Gallery in Rome, Italy.

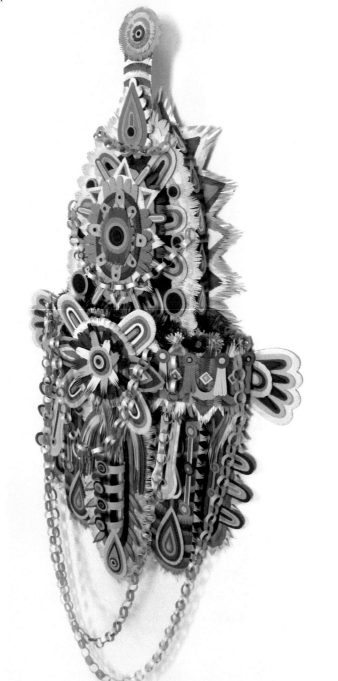

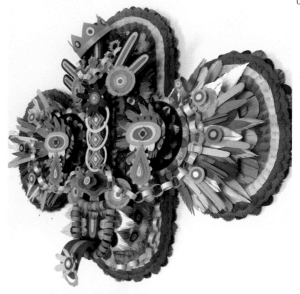

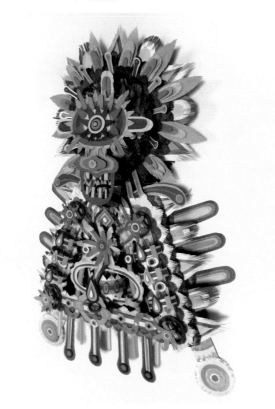

Michael Velliquette

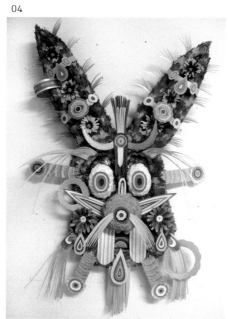

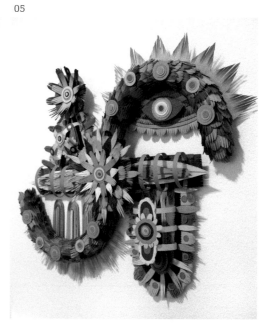

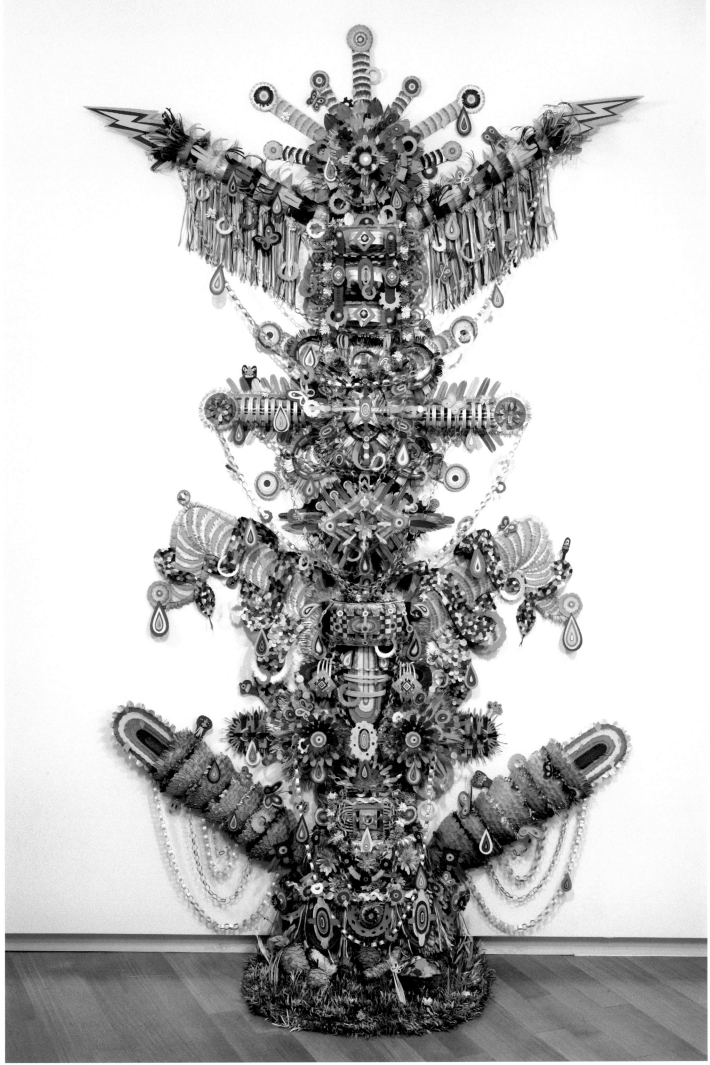

02

Setting the Scene

A few years ago, German art director Mario Lombardo paved the way for tangible, physical illustrations with countless lovingly stitched, embossed, or sliced editorials for the music magazine Spex. Following in the slipstream of repopularized "classic" illustrations, adding warmth and authenticity to magazines and brands alike, their physical incarnations have started to take over printed pages, products, and posters, even billboards and trailers. With their handmade touch and, occasionally, cutesy appeal, they not only imbue their subject with actual depth, but also press all the right subconscious buttons for instant sympathy and endearment, dedication and perceived preciousness.

An undisputed paragon of this trend, Yulia Brodskaya, embellishes campaigns by Penguin Books and Cadbury's chocolate with her jutting whorls and swirls, while Ersinhan Ersin's concert poster — a stylized piano layout, its keys doubling as rip-off information strips — highlights another part of the paper art spectrum. Firmly rooted in culture, fashion, and design, many of the assembled artists lend their talents to mags and music for a cross-pollination of styles, ideas, and — not least of all — kudos. Even superstar Lady Gaga, an artificial work of art in her own right, has discovered the power of collage for a smart reinvention and paper dissection of her carefully constructed self.

Playful assemblages of hole-punched dots, spools of tape, cuts and raised surfaces, these objects, designs, backgrounds, and environments help to set the scene for both medium and message: with the fake solidity of Spaghetti Western saloon storefronts or cleverly constructed Potemkins villages, they venture all the way into space and back to draw us into their world and narrative.

Here, considered use of negative space comes into its own by using the written page as a substrate for cut-out lettering. Simple and immediate, yet infinitely clever, these economical and careful cuts reveal only the essentials. And by relegating pre-existing words to little more than general context, the missing pieces come into their own and serve to spell out underlying statements. Furthermore, silhouettes and shadow play inject a touch of mystery and mystique into (mostly) literary explorations. Like hidden subtext, they afford a glimpse of the multiple layers couched in a particular storyline and help to fill simple, two-dimensional scenes with complex allusions to all those things left unsaid and hovering between the lines.

Delving deeper into the written word, expert typographers use paper and its variants to give shape to ambitious characters, from Arslan Shahid's almost painfully spiky and belligerent Splinter typeface, a reflection on the concept of war, to Ebon Heath's carefully choreographed font convolutes.

At the same time, paper's versatility and makeshift appeal lends itself incredibly well to stop-motion trickery and associated marketing measures. Here, Psyop's deep-set frames of shifting flipbook-style madness meets Bent Image Lab's stunning music video featuring folded paper, morphed backgrounds, monochromatic geometric shapes, and kaleidoscopic images. Both as a playground for experimentation and novel techniques (or rediscovery of forgotten ones), and as an immeasurably valuable marketing tool, this particular subset of animated paper art not only offers an effective — and affecting — means to tell a story, from saving the world (WWF) to brazen selling (UPS), but also opens up an entirely new frontier of engineering challenges, with no end to innovation in sight.

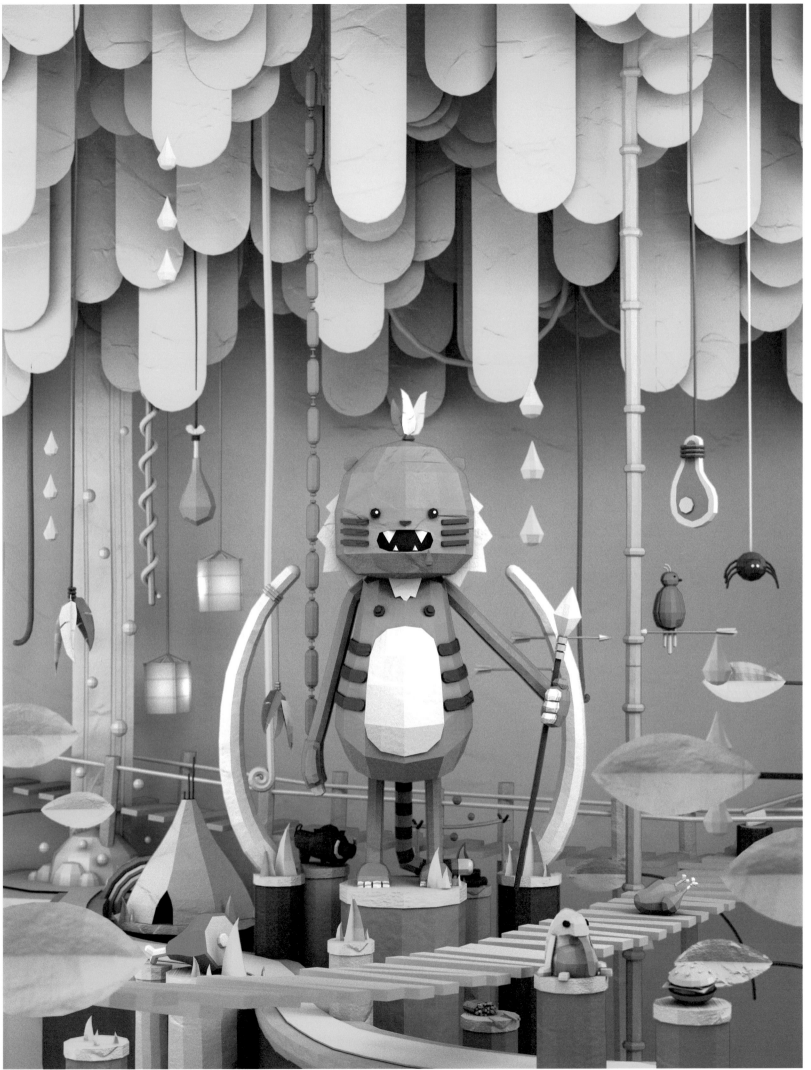

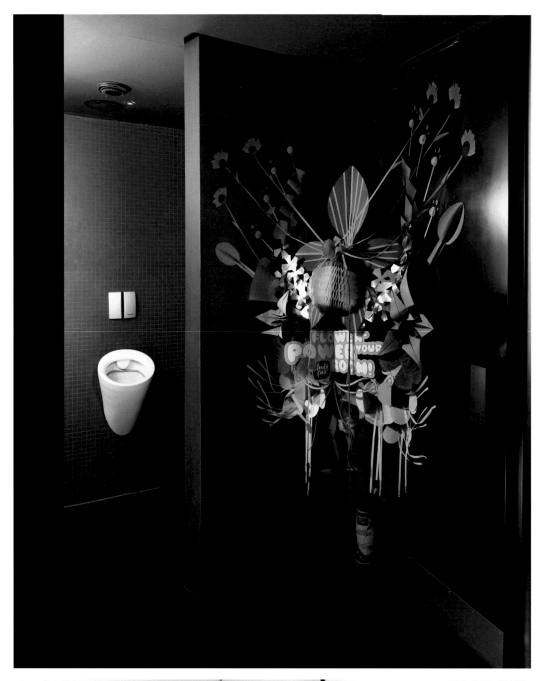

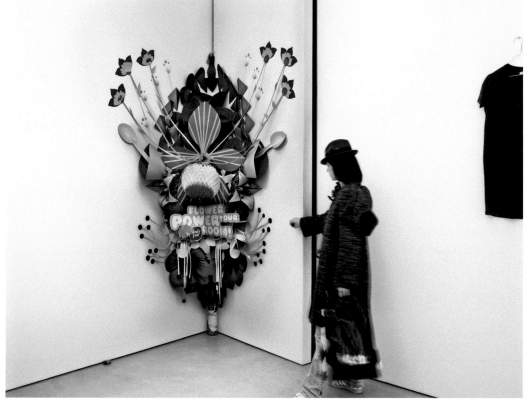

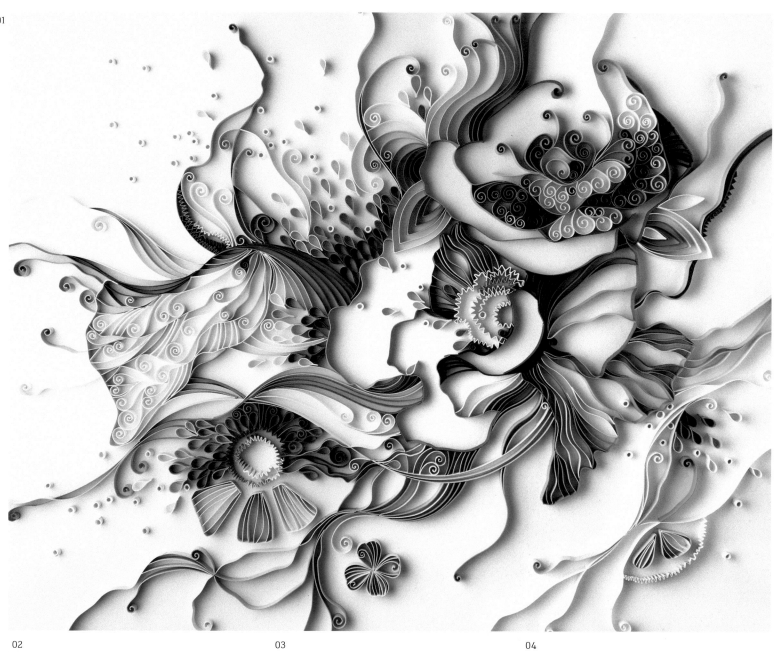

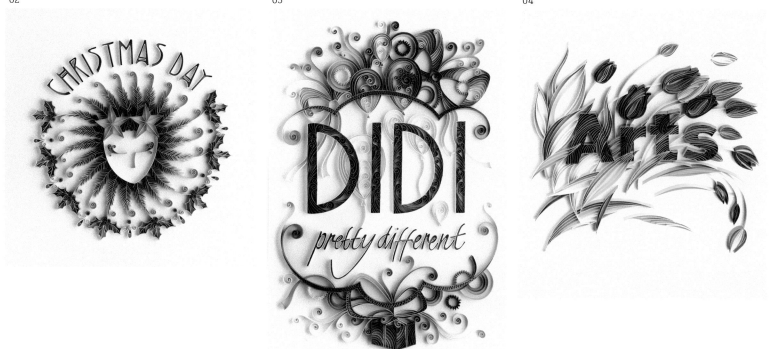

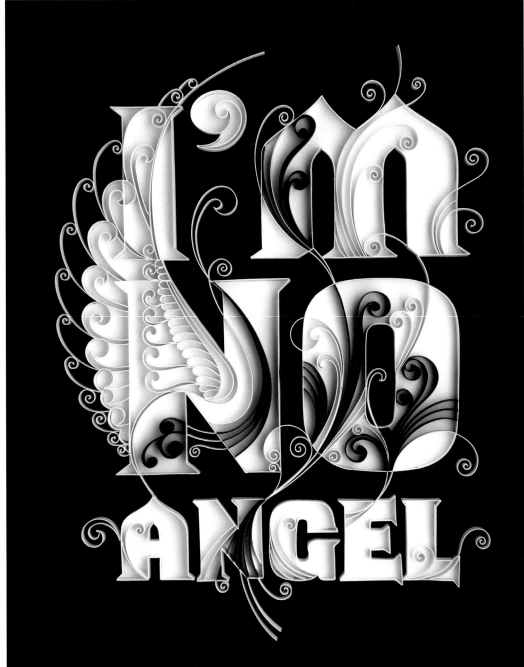

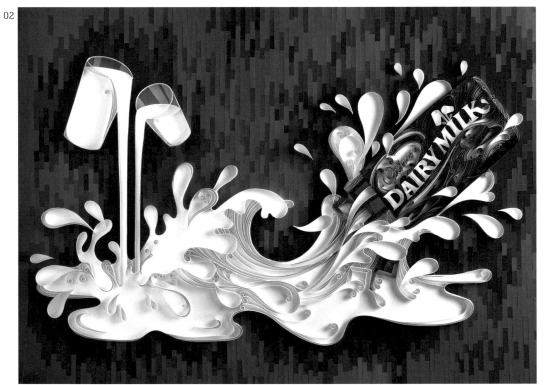

Yulia Brodskaya

01 I'm No Angel
Cover illustration for the book
Vanity Fair by William Thackeray.
Published by Penguin Books.

02 Cadbury
Illustration for a Cadbury campaign
in Ireland capturing the journey of
a glass and a half of milk into a
Cadbury Dairy Milk chocolate bar.

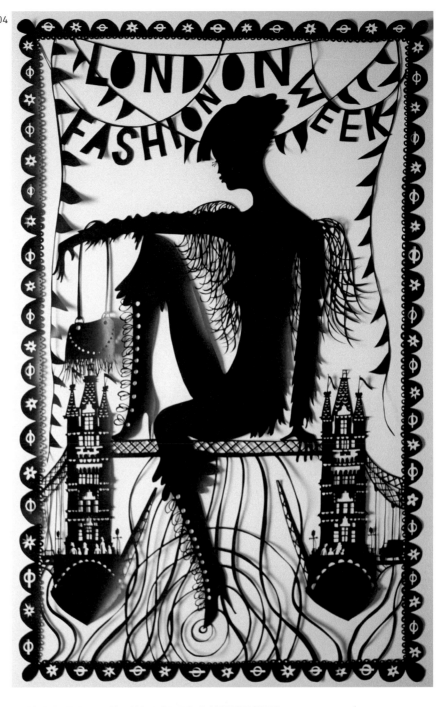

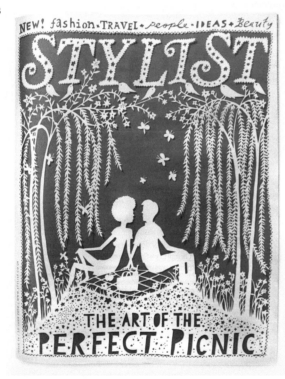

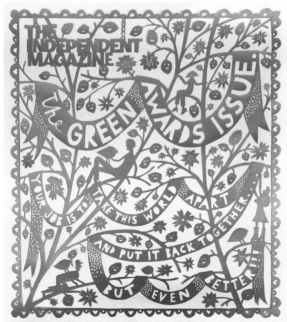

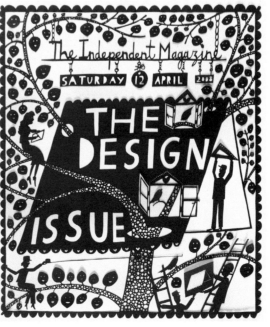

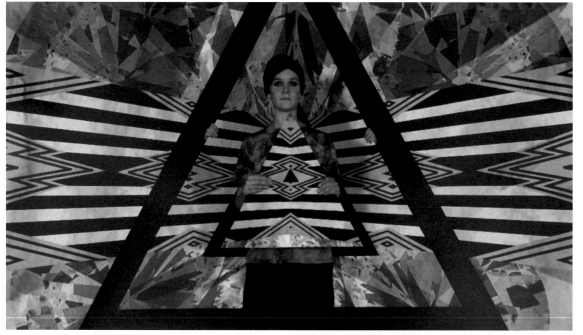

**Lucinda Schreiber &
Beatrice Pegard**
Midnight Juggernauts "Lara vs
The Savage Pack"
Stop-motion music video featuring
folded paper, morphed backgrounds,
monochromatic geometric shapes,
and kaleidoscopic images. The nar-
rative shows a continuous thread of
people — including the band — inter-
acting with animated paper while
merging in and out of the back-
ground. Both the symmetry used to
frame shots and the color palette
were inspired by the work of Chilean
filmmaker Alejandro Jodorowsky.
Video and stop-motion animation
were edited together then digitally
reprinted and reanimated, a process
that added further animated folds,
creases, and tears to the final piece.

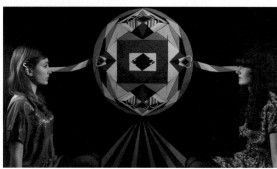

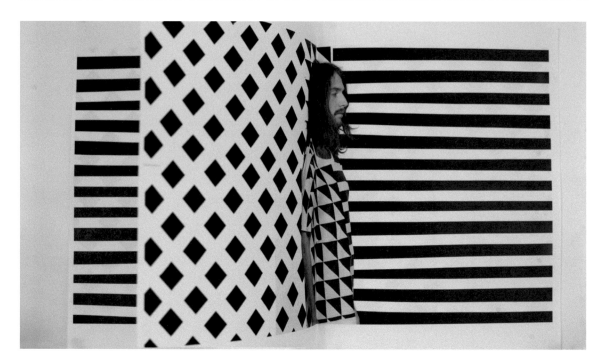

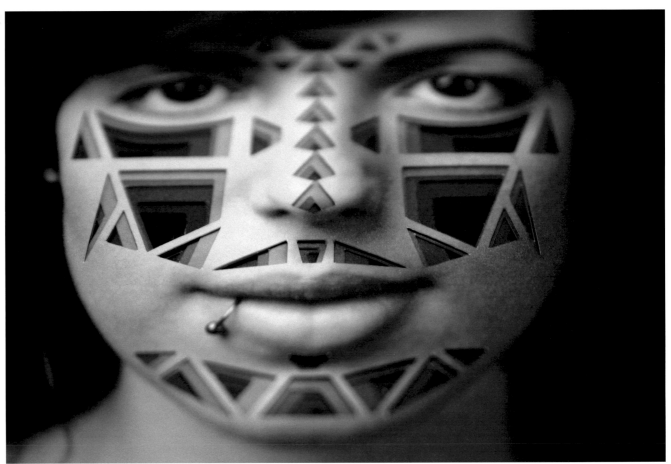

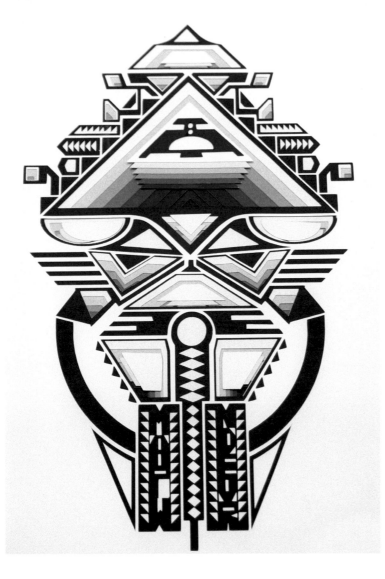

Le Creative Sweatshop

01 <u>Mamz'Hell</u>
Record sleeve design for the French DJ Mamz'Hell. Her minimalist electronic rhythms are reflected in layers of paper.

02 <u>Aztec Design</u>
A further collaboration between the French artists Ndeur and Make A Paper World; modern paper graphics influenced by Aztec patterns.

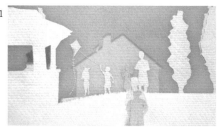

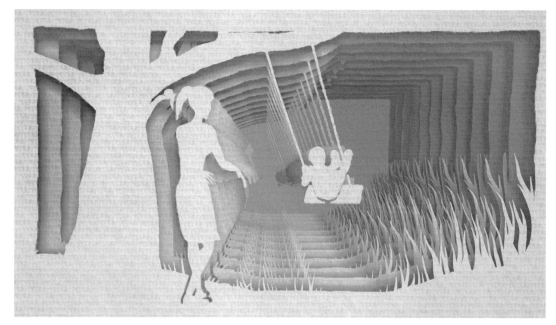

Bent Image Lab / David Daniels & Nando Costa

01 Scott Naturals: The Right Blend
Commercial that takes the viewer through a world made from hundreds of layers of paper towels using one continuous camera shot. Combining paper and CG, the piece was created with the stop-motion Stratastencil technique, which animates a stack of stencils that stretch away from the camera. Like cell animation, each frame captures a new stencil that is changed in small increments; unlike cell animation (in which one cell completely replaces another), each new stencil is placed in front of the stack while the older ones are moved back and away from the camera.

Lobo

02 IKEA: Catalog
Commercial promoting the 2011 Ikea catalog using stop-motion animation to follow the thoughts of a couple, who imagine different possibilities for their bedroom as they flip through the catalog. Stacks of pictures were assembled for the various pieces of furniture. The top layer of each stack was slowly folded, curled, and peeled away in order to reveal the layer underneath.

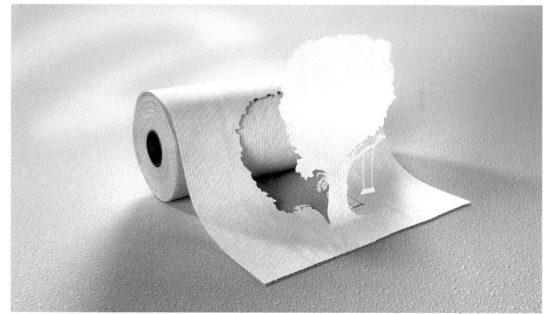

01

02

03

01

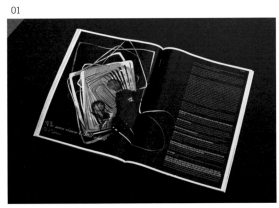

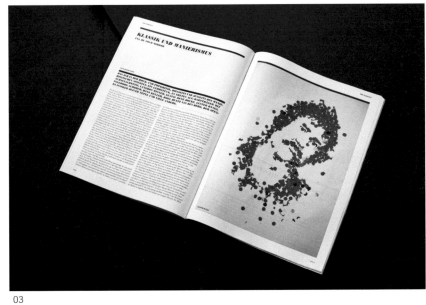

03

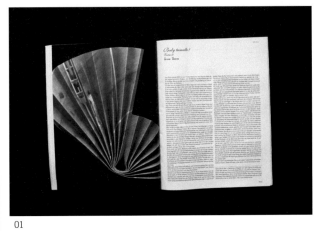

01

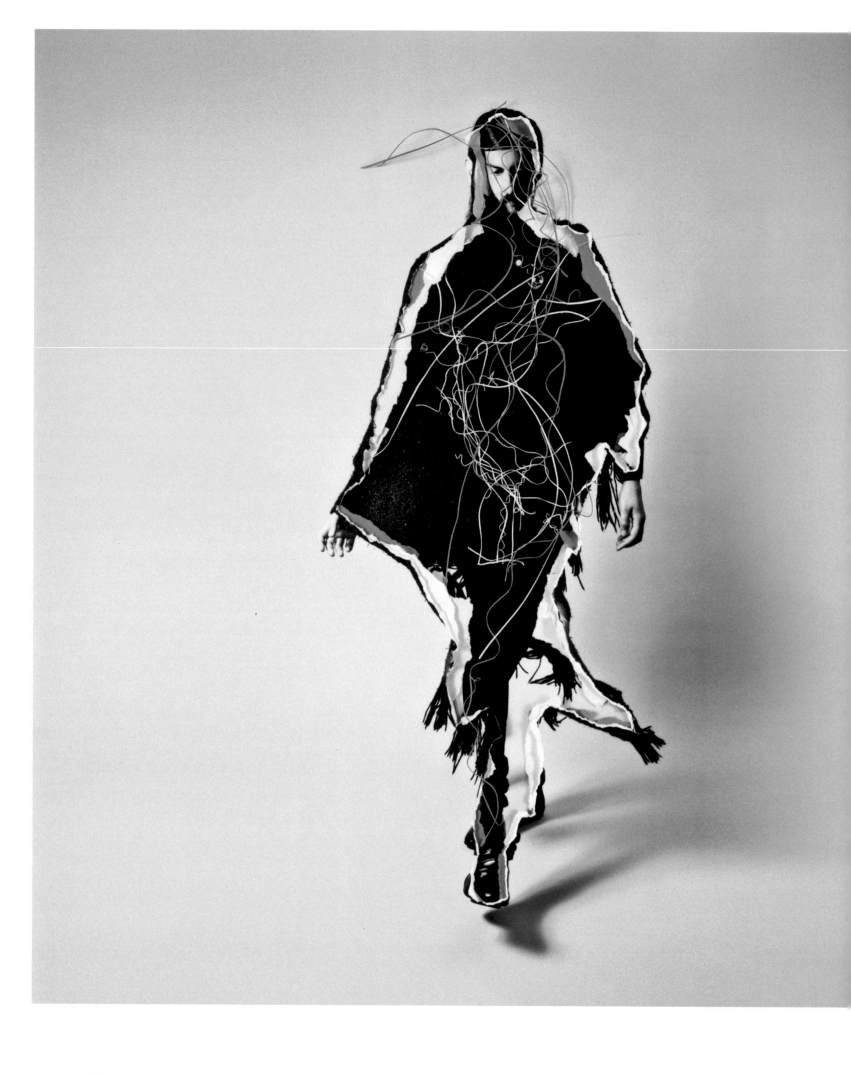

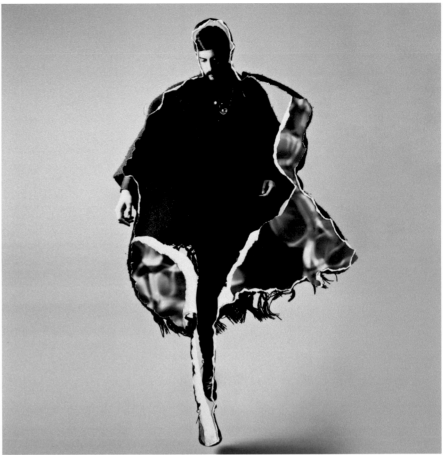

THERE IS AN OCEAN
MUSIC BY MARISOL LIMÓN MARTÍNEZ
LYRICS BY SCOTT WILLIAM MATTHEW

MY LOVE LIES OVER THE OCEAN
LONG AGO IT FUMBLED IN MY HANDS
I'M A FOOL TO STOKE AND TEND A DYING FIRE
THAT WILL NEVER MAKE IT BACK TO LAND

DROWN ME SWEETLY
SEA OF TEARS SO FAR FROM SHORE
I HAVE PLUCKED THIS LAST HEART STRING FOR A SONG
DRAG ME DOWN TO DEEPEST DEPTHS AND LEAVE ME THERE
I SHALL LONG FOR YOU NO MORE

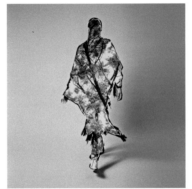

WHITEHORSE
MUSIC & LYRICS BY SCOTT WILLIAM MATTHEW

SHEPHERD ME FROM PAIN AND THE DOUBT
THROUGH THE BROKEN STREETS AND THE HEARTS
HERD ME HOME THOUGH HURT AND THE PAST
THEN LEAVE ME, ONE YOU HAVE NO CHOICE
AND NOW THERE IS A WHITE HORSE CAGED IN MY HEART
AND IT'S GOING TO KILL ME JUST TO GET OUT
NOW THERE IS A WHITE HORSE CAGED IN MY HEART
AND IT'S TRYING TO KILL ME JUST TO GET OUT
THOUGH WE'RE DIFFERENT CREEDS, WEAR DIFFERENT MASKS
IF YOU ONLY COULD CONCEIVE THAT THERE'S A CHANCE
AND HELL IS BENT ON SHOWING ME THE DARK
SHEPHERD ME TO LIGHT, MAKE IT STOP

GERMAN
MUSIC & LYRICS BY SCOTT WILLIAM MATTHEW

NO PSYCHIC WARNING
YOU WOULD LEAVE ME IN MOURNING
FROM CHILDISH SEDUCTIONS
WITH FAMILIAR CONCLUSIONS

HIGH ON THE PAVEMENT
THEN SO LOW IN THE AIRPORT
NO TEXT BOOK ON THERAPY
WILL STOP ME ADMITTING DEFEAT

IF MY ENGLISH WERE BETTER
COULD I'VE CURVED THIS DISASTER
I DON'T KNOW

THE SWEETEST OF FLOWERS
ON THE CRUDEST OF ALTARS
I CONFIDE IN A PICTURE
AS I'M BREAKING MY PROMISE

THAT IF I JUST HOLD IT TOGETHER
I CAN CURVE THIS DISASTER
I DON'T KNOW
I DON'T KNOW

IF I'D JUST FOUND THE HUMOR
COULD I'VE CURVED THIS DISASTER
WELL I DON'T THINK SO
I DON'T THINK SO

MAKE IT BEAUTIFUL NOW

Bureau Mario Lombardo
Scott Matthew: *There Is an Ocean That Divides and with My Longing I Can Charge It with a Voltage That's So Violent to Cross It Could Mean Death*
Album artwork that emotionally investigates the artist Scott Matthew by creating an empathic visualization of his music. The multilayered, colored paper uncovers many facets of Matthew; beauty, melancholy, and inner turmoil.

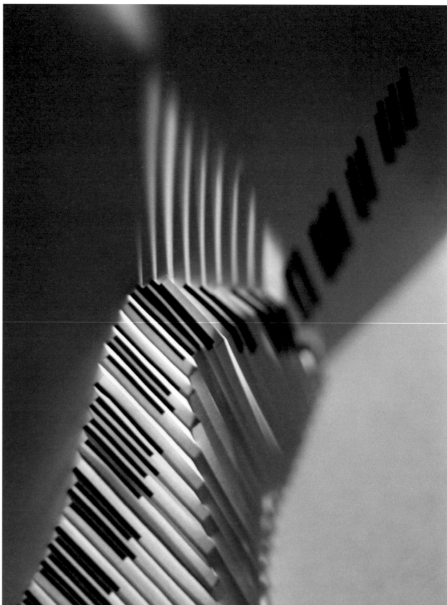

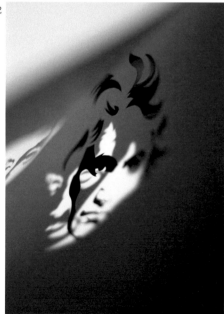

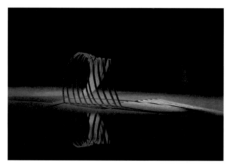

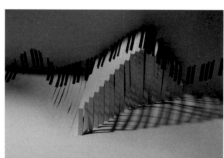

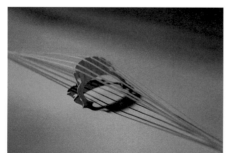

Andersen M Studio
Southbank Centre Classical Season
01 Catalog images for Southbank
Centre Classical Season 2007/2008.
02 Stop-motion animations for
Southbank Centre's 2007/2008
season. Single sheets of paper were
cut and shaped into a range of
instruments and composers' faces
for each short film. Images of the
animated models were used on the
event catalogs.

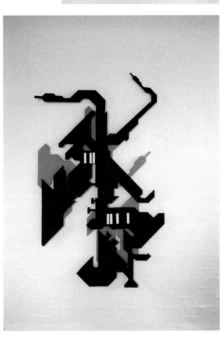

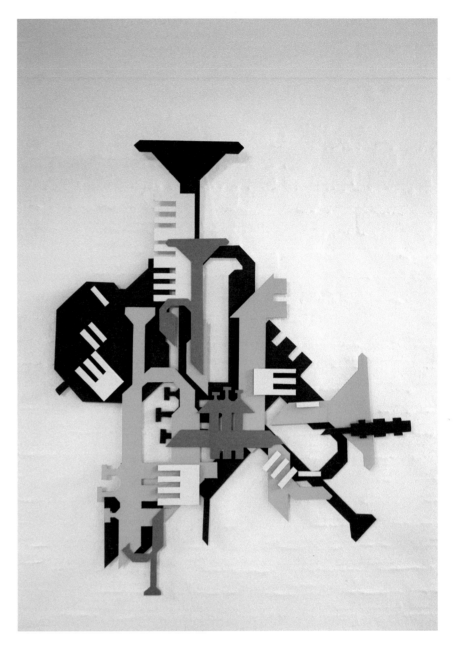

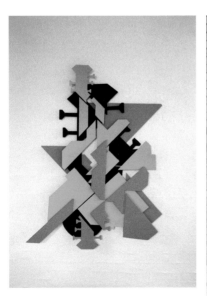

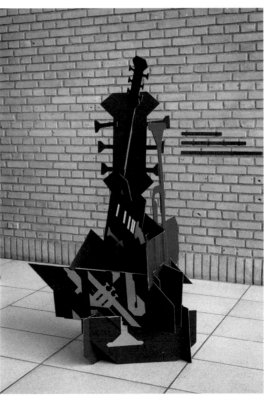

Rikke Otte
Jazz Scenography
Scenography created for a day of
experimental jazz concerts during
the 2009 Aarhus Jazz Festival
in Denmark. Experimental and
electronically remixed jazz music
was visually represented by decon-
structed shapes of traditional jazz
instruments.

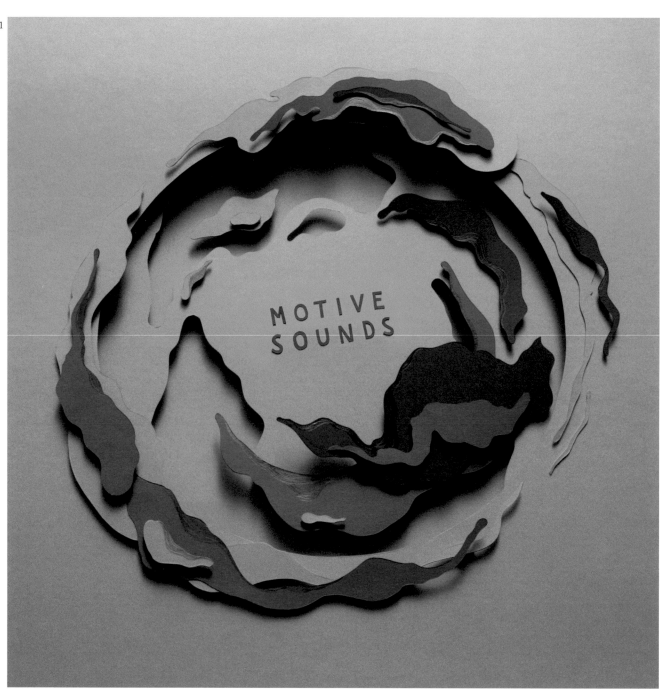

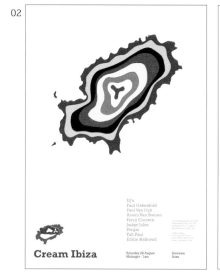
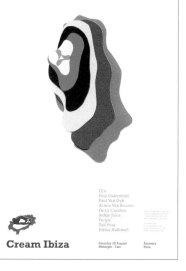
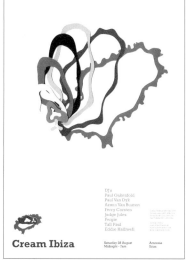

Owen Gildersleeve

01 Motive Sounds
Multilayered illustration created as a promotional piece for Motive Sounds Recordings, an indie record label based in the U.K.

Sarah Ferrari

02 Cream Ibiza
Poster series promoting the club Cream Ibiza. Paper cutouts of the island of Ibiza morph into the Cream logo.

03

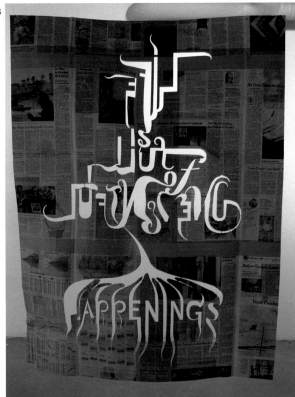

Satoru Nihei
03 Uneventful Stories (Illuminated)
An attempt to capture unseen moments, untold stories, and uneventful happenings so that they will not be forgotten.

Tom Bücher
04 Anatomy of a Layout
Research piece on the intrinsic structure of paper as a medium taking constraints such as baseline grid and column into account.

04

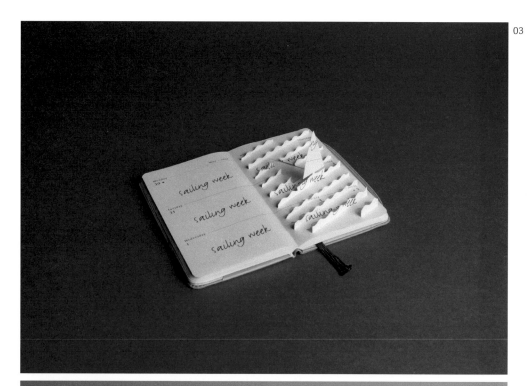

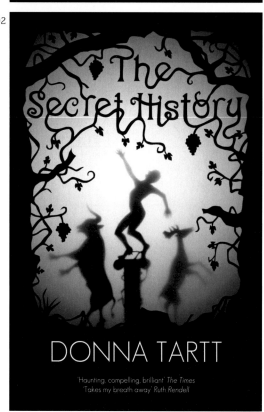

Zim & Zou

01 Please Recycle
A project based on recycling logos
using recycled papers.

Kyle Bean

02 The Secret History
Shadow puppets photographed on
a paper silhouette set for the cover
of *The Secret History*, a novel by
Donna Tartt.

Rogier Wieland

03 Mini
Stop-motion animation for the new
extra-small planners and diaries
from Moleskine. 533 animated
pages were reproduced in Illustrator,
printed out on Moleskine paper,
then cut out and glued inside the
planners.

Mathilde Nivet

04 Vanité
Invitation card for a solo exhibition
at the Vanves Theater in Vanves,
France.

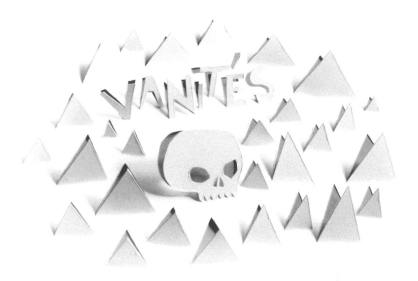

Sehsucht

05 <u>Smart: 10 Years</u>
Ribbons of paper form immediately recognizable shapes such as the Eiffel Tower, the Statue of Liberty, and the Smart Car.

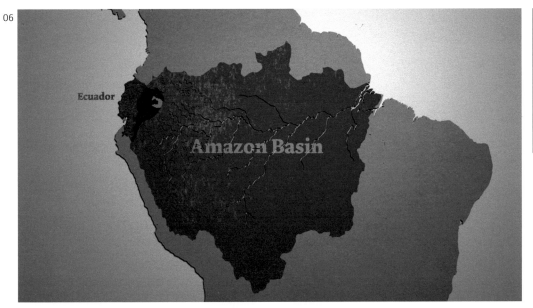

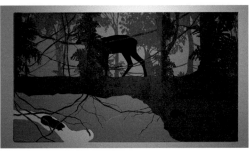

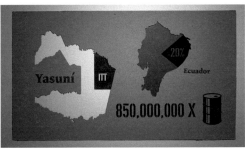

Rogier Wieland

06 Yasuní-ITT
Infographic video about the Yasuní-ITT, a project from Ecuador that proposes a new alternative to avoiding oil extraction in the Yasuní National Park. Produced in collaboration with Santiago del Hierro, an Ecuadorian architect who works on urban development patterns in the Amazon region in Ecuador and Peru.

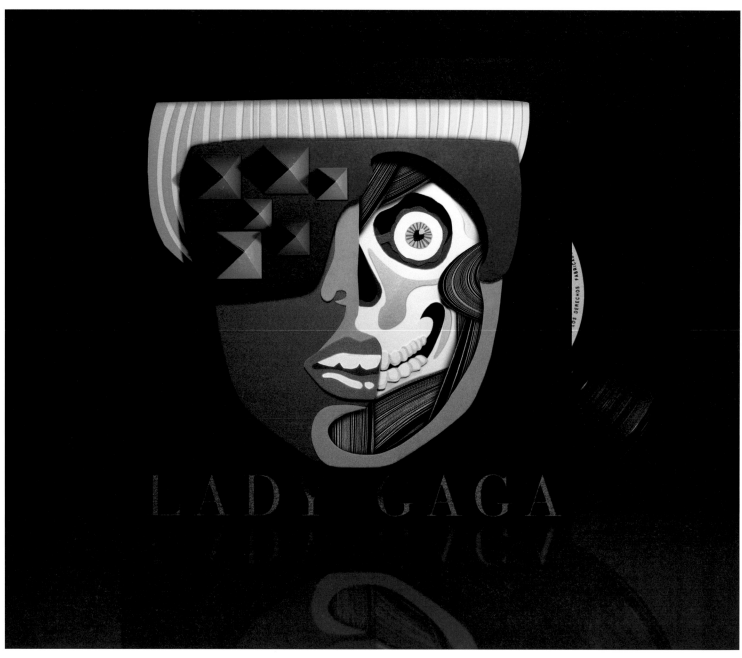

Lobulo Design

01 Lady Gaga Album
Album cover made with layers of
die-cut cards.

Yulia Brodskaya

02 Shift
Illustration for Oprah Winfrey's
magazine O.

03 5 March, 6 September
Illustrations for the Danish bank
Spar Nord highlighting special
dates on the calendar.

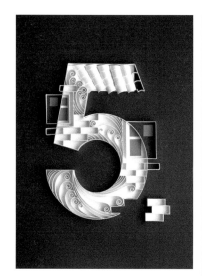

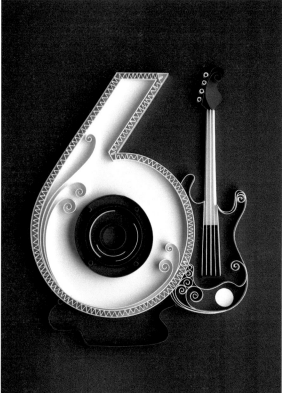

02

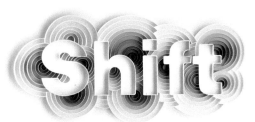

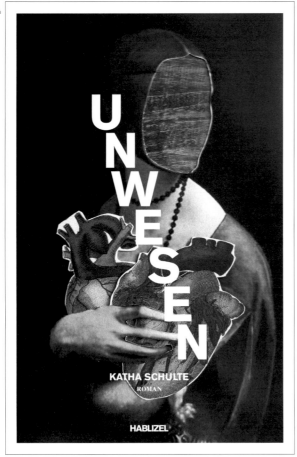

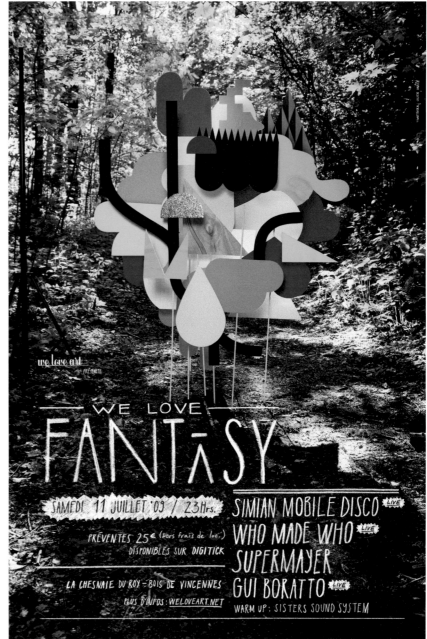

Bureau Mario Lombardo

Julien Vallée

Ersinhan Ersin

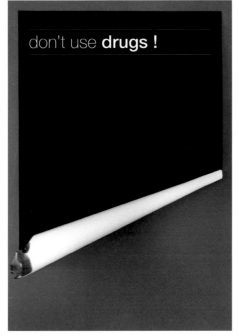

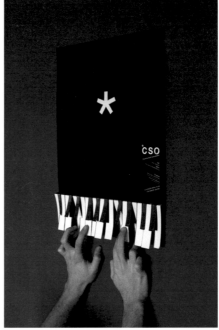

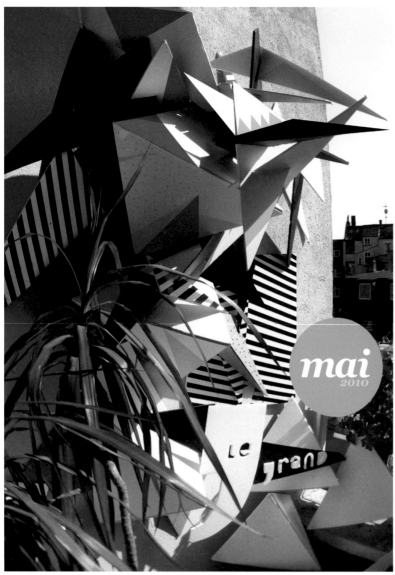

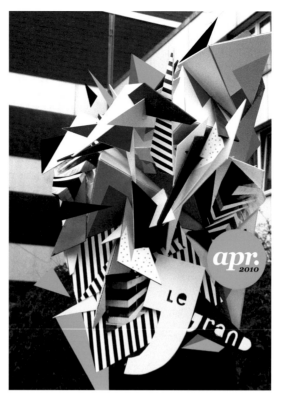

Clemens Behr
01 Le Grand Mai, Le Grand April
Monthly program design for Club
Le Grand in Dortmund, Germany
consisting of a three-dimensional
poster reflecting the surroundings
and the season.

Happycentro
02 PaperObject 004, PaperObject 001
Self-promotional piece.

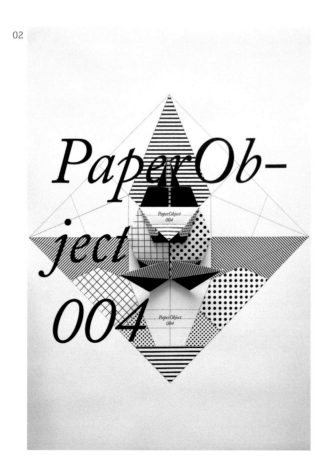

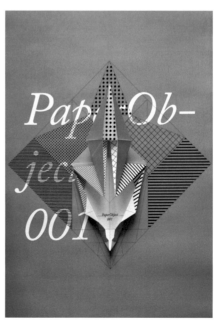

Arslan Shahid
<u>Splinter</u>
Typeface made from triangular
pieces of black mounting board to
reflect the concept of war. Each
piece stands no more than 23
centimeters tall.

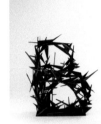

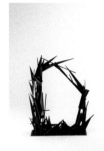

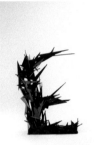

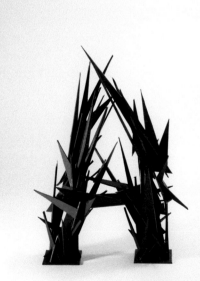

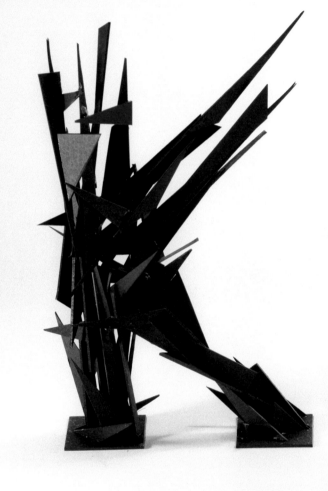

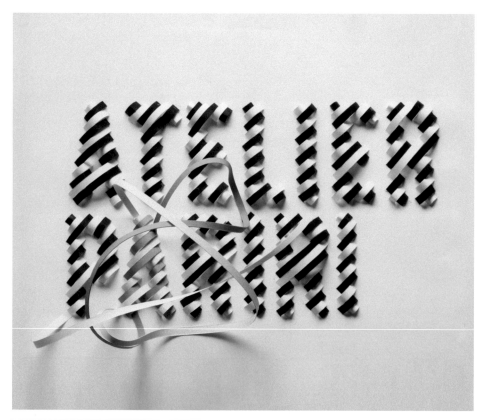

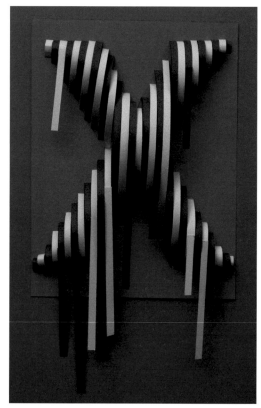

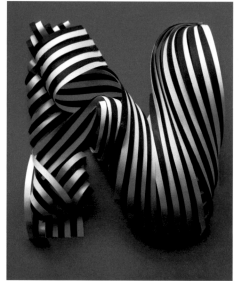

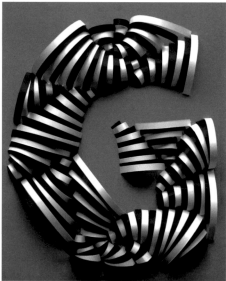

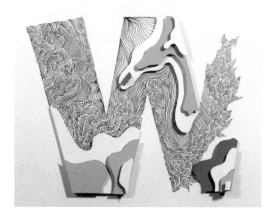

Pariri
Jérôme Corgier
3D Typography Experience

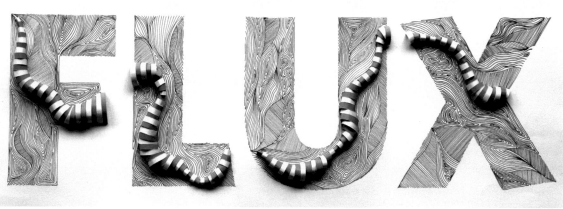

DIPLOMAT

ESTABLISHED 1947

JUNE 2010 £10

ISRAEL ISSUE

AZERBAIJAN'S ENERGY POLICY • UK ELECTION ANALYSIS

UKRAINIAN DEMOCRACY UNDER SCRUTINY

Benja Harney / Paperform

01 Woven Cover and Packaging Suite
for Shigeru Ban Architects
A woven paper report cover and
presentation box designed and
engineered for the Japanese archi-
tect Shigeru Ban. Constructed from
white and recycled brown card
stock, it is a nod to the simplicity
of Japanese design and the work
of Shigeru Ban.

Helen Friel

02 Diplomat Magazine
Cover illustration for *Diplomat*
magazine's "Israel" issue.

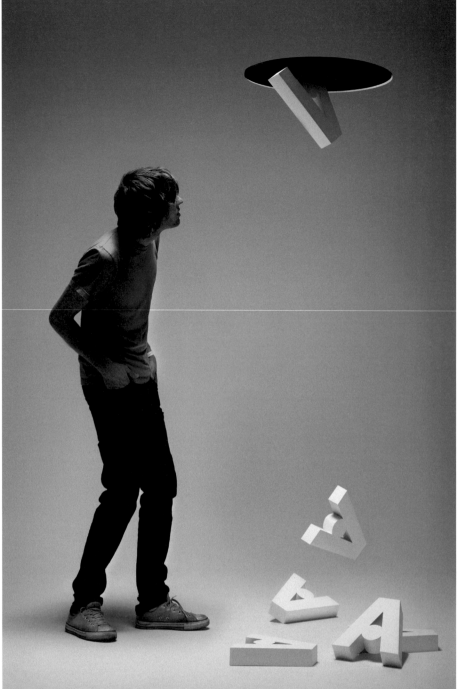

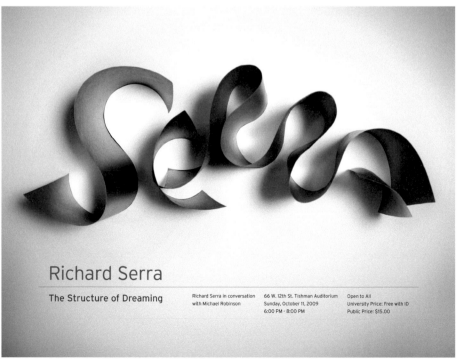

Richard Serra

The Structure of Dreaming

Richard Serra in conversation
with Michael Robinson

66 W. 12th St. Tishman Auditorium
Sunday, October 11, 2009
6:00 PM - 8:00 PM

Open to All
University Price: Free with ID
Public Price: $15.00

Julien Vallée

01 A is for Award
The "A" is an award presented to emerging creative talent by the creative agency YCN. Recipients are surprised with an "A" fabricated in a material or process related to their practice.

02 Arctic Is Melting
Illustration accompanying an interview with the artist in *XLR8R* magazine.

Daisy Lew

03 Richard Serra Lecture Poster
Poster promoting a lecture by Richard Serra using three-dimensional typography inspired by the sculptor's work.

Ebon Heath
04 Unknown Error
05 Green Delusion
Edition of prints on laser-cut
paper inspired by the four acts of
the artist's performance project,
A Typographic Ballet.

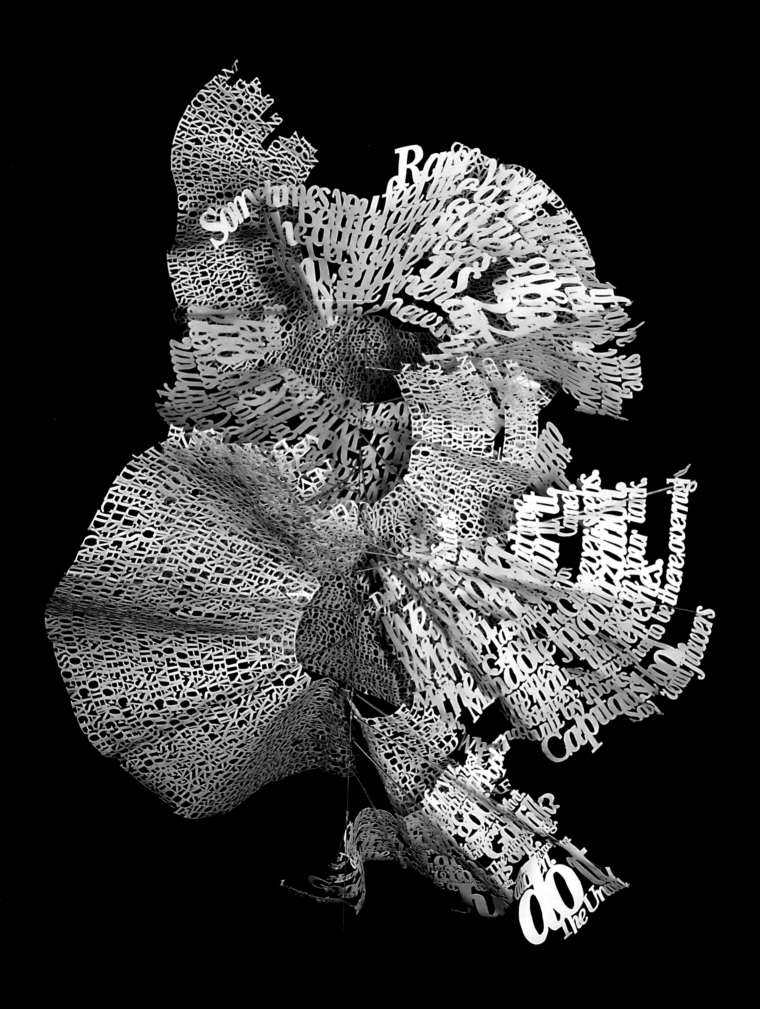

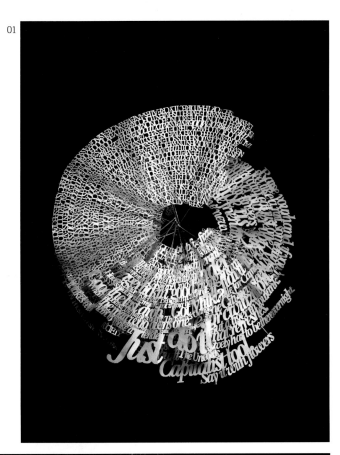

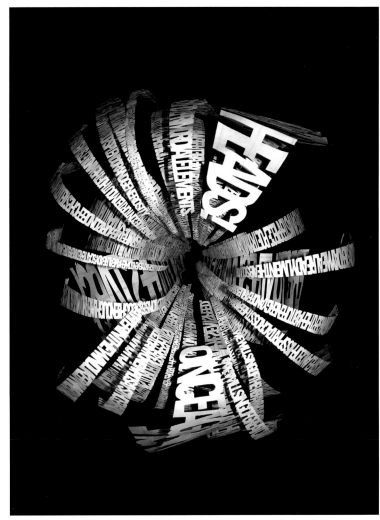

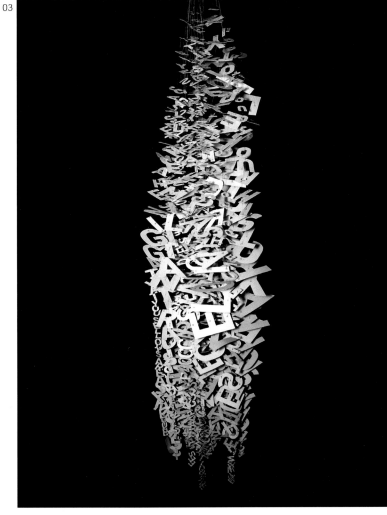

Ebon Heath

Stereo.type — Typographic Mobiles
Initial studies for three-dimensional
typographic grid systems. Made with
hand-cut Tyvek and Bristol.

01 Spiral Study: Channel Surfing
(side view and bottom view)
02 Cone
03 Line Study: Shout Out

Stuck for words? Look no further than Ebon Heath's concise typographic tangles and explosions of dense — and diligently filleted — tracts and treatises.

With his instinctive grasp of geometry and spacing, a knack and skill required in both typography and installation, the Berlin-based New Yorker explores the lines and lives of his chosen letters and takes characters, words, and memes to the point of dissolution.

Take *stereo.type*, a range of typographic mobiles that distort our sense of direction and, well, sense. Conquering space and semantics, they might form flocks and swarms, spiraling out of control, or venture into the depths of meta interpretation with shavings of text reappropriated from Tupac Shakur, Guy Debord, or Indonesian poetry, among others.

In his ventures beyond standard Western fare and alphabets, the artist remains equally open to less conventional materials (laser-cut gold paper, Tyvek) or alternative means of expression. A perfect example: his *Typographic Ballet*, a multimedia whirlwind of a performance that left his viewers literally lost for words.

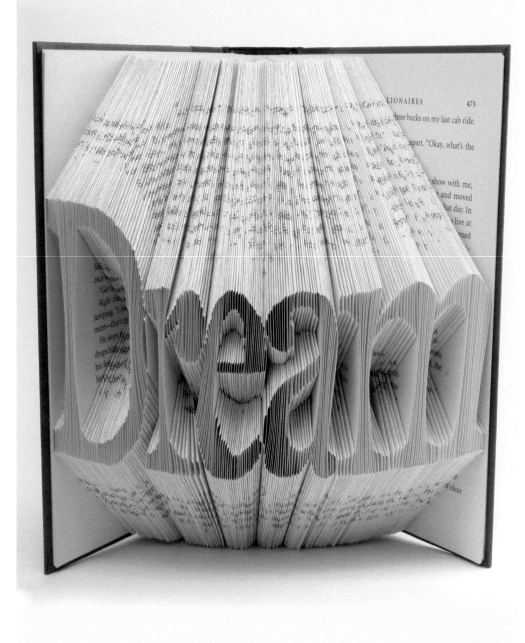

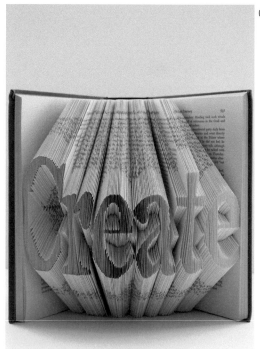

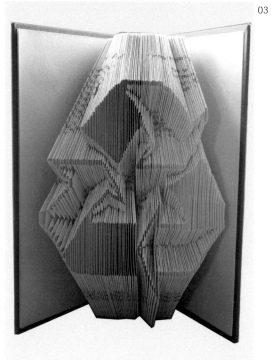

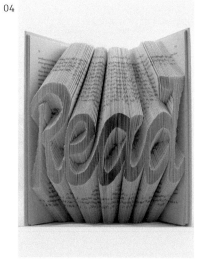

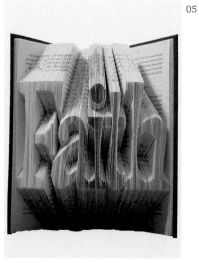

Isaac Salazar

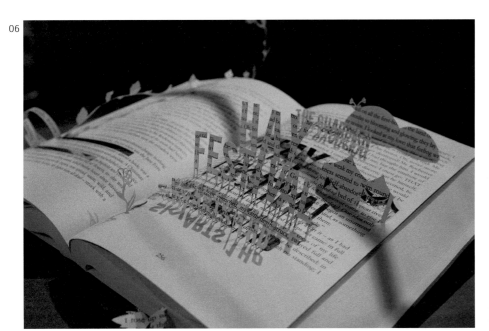

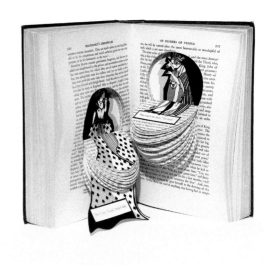

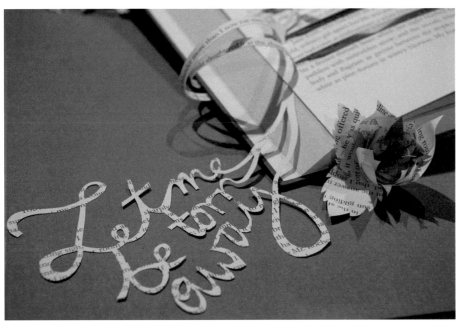

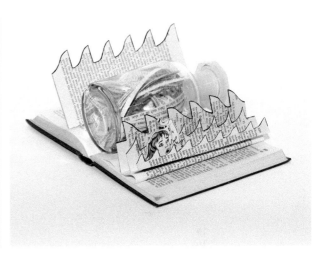

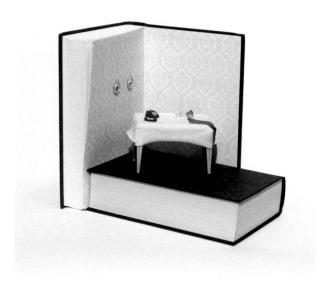

ContainerPLUS

06 <u>Hay Festival</u>
Book installation for SkyArts.

07 <u>Lutyens & Rubinstein</u>
Installations created for the book-
shop Lutyens & Rubinstein.

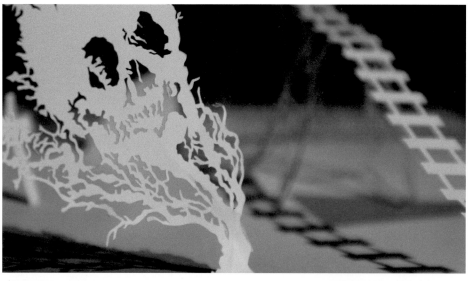

Andersen M Studio

Going West

Animated extract from Maurice
Gee's novel, *Going West*. The film
was used as a movie and television
commercial and released on DVD as
part of a promotional pack for the
upcoming film, *Under the Mountain*.

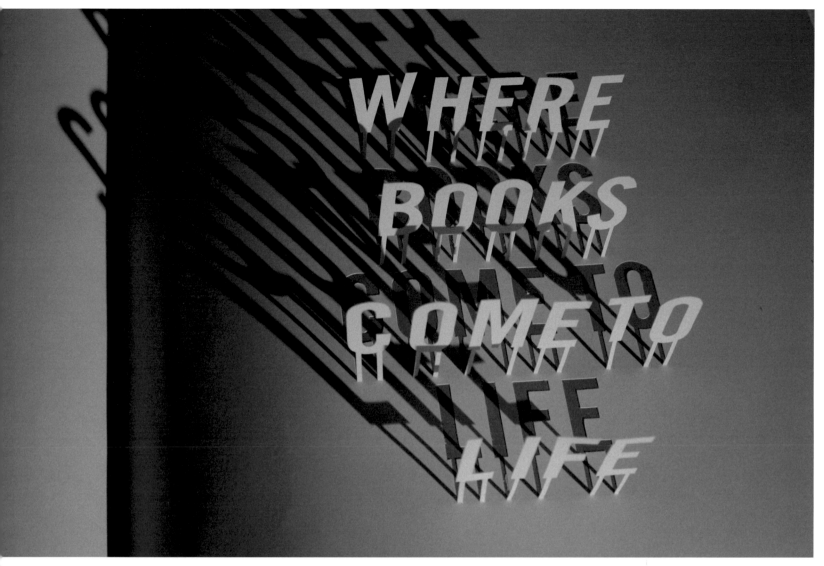

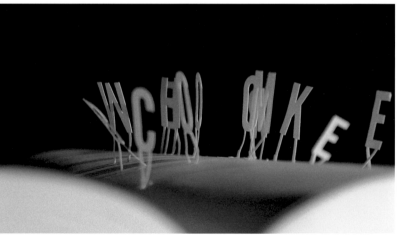

Experts of otherworldly stop-frame animations, siblings Line and Martin Andersen pool their prodigious skills to show us where books come to life — and to breathe a sense of joy and excitement into the humble medium. After all, every book has a story to tell beyond the one contained in its pages. In the studio's short clip for the New Zealand Book Council, words escape the cover to follow the train and trail into the wilds of New Zealand. Composed of around 3,000 still images, the entire animation was created by hand, using nothing but 10A scalpel blades, paper, and two SLR cameras.

Another foray into the written page, a teaser for Kate Morton's thriller *The Distant Hours*, added smoke machines, fire, and pigment dust to the mix in a rich, Victorian scare story that contains more than a hint of Poetic threat and justice. With the keenest of eyes for extreme tension and delight, wonder and ominous darkness, the two Andersens rely on dramatic lighting for added depth of field and suspense.

On a different note, their series of brief promo clips for Southbank Centre's Classical Season 2007–2008 turns single sheets of A4 paper into a range of instruments or iconic composers' faces. Cut to the music, these tiny snippets expose and underscore different sides, rhythms, and themes to the varied program, from basic chords to the most intricate of — paper and aural — interplays.

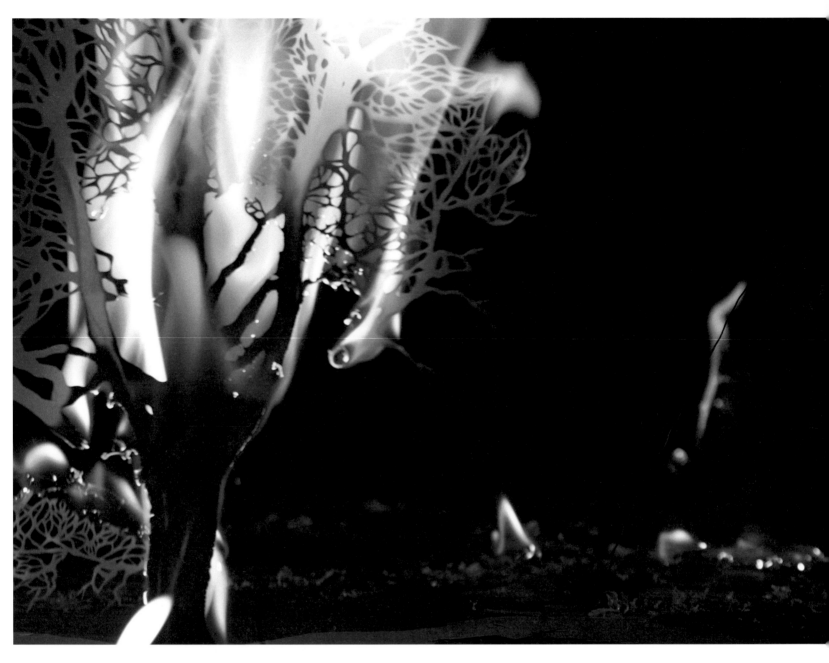

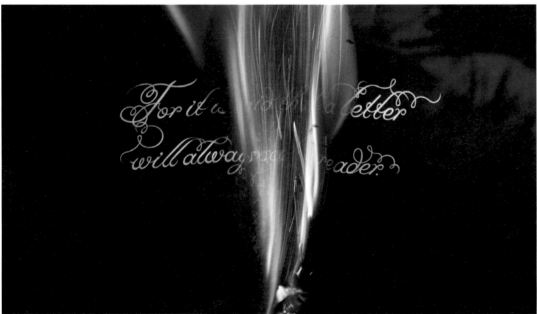

For it was written a letter
will always need a reader.

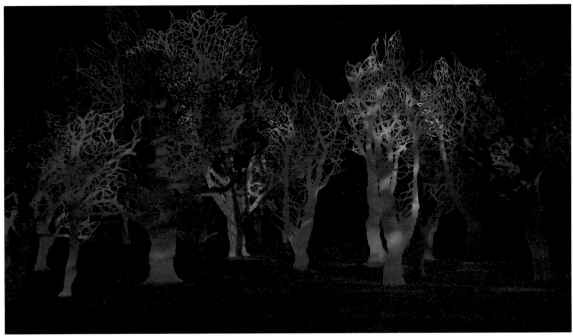

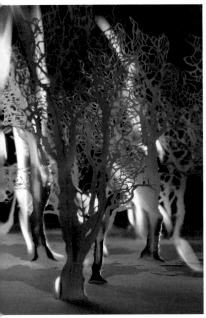

Andersen M Studio
The Distant Hours
Stop-frame animation promoting
Kate Morton's forthcoming book,
The Distant Hours, using paper, pig-
ment dust, smoke machines, and fire.

Psyop

Worlds made out of cardboard for a series of commercials. Because all of the scripts read like short films, attention was paid to fitting a visually powerful and epic tale into a 25-second time frame.

01

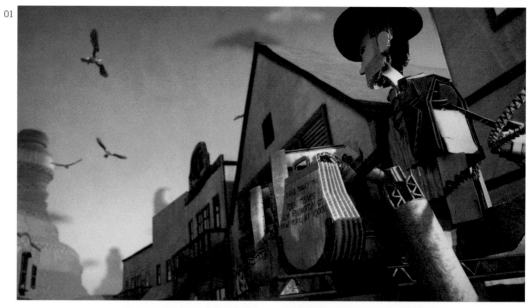

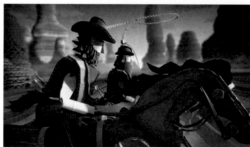
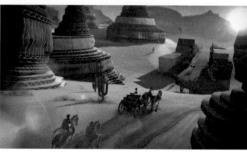

02

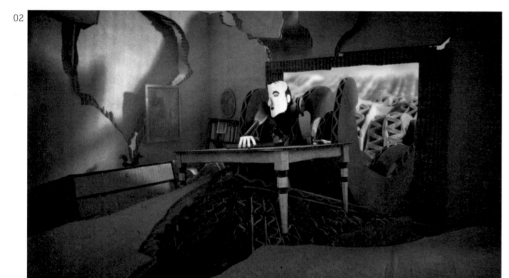

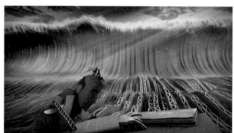

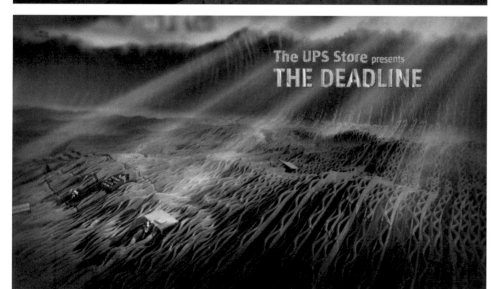

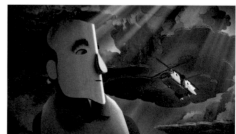

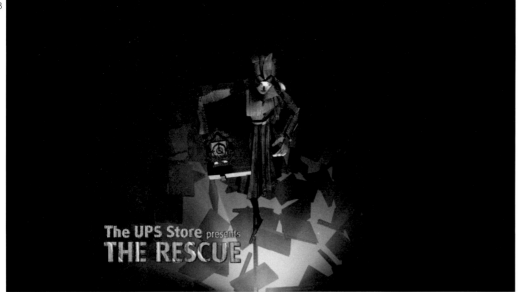

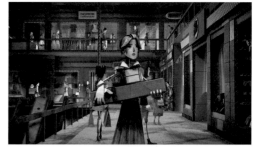

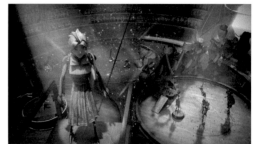

The UPS Store presents
THE RESCUE

Picking and mixing references from design, animation, and live action directing, Psyop bring paper to life in a range of commissioned stop-motion ads.

From the jagged, two-dimensional cutouts of Converse-clad hipsters, capturing the classic music video vibe, to the agency's fast-paced and impeccably edited UPS adventures, Psyop's spots provide a stage — or stadium — for an approach and technique that is cinematic to the core.

Cleverly lit for added depth and texture, all clips seem to thrive on a lightness of touch, backed by old-fashioned craft and discipline. The creative process invariably starts with still imagery generated by a team of designers, composed from drawn illustrations and photographs. Once storyboarded to perfection, the actual frames build on several layers of color, texture, and imagery, translated to a moving sequence designed to steal our breath away.

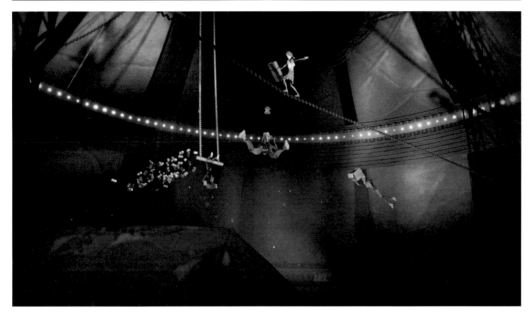

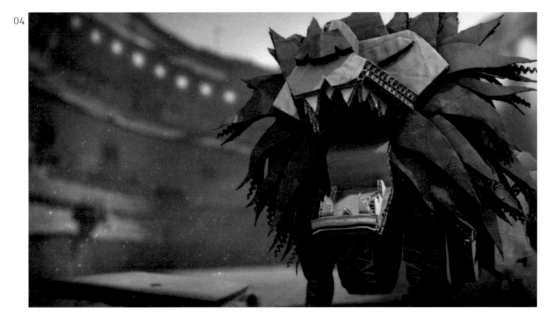

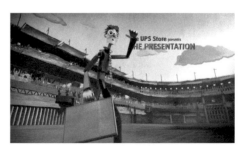

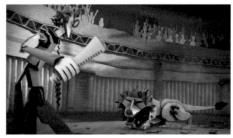

Verena Hanschke & Echao Jiang
<u>My Dream</u>
Animation inspired by the Mehinacu, an indigenous community in the Amazon forest who are being forced off of their land due to urban industrialization, rapid deforestation, and monoculture.

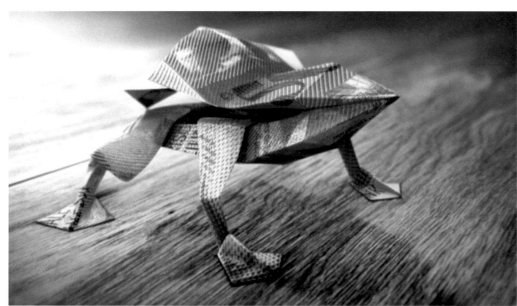

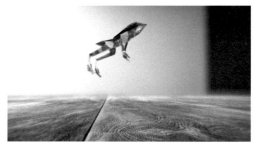

Sehsucht
<u>Bank Coop: Evolution</u>
Commercial for Bank Coop's sustainable investment funds in which banknotes of 10 to 1,000 Swiss Francs become animated origami creatures.

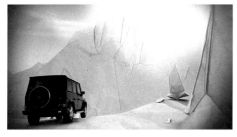

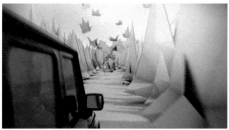

Sehsucht
Mercedes Benz G-Klasse: Unfold
Commercial created for the 30th anniversary of the Mercedes Benz G-Class.

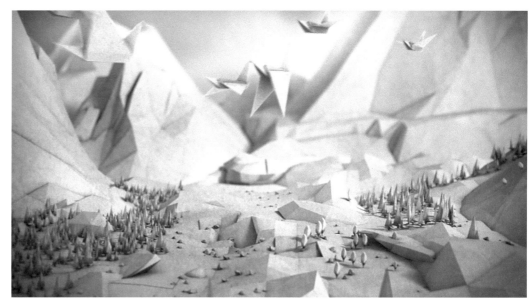

Psyop
Stella: Dove
Television commercial that references the history of Stella Artois as a seasonal beer, brewed only during the holidays. It tells the story of a master craftsman who creates a magical paper world. On a corresponding microsite, visitors can create intricate printable paper holiday ornaments.

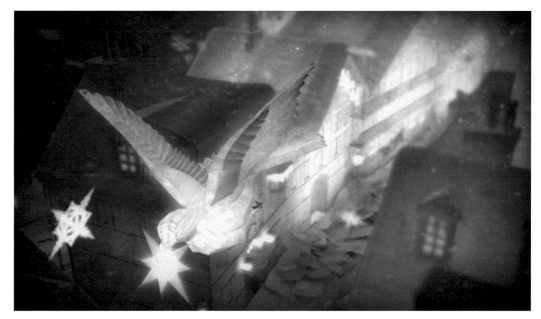

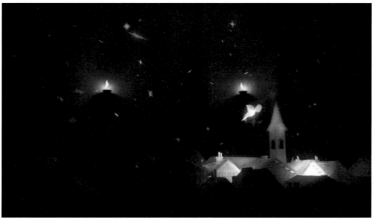

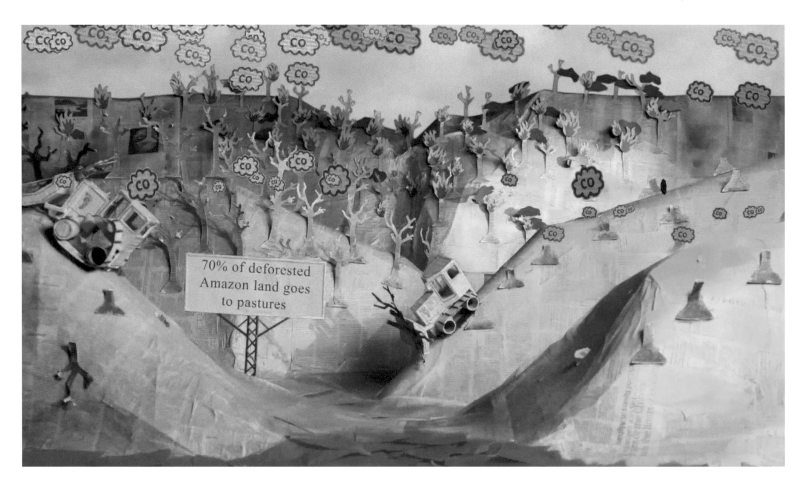

70% of deforested Amazon land goes to pastures

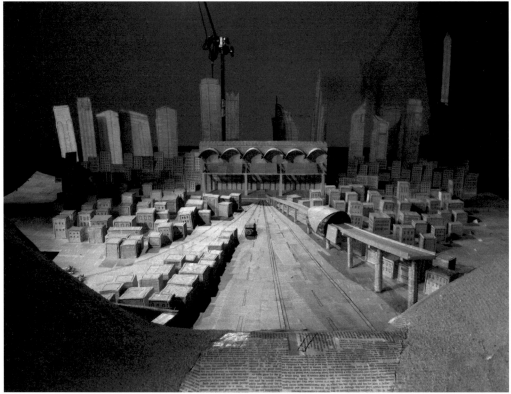

Households responsible 57% of UAE footprint

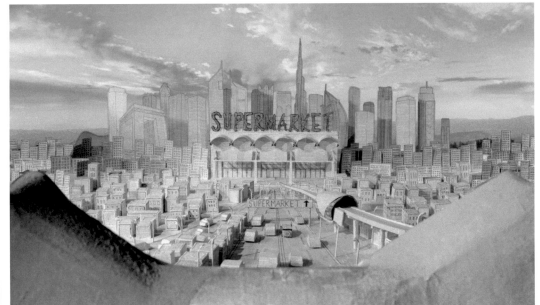

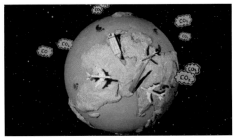

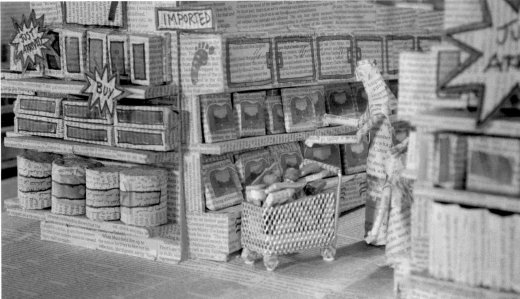

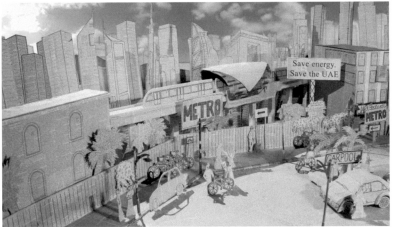

Asylum Films
WWF: Heroes of the UAE
Project promoting the reduction of
individual carbon footprints for resi-
dents of the United Arab Emirates.

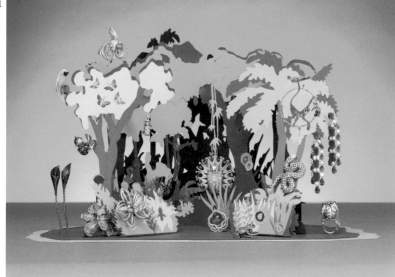

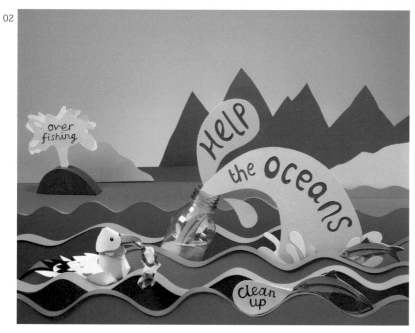

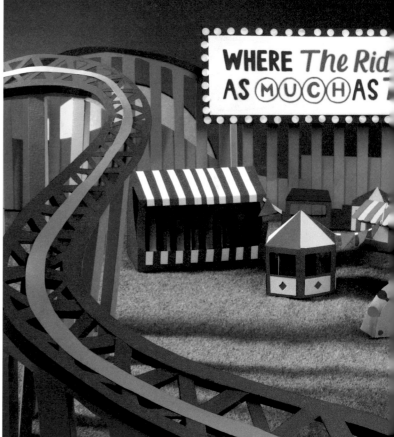

Helen Friel / Tatler

01 Treasure Island
Pop-up jungle set commissioned
by *Tatler* magazine for a piece
celebrating jungle jewelry.

Hattie Newman

02 Help the Oceans
Paper set for the environmental
charity Adventure Ecology.

03 Inspiration Is Everywhere
Paper worlds created for a project
by Honda.

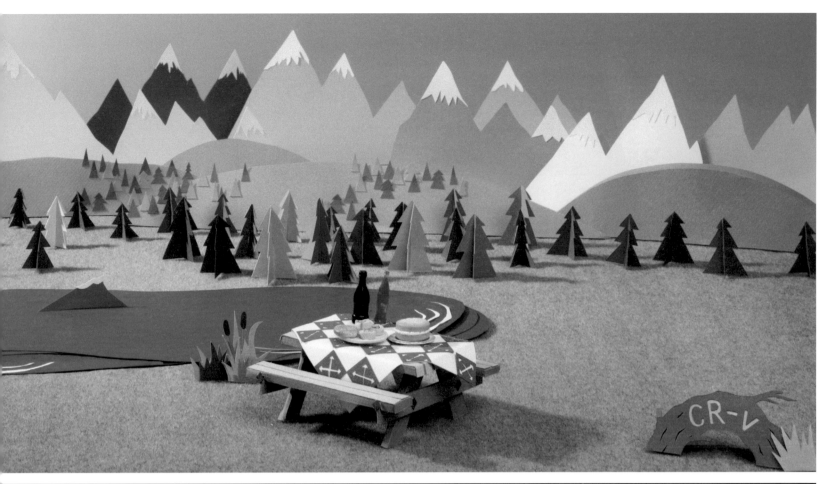

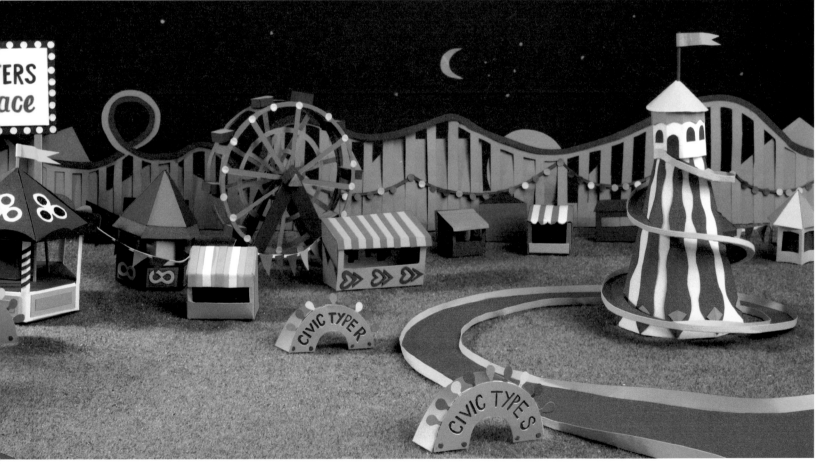

Alchemy
<u>Different</u>
Animation for the Girl Guides
Online Film Festival.

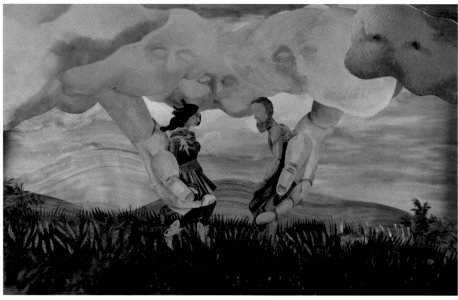

Hayley Morris / Curious Pictures
Joker's Daughter "Lucid"
Music video for "Lucid" by Joker's
Daughter, inspired by tarot cards,
fairytale illustrations, and the
animation work of Lotte Reiniger
and Yuri Norstein. The artwork was
handmade with watercolor and ink,
then assembled with wire joints
and turned into paper puppets us-
ing stop-motion animation. When
the sets, puppets, and props were
fabricated, each piece was animated
frame by frame on a multiplane.

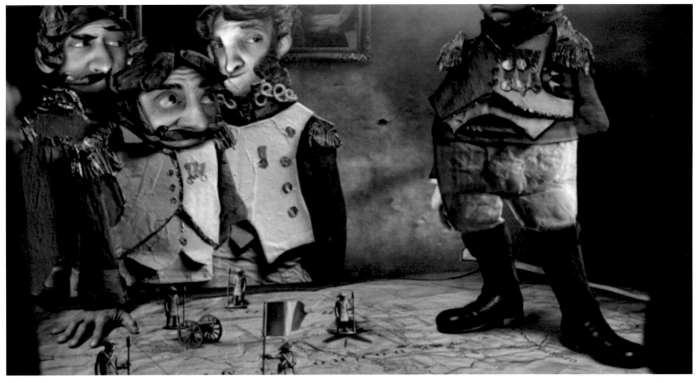

Bent Image Lab / Carlos Lascano
Al Balad: Napoleon / Beethoven /
Gandhi
Three animated commercials cre-
ated for the newspaper *Al Balad*
using a version of cutout animation
combined with filmed human eyes.

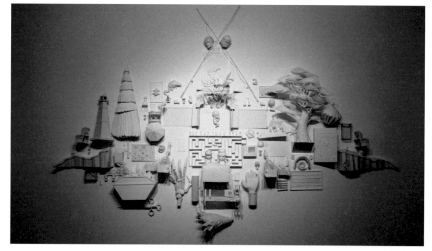

Mikey Please

01 <u>The Eagleman Stag</u>
Monochrome stop-motion animation based on a dark comedy about a man's perception of time and the extreme lengths he goes to counter its effects. The sets and puppets were constructed with various forms of paper, cardboard, and upholstery foam.

Sébastien Kühne & Camille Herren

02 <u>Basecamp 09: TV-Spot</u>
Television commercial for a national exhibition about the environment and current scientific research.

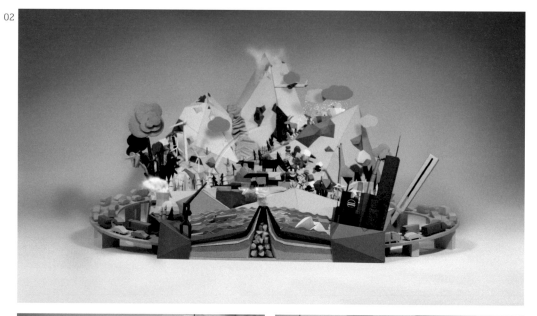

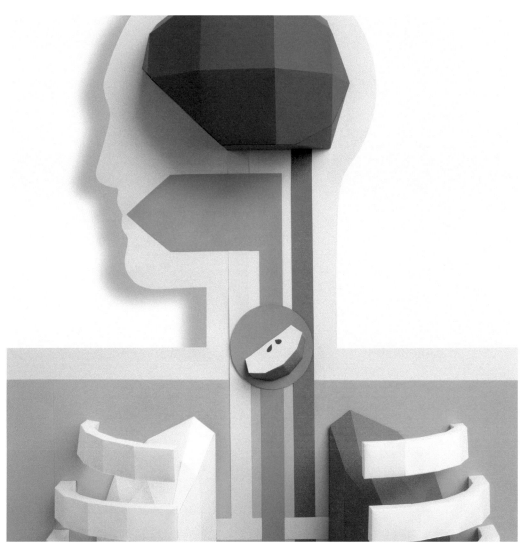

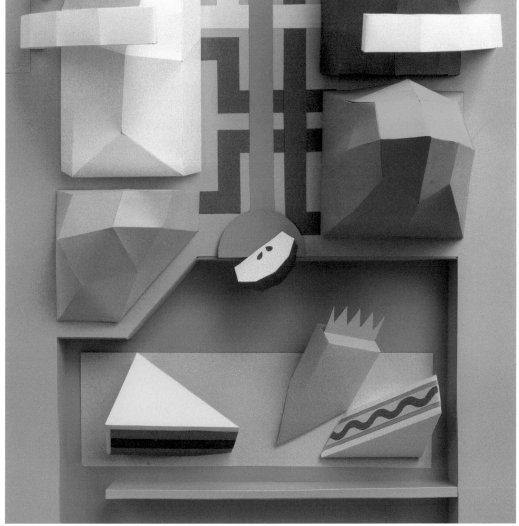

Johnny Kelly
The Seed
Stop-motion and Flash animation
following an apple seed on its voy-
age through the life cycle.

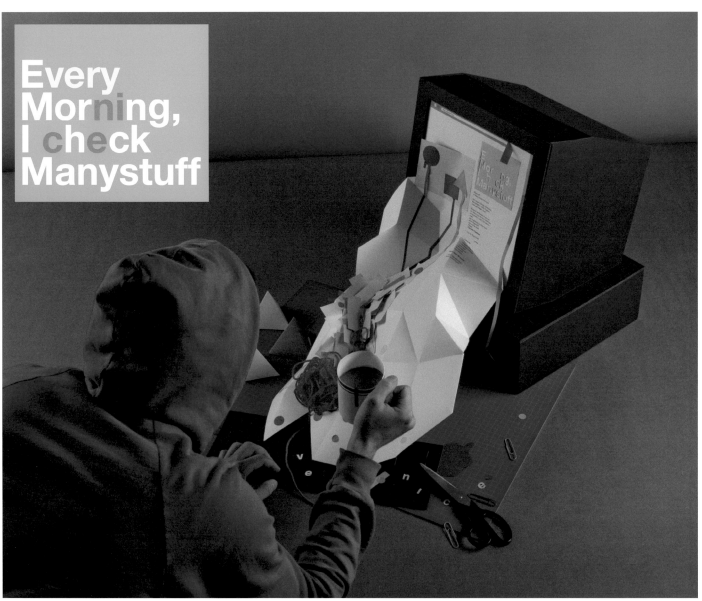

Every Morning, I check Manystuff

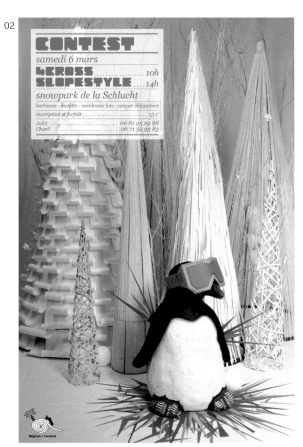

CONTEST
samedi 6 mars
4CROSS 10h
SLOPESTYLE 14h
snowpark de la Schlucht
barbecue - buvette - nombreux lots - casque obligatoire
inscription et forfait 15 €
Julia 06 81 25 29 88
Charli 06 71 59 93 83

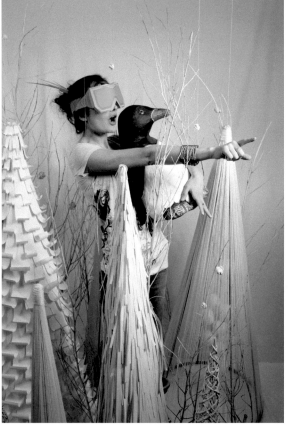

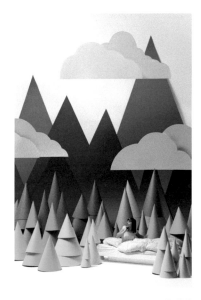

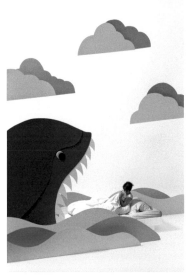

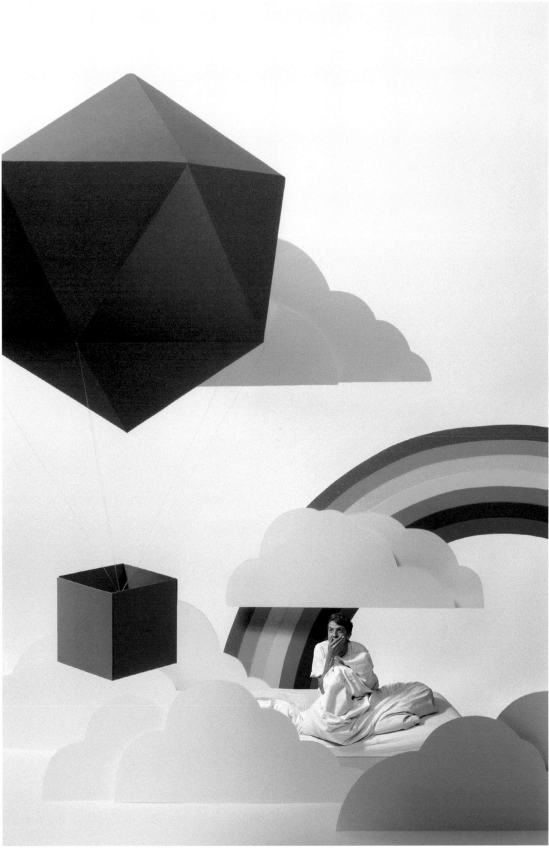

Julien Vallée

01 Manystuff Fanzine
Image created for *Manystuff*, a blog and fanzine questioning the roles of digital and handmade processes in design.

Zim & Zou

02 Penguin Rider
Poster and flyer for a ski and snowboard contest in the Vosges Mountains.

this page
Zayoba
The Border between Dream and Reality
Images for the project *Die Grenze* (the border), attempting to visualize the edge between dream and reality.

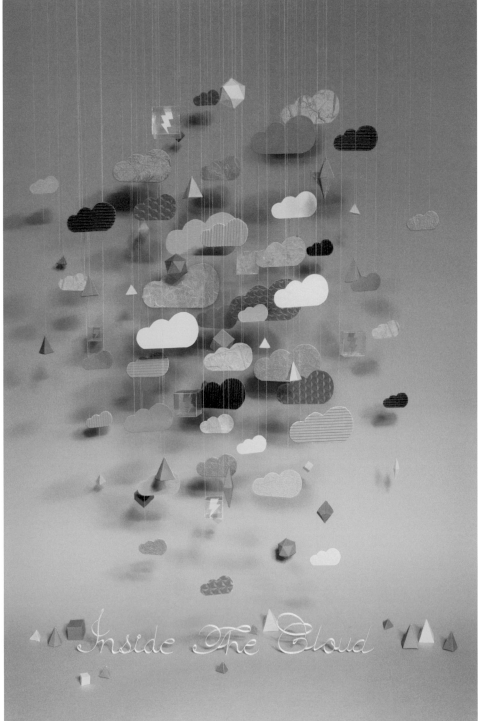

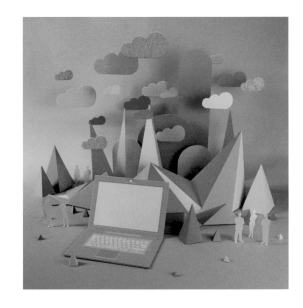

Zim & Zou
01 Inside the Cloud
Two illustrations inspired by
Microsoft's Cloud Computing
Services.

Lucas Zanotto
02 The Ostrich
Short story about an ostrich
who is tempted to investigate
the other side.

Johnny Kelly
03 Don't Panic

Javan Ivey
04 Sleeping at Last "Green Screens"
A stop-motion music video for
"Green Screens" by the band
Sleeping at Last.

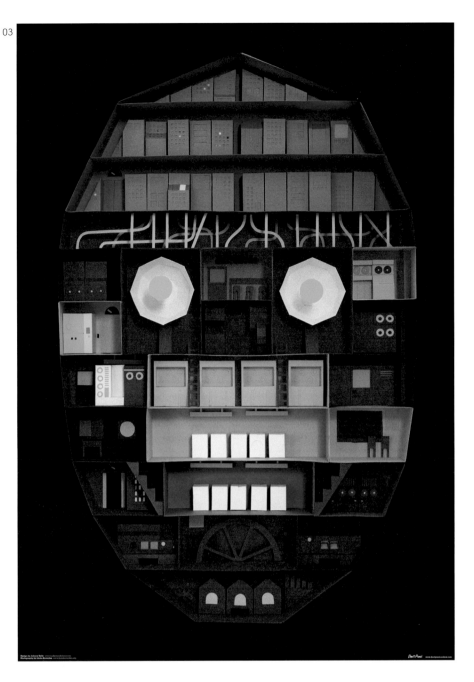

Chrissie Macdonald
01 Paper Shredder
02 Bier

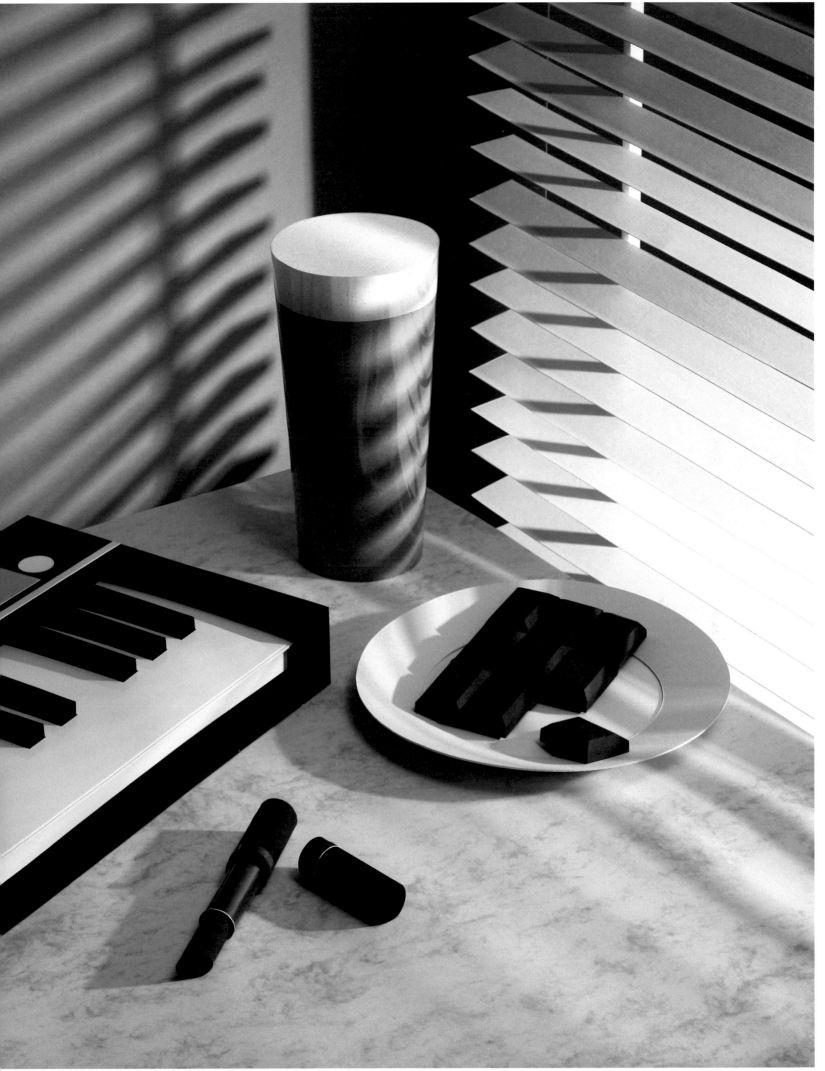

01

02

03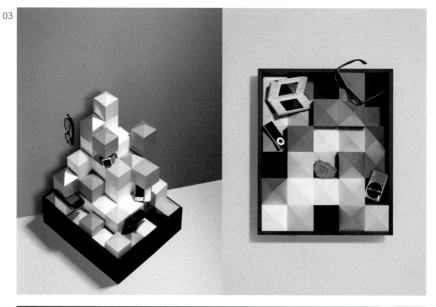

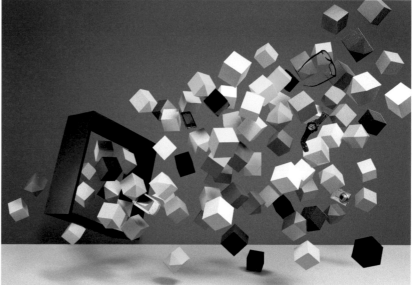

Romain Lenancker

01 Explosion
Editorial for *125* magazine.

02 Explosion
Exhibition for Kulte.

03 Bloc Party
Editorial for *Amusement* magazine.

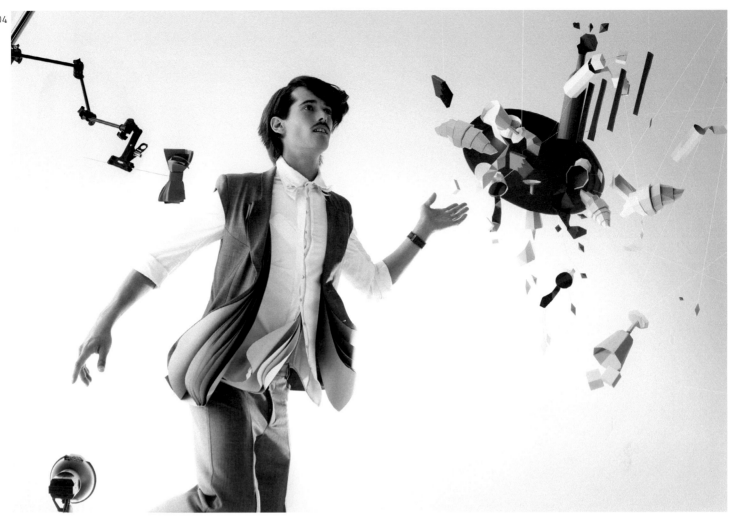

Le Creative Sweatshop

04 Fashion Shoot for Amusement
Magazine
Fashion shoot for *Amusement*
magazine. The computer virus was
interpreted by objects; shapes collide
and break up into an explosion of
pieces, mixing static and dynamic
movements with the clothing.

Le Creative Sweatshop

05 Transavia
Event installation for the Parisian
gallery L'Imprimerie. Intended as
a communication between art and
the mainstream media, different
elements were combined to create
a suitcase that calls to mind the
notion of travel: books were used
to relay the theme of inspiration,
musical instruments referenced
journeys without borders, and
exploding boxes evoked the explo-
ration of memory.

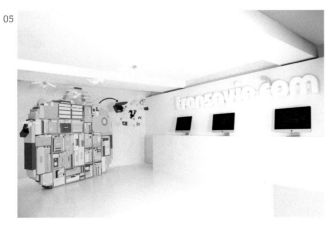

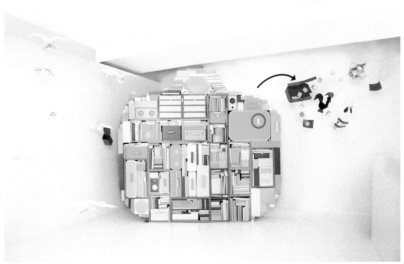

Le Creative Sweatshop

01 Series for Shoes-Up
Fashion shoot for the 24th issue
of *Shoes-Up* magazine based on
the topic of "creation at home."
Environments representing the four
stages of life were built using wool,
paper, mirrors, and Post-it notes.

01

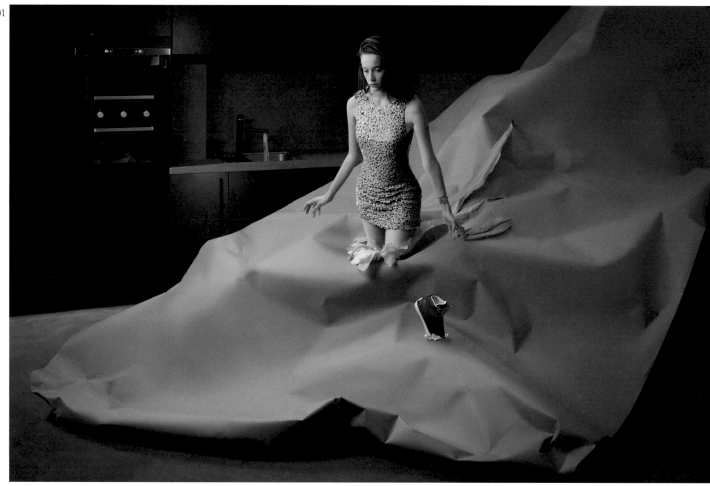

02

Superstackers Le Creative
Sweatshop are nothing if not me-
ticulous in their intricate endeavors.
Promising a distinctive twist, they
love to take a space or environment
and give it a thorough shaking-up
with plenty of paper and imagination.

After all, some things simply will
out: reams of material and a finely-
honed sense for scope and color in
tow, these rogue excerpts claim a
space and refuse to be reined back
in—just like the best of ideas. Bursting
from a tightly packed example of
stacked efficiency, their installation
for the Parisian L'Imprimerie gallery,
for example, combines a variety of
elements in a modern suitcase. The
resulting stream of paper-clad con-
sciousness relays the notion of travel
without borders, stored memories, and
poetic journeys, all aflutter.

Other works add a human ele-
ment to frozen explosions in time
and space. Imbuing people and
props alike with a sculptural quality,
Le Creative Sweatshop transform
paper's ephemeral and flimsy nature
into objects and scenes of impres-
sive volume, solidity, and plasticity.
Artificial, yet momentous, and almost
contemplative in their dynamic still-
ness, the resulting works recreate
nature on a grand scale or rebuild the
flaws of the digital realm. In this, Le
Creative Sweatshop imprint their own
viral proliferation on the world that
surrounds us.

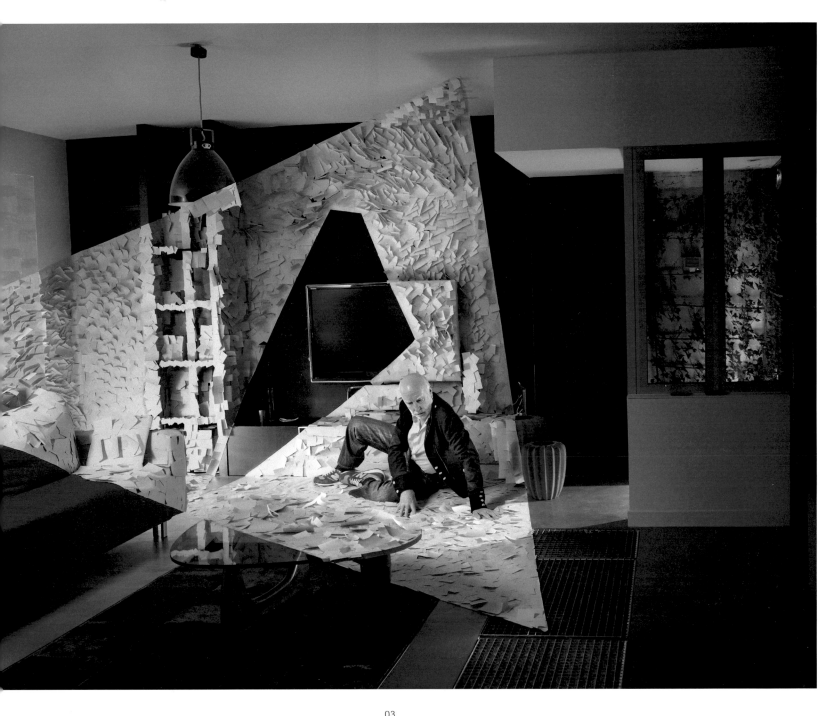

03

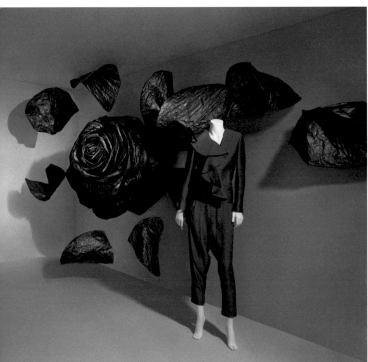

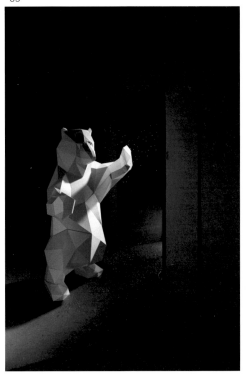

Le Creative Sweatshop

02 <u>Stella McCartney Installation</u>
Monumental flowers for the Stella
by Stella campaign for Stella
McCartney. Based on Stella's
identity, paper was torn by hand to
achieve a vibrating muslin effect
with a life-like quality.

03 <u>Ours</u>
Personal project that generated
a universe by mixing illustration,
design, fine art, and an obvious
reality.

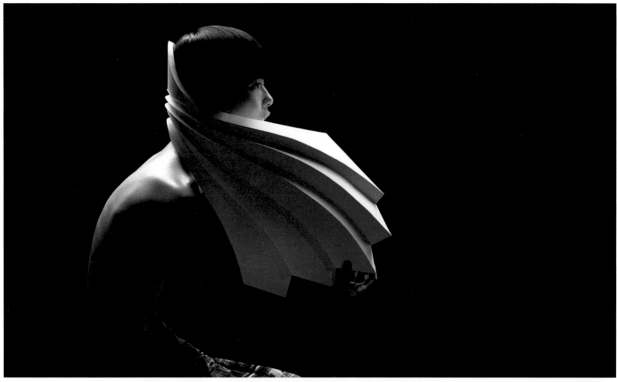

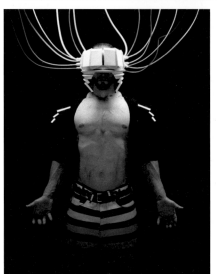

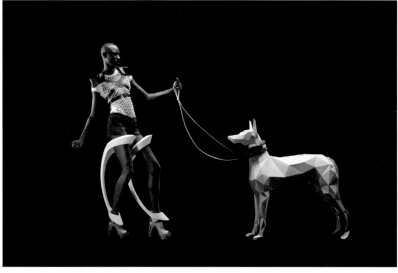

Le Creative Sweatshop

01 <u>WAD#45</u>
Fashion series created in collaboration with *WAD* magazine. Models were photographed in situations that suggest revolution; the resulting imagery references political, social, and historical issues and events from Africa, Europe, and China.

02 <u>La Rinascente</u>
Window displays designed for La Rinascente's new shop in Palermo, Italy. Five different environments with five different color schemes were created to look like a fashion shoot.

02

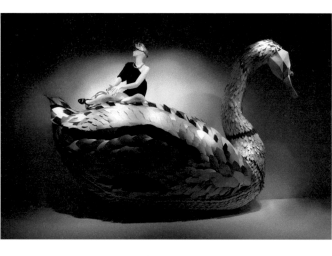

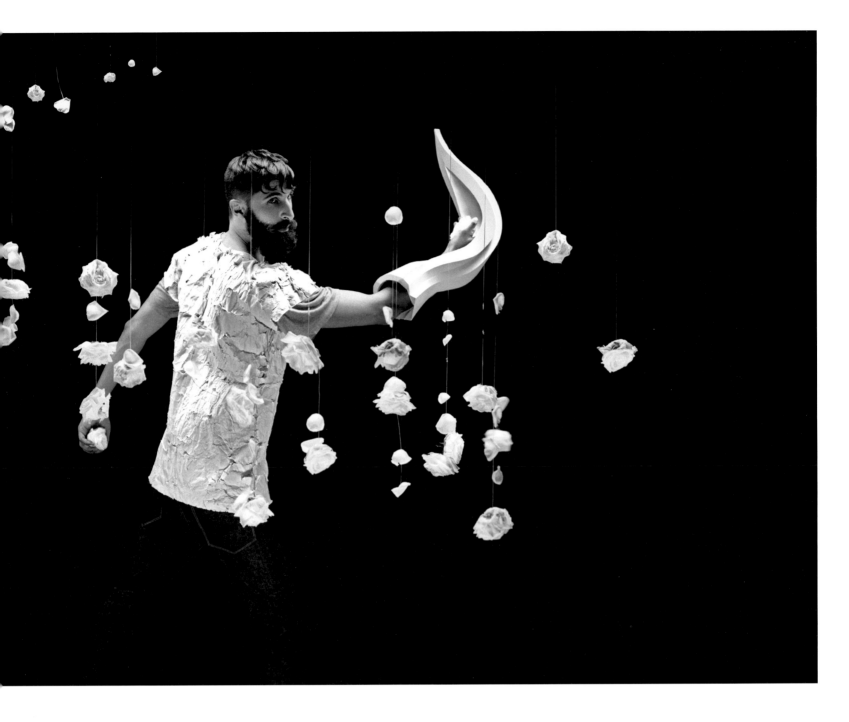

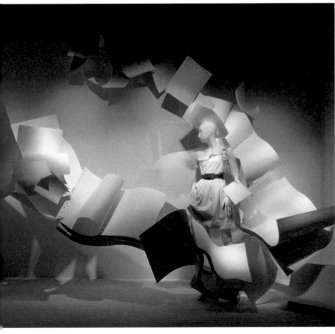

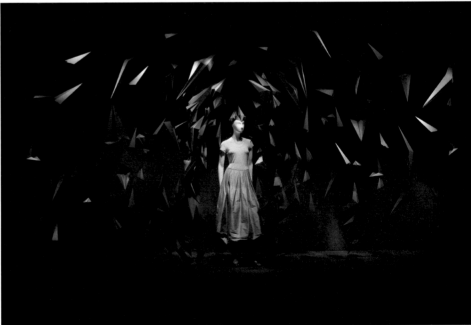

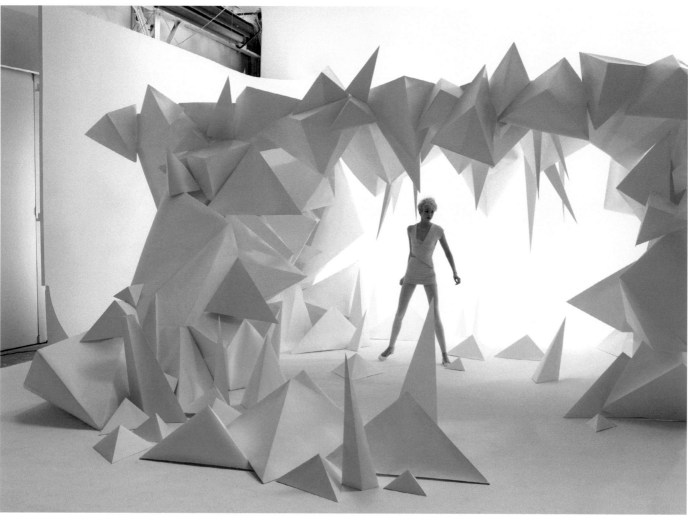

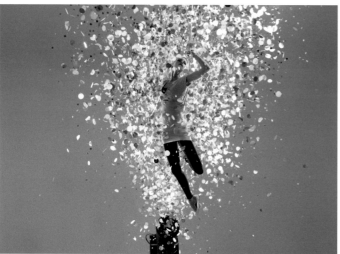

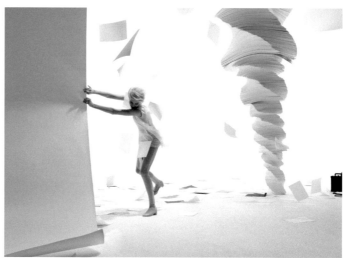

Grégoire Alexandre

Arjowiggins — Curious Story

When paper purveyors Arjowiggins relaunched their *Curious Collection*, brimming with novel colors and textures including tracing paper and metallic variants, they decided to stage these idiosyncratic additions in a photographic universe: a land of fibrous fairy tales where paper comes alive and reveals its hidden properties.

Mis-en-scene by photographer Grégoire Alexandre, the series and sequence was realized by an entire team of stage hands, set designer, art director, and paper specialists who chopped, crumpled, and sliced this journey through parallel worlds into shape; from cavern to ocean, from garden to ice storm.

Inspired by the material's inherent versatility, Alexandre stated that "paper is an important part of the photo studio — and there are lots of different dimensions to it. After all, a plain sheet of paper can become an haute couture dress. Here, we promote it from mere backdrop to the star of the show."

For a sense of scale and composition — and a touch of authenticity — the photographer decided to integrate props found in the studio to give the viewer a glimpse of the process behind the scenes. In her close encounters with cellulose creation and even an origami unicorn, sprung to life and rearing up in a spirited

pose of newfound abandon, the featured model, too, served as a mere unifying element and "human backdrop" for these paper-based forces of nature: sheltering from a solid paper tornado, caught up in a manic — yet intensely pretty — snowstorm or ensconced in a grotto of glittering cardboard crystals.

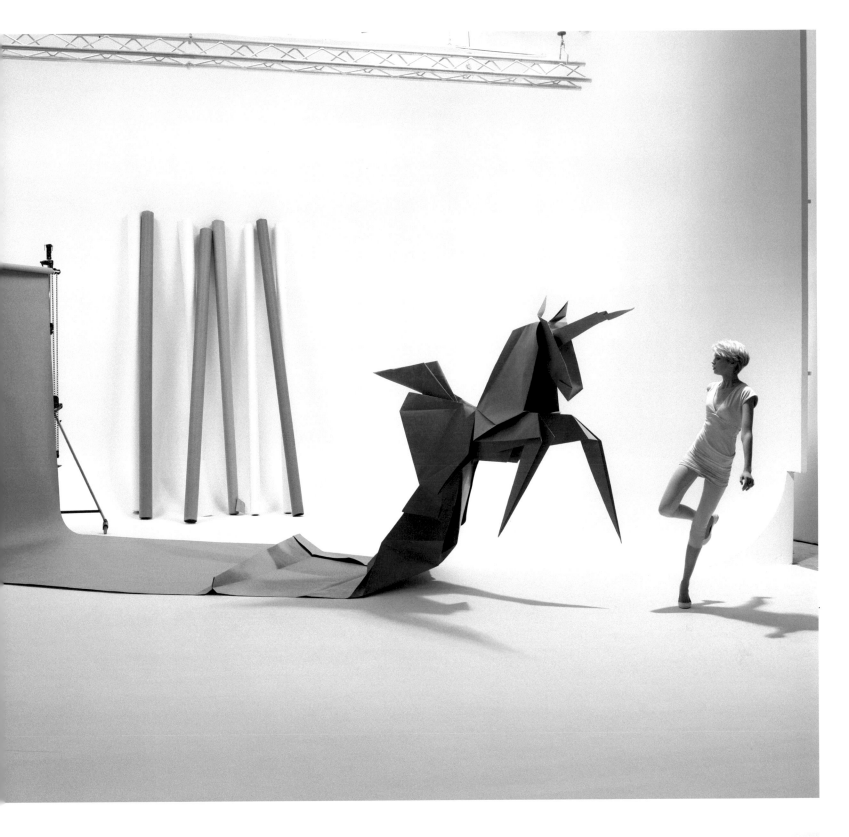

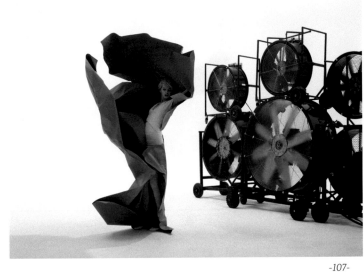

03

Style and Substance

If you've got it, flaunt it. And if you haven't ... well, fake it! The first rule of fashion—and its fickle flavors—finds a new spin in this particular realm of paper concoctions. Just like the masters of Buddhist vegetarian cuisine, who have perfected the taste and texture of mock meat down to the pores of a duck's plucked feathers, the following createurs love to spin new tales and tease novel textures out of their chosen material. From silky cushions to brittle chairs, from lacquered wood to twisted reeds, they indulge in the experimental exploration of the material per se and envisage a stylish future fashioned from paper—albeit with a so far unprecedented level of elaboration and intricacy.

Marking the return of pleats, sequins, and voluminous geometric shapes, reminiscent of 1980s Japanese couture, exercises in statement dressing meet their newfound paper equivalents, richly lacquered or treated to suggest a metallic or manmade origin. Tyvek, too, enjoys an unrivaled renaissance in line with the resurgence of 1990s minimalism and utility chic. Meanwhile, its close cousin, recycled or biodegradable cotton-laminated paper, panders to our eco sensitivity while lightweight synthetic versions moonlight as waterproof alternatives to vinyl and leather.

In an entirely faithful yet humorous take on haute couture gowns and their ostentatious symbolism, Test Shoot Gallery's frocks of brown paper bags, toilet roll, tracing paper, old magazines and newspapers serve as a gentle "up yours" to precious souls who take this business far too seriously. Here, wearability is not an issue. But then again, when has high fashion ever been about something as mundane as comfort or practicality?

Benja Harney bridges the gap between the remarkably varied works on display with a bespoke pop-up book for fashion bible Harper's Bazaar that turns table to catwalk with a wealth of immediate, in-your-face pop-up designs. Emerging from flatness, from lightweight stock or heavy card, lacy silhouettes, towering castles, and literary constructs gain a new dimension by a mere mechanical motion, by the turn of a page or pull of a lever.

Here, embracing calendar, music video, and data visualization tool, the pop-up genre branches out to explore a wealth of new genres and applications. In their single-frame incarnation, they add yet another tool to the box of those eager to enliven their own characteristic illustration style, frequently in the guise of magical adventures and enchanted stories that lend a face and proper stage to the fabled, well-known classics of our childhood and beyond. In his take on traditional tales—Grimm and otherwise—Benjamin Lacombe, for example, distils firm favorites into stunning moments of breathtaking beauty, into single yet moving and moveable frames. Self-contained stories one and all, these carefully engineered mini installations thrive on a liberal, immersive smattering of petals, butterfly wings, a scattered deck of cards, or Pinocchio's jutting nose. And those not content with static stories turn a page with lovingly sliced three-dimensional narratives that take us all the way to The End.

At the same time, there is a strong sense of liberation from the tried-and-tested book format. Spanning an eclectic range from foldout peacock fan to ambitious architectural marvel, many artists in the following section use folds and pop-ups as a mere starting point for dizzyingly complex geometric or abstract models, objects, and sculptures in their own right. Turning the whole technique upside-down, some of them even employ the aesthetic without actual engineering: exploiting the mere allusion to a center fold, to the possibility of a pop-up, Mathilde Nivet's photo montage of a topsy-turvy Paris throws reality into sharp relief. Pervaded by a sense of "how did they do that," Nivet and her peers' work evinces a magician's sleight of hand: they invite us to simply enjoy the show—and the paper marvels on display.

right page
Benjamin Lacombe
Il Était Une Fois ...

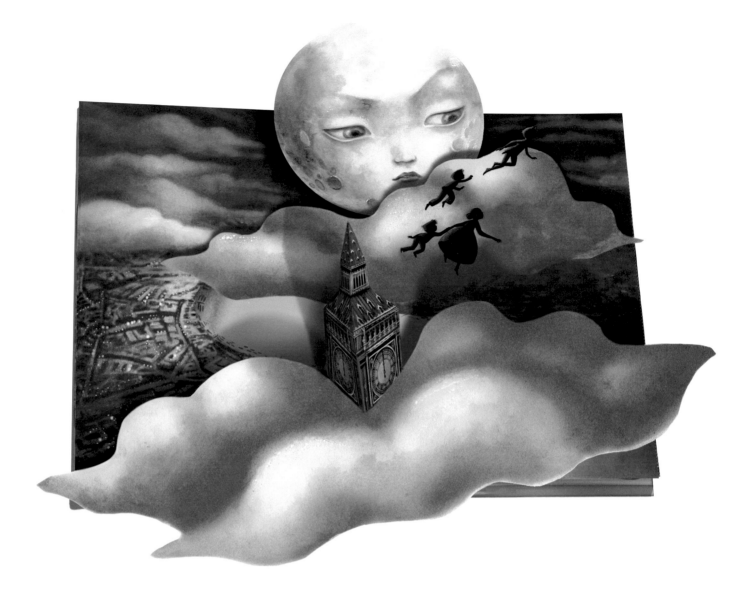

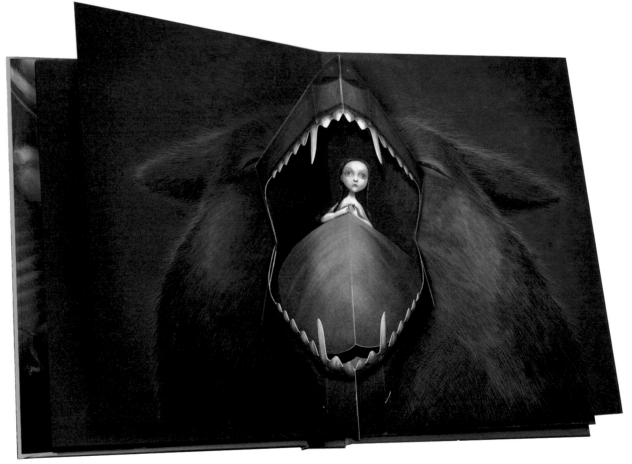

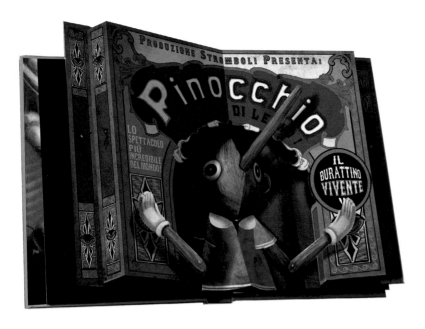

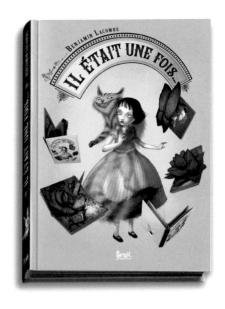

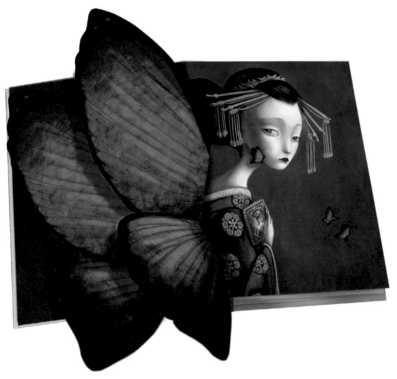

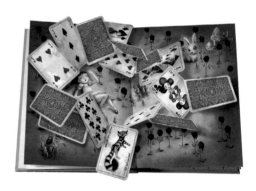

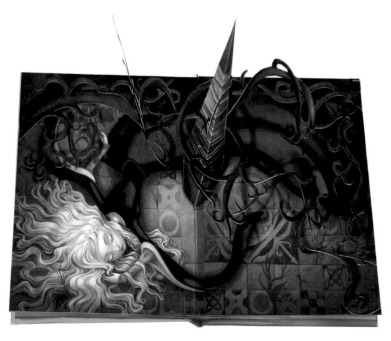

Benjamin Lacombe
Il Était Une Fois…
A pop-up book about classic tales
using personal paintings and inter-
pretation.

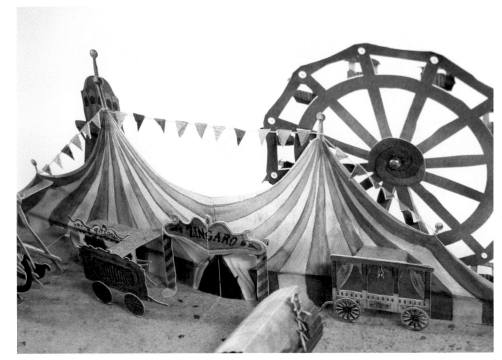

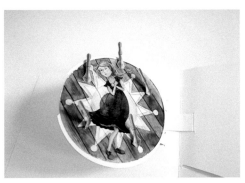

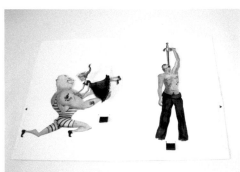

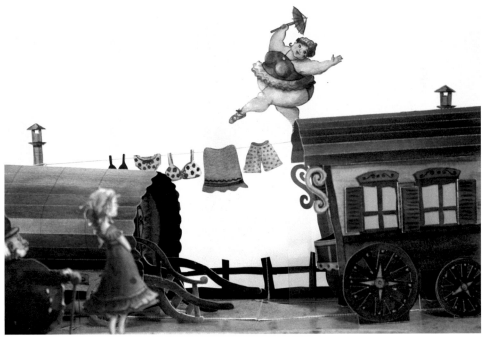

Tina Kraus

Circus Zingaro

A pop-up book created as the final
exam project for a design and
illustration degree at the University
of Applied Sciences in Münster,
Germany. The atmosphere of the
book is inspired by the freak and
side shows of the 1950s as well as
vaudeville shows and gypsies. The
story revolves around a homeless
girl who wants to join a traveling
circus. However, when she intro-
duces herself to the ringmaster he
does not take her seriously. Instead
he introduces her to the freaks in
his show, hoping to convince her
that she does not fit in. Little does
he know that she has a special gift.

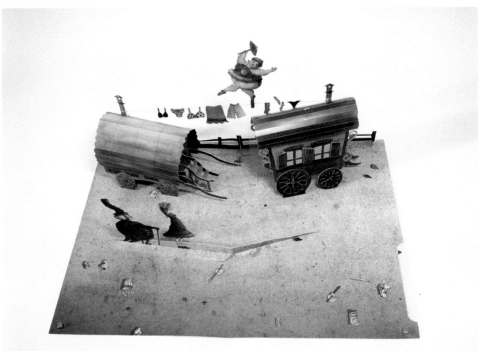

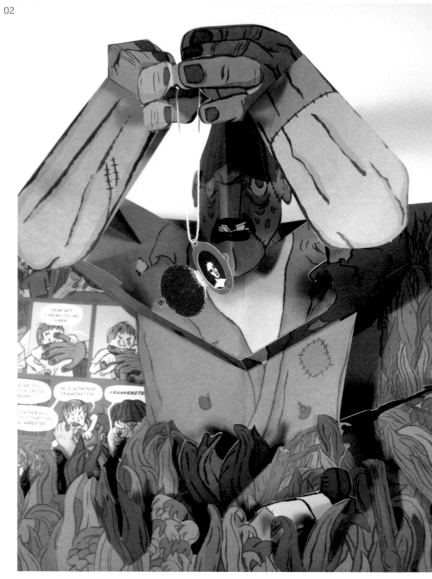

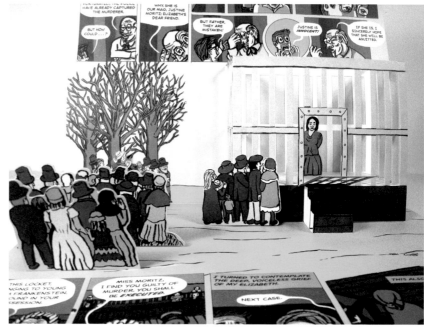

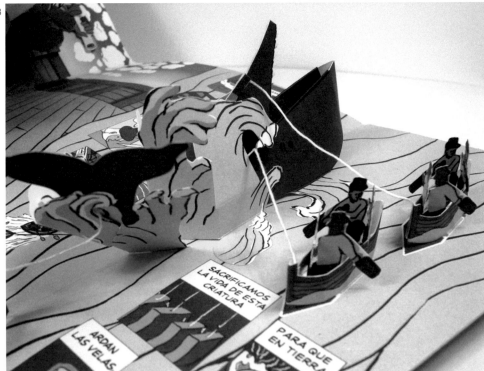

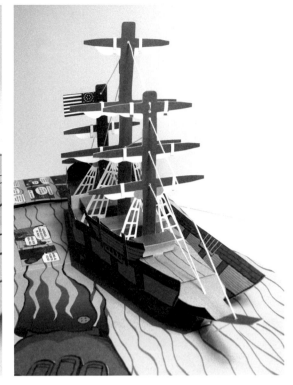

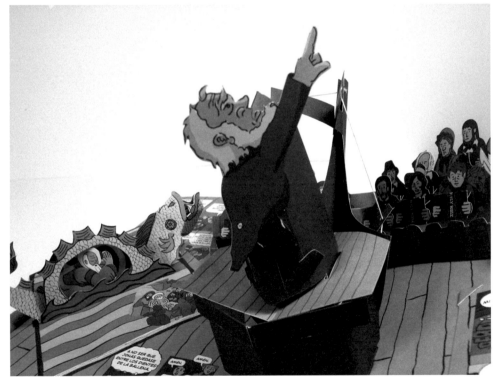

Sam Ita

01 20,000 Leagues Under the Sea:
A Pop-Up Book

02 Frankenstein: A Pop-Up Book
Pop-up comic book based on Mary
Shelley's classic novel, *Frankenstein*.
True to the original, the monster's
crimes occur automatically, but the
reader must pull a tab to activate
human misdeeds.

03 Moby Dick: A Pop-Up Book

Sam Ita's lovely and lovingly as-
sembled three-dimensional graphic
novels breathe new life into nine-
teenth century classics — and the
entire pop-up book genre — with
twenty-first century techniques and
eye-popping comic aesthetics.

Not one to baulk at a challenge, Ita
picked a veritable monster for his first
iteration: literature's infamous battle
with inner demons, *Moby Dick*. Sprucing
up Captain Ahab's epic and obsessive
hunt, the resulting three-dimensional
tome integrates multiple pop-ups per
spread to provide an immersive experi-
ence of the drama unfolding — spiced
up with plenty of extra "gifts" hidden

away under folds and flaps. A true
marvel of paper engineering, the now
published work allows characters, the
ship and the whale to rise all the way
out of the page.

Undaunted by years of painstaking
work, Ita took his next pop-up quest
below the surface with Jules Verne's
visionary sci-fi classic *20,000 Leagues
Under the Sea*. Here, he invites us to
find Captain Nemo among all the pul-
leys and levers, wondrous creatures
and periscopes. This work is followed
by a pleasantly humane look at Mary
Shelley's most human of monsters,
Frankenstein.

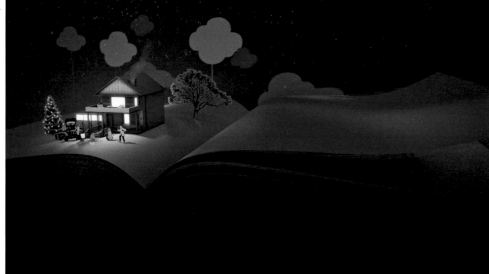

Psyop
01 <u>Chase: Change</u>
 An animation created for JPMorgan Chase featuring a pop-up book of houses and cities.

Victoria Macey
02 <u>Bodoni Bedlam</u>
 An alphabet pop-up book, using the Bodoni font while telling a charming tale about a quest for the "Dees" that have been captured by an evil Dee catcher.

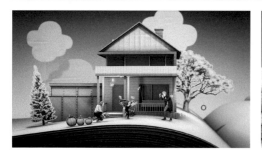

02

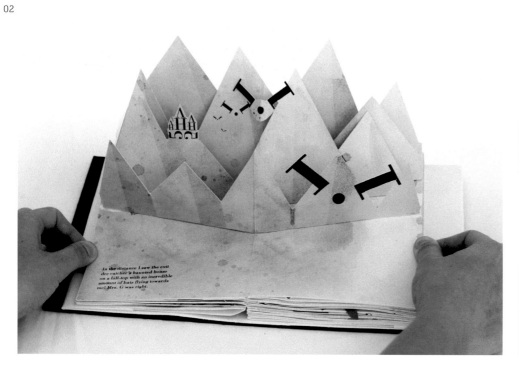

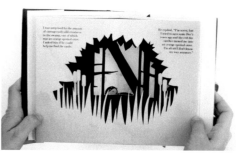

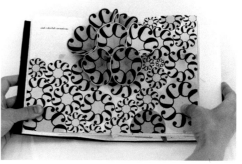

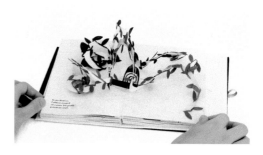

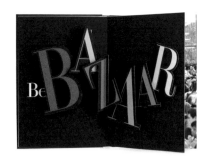

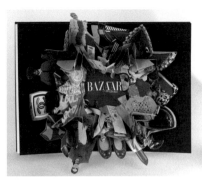

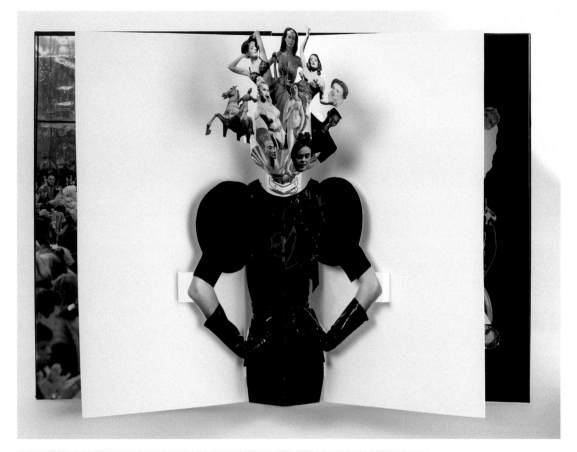

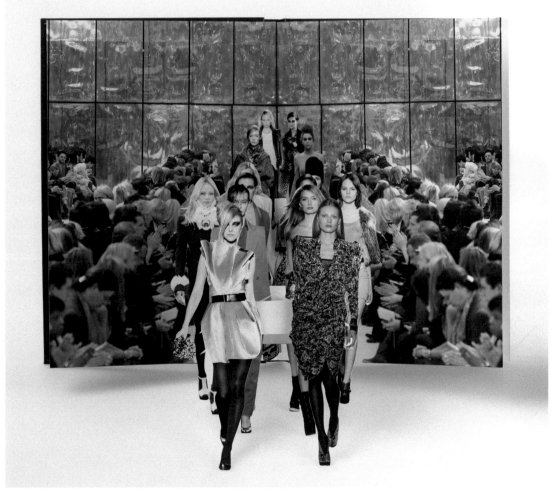

Benja Harney / Paperform
Harper's BAZAAR Pop-Up Book
A bespoke creation for *Harper's BAZAAR* Australia, the book was used by the magazine's editor as a promotional piece for the September issue.

01

02

Price James

01 <u>Shitdisco "OK"</u>
A video for the "OK" single by
the Scottish band Shitdisco.
Photographs of the band were
made into a pop-up book with
moveable parts, which an unseen
reader manipulates to perform the
song in the video.

Ciara Phelan

02 <u>A Novel Idea</u>
A pop-up book with a fall-like feel
created for an article in *Heaver*
magazine about reading and relax-
ing in fall.

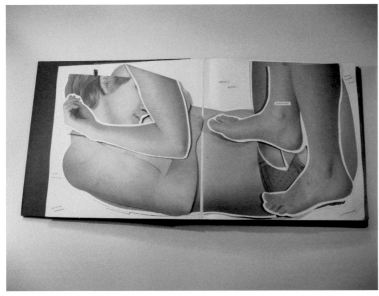

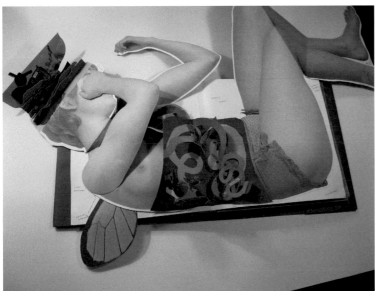

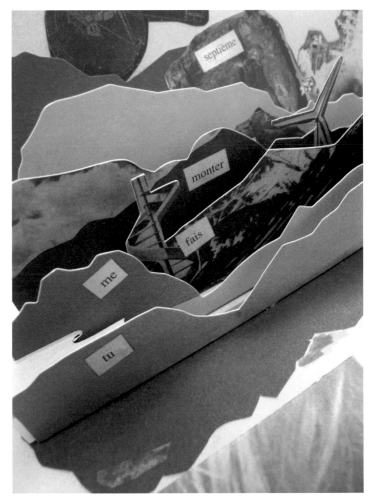

Eric Singelin

L'Effet Que Tu Me Fais

A book that reveals the anatomy of a body in love. A 1:1 scale was achieved using folded paper within a pop-up book format.

Johann Volkmer
Faltjahr 2010
A wall calendar consisting of 12 separate pop-up sculptures made from white paper. The calendar data is represented by charts and graphs that are individually adapted to fit the shapes of the sculptures.

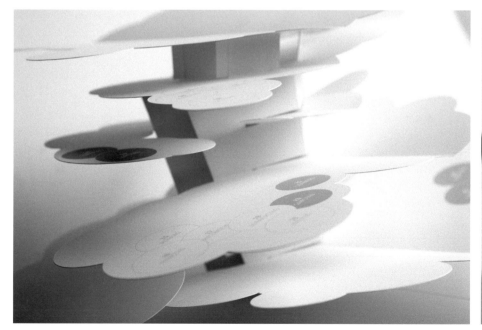

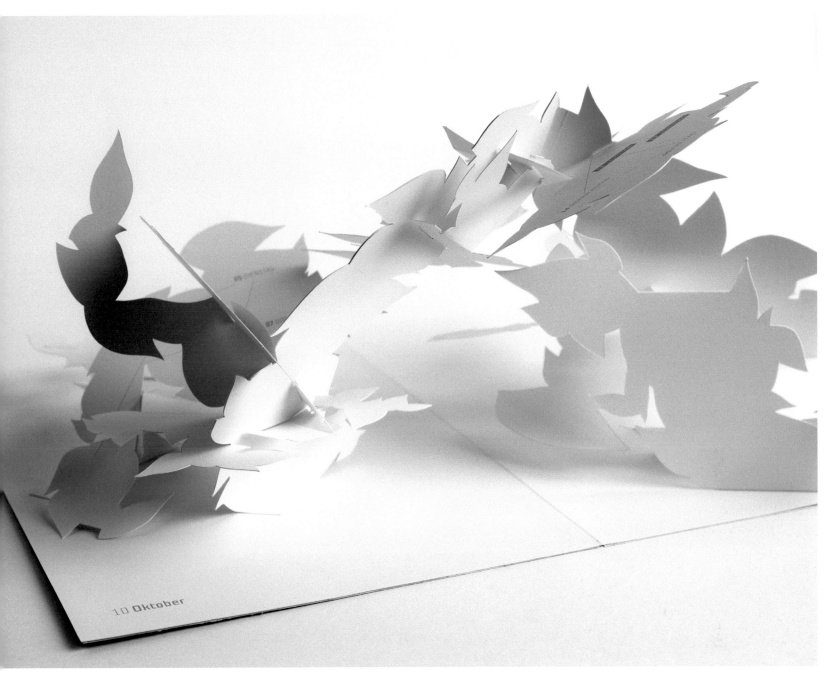

10 Oktober

Faltjahr 2010

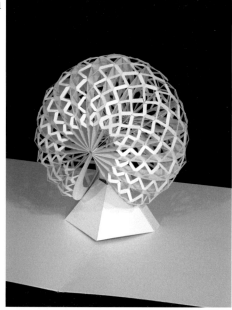

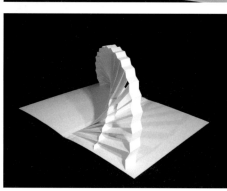

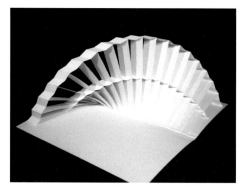

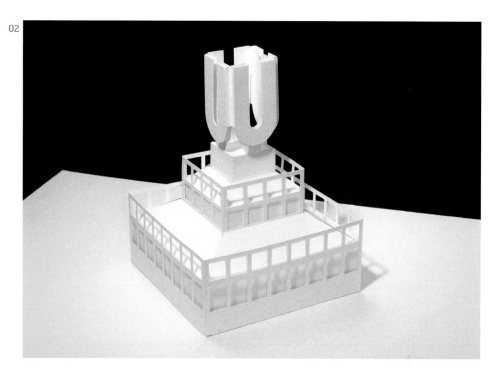

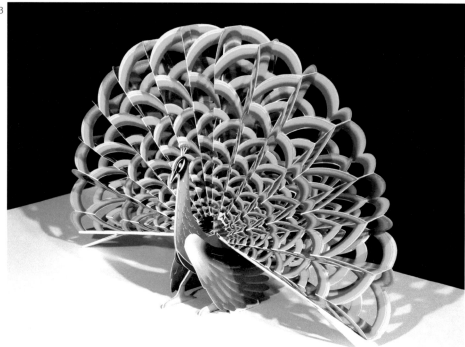

Peter Dahmen

01 <u>Untitled</u>
A series of paper sculptures that open and close, creating a pop-up effect.

02 <u>Dortmunder U</u>
Pop-up sculpture showing the tower of Dortmund University. The paper sculpture is a single piece of paper that was cut using a cutting plotter.

03 <u>Peacock</u>
Designed to be a unique piece, this paper sculpture was made with a cutting plotter.

Mathilde Nivet

04 <u>Shadow City</u>
A hand-cut pop-up sculpture playing with the contrast between light and dark and day and night in the city. It depicts a nocturnal city scene in which large windows, stacked one on top of the other, appear as mini theaters. Detailed silhouettes and intricate shadows narrate the banal scenes of day-to-day life.

05 <u>Upside Town</u>
This double-sided paper sculpture shows the exterior view of buildings on a street as well as the interiors of those buildings. By

allowing the viewer to see the interiors, which could ordinarily only be imagined, it references voyeurism and obsession with the lives of others as well as the dense living conditions in large cities.

06 <u>Paris</u>
Photos of Paris and several other cities have been cut out, folded, and joined together to create a new version of Paris as a photomontage relief.

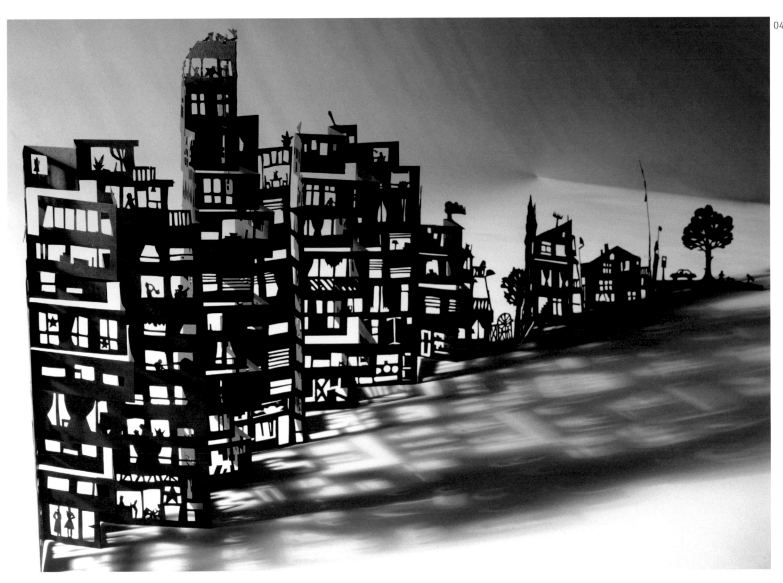

05

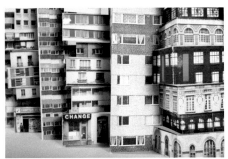

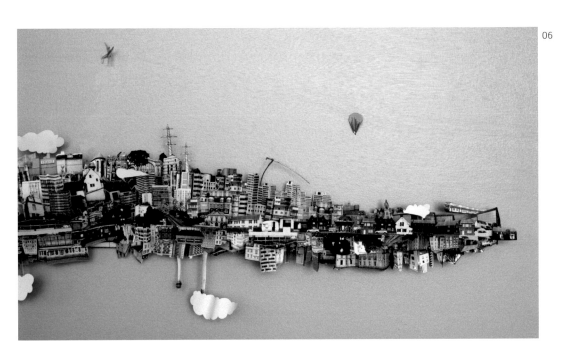

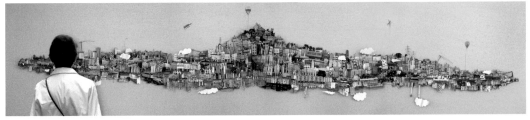

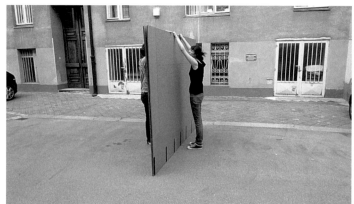

**Armin B. Wagner &
Liddy Scheffknecht**
Pop Up

A life-size pop-up sculpture made out of cardboard and tape that can be opened and closed like a book. A desk, a chair, and a laptop constitute this mobile workstation, which can appear and disappear by unfolding and folding. Although the sculpture may seem to provide an office furniture solution for a market that demands flexible, mobile employees, the workstation is neither flexible, solid, nor practical. What might seem innovative at first glance turns out to be fragile and dysfunctional — a reflection of current working conditions and trends.

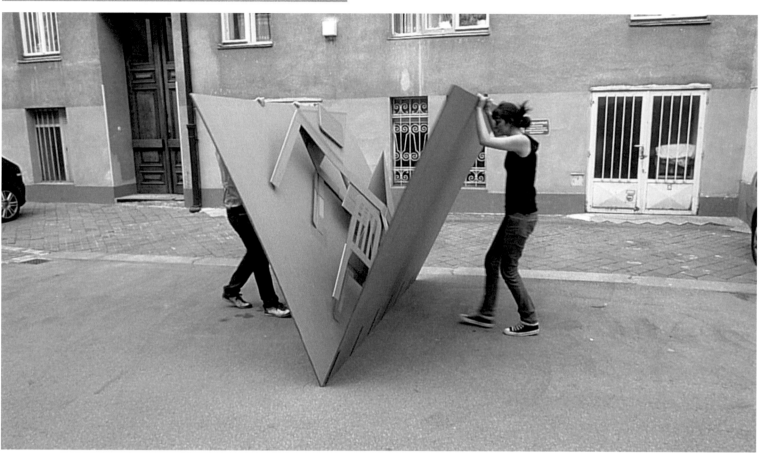

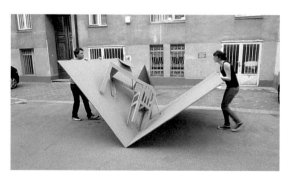

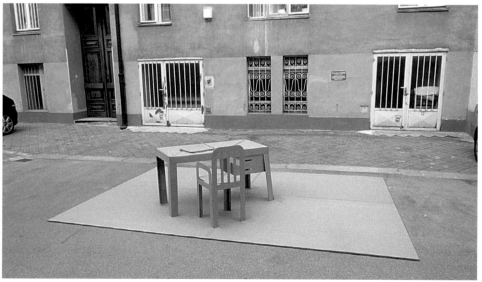

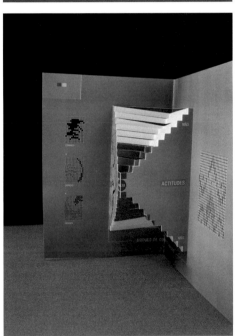

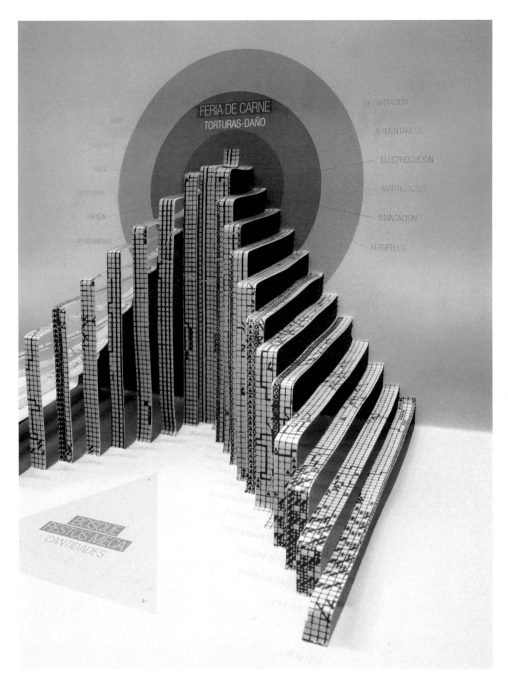

Mariano Sidoni

<u>Pop-Up Book</u>

Visualizing data helps readers comprehend data. The objective of this project was to create an emotional analysis of the movie *Artificial Intelligence*, from which Sidoni intended to develop a landscape that reflected a personal view about technology and programming. He chose the pop-up book format because it creates a manageable dimension for what could otherwise be hard-to-comprehend facts. It allowed him to play with paper and at the same time develop a theoretical analysis about the communion between technique and theory in order to achieve abstract but logical results. The objective of combining the folds and cuts with the shapes and patterns was to cross the pop-up with the graphic representation of another mechanical act.

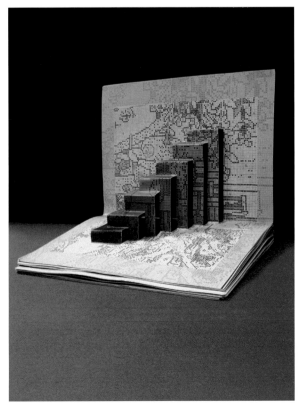

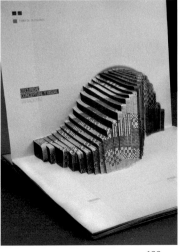

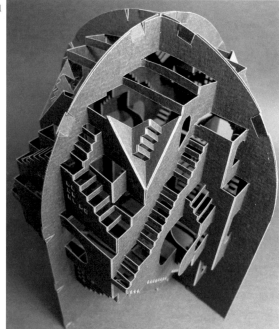

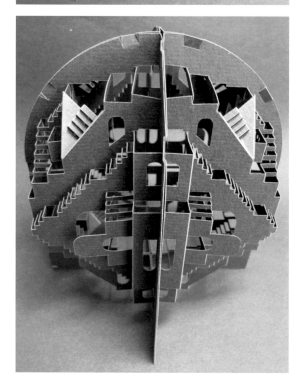

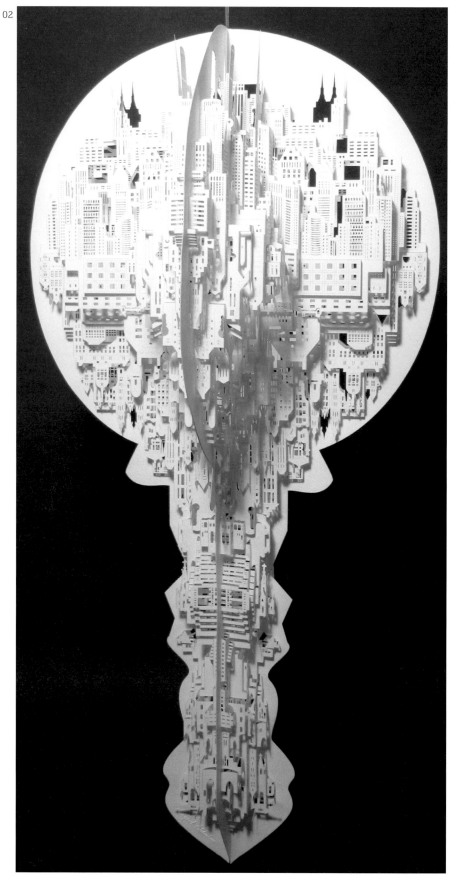

Ingrid Siliakus

01 <u>Rondding Histair</u>

An abstract piece constructed using four sides attached to one another with integrated slits and tabs that can be separated in order to fold the artwork flat.

02 <u>Key</u>

Paper architecture in the shape of a key for the cover of the October 2010 issue of the *New York Times Magazine*. The key contains two mirrored sky-lines: New York City and Amsterdam. When the design was finished, four identical sides where cut and folded and attached to each other with integrated slits and tabs that allow the sculpture to be folded into a two-dimensional surface.

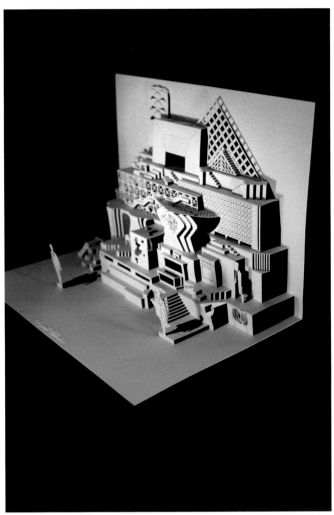

Wallpaper*

UK £4.20
US $9.50
AUSTRALIA $ 10.50
CANADA $9.50
DENMARK DKK 75.00
FRANCE € 8.50
GERMANY € 10.50
HOLLAND € 8.50
ITALY € 9.00
JAPAN ¥ 1740
SINGAPORE S$ 18.20
SPAIN € 6.50
SWEDEN SEK 75.00
SWITZERLAND CHF 16.00
UAE AED 45.00

FEBRUARY 2009

***DESIGNINTERIORSFASHIONARTLIFESTYLE**

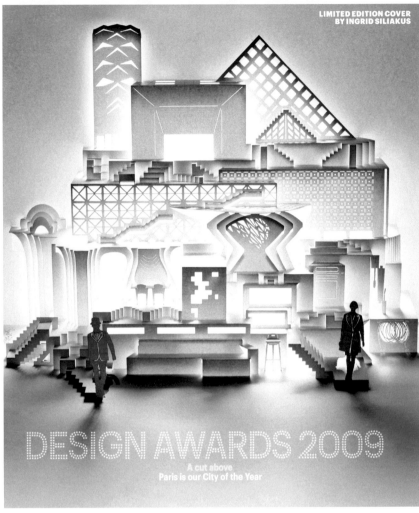

LIMITED EDITION COVER
BY INGRID SILIAKUS

DESIGN AWARDS 2009

A cut above
Paris is our City of the Year

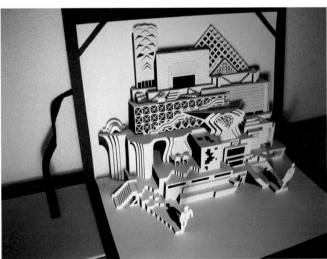

Ingrid Siliakus
Cover Wallpaper*
Paper architecture design created
for the cover of *Wallpaper** maga-
zine's limited edition Design Awards
2009 issue. The piece included
elements and products of the award
winners as well as a reference to
Paris, which had been chosen as
*Wallpaper**'s city of the year.

It's construction time! Ingrid
Siliakus' stunning three-dimensional
models of utopian and dystopian
cityscapes—above ground and
below—offer a fascinating glimpse
of things to come, of real or imagined
futures in space and time.

Always based on a single piece
of paper, these prime examples of
paper architecture can require 30+
iterations and prototypes until the
outcome is just right. To this end,
Siliakus adds layer upon layer, from
basic shape to Escheresque stair-
case, with surgical precision and an
architect's eye for pivotal structural
strengths and weaknesses.

The final, often backlit, models are
the result of near infinite patience.
According to the artist herself,
"Working with paper forces me to
be humble, since this medium has a
character of its own that demands
cooperation. Paper architecture does
not tolerate haste—it is its enemy;
one moment of loss of concentration
can lead to complete failure."

Sheung Yee Shing
The King of Pop-Up Card
(Athens Parthenon)
It took approximately one year to
design this pop-up sculpture based
on the Parthenon. When opened, 58
three-dimensional columns emerge.
The piece was designed using a
system of interlocking parts. With
the exception of two pieces on the
baseboard, no glue was used.

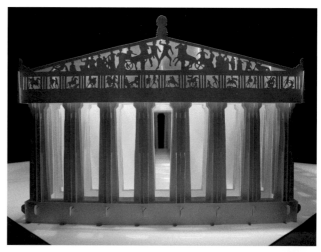

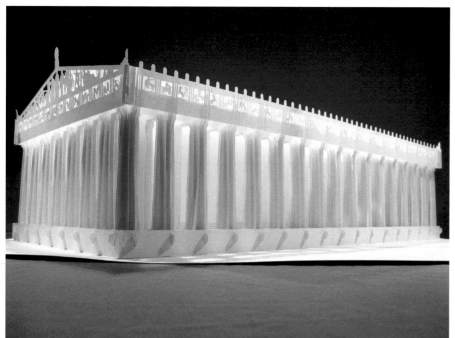

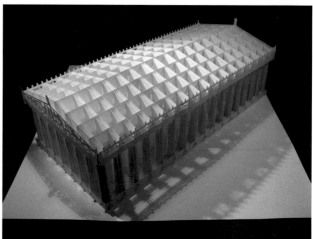

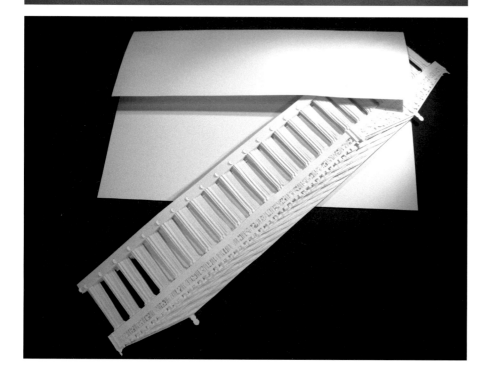

right page
Jill Sylvia
01 Untitled (U.S. Capitol Building)
02 Untitled (U.S. Treasury Building)
03 Untitled (White House)
04 Untitled (Yellow Book)
Sculptures made from hand-cut led-
gers. Each blank space of a ledger
sheet was cut out by hand, creating
a transparent grid of paper. Sheets
were glued together to intricately
recreate delicate miniature versions
of their real-life counterparts. Most
pieces are no more than 30 centi-
meters at their largest dimension.

01

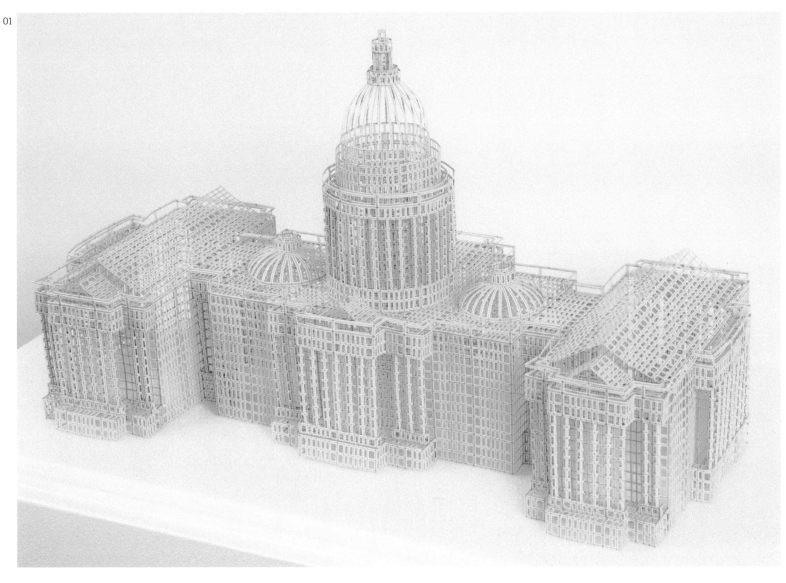

02

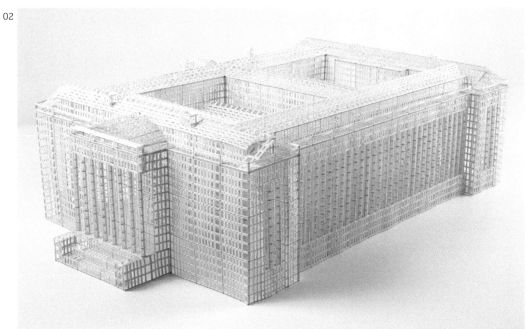

03

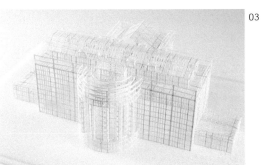

04

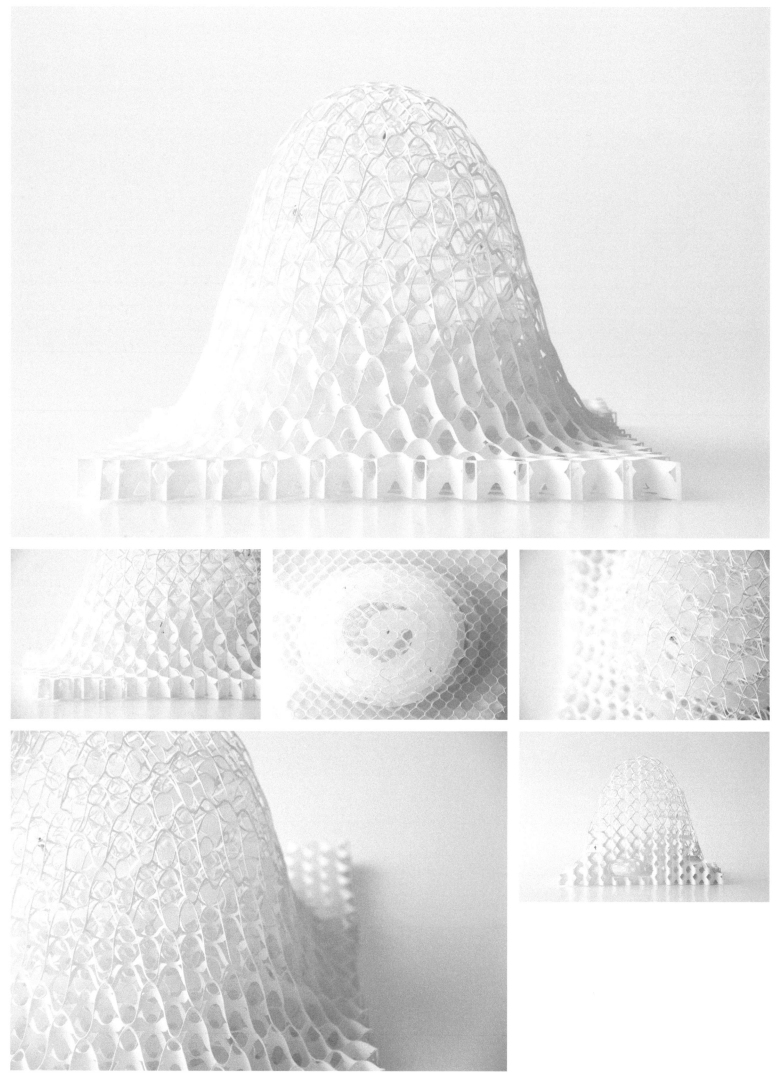

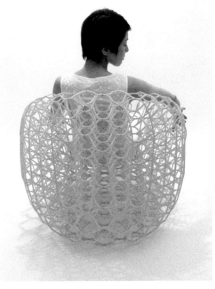

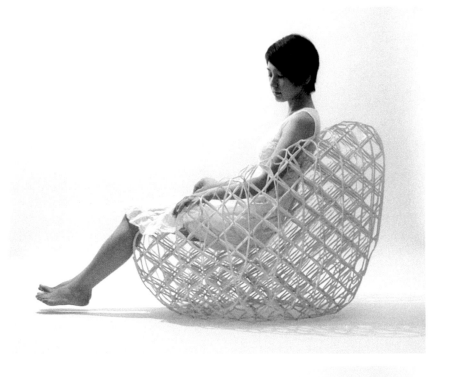

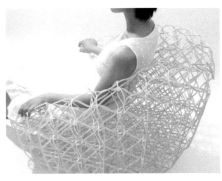

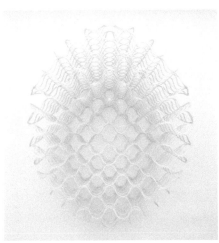

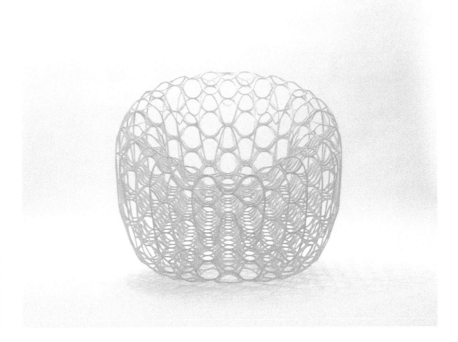

Ryuji Nakamura

left page

Mont Blanc

Paper sculpture of the landmark
and observatory in Paris, where the
visibility improves upon ascent.

this page

Hechima 4

Chair made of vulcanized fiber that
is visually and physically porous
and light.

While Ryuji Nakamura's airy cell
textures and honeycomb objects are
a definite presence in physical space,
they also serve as mental exercises in
extending the medium and bending
it to the creator's will. Probably as far
removed from paper's origins as the
first scribes might have envisioned,
the architect's sculptures and instal-
lations explore the structure — and
strictures — of the material itself.

Driven by a healthy obsession for
geometry, and the limits, strengths,
and weaknesses of paper, of its ar-
chitectural and sculptural properties
or calculated breaking points, based
on algorithms gone wild, Nakamura
uses vulcanized fiber paper to craft
stunningly spindly works of art remi-
niscent of sintered three-dimensional
printer prototypes. Light-weight, yet
weight-bearing, these creations are
the product of a custom technique
that allows for virtually anything
to be shaped and folded through a
simple and automated process, from
bed or table to partition.

On a more ambitious scale,
Nakamura translates this process to
encompassing installations. Taken
to the extreme, the resulting hyper-
real three-dimensional grids, grills,
and grates are stunning exercises of
geometry in space — akin to digital
inserts or augmented renditions of
reality superimposed on a given en-
vironment's real world structure.

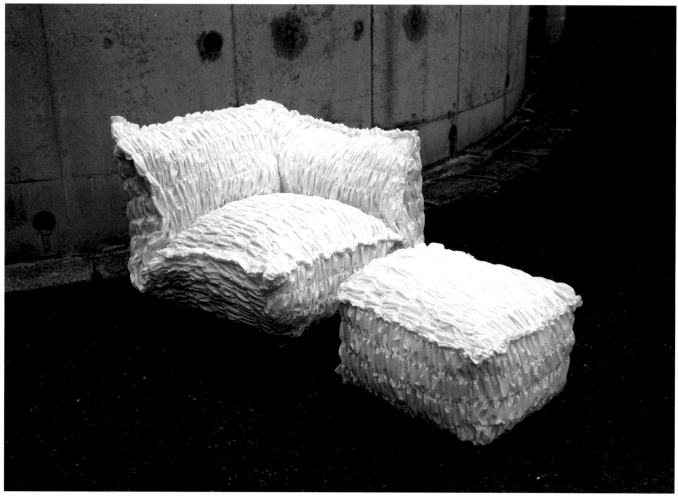

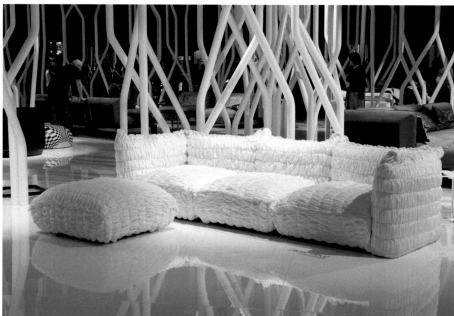

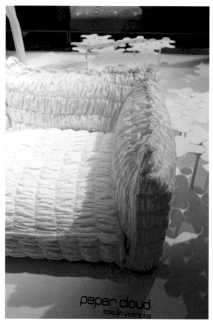

Tokujin Yoshioka

Paper Cloud

Full-scale paper prototypes developed by Tokujin Yoshioka for furniture design company Moroso. Always fascinated with the elements of nature and the possibility of expressing these elements with industrial production, Yoshioka chose to work with a "cloud" theme for this project. His appreciation of the natural world extends to his own process, which relies on a dialog between materials and the human hand. The unexpected results that this dialog can bring are valued by Yoshioka and result in a manipulation of common materials that others often mistake for new technology.

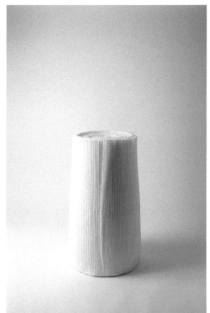

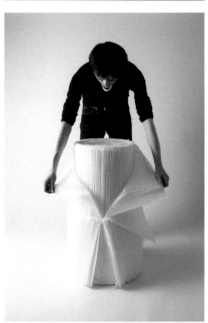

Nendo

Cabbage Chair

A paper chair designed for Miyake using the pleated paper produced — and usually abandoned as an unwanted byproduct — during the process of making pleated fabric. The design is interactive; a chair slowly appears from a roll of paper when its outside layers are peeled away. The resins added during the original paper production process add strength and hold the chair's form, while the pleats themselves give the chair elasticity and resilience, providing a comfortable seating experience. The chair is shipped as one compact roll for the user to cut open and peel back at home. As it has no internal structure, it is assembled without nails or screws. This simple design addresses current concerns regarding fabrication and distribution costs as well as environmental issues.

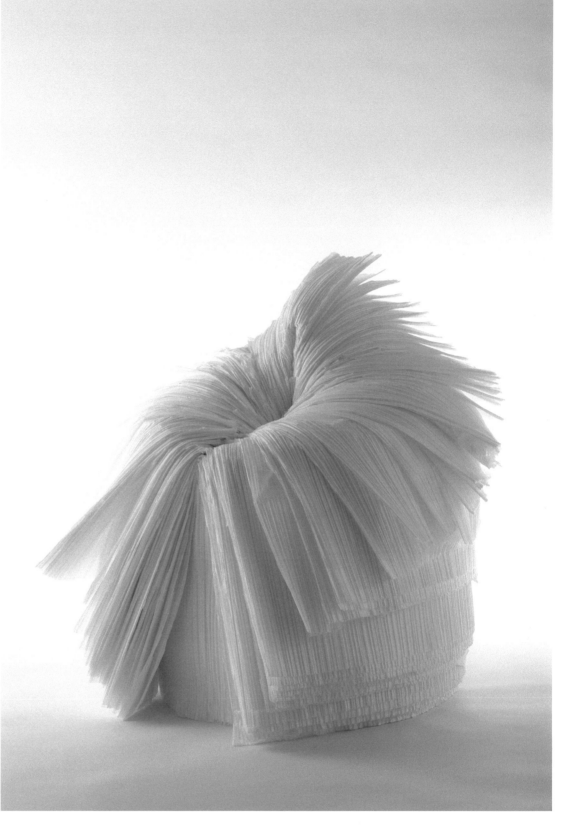

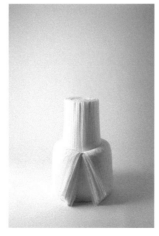

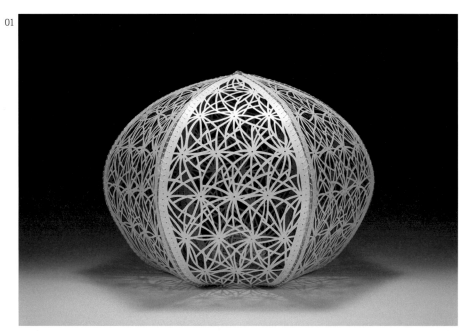

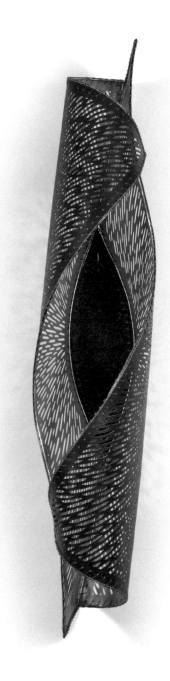

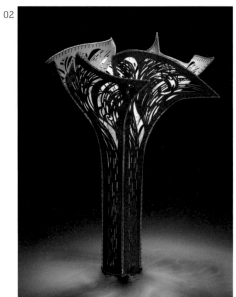

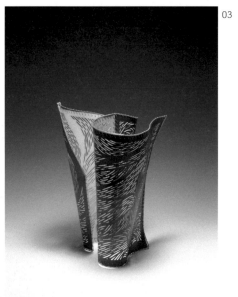

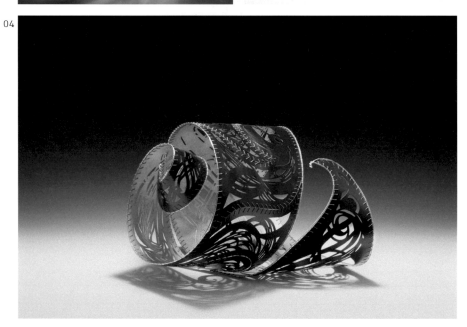

Jennifer Falck Linssen

01 Order and Chaos
02 Crest
03 Wind Folds
04 Chasing the Curl
05 Sheathe
06 Comfort

Katagami, the Japanese technique of creating detailed patterns on material with stencils, influences the style of Jennifer Falck Linssen's hand-carved paper sculptures. Her work explores the sculptural possibilities of the stencil by creating baskets, vessels, and abstract objects that address themes of nature, time, and emotion.

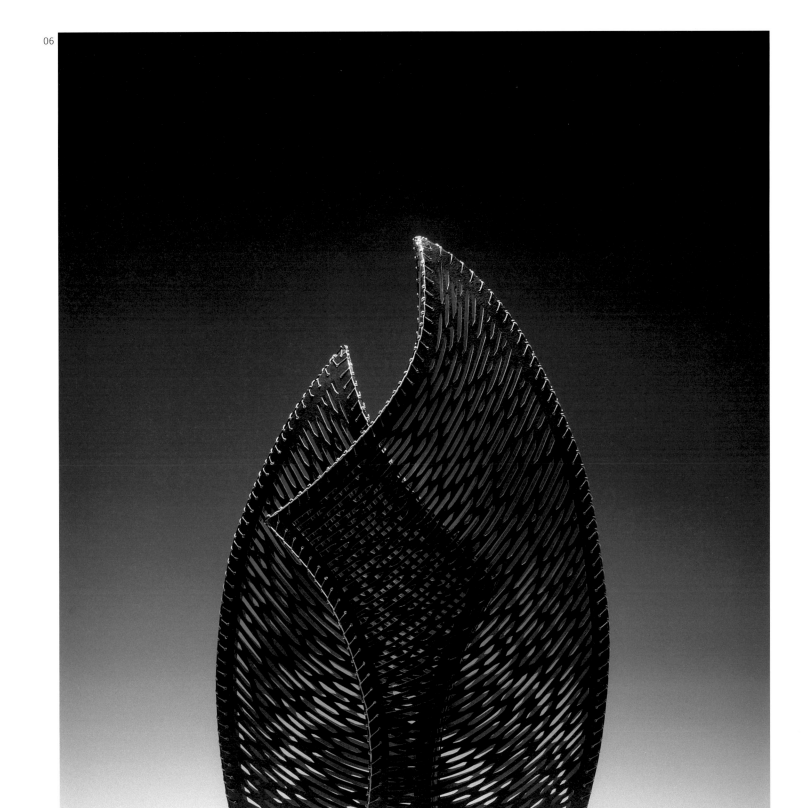

WHAT IT REALLY IS

Jennifer Rose Sciarrino

01 Stalactitic Pendants,
Supposed Stalagmites
The sculptures of Jennifer Rose
Sciarrino contain between 700 and
1,000 layers of hand-cut paper.
Using a repetitive methodology,
each layer is based on the previous
layer. This process mimics the slow
geological formation of stalactites
and stalagnites and attempts
to construct time as a tangible
object. In her series, "Supposed
Stalagmites" and "Stalactitic
Pendants," Sciarrino presents
sculptures with tonal gradations of
bright greens, blues, purples, and
pinks. The sculptures become an
abstracted representation of these
geological forms and are installed
on the ground or a few feet above
the viewer's head.

Riki Moss

02 Glow Globe, Glow Lamp
The illuminated sculptures in the
"Studio-Glow" series from Riki
Moss (in collaboration with Robert
Ostermeyer) are created using 75 to
100 sheets of embedded and beaten
handmade abaca paper mounted on
a metal form.

emocja

03 Blop Lamp
Made from discarded paint chips
that are joined by rivets, the Blop
Lamp has a flexible shape, allowing
it to respond to its surroundings.

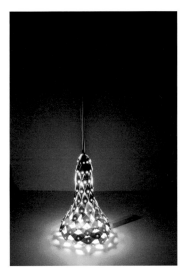

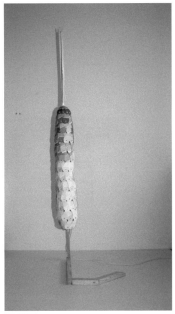

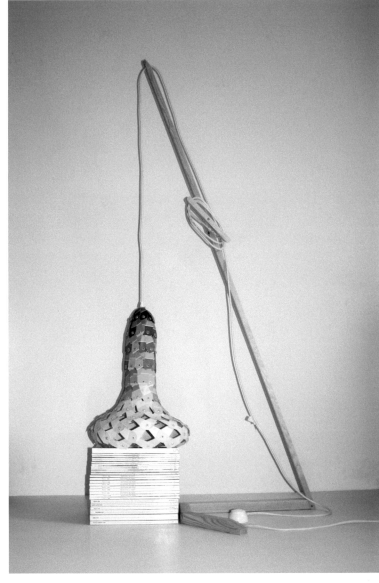

03

Mieke Meijer & Vij5
04 Newspaperwood / KrantHout

04

Ilvy Jacobs

01 Paper Taped Bags
 Bags made of paper and white
 sports tape.

02 Crunchbags
 Sports bags made from cotton
 laminated paper explore the bound-
 ary between what is disposable and
 sustainable.

01

02

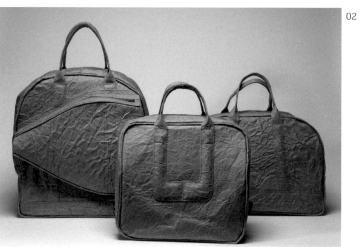

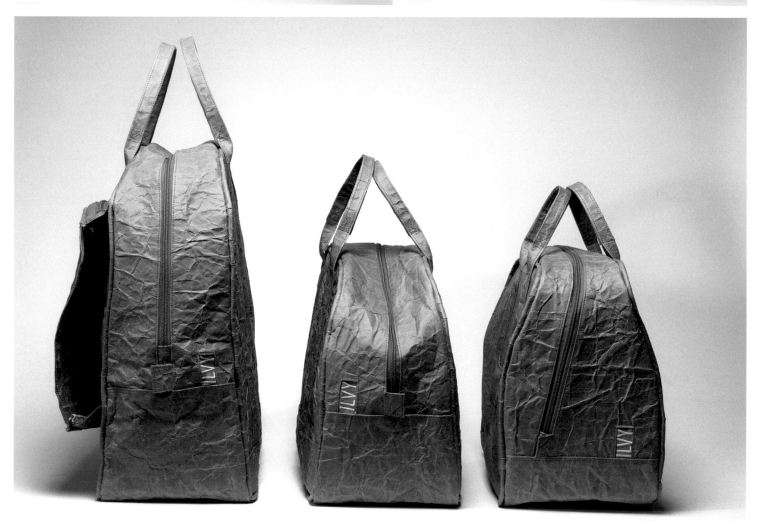

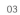

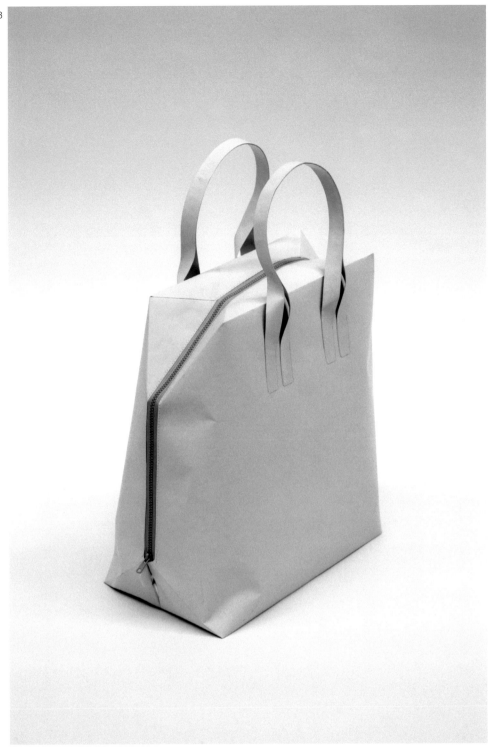

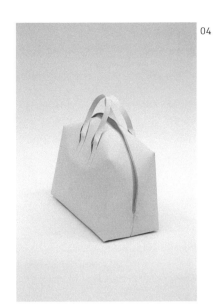

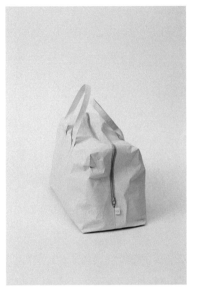

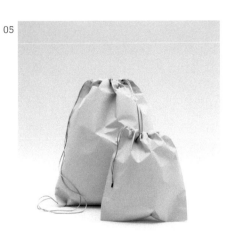

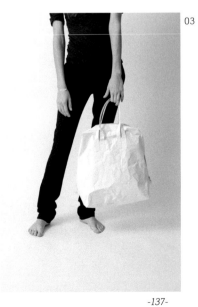

Saskia Diez / Stefan Diez

03 PAPIER 115g
04 PAPIER 135g
05 PAPIER handbag and
 PAPIER backpack

A travel bag made from Tyvek, a synthetic paper that is lightweight, tear proof, and waterproof. As an alternative to leather and reinforced textiles, Tyvek produces a durable and lightweight bag — 135 g for the large size and 115 g for the small size — that is completely recyclable and can be embellished with silk-screening.

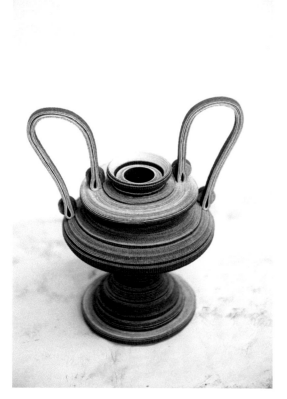

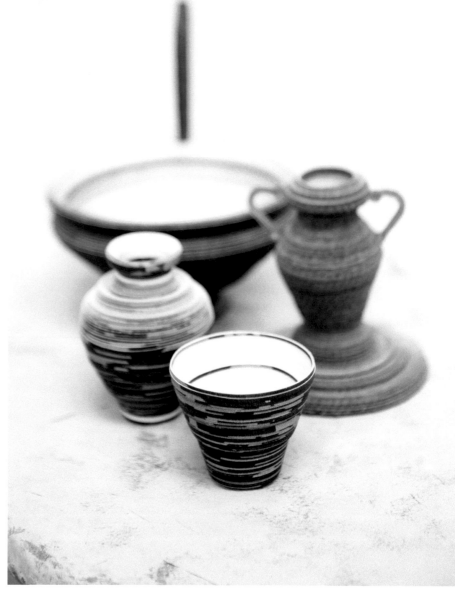

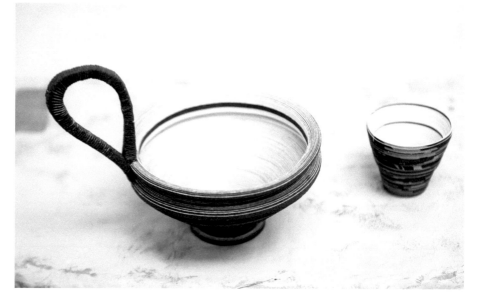

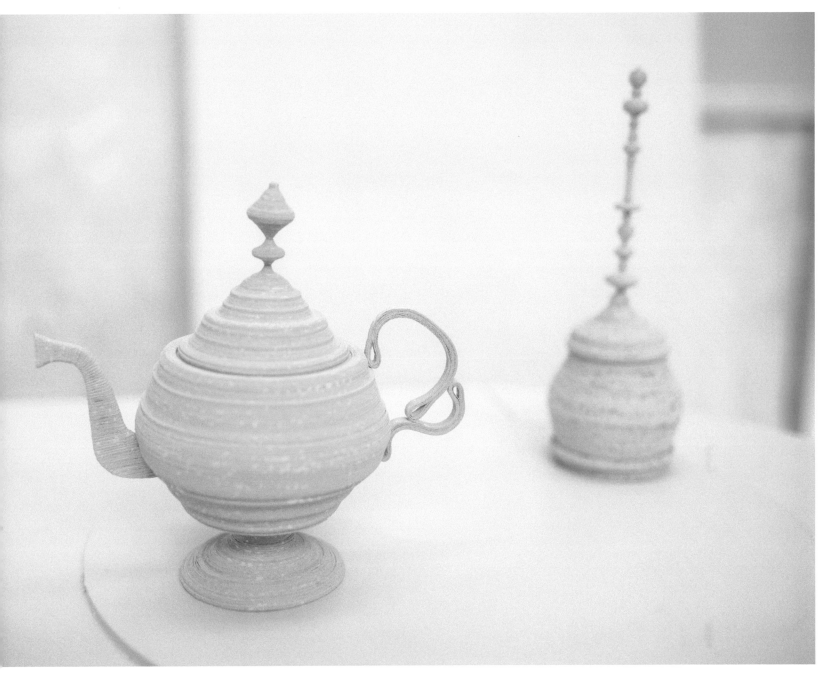

Appearances can be deceptive: these are no traditional clay teapots, turned on a potter's wheel according to the lore and skills of previous generations. Instead, German / Iranian artist Siba Sahabi takes the best of both worlds — European and Middle Eastern aesthetics, ancient craft and modern technology — to highlight the cultural interactions between ages and nations and their fruitful interminglings.

Fashioned entirely from paper strips — glued in thin layers, transposed by a mere millimeter or so — Sahabi's fragile marvels and tableware sculptures demand ample time and attention. The result of a slow, steady build-up from top to bottom, a meditative rhythm in its own right, they reflect the traditions of ceramic mastery in different parts of the world and recombine them in a range of delicate and contemplative pieces of paper art.

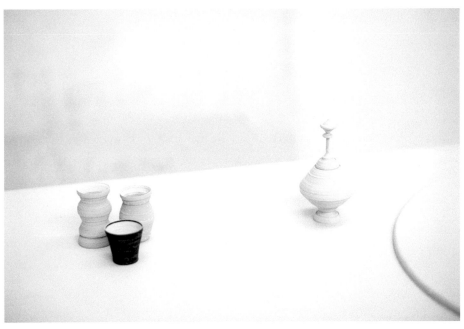

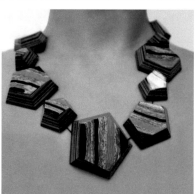

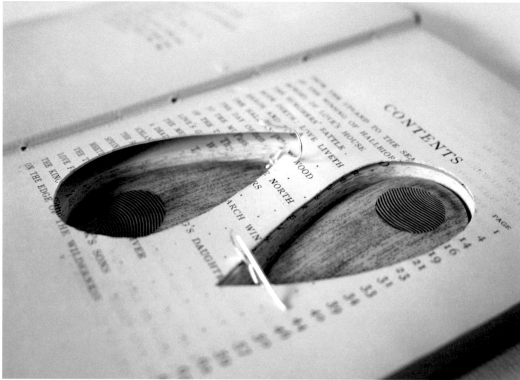

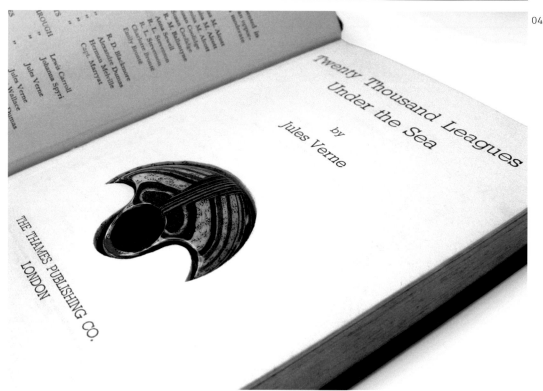

Jeremy May for LittleFly

01 Serial no# 013, *Dramatic Works*
"... To all that heavenly piety inspires, To all that praise repeats through lengthen'd years that honor sanctifies, and time reveres."

02 Serial no# 007, *Robinson Crusoe*
"I was born in the year 1632, in the city of York, of a good family, though not of that country..."

03 Serial no# 030, *Poems by The Way*
"Love makes clear the eyes that else would never see: Love makes blind the eyes to all but me and thee."

Jeremy May for LittleFly

04 Serial no# 105, *20,000 Leagues Under the Sea*
"The light produced a thousand charming varieties, playing in the midst of the branches that were so vividly colored."

05 Serial no# 069, *Senodoseio Saggai*

Recycling is rarely this enticing: fashioned from reclaimed newsprint, classic tales, and unwanted sheets of construction paper, Jeremy May's polished jewelry for LittleFly appears to be carved from the nearest rock face – or smoothed by millennia spent in a riverbed.

Instead, these semi-precious gems are the result of assiduous stacking and lamination, whittled from up to 200 layers of paper. Reminiscent of geological striations, May's accessories take the Brian Dettmer school of page-mining to a new level and present the finished essence in its source tome to honour the literary origin.

Thus imbued with the spirit of storytelling, May's deceptively light yet satisfyingly solid pieces might take their new owner *20,000 leagues under the sea* – or at least remind them of the joy of reading.

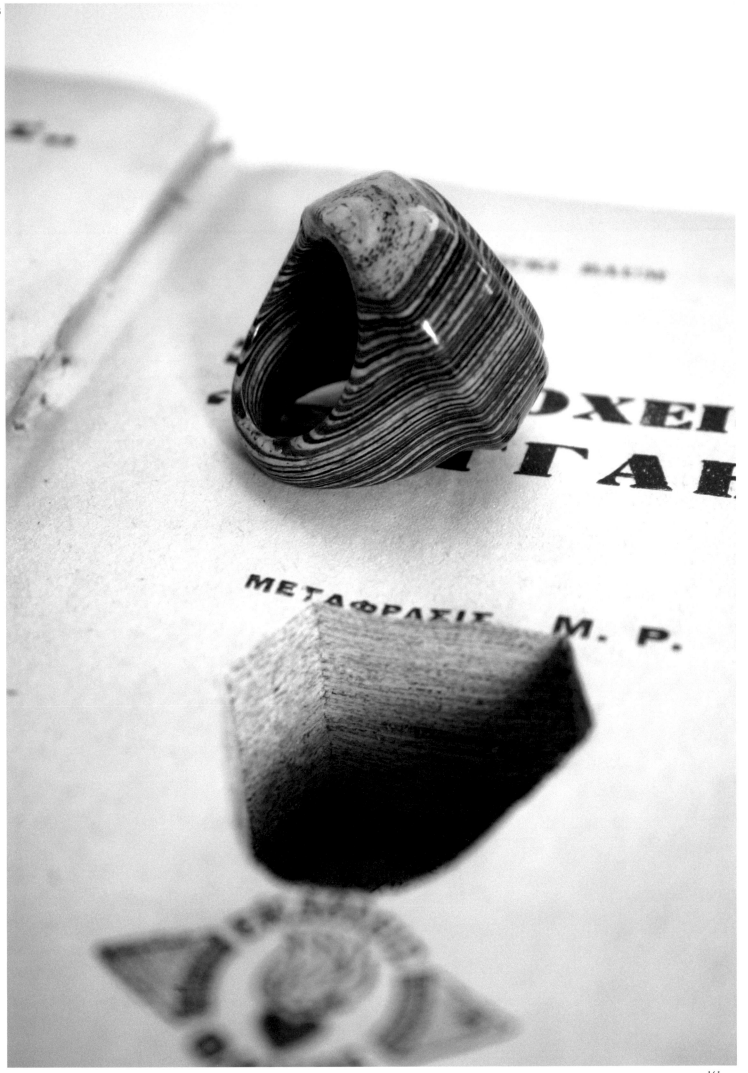

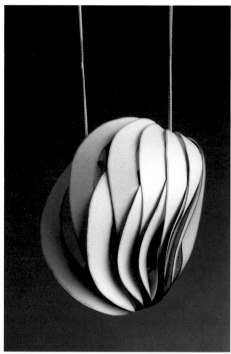

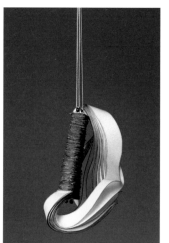

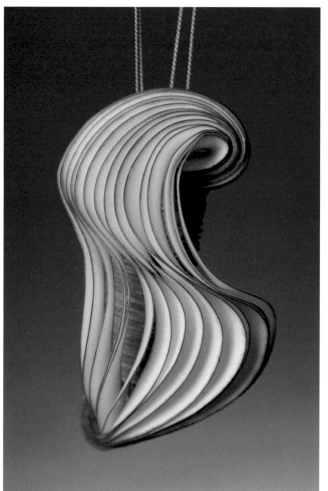

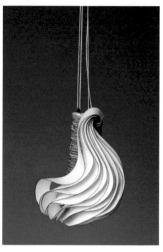

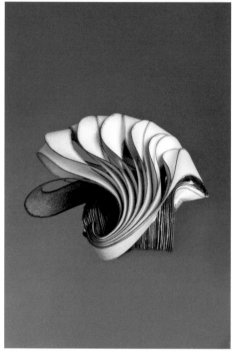

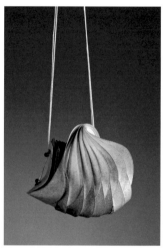

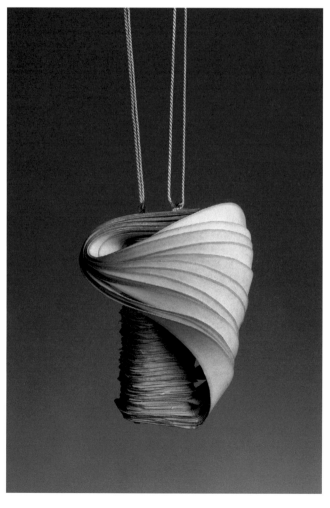

Lydia Hirte

Untitled

The sculptures of Lydia Hirte are characterized by twisting, strengthening, and spring-like tension. She responds to her material — a fine cardboard — as it exhibits resistance to her manipulation. Her process involves creating bundles of flat shapes, then applying large amounts of pressure to them until they become deformed by her tearing and twisting.

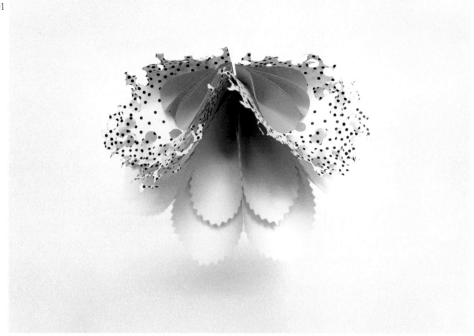

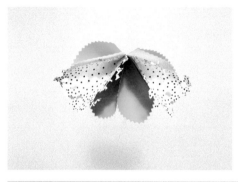

Sascha Nordmeyer

01 <u>Artificial Plants and Flowers</u>
Inspired by the tropical flora in
Singapore, these paper plants and
flowers are made from colored,
printed, and punched paper.

02 <u>Artificial Cactus AOL</u>
Paper cacti commission by AOL
Inc. for use as backgrounds for
their website and other marketing
materials.

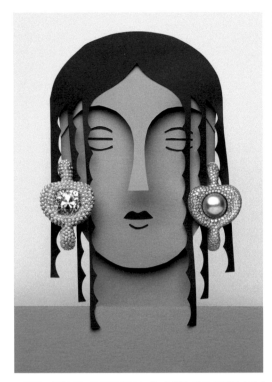

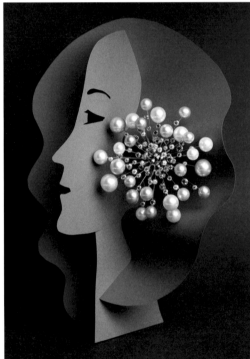

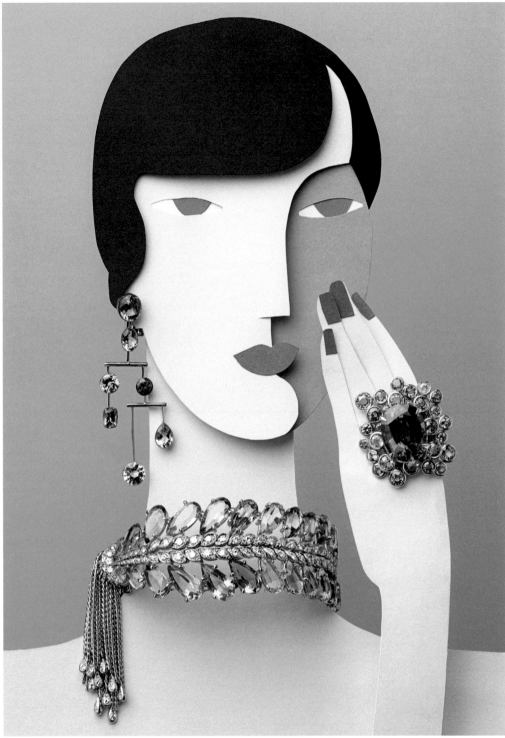

Bela Borsodi
La Mystique des Femmes
Inspired by the art deco style, these
shapes and figures were designed
to display a mixture of vintage and
contemporary jewelry featured in the
2009 "France" issue of *Departures*
magazine.

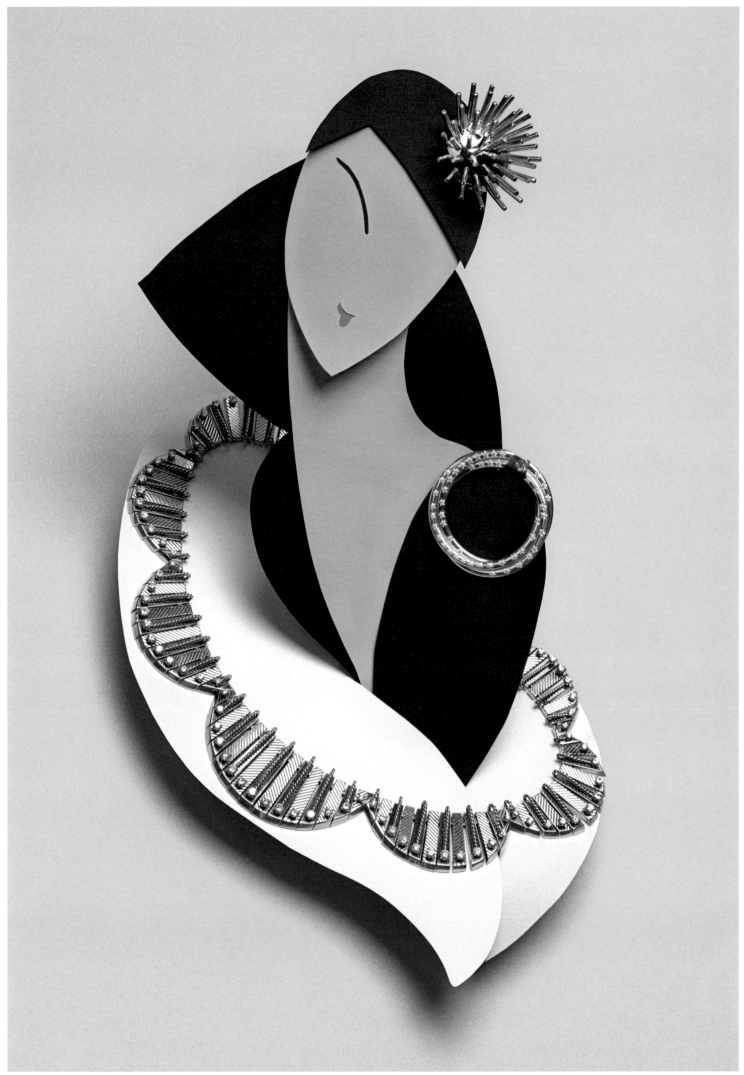

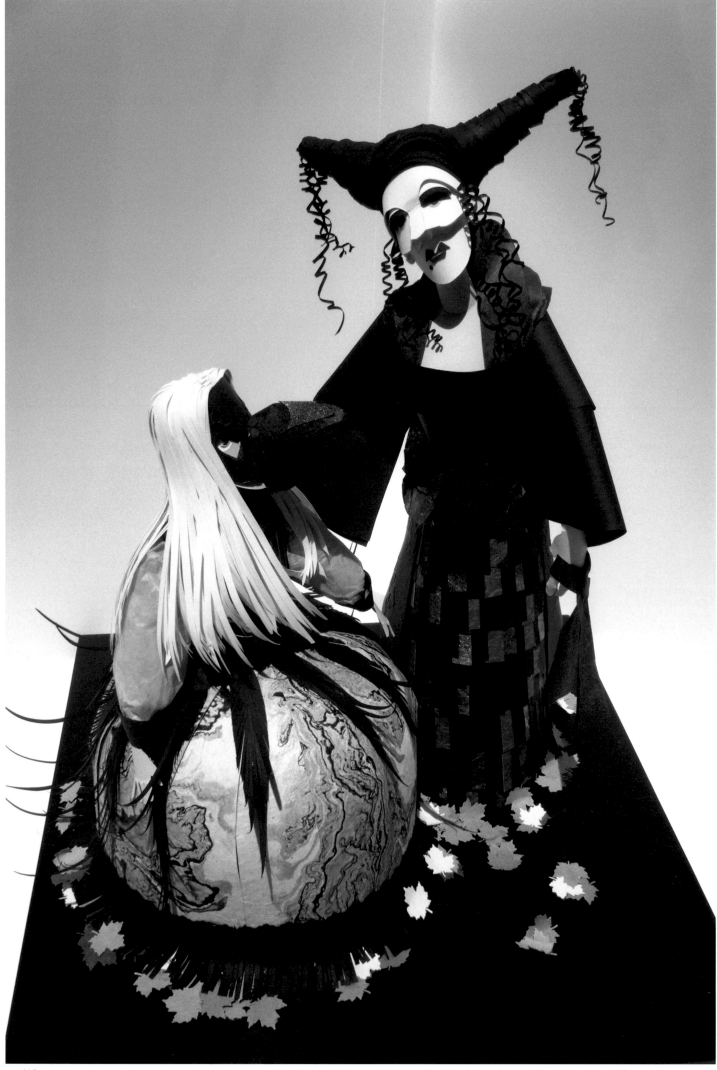

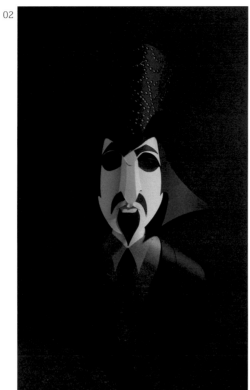

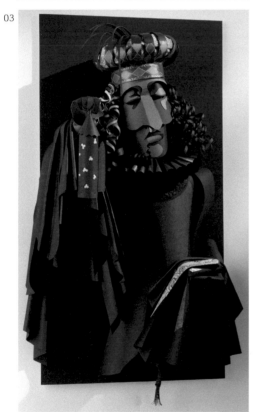

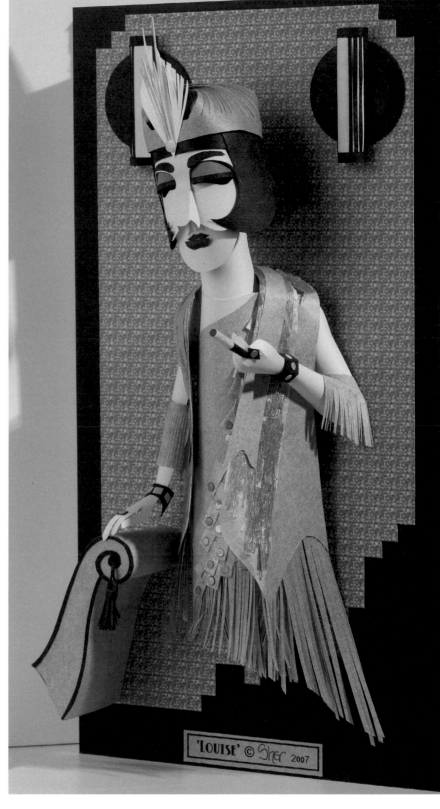

'LOUISE' © Sher 2007

Sher Christopher

01 Carnevale (Bird)

A sculpture inspired by the Carnival of Venice and the elaborate hairstyles of the main female figures. As with all of Christopher's sculptures, the figure is built in detailed layers, constructing the paper body before building the costume on top. The bird costume is a skirt that hangs over a stripped shirt complete with collar and tie over a puffed sleeve blouse. A highly detailed piece, the sculpture stands at only 33.5 centimeters tall.

Sher Christopher

02 Halloween Jack

Paper figure inspired by a combination of Halloween, the Victorian era, and Gothic storytelling.

03 Merchant with a Lamp

One in a series of sculptures inspired by *The Merchant of Venice* by William Shakespeare. Close attention was paid to giving stiff paper the illusion of being a soft and flowing material.

Sher Christopher

04 Louise

Based on the 1920s actress Louise Brooks, this sculpture expresses the art deco influences of the period through its geometric construction. The hand-cut embellishments on her dress were influenced by the paintings of Gustav Klimt.

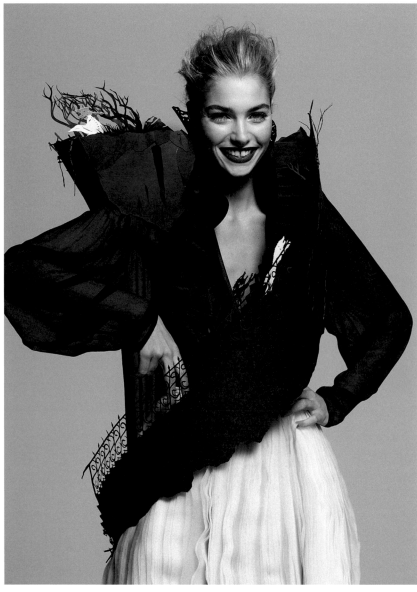

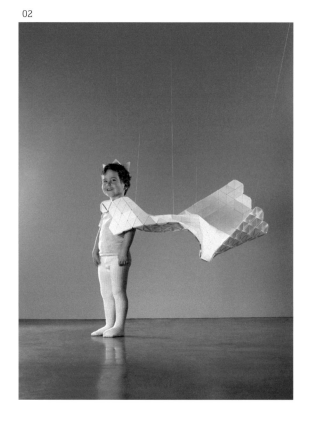

Stuart McLachlan
01 Black Stairway
Based on a story written by the
artist, the "garment" depicts a girl
on a stairway as she is pursued by
wolves. Created originally for the
fashion runway, it later appeared
in a fashion spread for *Karen*
magazine.

Le Creative Sweatshop
02 Bonbek
Interactive game for children.
Paper triangles are assembled from
patterns turning imagined objects
into reality.

Grégoire Alexandre
03 Installation

Grégoire Alexandre
*In cooperation with Claudia
Roethlisberger*
04 Minh Anh, Libération

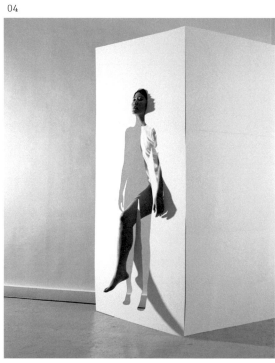

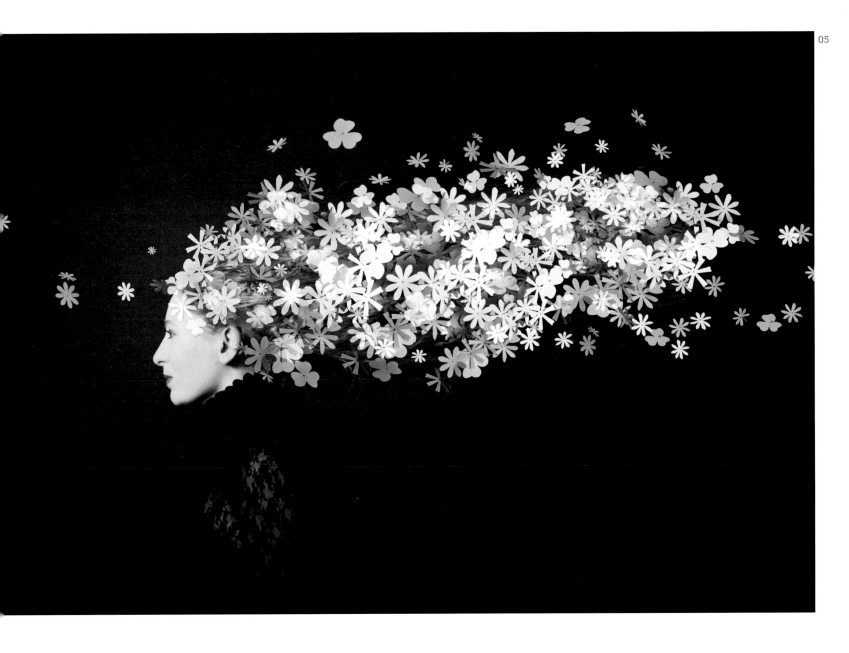

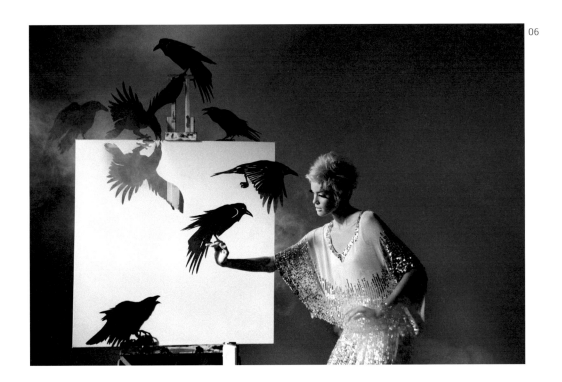

06

Coming Soon
05 Zefiro Torna
Paper flowers added to previously
photographed images as part of
the annual program calendar for
the classical music ensemble
Zefiro Torna.

Stuart McLachlan
06 The Call

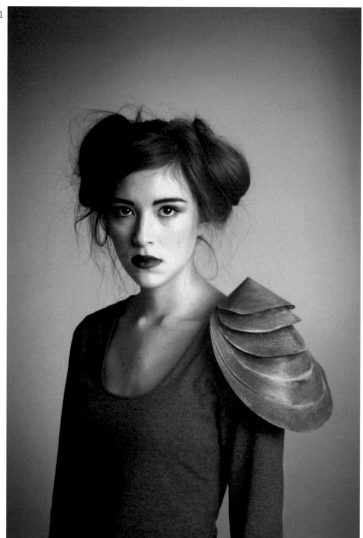

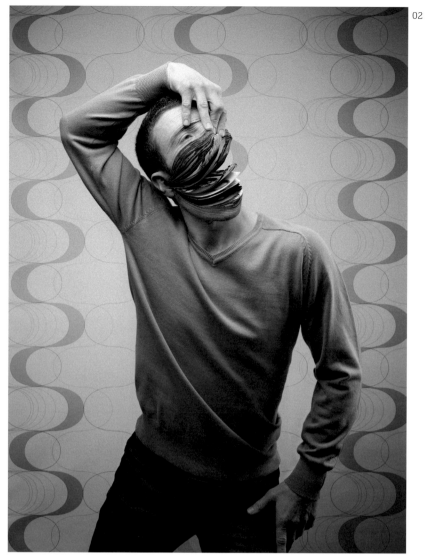

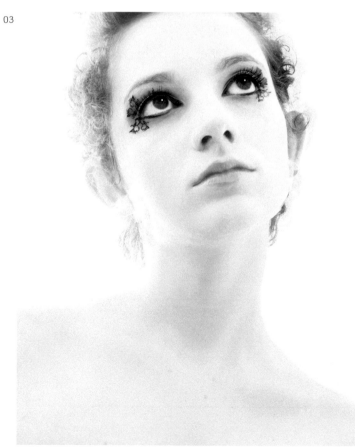

Hattie Newman

04

05

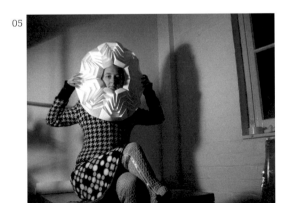

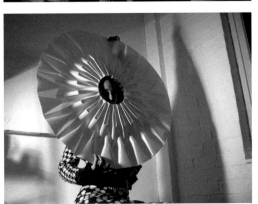

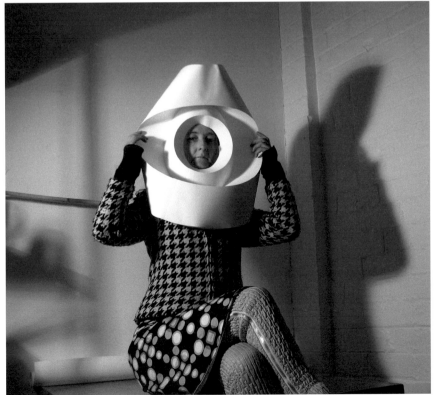

01

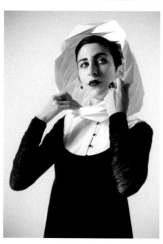

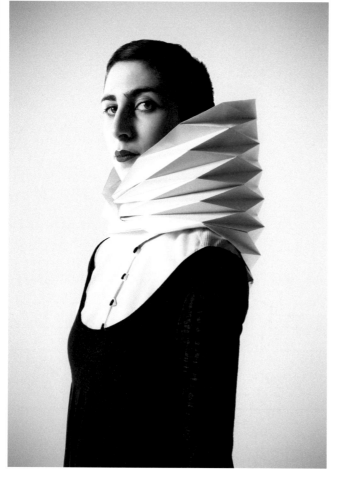

GAIAdesign
<u>VEASYBLE unfold a beautiful intimacy</u>
01 VEASYBLE ruff / hood
02 VEASYBLE barrette / visor
03 VEASYBLE bag / shell

A four-piece collection of accessories made from paper bonded to polyethylene and fabric. The concept of the collection is based on themes of isolation, intimacy, and ornament and asks how much a sense of personal space is affected by the contemporary public environment. The pieces work as screens for different parts of the body (eyes, ears, face, and upper torso) by using adjustable shapes that vary in scale and proportion according to the user's need for privacy. A scarf becomes a hood, screening ears from outside noise; a headband becomes a mask, protecting the face from external odors and sights; a barrette becomes a visor, concealing eyes from exterior views; a bag becomes a shell, hiding a body (or two) from the outside world.

02

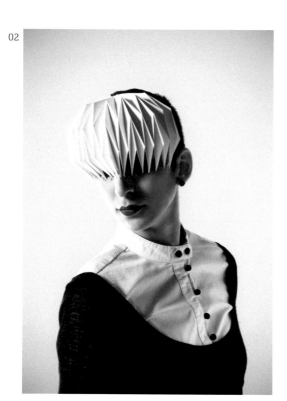

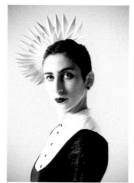

03

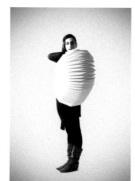

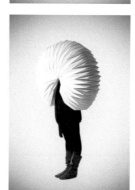

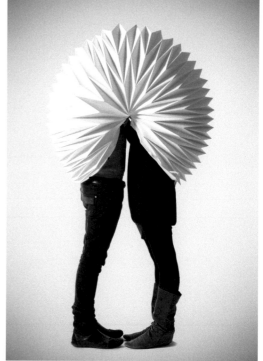

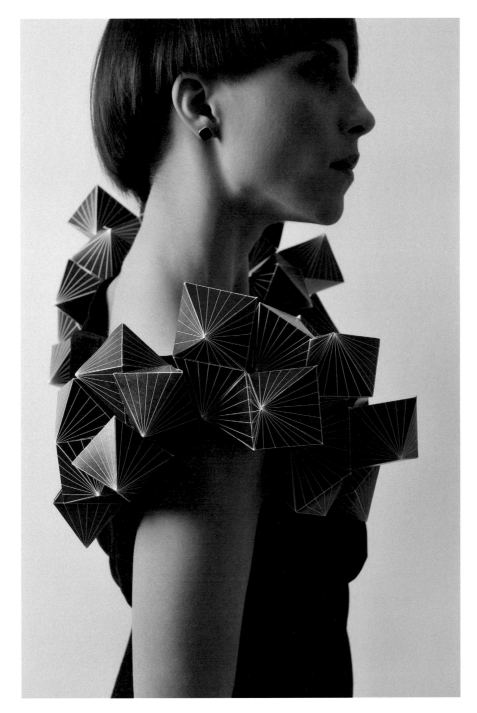

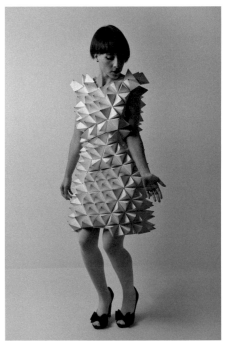

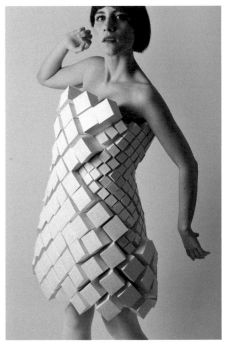

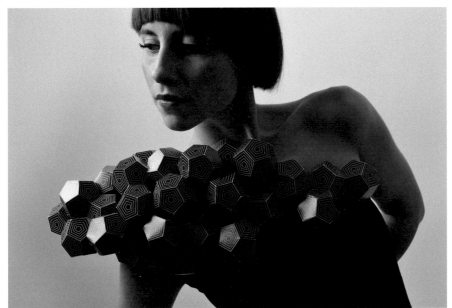

Amila Hrustić
Plato's Collection
A collection of five unique dresses handcrafted from a combination of textiles and paper. The project examines relationships between geometrically structured space and the human body by using one of the five platonic solids for each dress. Simplicity of form, and black and white patterns on rigid paper emphasize the body and its overall expression in space. The pieces in the collection are stage costumes intended for performances and fashion editorials.

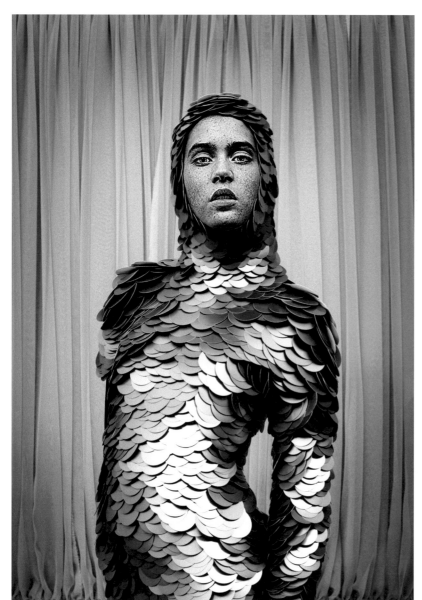

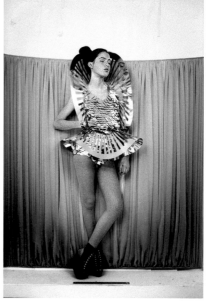

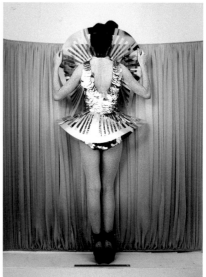

Bea Szenfeld
Sur la Plage

Twelve paper outfits pleated, pinned, sewn, and glued by hand. Inspired by tropical seabeds, rolling waves, uninhabited islands, and the folklore of sailors, the garments were also influenced by paper itself, finding inspiration in its complex character, which requires problem solving and technical solutions in order to achieve the desired effect.

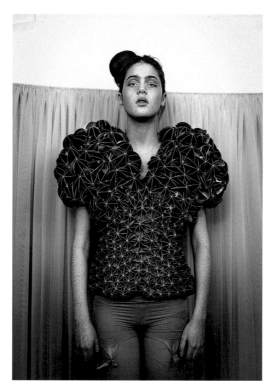

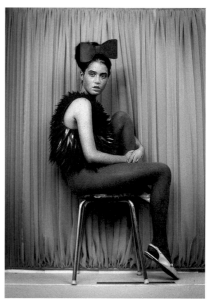

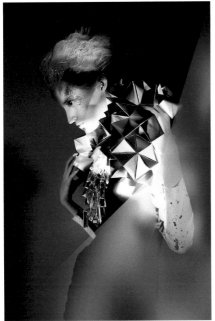

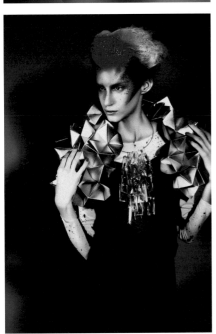

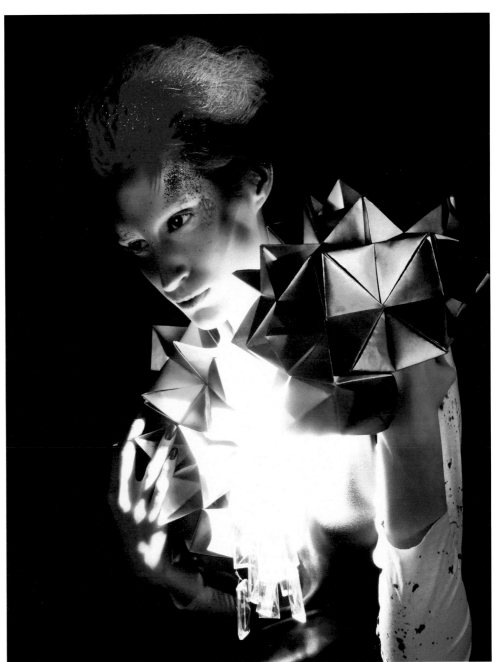

Anna Daubner
<u>Prismatique</u>
Accessories for women based on
crystal and origami shapes.

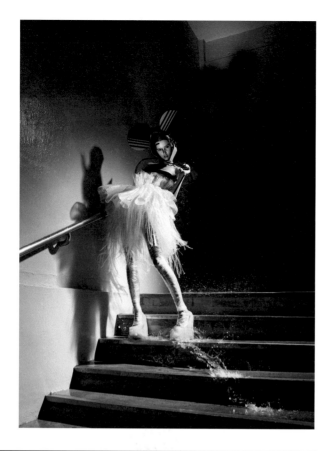

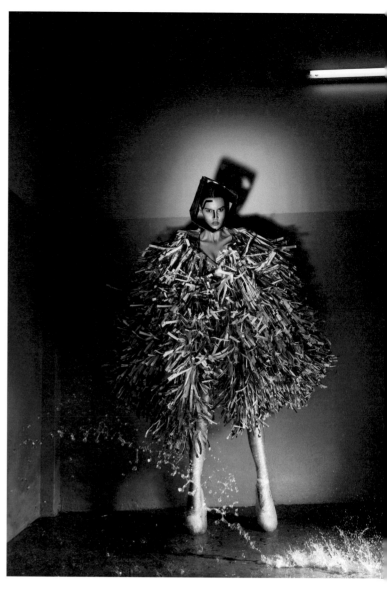

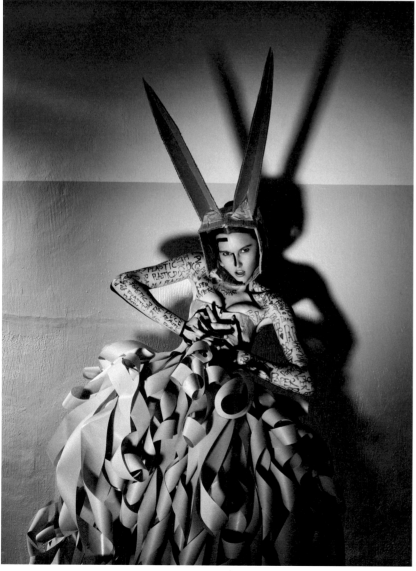

Test Shoot Gallery
Paper Couture
Gum tape, raffia string, aluminum foil, saran wrap, egg trays, bubble wrap, and trash bags were used to turn brown paper, toilet paper, tracing paper, old magazines and newspapers into paper couture. This series acknowledges the ubiquity of paper in daily life and transforms trash into wearable art.

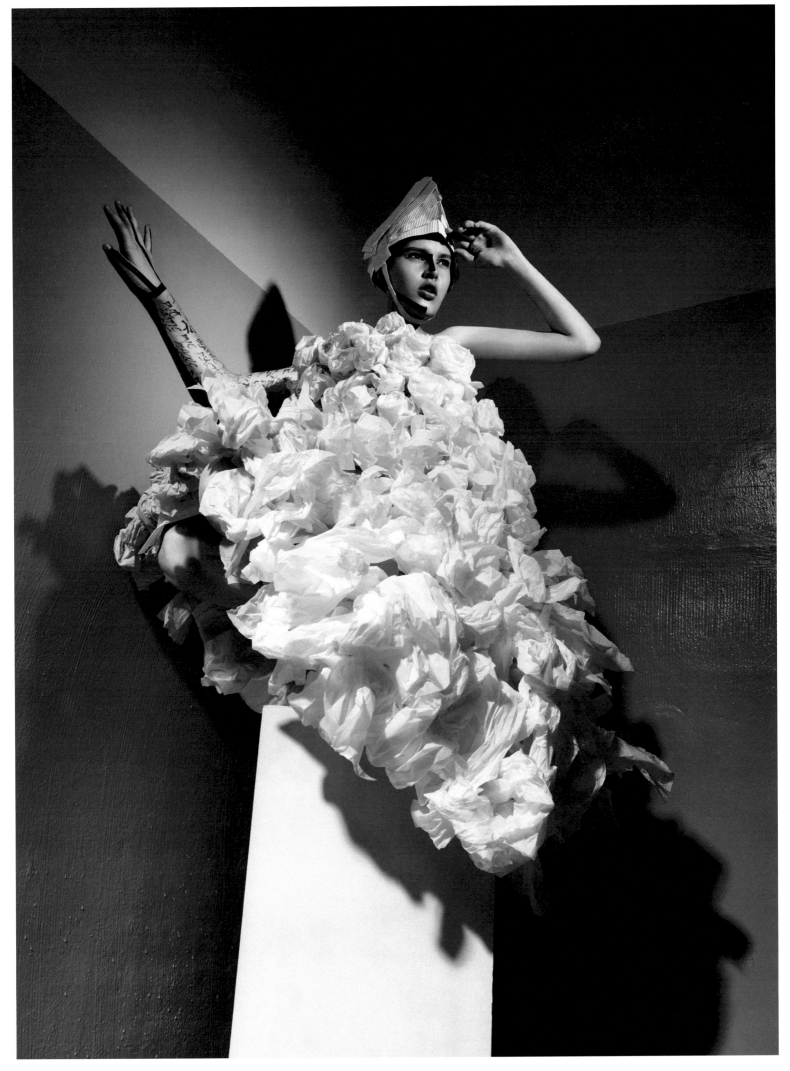

04

Text and Texture

One of the oldest tricks in the book — or framed on your grandparents' wall — are silhouettes and paper cuts that distil the complexity of stories, shapes, and singular personalities down to their outlines and overt characteristics. Defined by clear borders and the simple either-or dichotomy of paper/no paper, they throw their subjects into sharp relief while highlighting the undeniable skill of their creator.

Well, so much for theory: armed with scissors, scalpels, and, in some cases, computers and laser-cutters, some brave souls have started to boldly go where no paper artist has ventured before: with elaborate layering, physical depth, added color and (con-)text, or a level of intricacy previously unseen in this particular discipline.

Caged behind the flimsiest of grills and lattices, these meticulous masters of slice-and-dice set out to explore the rich, organic ramifications of overlain and intertwined natural growth, of busy hide-and-seek picture puzzles brimming with butterflies, blooms, and leafy textures. Reminiscent of modern-day church windows or seasonal transparencies, often strategically illuminated or inlaid with colored sheets for dramatic effect, the results can be retro and romantic — or overlaid to the point where the tale told becomes virtually unintelligible, but no less compelling for it.

Such dense and convoluted samples of information overload might retrace our own body's interior — from veins, muscle strands, and intestines right down to the tiniest bronchioles (Kako Ueda) — or explore the spell-binding tension between natural growth and geometric patterns. Fractal, yet organic, these self-repeating designs delve deep into the undergrowth of nature running rampant to produce almost impossibly complex and multilayered examples of scissor-

based magic: take the filigree whorls, whirls, and patterns of Andy Singleton's panoramic Dust Clouds in the Eagle Nebula, a work that spins run-of-the-mill paper strands into something akin to wool or twine, spreading across a micro-universe.

Faced with such intense challenges, pragmatics rely on machined precision, while others relish in the finest of hand-sliced divisions, fully aware that a single misplaced cut could send them back to square one. Symbolic to the core, here it is the technique itself that ensures continuity: nothing can exist in a vacuum or without at least some connection to the greater whole.

Bovey Lee's filigree rice paper pieces, for example, — one-sheet optical illusions of implied overlayering — incorporate added depth of field and perspective with faux three-dimensional views and impossibly detailed encoded messages. In this, she finds herself in good company: unashamed storytellers one and all, the following artists fill their framed creations with life and lettering, growth and decline, held together by the flimsiest narrative or paper thread.

Along these lines, Natasha Bowdoin's thickly textured paper objects — and truly poetic reappropriations of actual poetry — allow the words and meanings of existing stories to branch and feather out, to take over space itself with new context born from dense paper nuclei. Adding almost infinite layers to alien-like lifeforms protruding from a gallery wall, or, alternatively, disappearing into perceived infinity à la Jen Stark or Charles Clary, the resulting installations epitomize immense amounts of time, love, and skill in their tangible representation of effort and enthusiasm, vision, patience — and, possibly, just a touch of inspired madness.

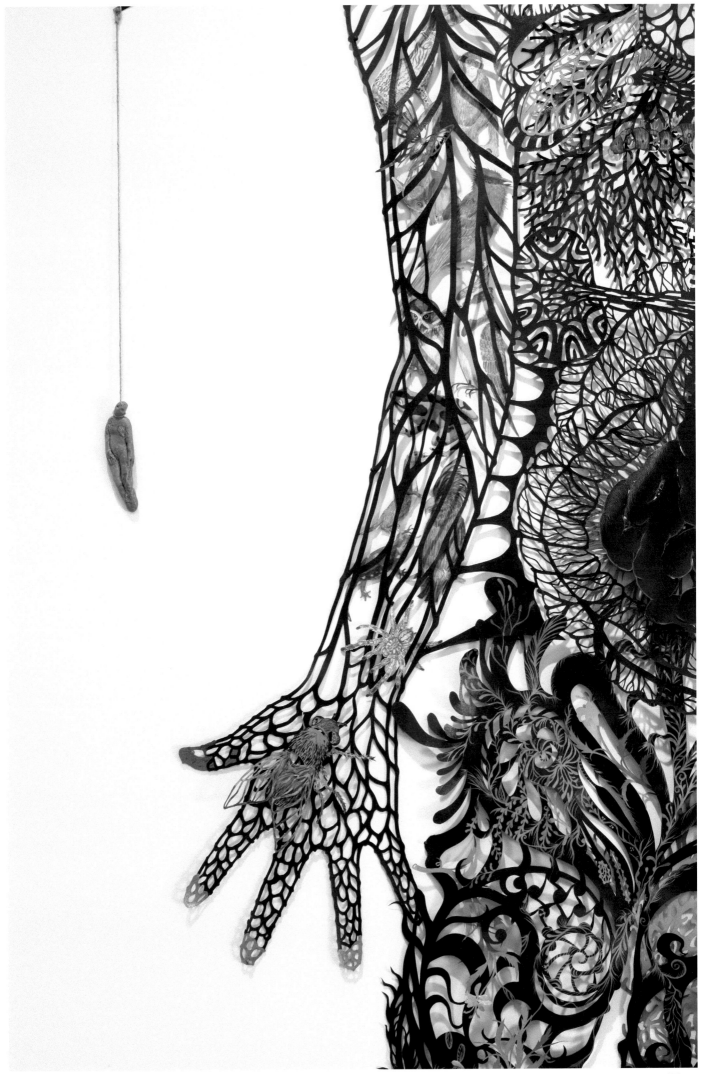

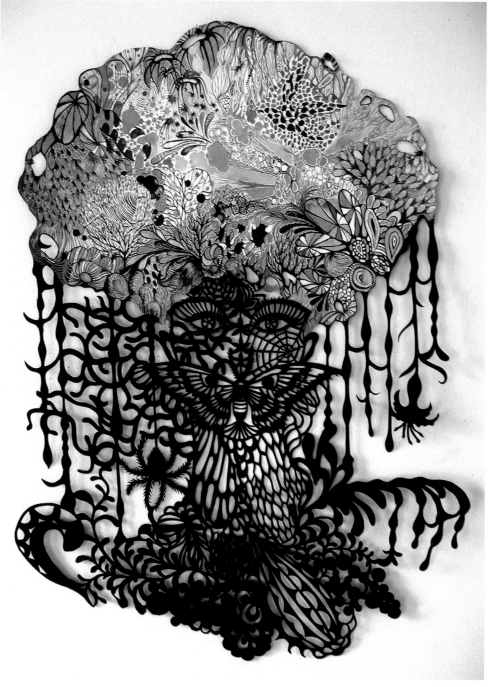

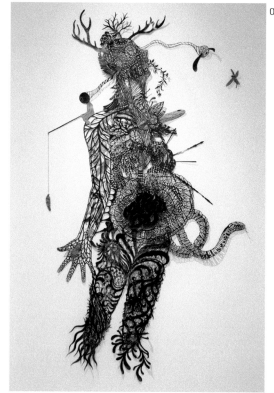

03

Kako Ueda
01 Gaze
02 Reciprocal Pain
03 Vanitas
04 PJS (portrait series I)

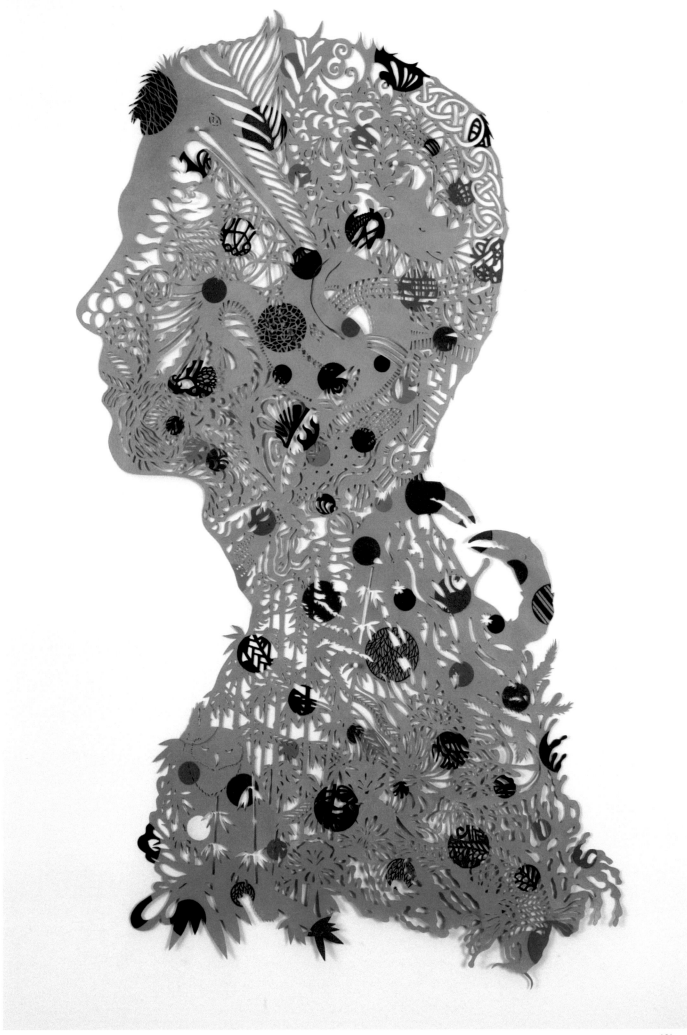

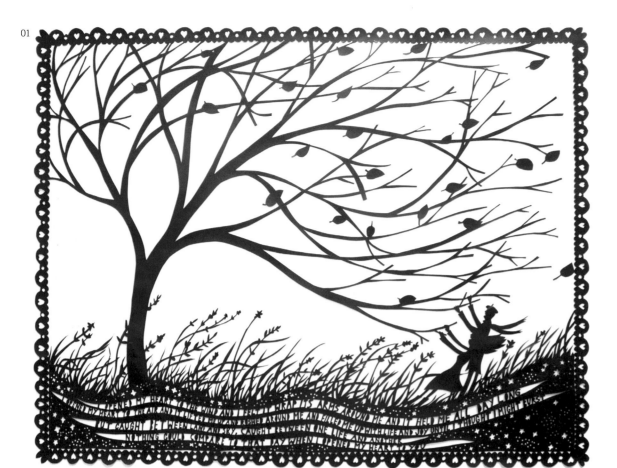

A few years ago, trained print-maker Rob Ryan left his chosen trade to explore and dissect his favoured medium. "After screen-printing, I fancied doing something a bit simpler — right now, all I need is a pencil, paper, and a blade. It's not about color or perspective, but all about silhouette and shape."

A romantic at heart, Ryan now takes a leaf out of Fine Art, from Titian and Raphael to Schinkel and Friedrich, adds a modernist color scheme to the sheet and throws in a few pithy words — or "verbal doodles" — for good measure. Thus retracing the bows, not arrows, of outrageous fortune, his whimsical visual poetry, framed by the daintiest of lace borders, delights with interlaced narratives, often hidden away in the tiniest of incisions.

Idyllic, intricate, and intimate in their autobiographical allusions, Ryan's classic cuts and silhouettes are welcome additions to editorials, brand campaigns — and bespoke exhibitions.

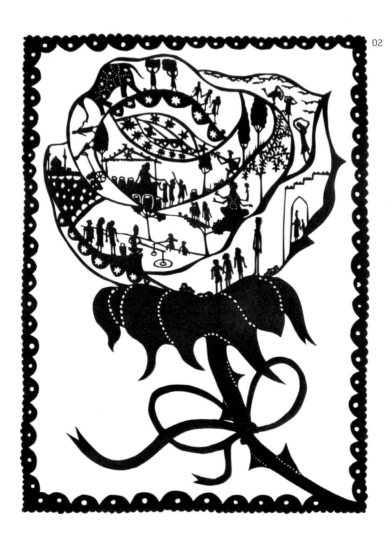

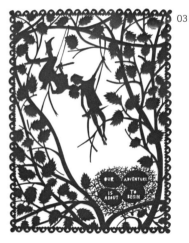

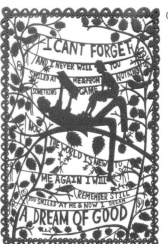

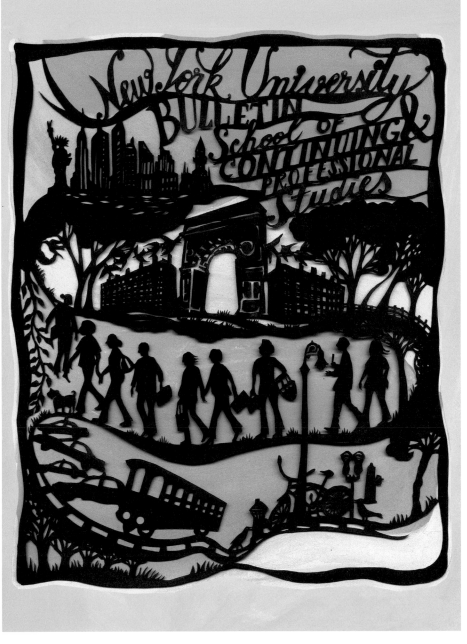

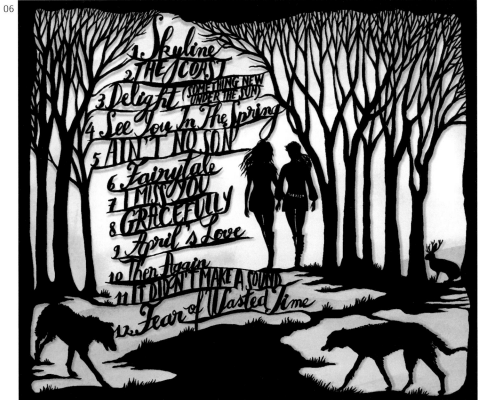

Andrea Dezsö

05 New York University 2009 Summer
Bulletin
Cover illustration for New York
University's 2009 Summer Bulletin.
Created using cut Ise-katagami
paper on a painted background.

06 Court Yard Hounds Album Cover
Artwork for the Court Yard Hounds'
debut album.

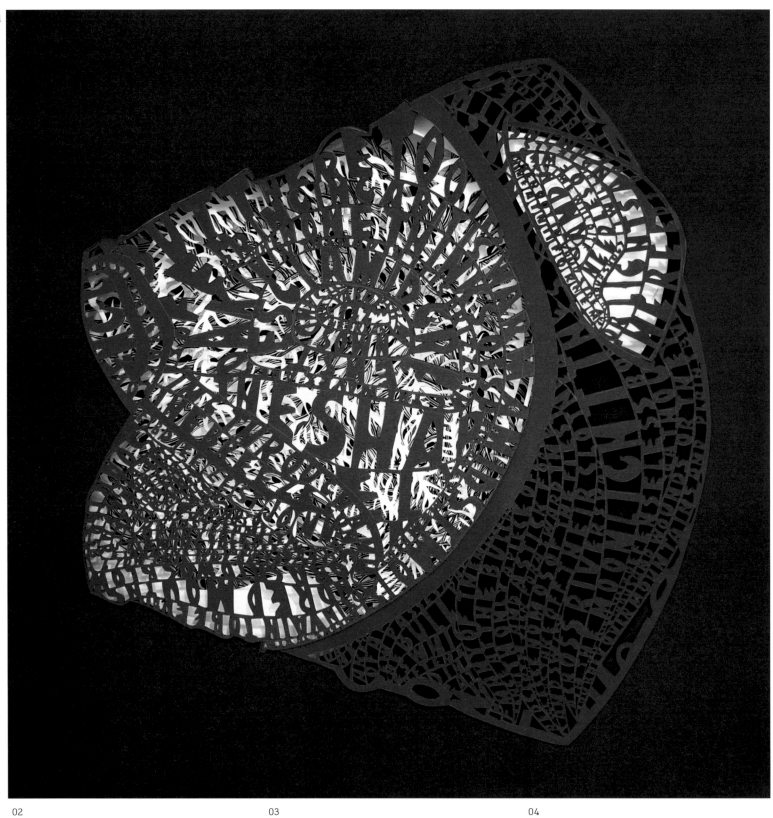

02　　　　　　　　　　　　03　　　　　　　　　　　　04

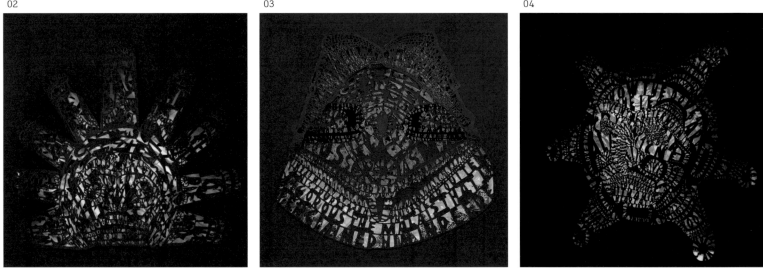

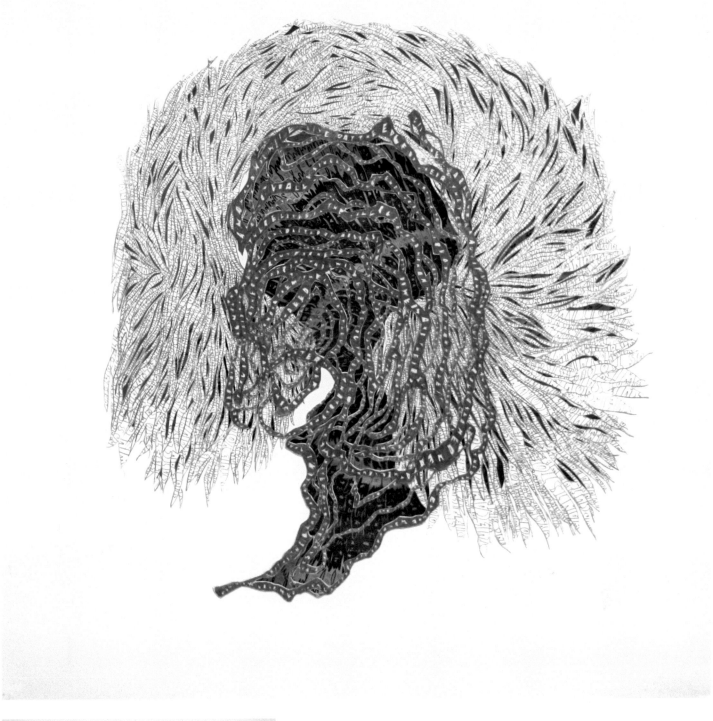

06

Natasha Bowdoin

Natasha Bowdoin's process begins with poetry. She transcribes the poems of others into drawn patterns before cutting those patterns into pieces that she can reassemble into visual interpretations.

01 <u>Poem of the Bull</u>
Multiple poems by Federico García Lorca.

02 <u>In Memoriam: A.R.</u>
Jorge Luis Borges's poem "In Memoriam: A.R."

03 <u>Skeleton Larks and Wolves of Penumbra</u>
Excerpts from Federico García Lorca's poems.

Natasha Bowdoin

04 <u>Open with Sure Fingers the Flower of His Skull</u>
Federico García Lorca's poem "Lament for Ignacio Sanchez Mejias."

05 <u>Avatsiu (Language of the Birds)</u>
Various poems by Jorge Luis Borges from his *Dreamtigers* collection.

06 <u>Heads of the Dead</u>
Excerpts from poems by Federico García Lorca and Jorge Luis Borges.

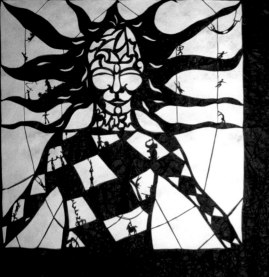
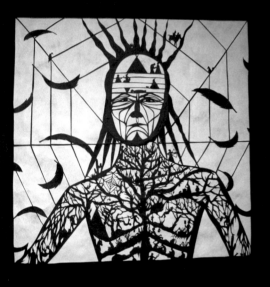
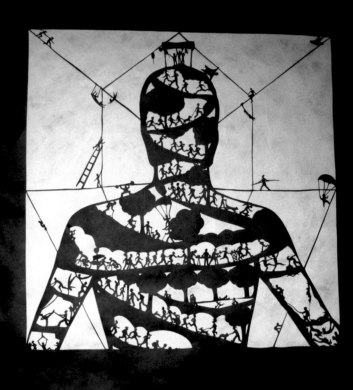
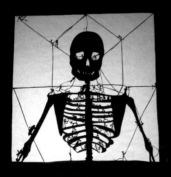
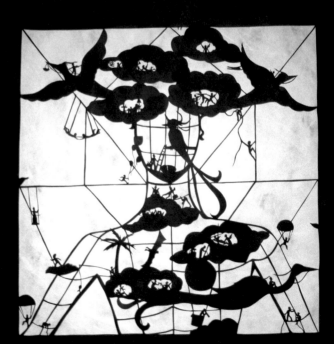

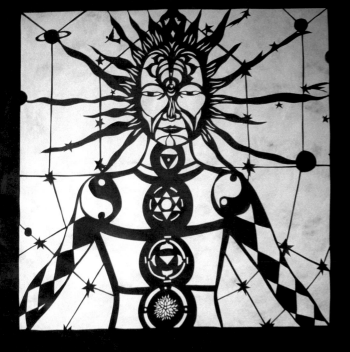

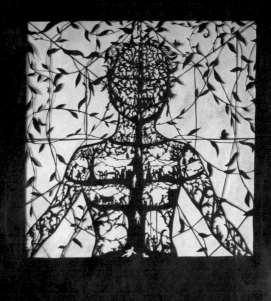

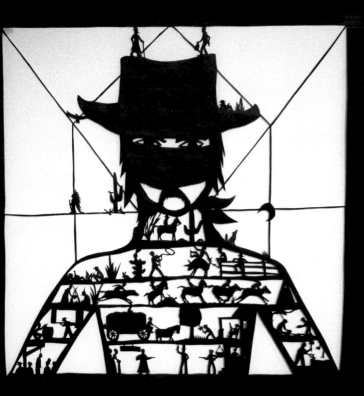

Béatrice Coron
Identity Series
Oversized, hand-cut Tyvek pages
hung from the ceiling present
different constructions of the self.
When viewed from a certain angle,
the pages form a visual path that
viewers can look through to see
various layers of personality.

Filled with silliness, mirth, fig-
ments and fancies, airy and eerie
thoughts and ideas, Coron's laser,
scalpel and die-cut *Identities* create
entire microcosms of traits: from
prairie trail cowboy to cloudy airhead
and sunny disposition, each presents
a different construct of perceived self.
Reminiscent of Gulliver's travels, these
creations tend to be powered, popu-
lated, yet also controlled by miniature
tribes eager to add insights, insides,
and character to the mix. Taken
together, in all their navel-gazing
glory, they form a path that offers
a new perspective of our collective
consciousness.

The technique itself allows for no
gray areas: everything is black and

of clear dichotomies, Coron explores
topics ranging from the concept of
free will and human responsibility
(Heavens and Hells), "Freudian Cities"
containing all essential elements of
an individual's life or Italo Calvino's
seminal *Invisible Cities*. An allegory
of modern day urban arrangements,
the latter follows the structure of
Calvino's stories across three 8-meter
paper cuttings to show slightly dif-
ferent, shifting variants of a world
in transition, filled with tiny pockets
of life. Disconnected from the whole,
yet chopped out of a single sheet to
highlight the many divergent op-
tions, the work explores the futures
and possibilities inherent in any
cityscape.

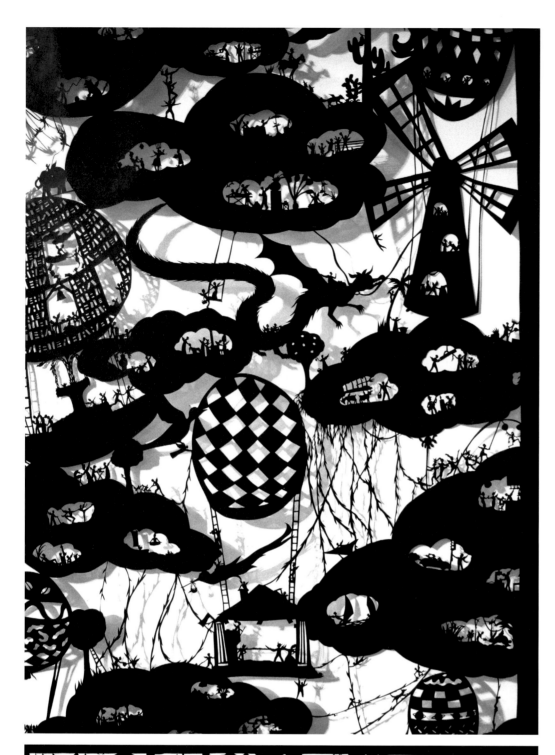

Béatrice Coron
Heavens & Hells (detail)
Hand-cut Tyvek pieces exploring themes of free will and human responsibility, morality and fate, heaven and hell, and the philosophy of Clément Rosset. The narrative elements are repeated in both panels but with different outcomes.

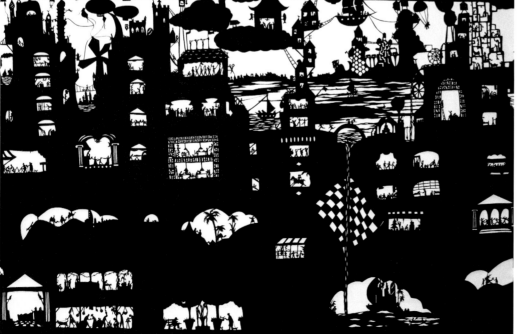

Béatrice Coron
Invisible Cities
Three nine-yard paper cuttings attempting to visualize the structure of the stories in Italo Calvino's 1972 book, *Invisible Cities*. In his book, some cities are made out of garbage while others are constantly under construction; nearly forty years later, his cities are even more accurate conceptions of the contemporary urban environment. The three layers were first cut together, then separately, making the skylines similar but showing different versions of a world in transition.

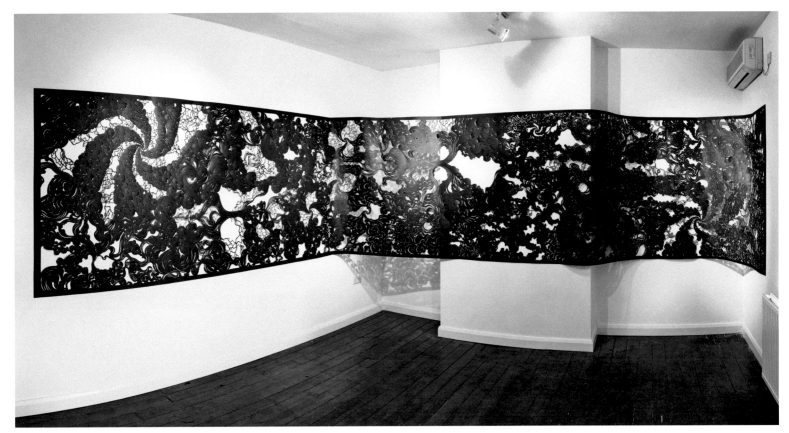

Andy Singleton
<u>Dust Clouds in the Eagle Nebula</u>
Paper installation for the "Cut
Paper" exhibition at Bowery Gallery
in Leeds, U.K. Inspired by photo-
graphs from the Hubble telescope,
Singleton explored the use of intri-
cate detail in a large-scale paper
cutting.

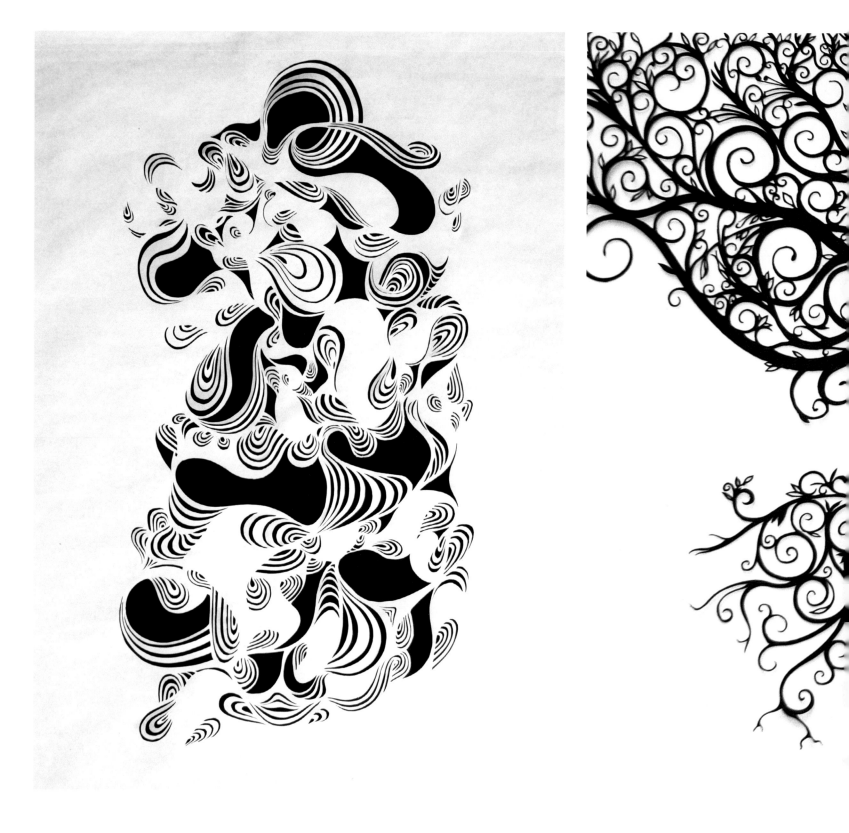

Andy Singleton
Suspended Spirals
Personal work exploring movement
and form using lightweight paper.

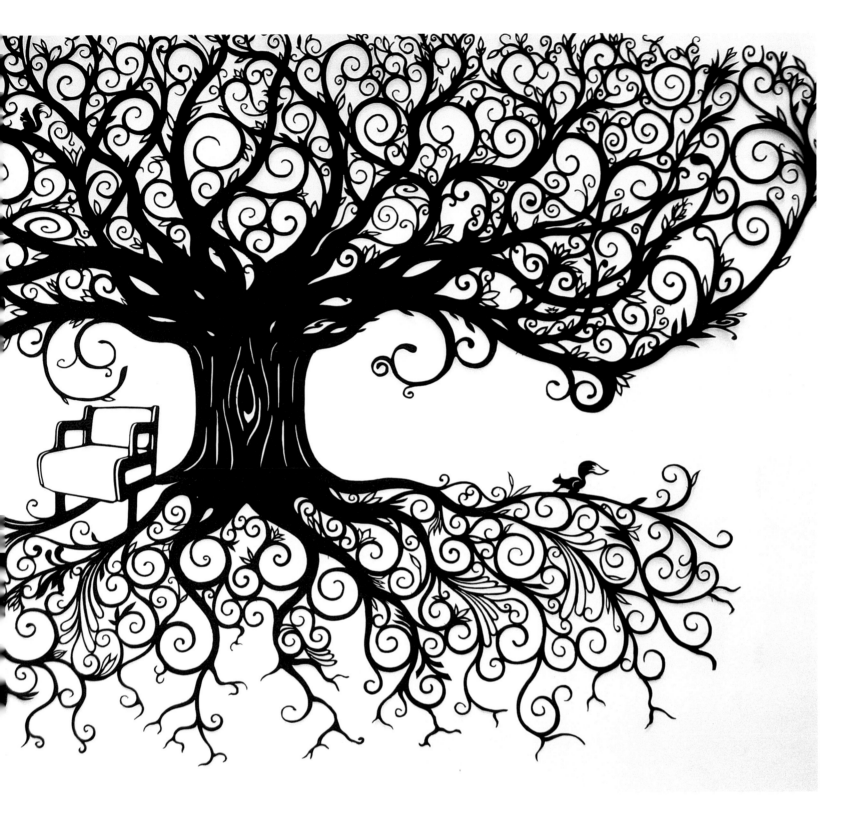

Andy Singleton
Lazerian Furniture, Van Graphic
Graphic created for Lazerian
Contemporary Furniture to decorate
its van. Based on a growing tree, it
incorporates a chair by Lazerian.

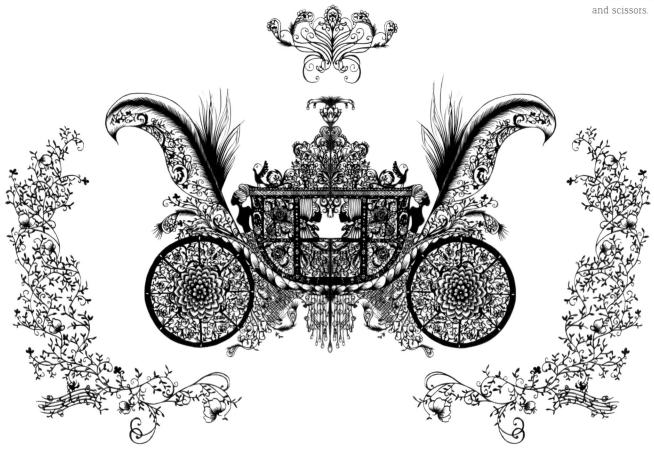

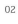

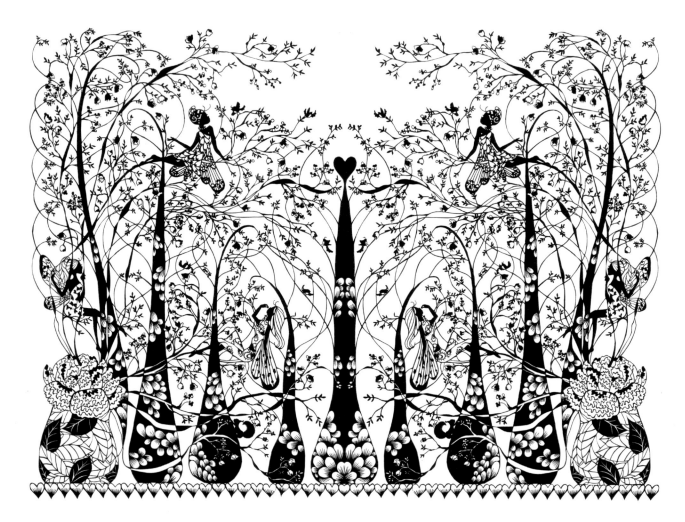

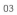
03

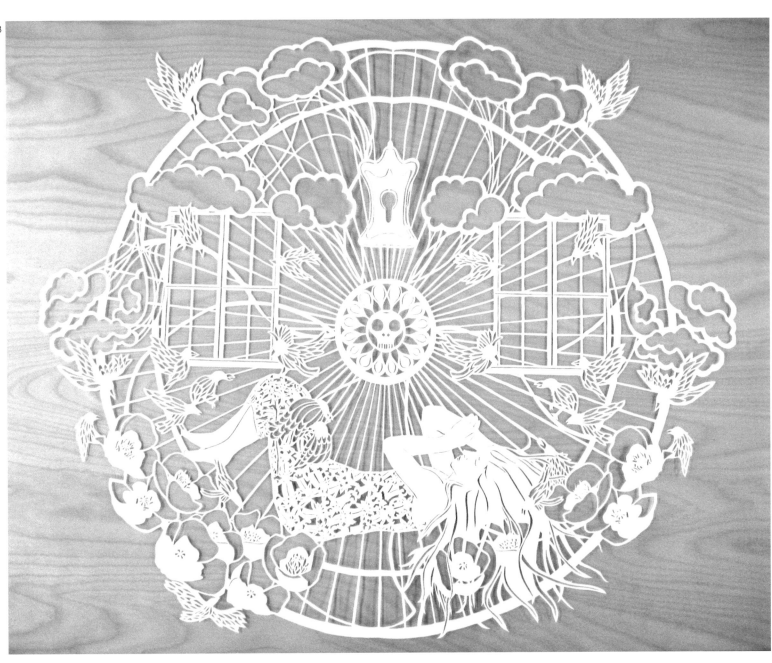

04

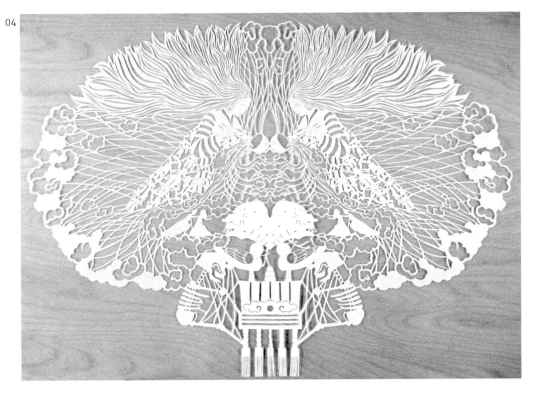

Lorraine Nam

03 Asphyxiation
Inspired by a Korean myth about fan death – a myth about being suffocated by the circulating air from a ceiling fan while asleep in a closed room.

04 Rice Husband
Hand-cut paper pieces based on Korean superstitions. This piece illustrates the superstition that each grain of rice a woman fails to eat will become a physical mark on the face of her future husband.

01

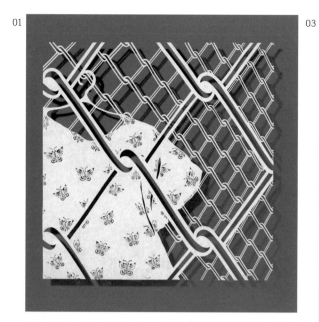

03

02

Bovey Lee

01 The Butterfly Gown I, II
A rice paper cutout on silk, the image offers multiple perspectives of a butterfly-patterned gown hanging inside a chain link fence.

02 The Bird That Thinks It's a Plane
An examination of self-image and self-projection using hand-cut rice paper on silk.

03 Memory Windows I, II

04 Rescue Mission
Response to the United States government's rescue package of large corporations. Hand-cut rice paper on silk.

05 Drum Dash
A piece about dysfunctional institutions and the loss of control and power. Made from hand-cut rice paper on silk.

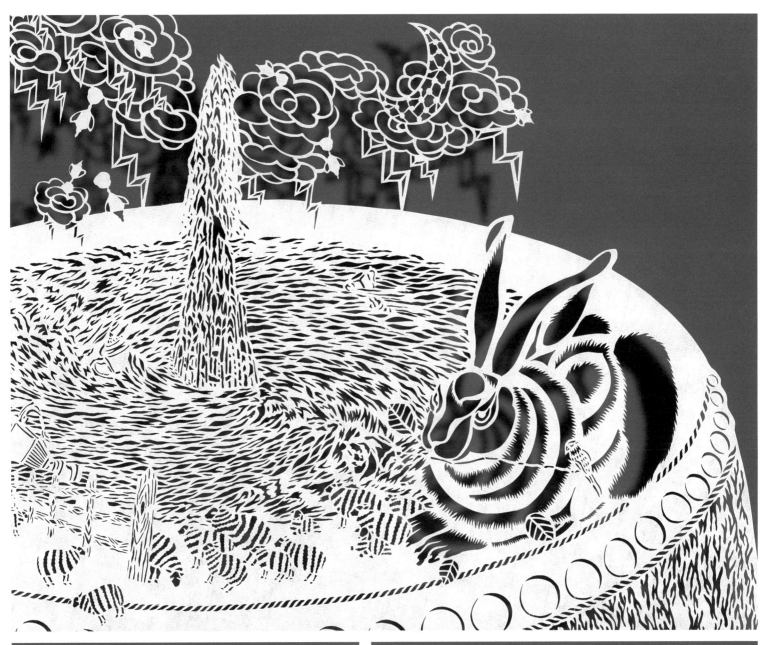

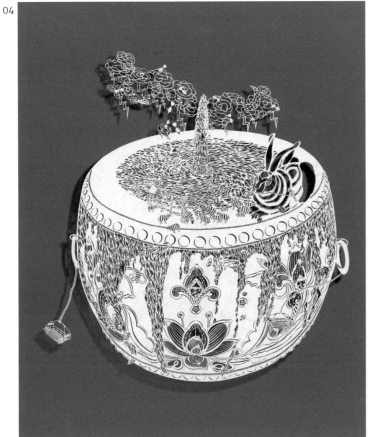

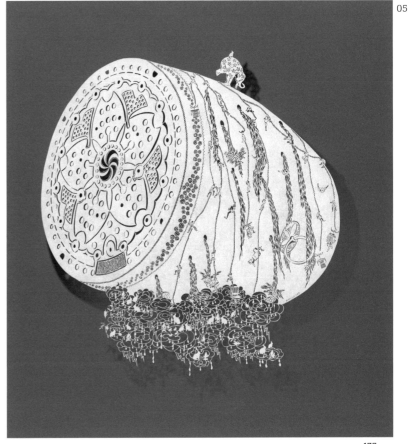

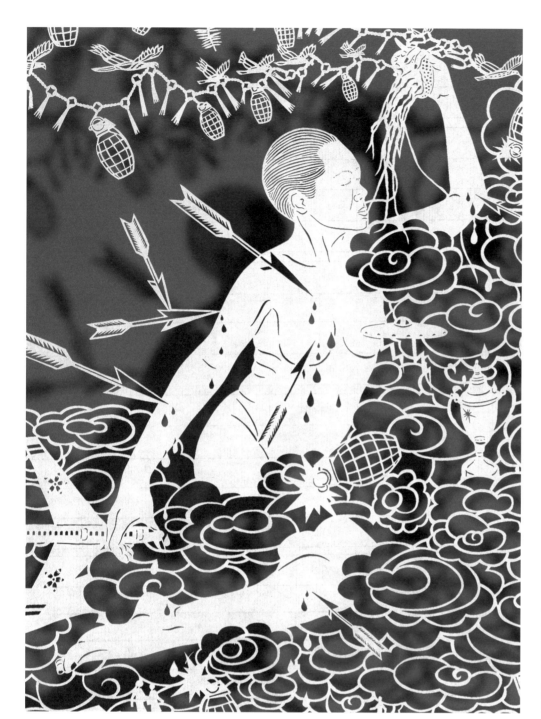

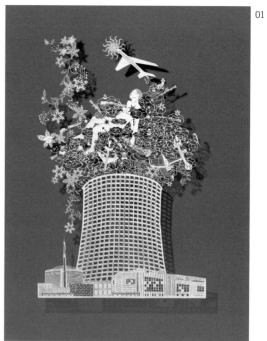

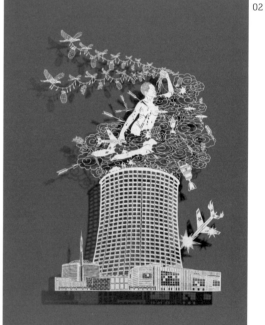

Bovey Lee

Power Plant

Power, sacrifice, and survival on
top of a power plant. A series made
from hand-cut rice paper on silk.

01 The Capture of Pieta
02 The Sacrifice of Dawn
03 The Butterfly Dream

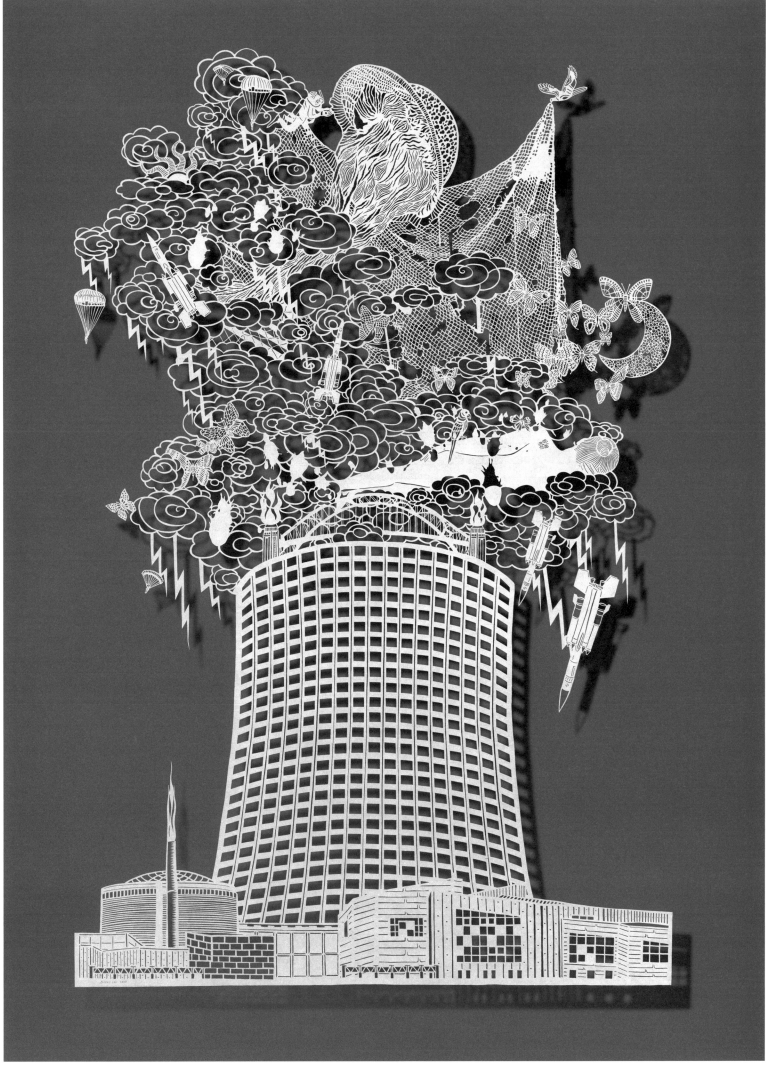

Georgia Russell

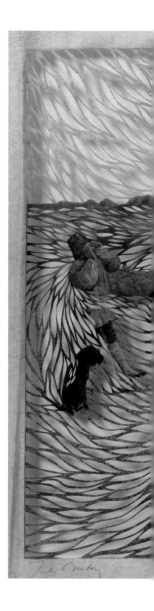

01

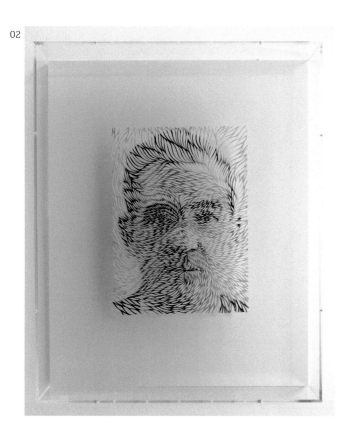

02

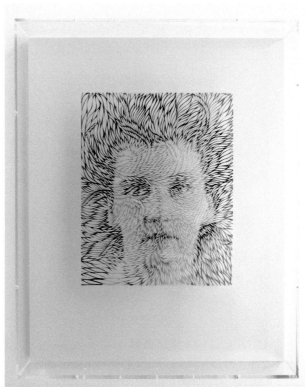

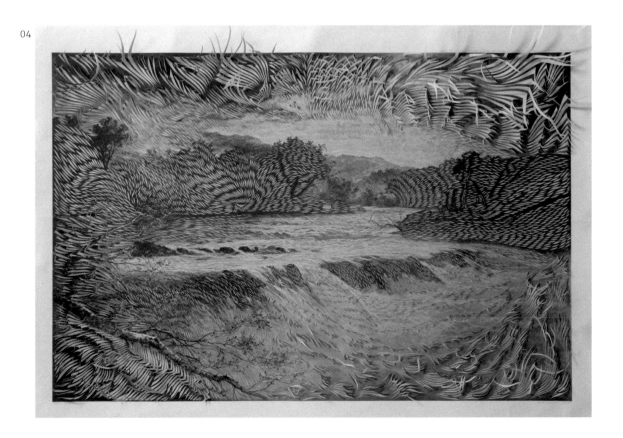

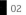

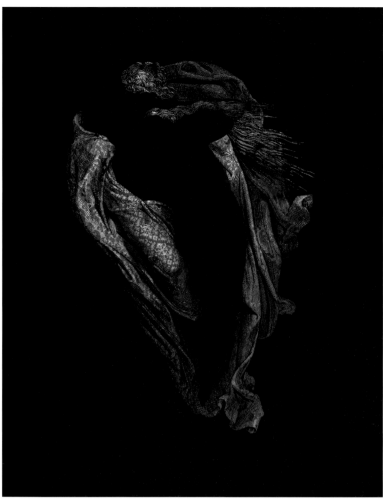

Tom Gallant

01 <u>The Collector V, Would I To Those</u>
Response to a group show invita-
tion that asked participating artists
to work with historical references.
Gallant chose Ary Scheffer's *Dante
and Virgil Encountering The Shades of
Francesca and Paolo Di Rimini in the
Underworld*.

Tom Gallant

02 <u>The Collector V, Even to the Wall</u>
Series of large-scale works about
the tradition of collaged paper con-
structs. Extracts from pornographic
magazines become abstracted
fragments of bodies and are lay-
ered beneath images of cloth and
clothed forms taken from Gustav
Doré's Bible illustrations.

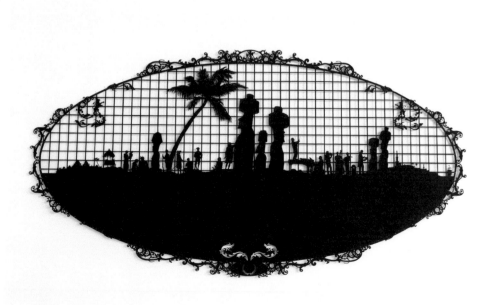

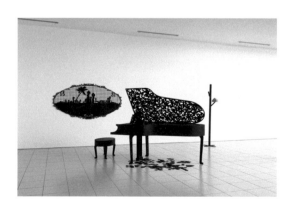

Dylan Graham
03 <u>The Cusp</u>

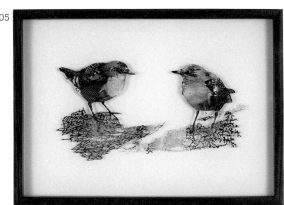

Tom Gallant

04 <u>The Collector II, St James's Palace</u>
A series of hand-cut work based on wallpaper designs by William Morris and Graham Sanderson. The women in this work become entrapped within the layered designs, much like the protagonist of the Victorian feminist novel *The Yellow Wallpaper*, who sees the wallpaper in her home as a symbol for the trappings of domesticity.

05 <u>British Birds, Dipper</u>
Magazine images of birds taken by amateur photographers. Framed to resemble nineteenth century taxidermist birds, the pieces reference upper-class pursuits of leisurely scientific exploration, colonialism, and animals forced into extinction by Western actions.

06 <u>The Collector III, Iris & Golden Lily</u>
Series inspired by the novel *The Yellow Wallpaper*, the compulsive nature of pornographic consumption, and the Victorian desire to control nature — and women. The women in Gallant's work are shown in repetitive poses.

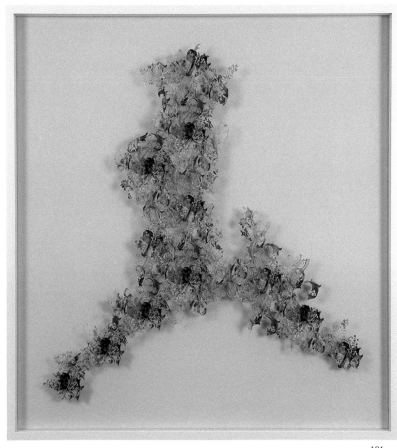

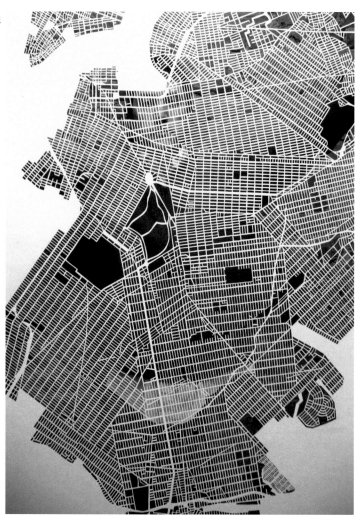

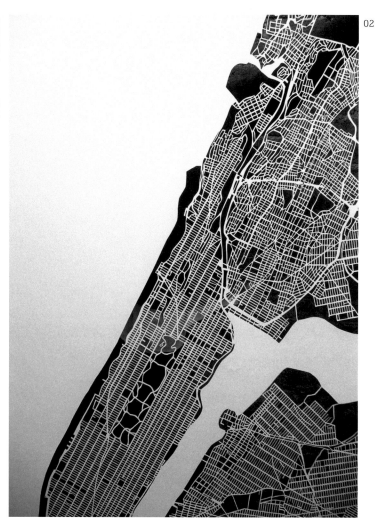

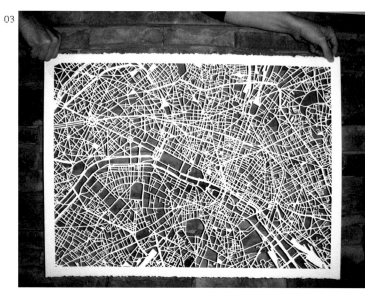

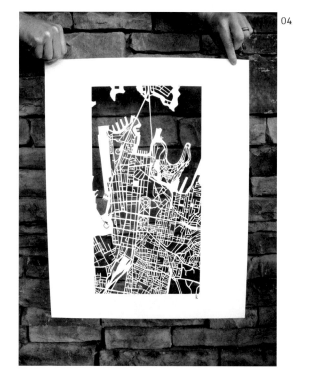

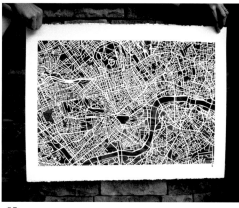

05

Karen Mee Hyun O'Leary

01 <u>BK MN</u>
One of four panels depicting city blocks in Brooklyn and Manhattan, New York City.

02 <u>MN BX</u>
One of four panels depicting city blocks in Manhattan and the Bronx, New York City. The four panels fit together to make one piece.

03 <u>Paris Mapcut on White</u>
Hand-cut map of Paris, France.

04 <u>Sydney Mapcut on White</u>
Hand-cut map of Sydney, Australia.

05 <u>London Mapcut on White</u>
Hand-cut map of London, England.

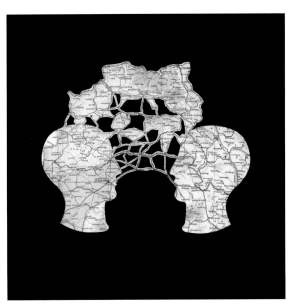 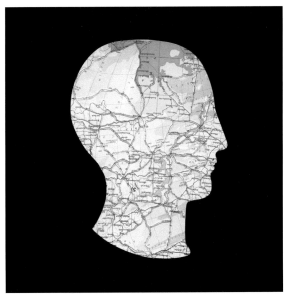

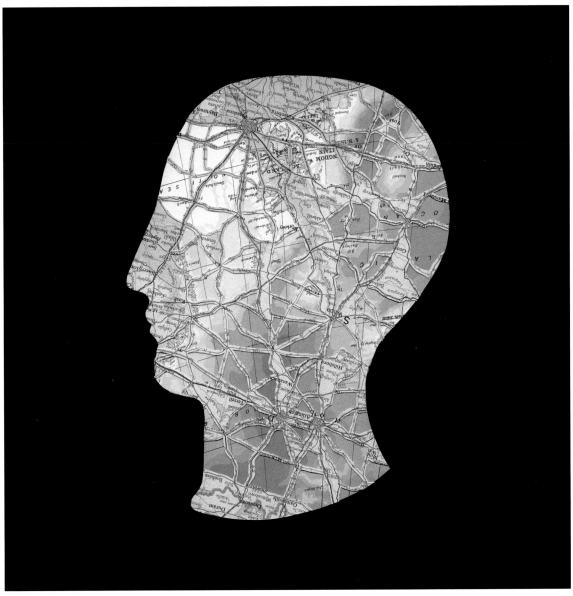

this page

Shannon Rankin

<u>Anatomy Series – Heads</u>
For Shannon Rankin, map illustrations of mountain ranges, roads, lakes, and rivers resemble the anatomy, structures, and networks of the human body. In her work, symbols of cities become acupuncture points, and meridian lines and rivers represent an internal system of communication and transport.

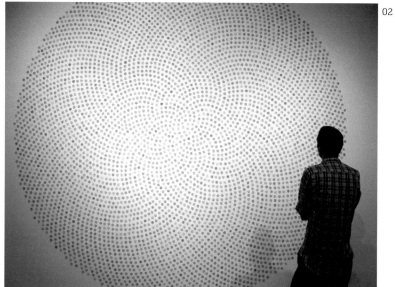

02

01

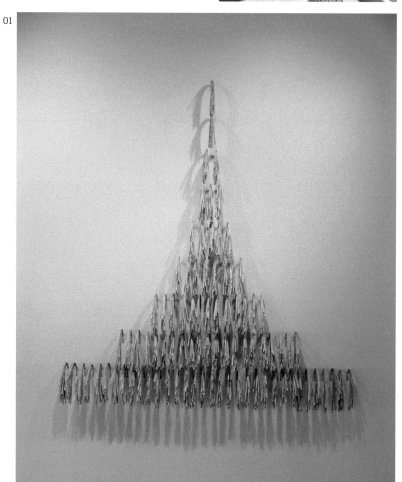

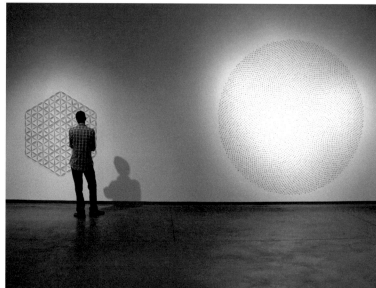

03

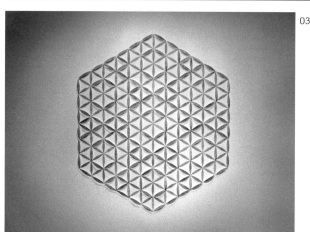

Shannon Rankin

01 <u>Falls</u>
Installation exhibited at the Center for Maine Contemporary Art in Rockport, Maine, USA, as part of their 2010 juried biennial. It was composed of hundreds of strips of maps arranged according to the pattern of the Fibonacci Sequence.

02 <u>Germinate</u>

03 <u>Matrix</u>
Installations exhibited at the Maine College of Art as part of the juried show "Aggregate."

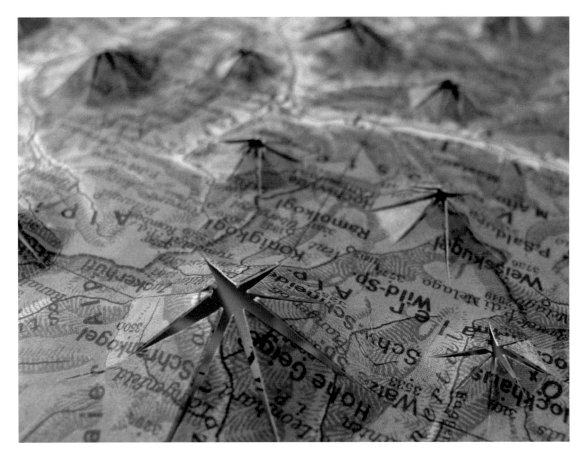

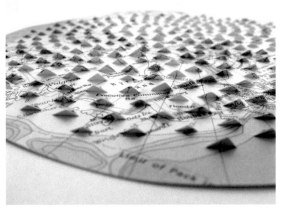

Shannon Rankin
Uncharted Series
Series of work exhibited at the
Maine College of Art as part of the
juried show "Aggregate."

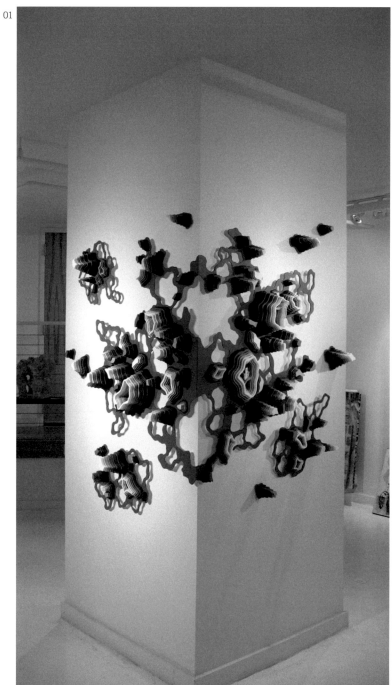

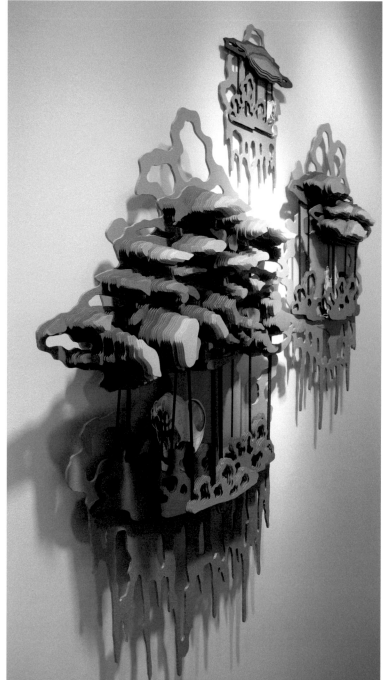

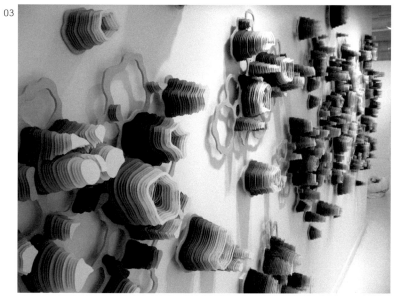

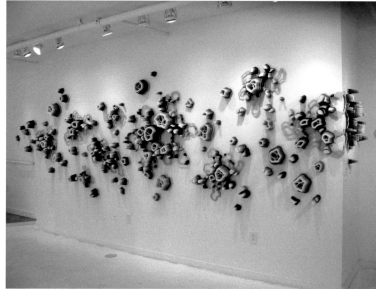

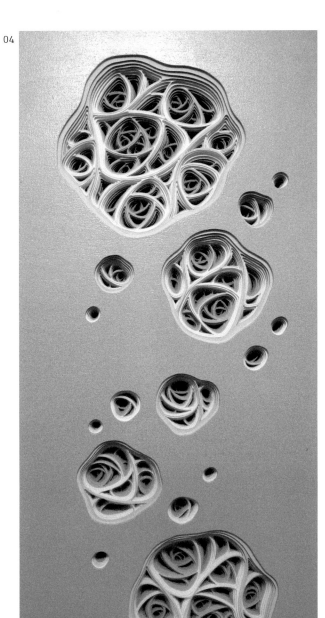

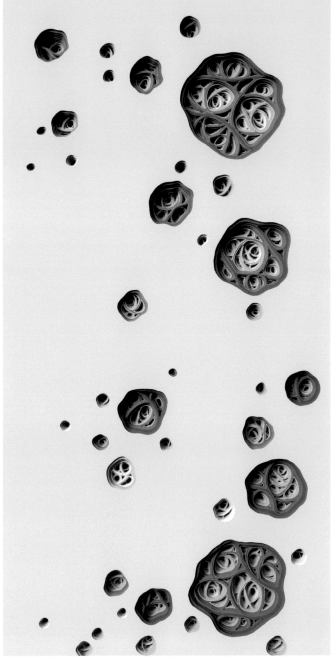

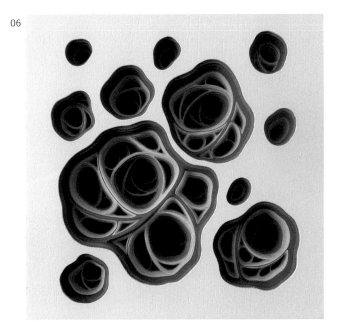

Charles Clary

01 <u>Muted Melody Movement #2</u>
Reinterpreted from a larger instal-
lation.

02 <u>Codastic Diddle-Let</u>
Installation created for the exhibi-
tion "Flamtastic Fantasia" at the
Savannah College of Art and Design
in Savannah, Georgia, USA.

03 <u>Flameobic Opulation</u>
Installation created for the exhibi-
tion "Flamtastic Ejections" at
the Rymer Gallery in Nashville,
Tennessee, USA.

04 <u>Diddle Daddlation</u>
Work created for the exhibition
"Flamtastic Ejections" at the Rymer
Gallery in Nashville, Tennessee, USA.

05 <u>Fermatic Pandemic Movement #1</u>
Project commissioned by a private
collector.

06 <u>Flamungle Gestation</u>
Shadowbox created for an exhibition
at Sloan Fine Art in New York City.

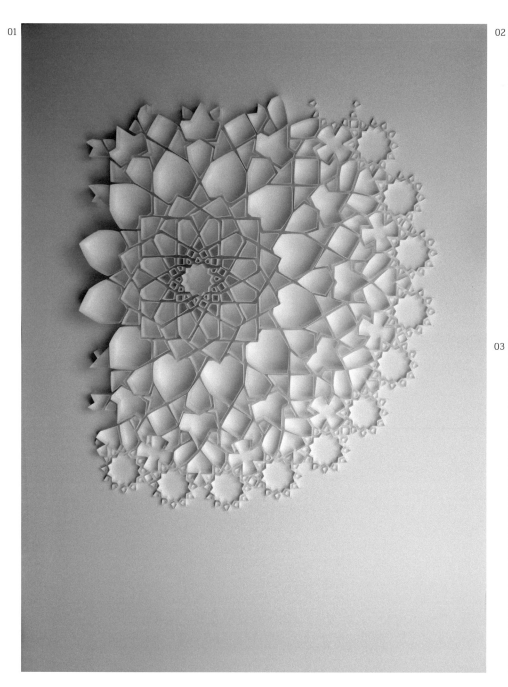

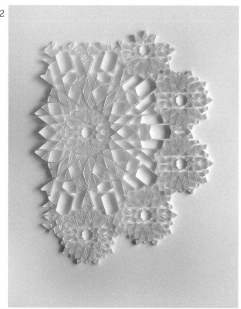

Matthew Shlian
01 <u>Ara 51</u>
02 <u>4 Days in August</u>
03 <u>Mechanical Movement</u>
04 <u>Converge</u>
05 <u>Fred and Me</u>

06

08

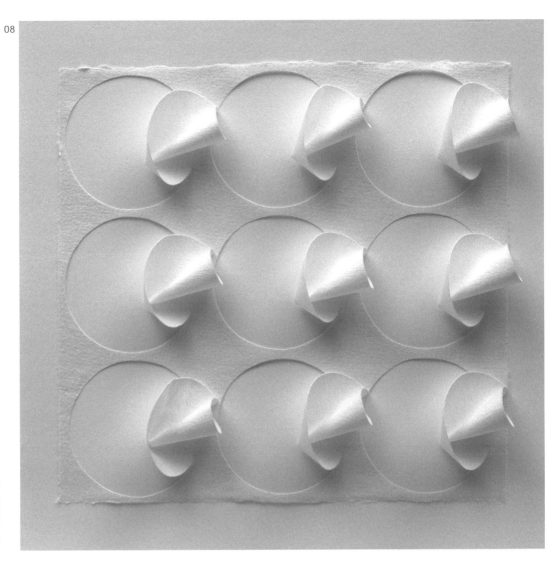

07

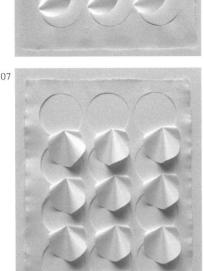

Liz Jaff

06 Flick
07 Linger
08 Duster
 Series of paper works about how the
 senses can elicit an intense memory
 of a place, thing, or experience more
 intensely than a physical object or
 image can. Single sheets of paper
 were hand-cut and folded, repeating
 an abstract shape that represents a
 particular sensory experience.

Matthew Shlian

09 Ghostly 8

09

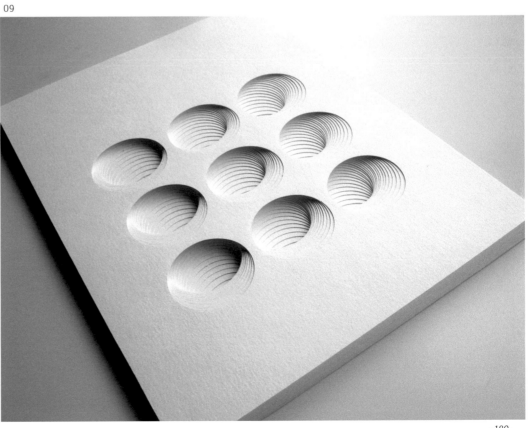

01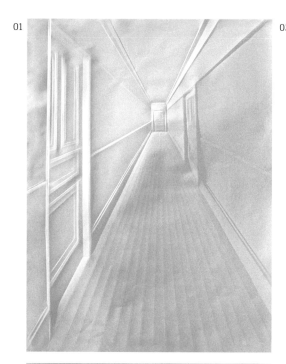

02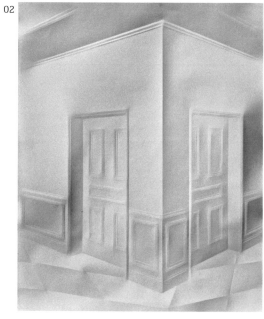

03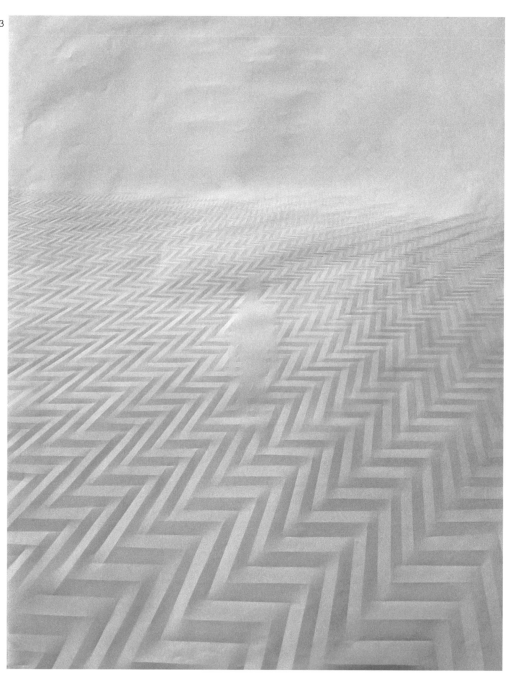

04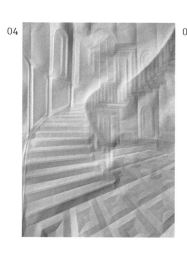

05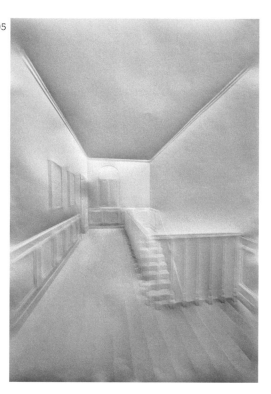

06

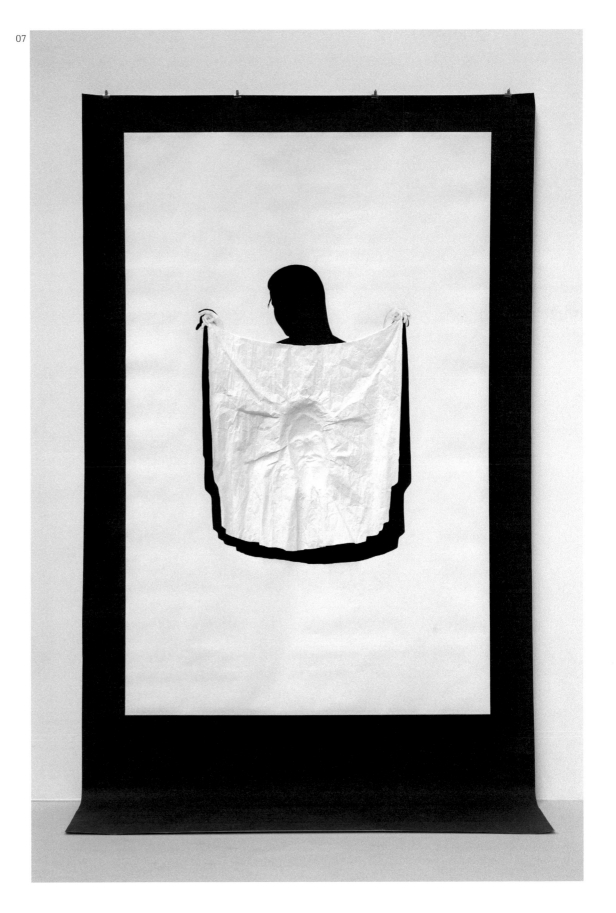

Images created only by folds in the paper; no pencil or color were used. Changes in light and shadow affect the visibility of the image.

Large-scale paper installation.

01

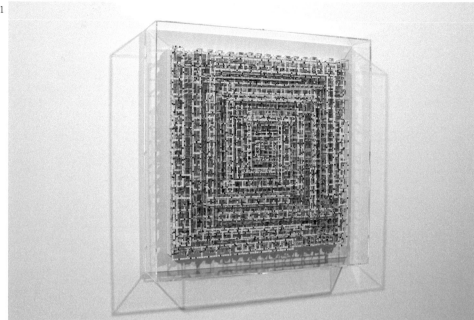

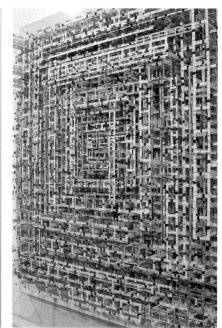

02

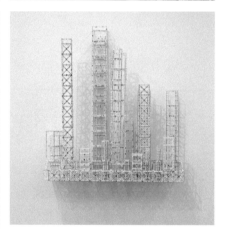

Katsumi Hayakawa
01 Composition 7
02 Wireframe Modeling

Yuko Nishimura
03 Paper Relief "Organic"
04 Paper Relief "Stir"
05 Paper Relief "Organic-02"
With just one piece of paper, which he creases and folds, Yuko Nishimura creates paper works that reflect the Japanese tradition of folding. His work goes beyond the practice of origami, embracing new forms and techniques.

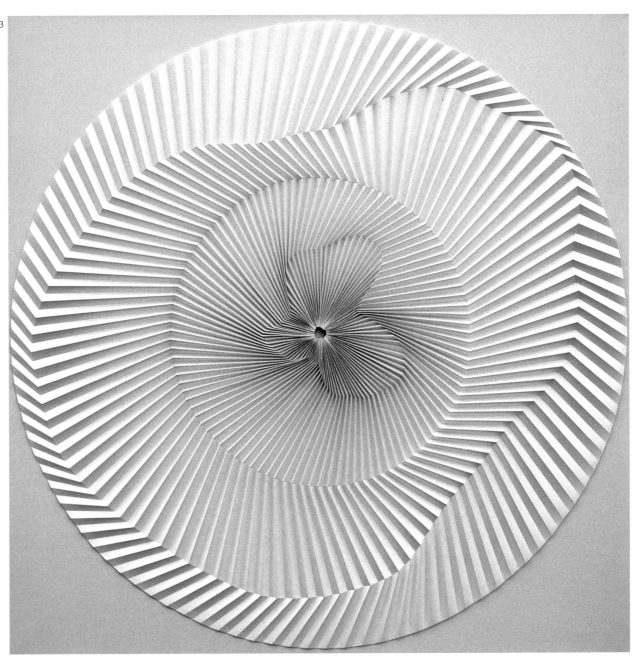

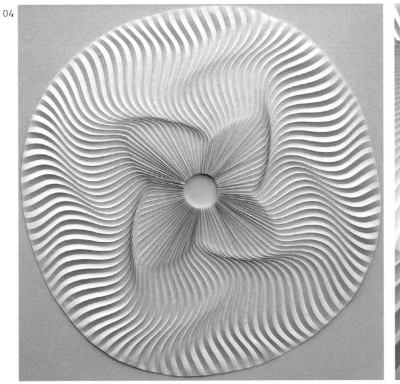

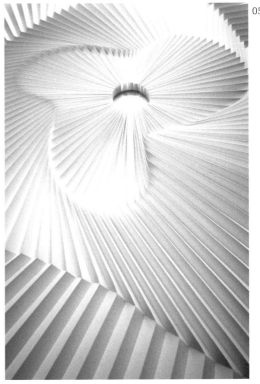

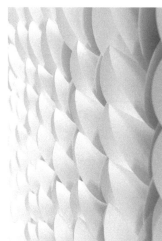

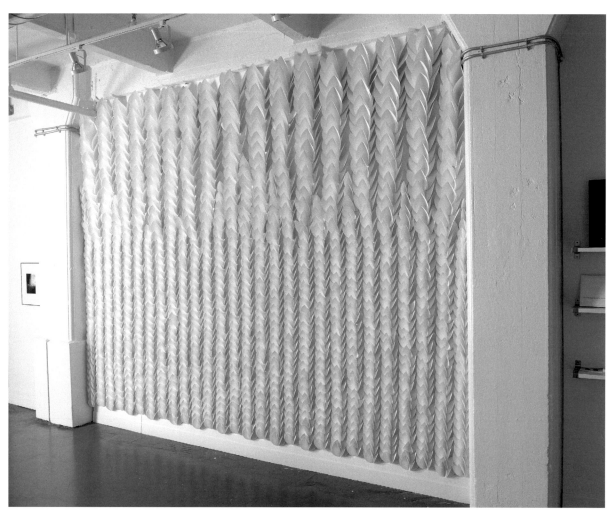

Liz Jaff

01 Hedge

Site-specific installation construct-
ed over a thirty-day period within
the gallery, which was open to the
public for the duration of its con-
struction. Hedges are walls of foli-
age; organic barriers that surround,
separate, and protect. They create
a dichotomy by defining public and
private space. For this installation,
the hedge is reinterpreted as an
abstract wall relief composed of
over 1,700 parts.

Lauren Vanessa Tickle

02 Weathered

Singe marks on vellum are evidence
of destruction and used to represent
the history and decay of an object.
The decay of the vellum is not
complete when it is hung on the
wall; the piece continues to evolve
as charred borders peel, holes tear
wider, and areas split apart.

02

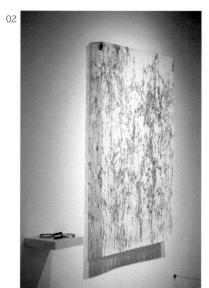

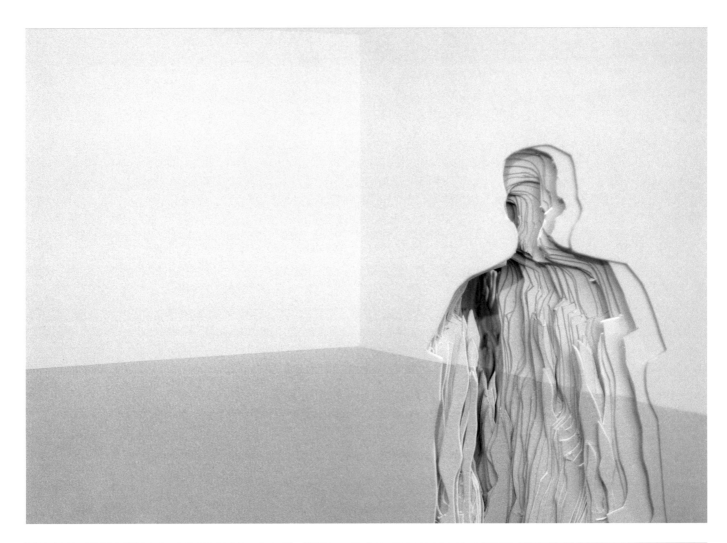

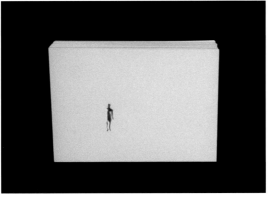

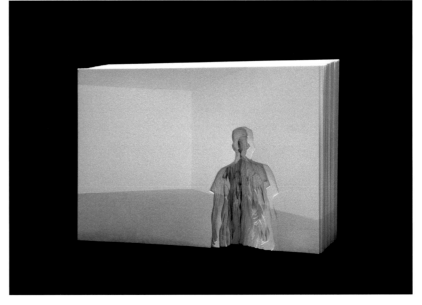

Jennifer Rose Sciarrino
Stop. Room. Remove. Locomotion.
A small-scale sculptural series addressing themes of time and movement by illustrating the occupation of space using scale, position, and perspective. Fabricated with simple materials, the project's process began by filming people moving though spaces, then converting that footage into still images. The figures were cut out, leaving a silhouette on each frame. The cutouts were traced onto images of model rooms and cut out again — a process that left stacks of photographic objects depicting the scale and position of the figure in an ambiguous space. The stacks become a tangible amount of time that can be perceived through the means of still photographic images.

01

Javier Leon

01 <u>Papel Negro</u>
Constructed of Japanese washi paper, this abstract work falls somewhere between painting and sculpture. Nature is a strong component in the work in both the materials and the manner in which they are used. The paper is painted, folded, cut, and delicately arranged into paper masses that conjure natural rhythms, germination, and growth.

Célio Braga

02 <u>Untitled</u>
Fragments of photographs of human skin are used to address the fragility of the human body as well as the ritualized attempts to embellish, protect, save, and cure it.

02

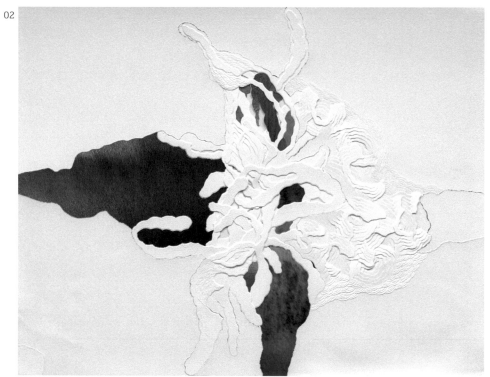

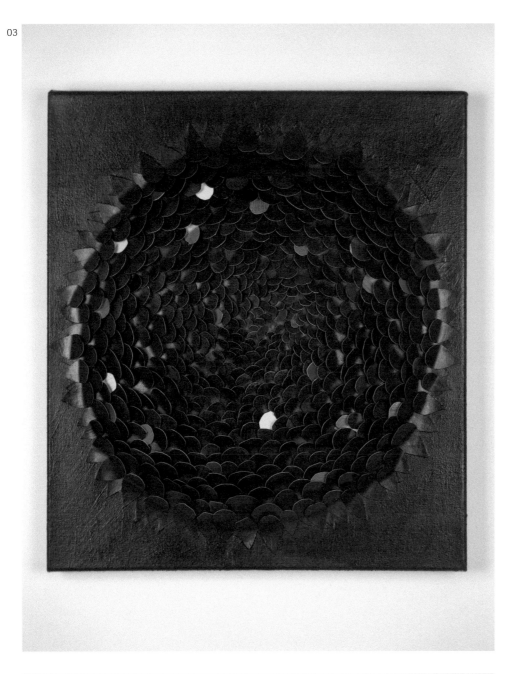

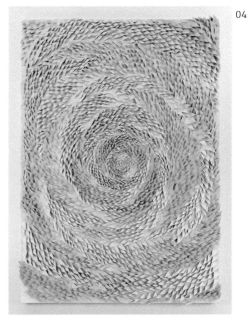

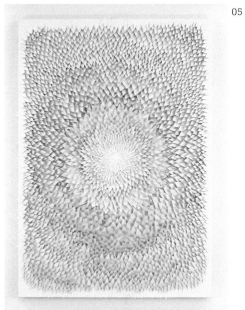

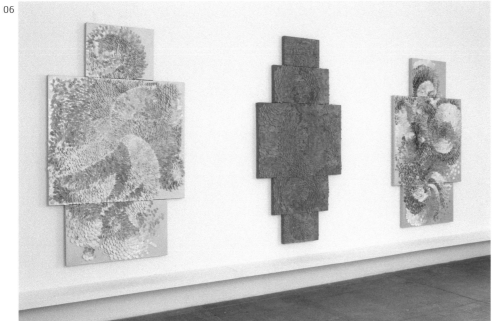

Siobhan Liddell
03 Untitled
04 Usunder
05 The Light of Day
06 Untitled
Pieces made by applying cut paper to canvas. The reflections caused by the changing ambient light cause it to change its appearance.

01

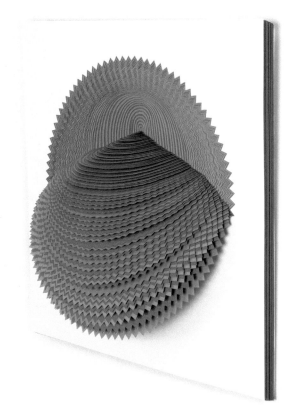

02

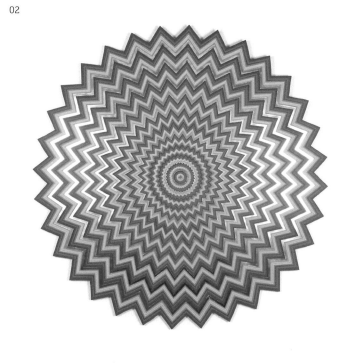

03

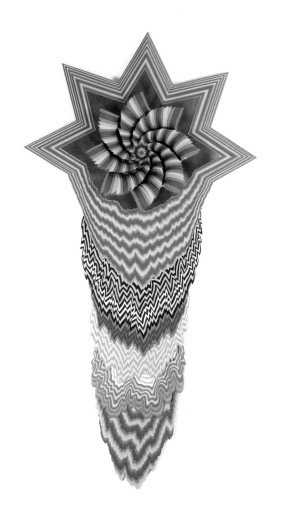

04

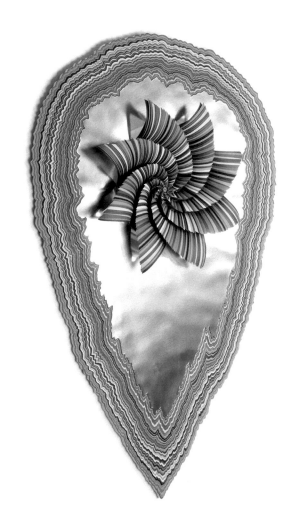

05

06

07

Jen Stark
Centrifugal
A piece inspired by hurricanes,
tornadoes, and other cyclone shapes
found in the natural world.

Jen Stark
Sunken Sediment
Installation mimicking an endlessly
eroding hole. As the hole gets deep-
er, the shape changes and evolves.

05

Sculpted Space

Paper art has come a long way from its basic incarnations, the seminal origami crane and its Western counterpart, the ubiquitous paper boat or plane. And while these staples might still sneak into the odd work as a starting point or reference, they are as amoeba to mammal, as crude hand axe to fully-automated food processor when compared to the following exercises in paper-sculpting skill.

In their exploration of given limits, several artists featured in the following chapter work with paper's deliberate, inherent weaknesses by exposing their seemingly sturdy creations to the elements, by encouraging rips, burns, or simple disintegration. Other "materialists" have switched their focus to a cunning trompe l'oeil effect: cutting the link between cause and effect, they conjure up something heavy and solid, emulating the look and feel of gleaming plastic, knitted fabric, liquid drips, tufted quilt, flowing locks, warming fur, spiky metal, richly textured leaves and feathers, or even malleable clay and brittle china. In this particular incarnation, paper becomes a mere means to an end, one material among many.

Shaped into objects or tableaux, nature abounds with luscious lianas, avian life, beauteous blooms and a selection of common or garden variety creepy-crawlies. While some of these displays highlight artifice, not artificiality, with picture perfect representations that provoke a striking double-take when viewed up close and revealed as fake, others love to betray their work's origin as a mere model of life itself with chunky folded blossoms, leaves, and twigs that emphasize their man-made nature.

Nevertheless, both approaches explore a similar theme: that of a safe, alternative reality shaped from a substance perfect for facades and ephemeral instances, one that is easily taken apart, destroyed, pulped, and remade. At its logical conclusion, this idea of being removed from "real" nature, from our surroundings, from being couched — and possibly happier and more comfortable — in a semblance of (pre)fabrication and digital reproduction, stretches all the way to crudely pixelated versions of our complex animated matter or enlivened abstract algorithms. After all, why pursue a subtle curve if a cheeky, concrete fold will do?

Taken to its extreme, we end up with polygonal landscapes of the most basic building blocks and simple geometric shapes, reshuffled into a rough, three-dimensional jigsaw version of life itself. Here, jutting spikes and icicles are firm friends and frequent favorites, from plain white and pristine to illustrated, patterned, or photo(realistic) representations of the space to be conveyed.

Treating the world as their set, all of these wildly different works demand their fair share of our attention. From sociopolitical manifestations like Nava Lubelski's spellbinding sculptures, fashioned from love letters or shredded and rolled financial documents, to — supremely aestheticised and hardly controversial — shop window installations, these self-assured visual statements evince an elegant delicacy, a quiet self-confidence not previously evident in this discipline. Caught between nightmare and wonderland, their disparate strands and motivations culminate and dissolve in the exuberant excess of Andrea Mastrovito's Island of Dr. Mastrovito, an installation featuring 1,300 hand-cut flower and animal encyclopaedias.

right page
**Kasia Korzeniecka &
Szymon Roginski**
Piramid

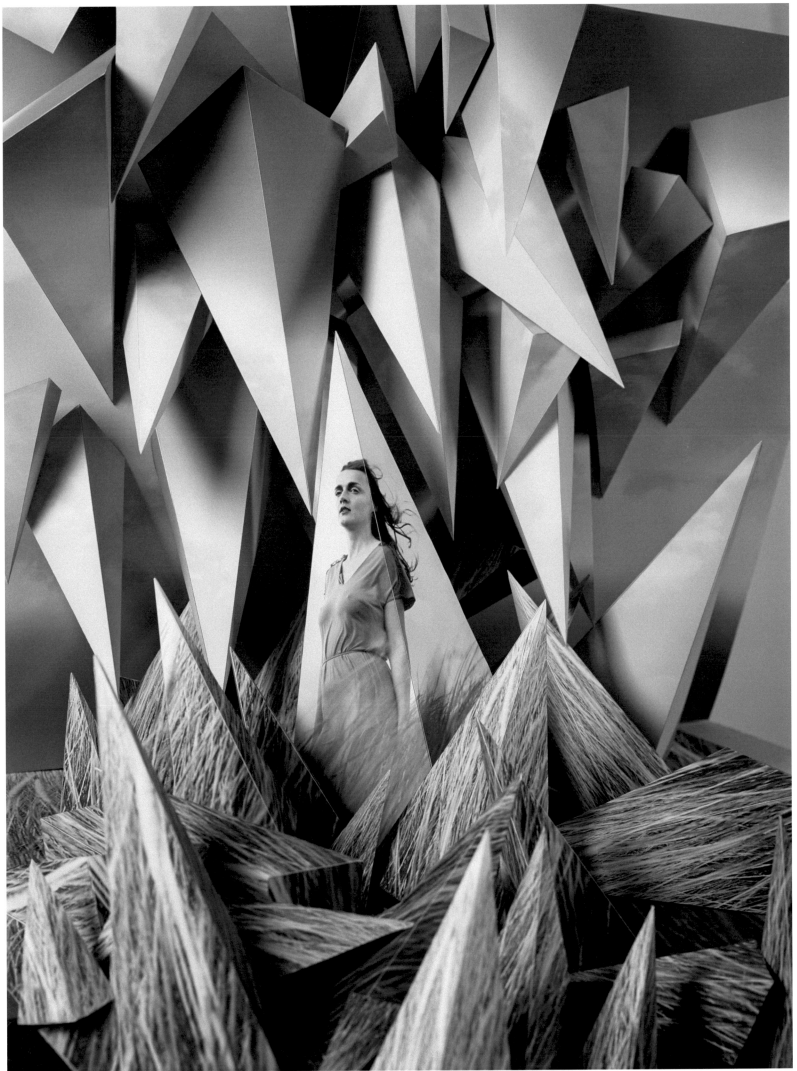

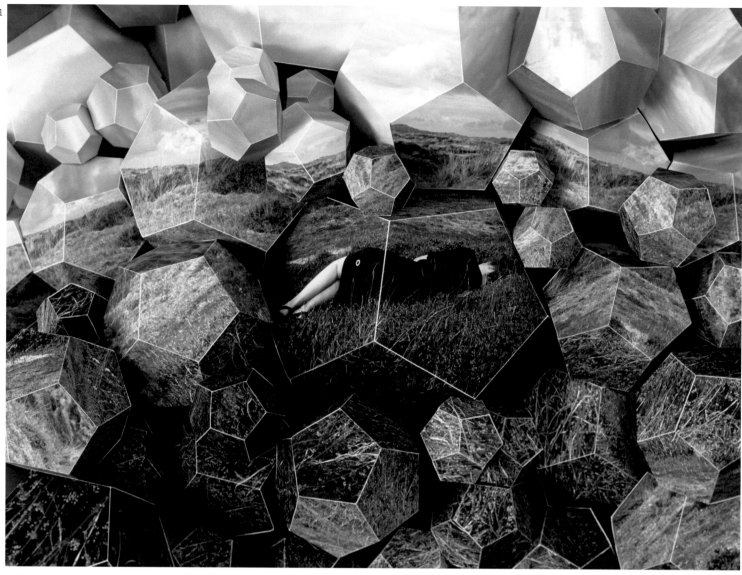

01

02

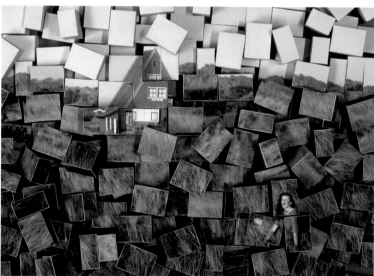

03

**Kasia Korzeniecka &
Szymon Roginski**

01 Dodecahedron
02 K-dron
03 Boxes
Photography for the Ania
Kuczynska Spring/Summer 2009
collection. Images were shot on the
Dutch island of Terschelling and
then recreated using hundreds of
handmade materials that were cut,
folded, and glued.

Susy Oliveira

These sculptures are part of a larger body of work entitled "Your face, like a lone nocturnal garden in worlds where suns spin round!" Gardens are constructions made for human pleasure; they offer a way to feel closer to nature without having to deal with any of its discomforts. This work creates a simulated garden and examines the impulse to replace nature with fabrication as well as digital and technological reproduction.

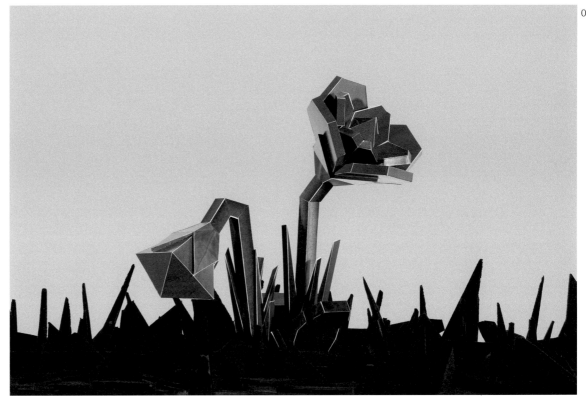

04

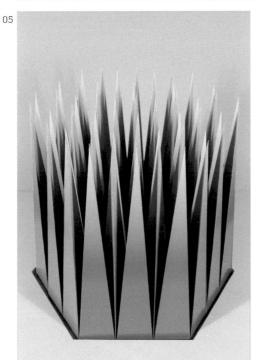

05

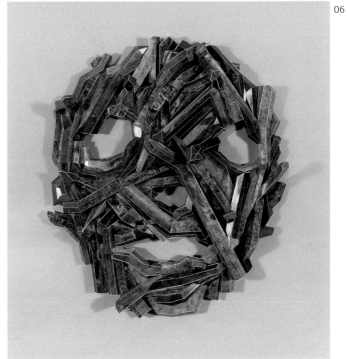

06

07

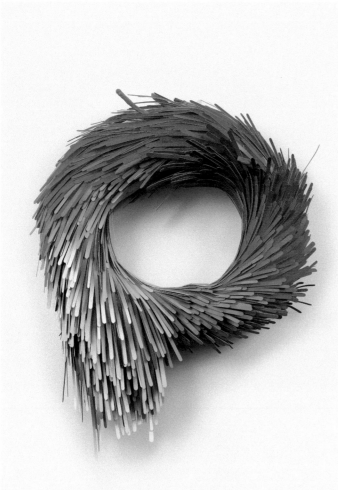

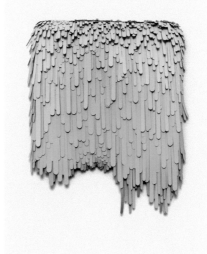

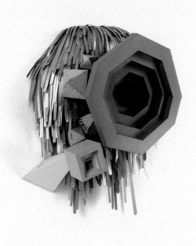

Lauren Clay

01 <u>The Unending Amends We've Made (Imperishable Wreath)</u>
The wreath symbol, used in Western architecture and decorative arts, becomes a symbol for the cycle of sin and forgiveness. The paper wreath is both imperishable as well as temporal and alludes to the line between mortality and the infinite.

02 <u>Lonely Rainbow Picket Hoarding the Ten Thousand Things</u>
Sculpture that reproduces a portion of Judy Chicago's minimalist sculpture *Rainbow Picket*. The polygons underneath the form loosely refer to "the ten thousand things," a term used in the *Tao Te Ching*. The modernist sculpture tries to compensate for its emptiness by hoarding everything in the world under its reductive form.

03 <u>A Good Measure, Pressed Down, Shaken Together, Running Over</u>
This piece references the modernist tradition of monochrome painting as a talisman of spiritual search. Under the guise of formal asceticism, the piece examines our relationship with the infinite.

04 <u>One Way Ticket Into the Nirvana Thickets (Tunnel-Funnel-Cornucopia)</u>
The title of this piece alludes to a line from *The Electric Kool-Aid Acid Test* by Tom Wolfe. The tunnel forms come from Josef Albers's *Homage to the Square* as well as sacred geometry.

05 <u>Both Sides in Equal Parts</u>

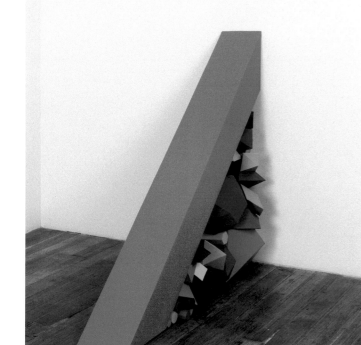

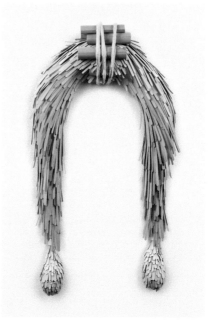

right page
Susanna Hertrich
<u>Chrono-Shredder</u>
A limited edition time-object that functions like a calendar and a clock, shredding each day in realtime. In doing so, time — which is usually lost — receives a tangible existence in the form of shredded paper. As time passes, the tattered remains of the past pile up under the device.

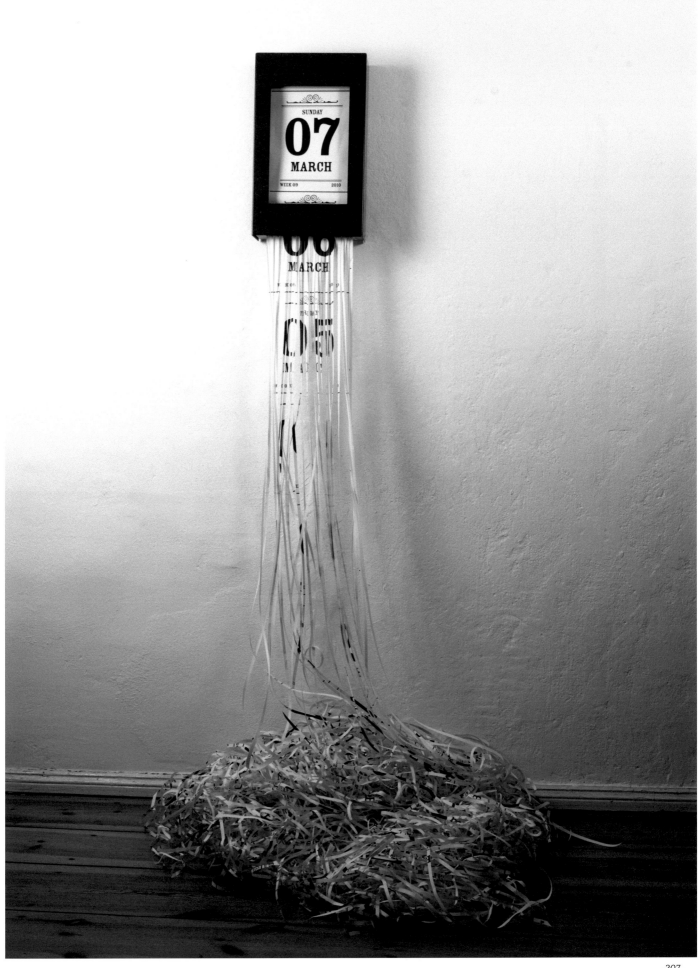

01

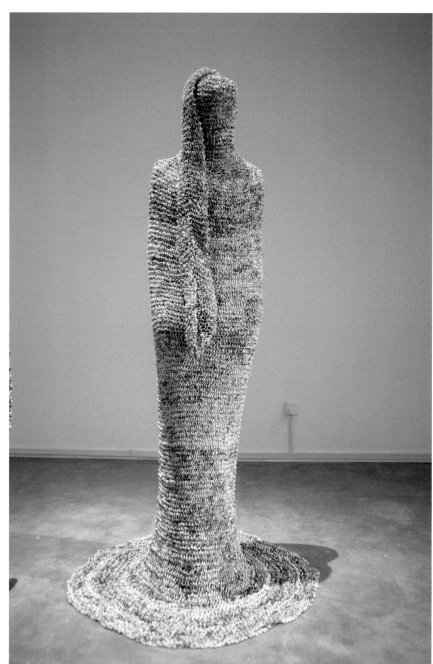

02

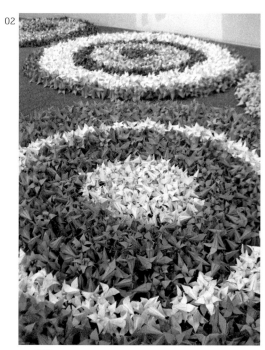

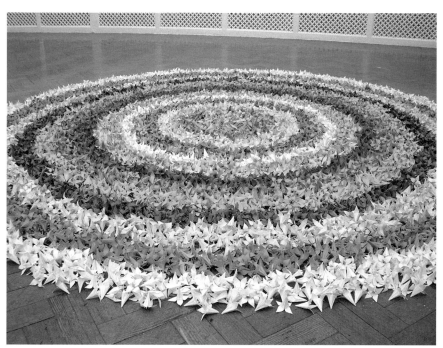

03

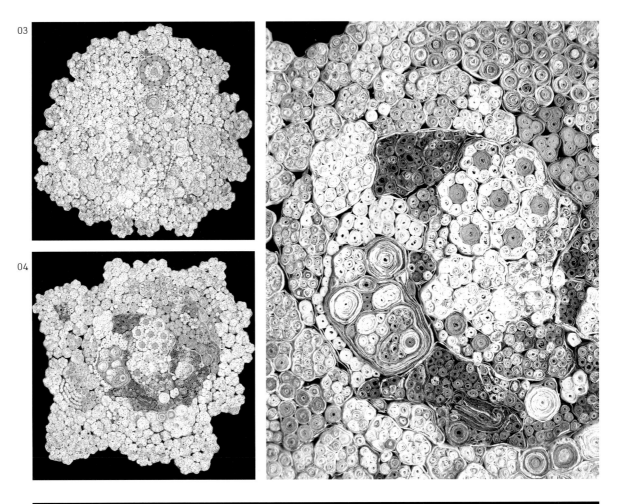

04

05

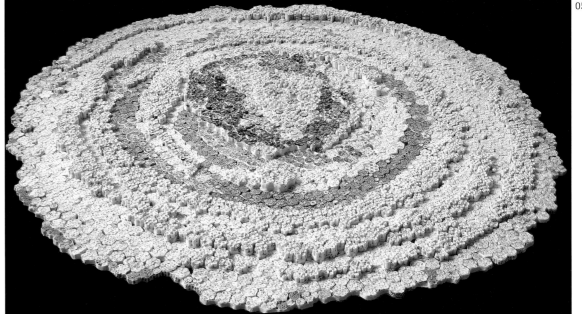

Movana Chen

01 Body Container IV
Body container sculptures that
examine the relationship between
clothes and the media. Fabricated
from multi-language magazines
and newspapers, they reflect on
the consumption of disposable
commodities.

James Roper

02 Devotion
Installations made from ten thou-
sand origami flowers created over
the course of three years.

Nava Lubelski

03 1998 Tax File
04 1997 Tax File
Sculptures created from shredded
and rolled financial documents
that are grouped according to
content and condensed into slabs
reminiscent of the cross-sections
of trees. The reuse of paper ad-
dresses waste and unsustainability
as well as the impulse to keep
what is no longer needed.

Nava Lubelski

05 Crush
Sculpture created from a box of
found love letters and ephemera.
Each piece of paper in the box was
arranged according to its content.
The entire collection was then
cut, rolled, and glued together in
a compressed format. In the final
piece, the specifics of the original
letters are not visible, but the over-
all sense of the infatuation and
compulsion is felt.

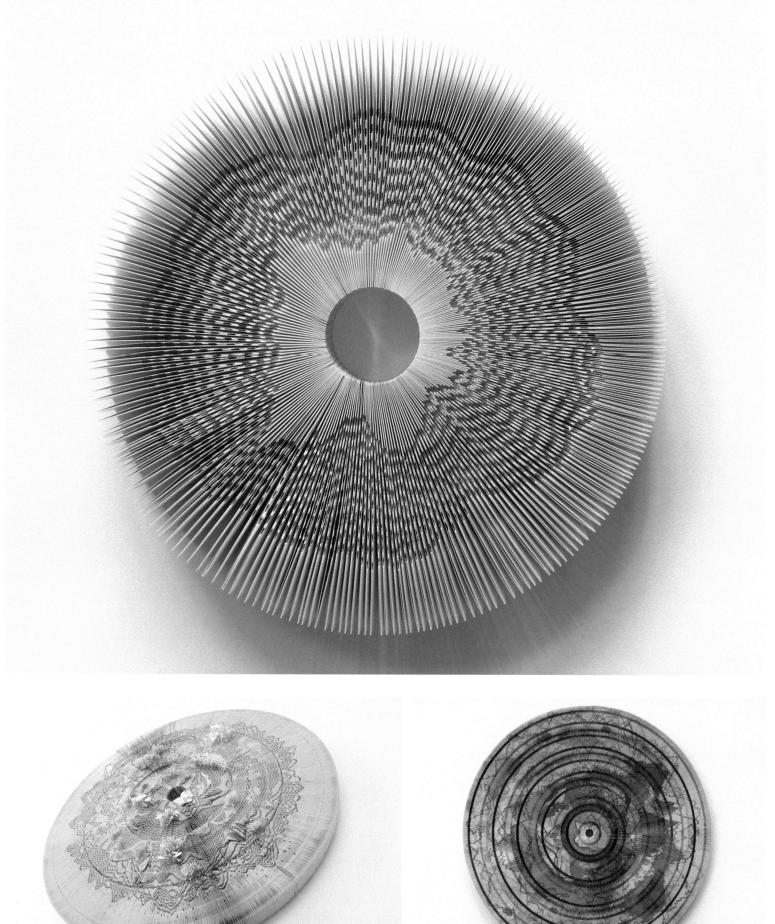

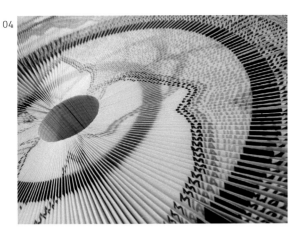

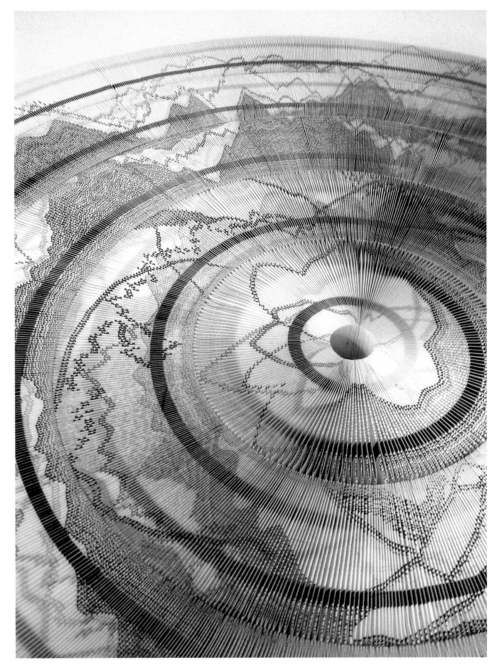

Mia Wen-Hsuan Liu

When asked about her work, Mia Wen-Hsuan draws a blank—a blank admission slip to her home away from home, the Solomon R. Guggenheim Museum, that is. A former employee, she made the iconic museum an integral building block of her work, using bundles of unused tickets to this treasure trove of artistic endeavors as raw materials and a versatile starting point for her forays into New York City.

Now, Liu's paper objects retrace the artist's everyday journeys through NYC and its idiosyncrasies: from intensely personal experiences—her daily donut routine at the museum's café—to explorations of Brooklyn's Botanical Gardens and the exotic surprises they hold.

These abstract documents of her routines visualize Liu's thoughts and ideas via the many stacked and modified sheets on exhibit. Here, (hole)-punching a ticket does not serve to devalue it, but adds to the layers and textures of her thick, circular folded and cut creations, hiding regular, two-dimensional drawings in the resulting spatial sculptures. Taken to the extreme, it turns the holes into a drawing that illustrates the subsequent void.

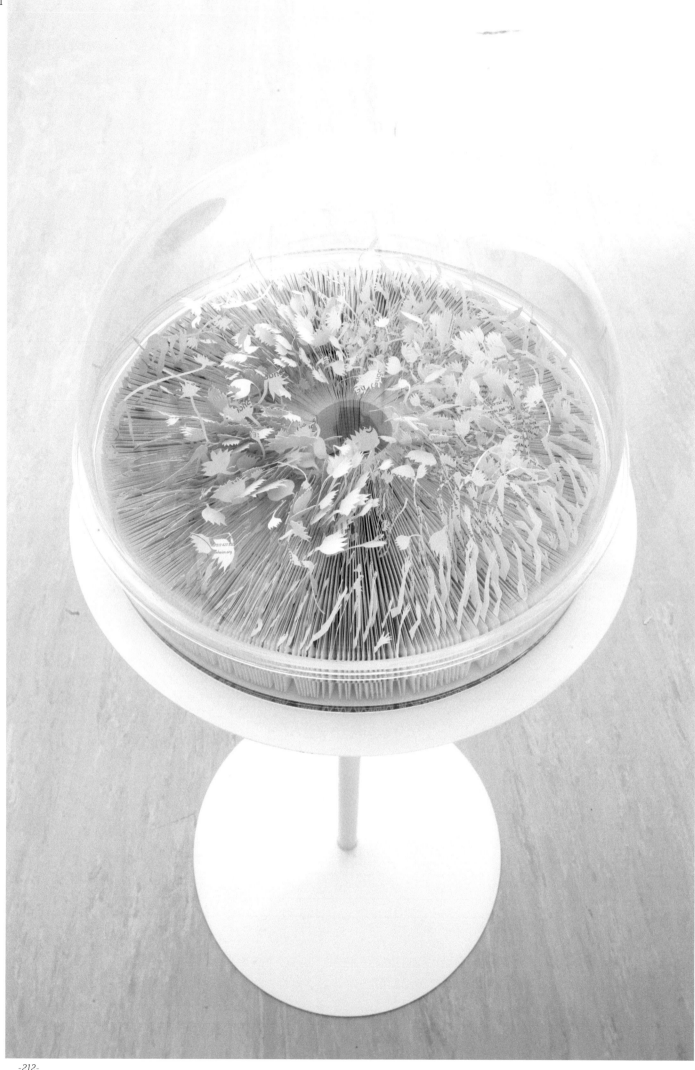

Mia Wen-Hsuan Liu

02

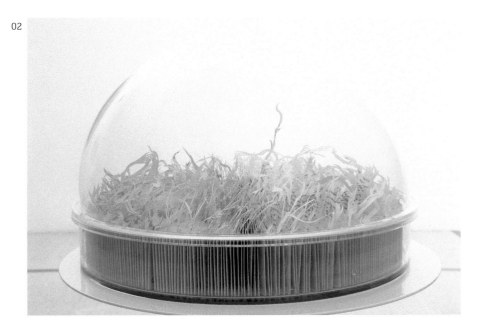

Georgia Russell

03

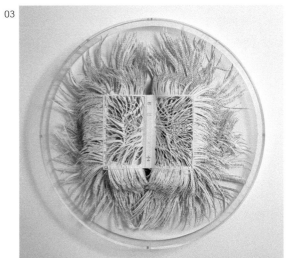

04

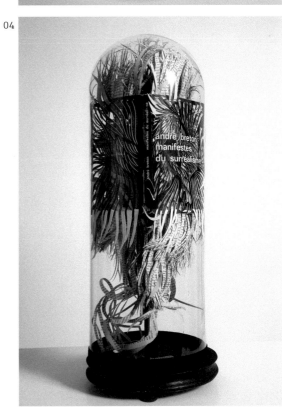

05

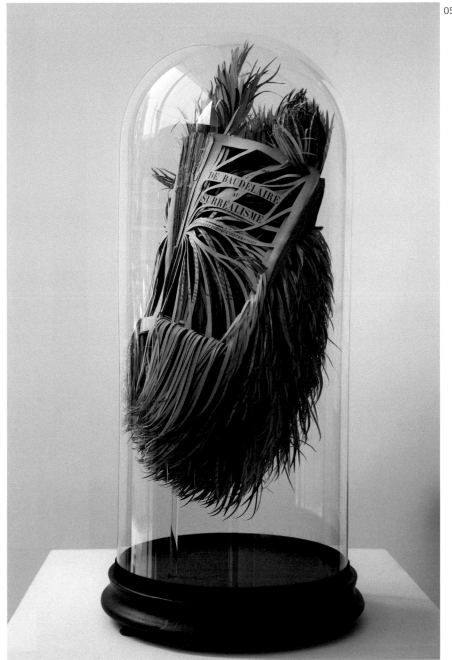

-213-

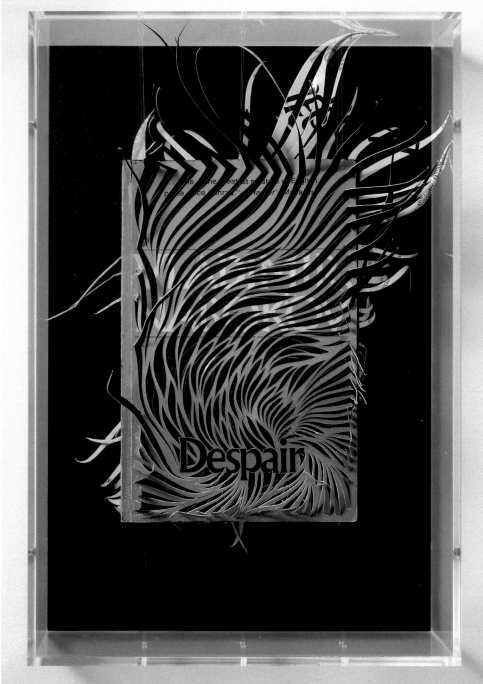

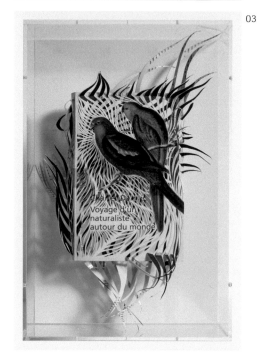

Georgia Russell
01 Despair (Nabakov)
02 Le Diable au Corps
03 Voyage d'un Naturaliste autour
 du Monde

right page
Peine d'Amour

Georgia Russell slashes, cuts, and dissects printed matter for reconstruction into extravagant and ornamental paper sculptures. Underscoring the decorative qualities and inherent potential of her found ephemera, she transforms books, music scores, prints, newspapers, maps, or photographs into chimerical juxtapositions of object and image.

By focussing on the essentials, Russell pulls off invisible scabs, carefully peeled from their foundations, to erase markers of the original via carefully placed cutouts that leave nothing but the central motif or significant statement, key protagonist, or pertinent features. In this deliberate distortion of facts, her "editing" highlights essential elements and the work's underlying character.

To Russell, books are sculptural objects "that represent the many hands which have held them and the minds they have passed through." Here, each construct conveys a simultaneous sense of loss and preservation to retain and reclaim the past as much as her techniques might attack it.

In the most literal of senses, the artist lets the story unravel and the plot thicken: surrounded by a dissolving landscape, she creates organic textures, from hair and straw to fur or feathers, and thus a new, living being that sends its spores and tendrils out into the world.

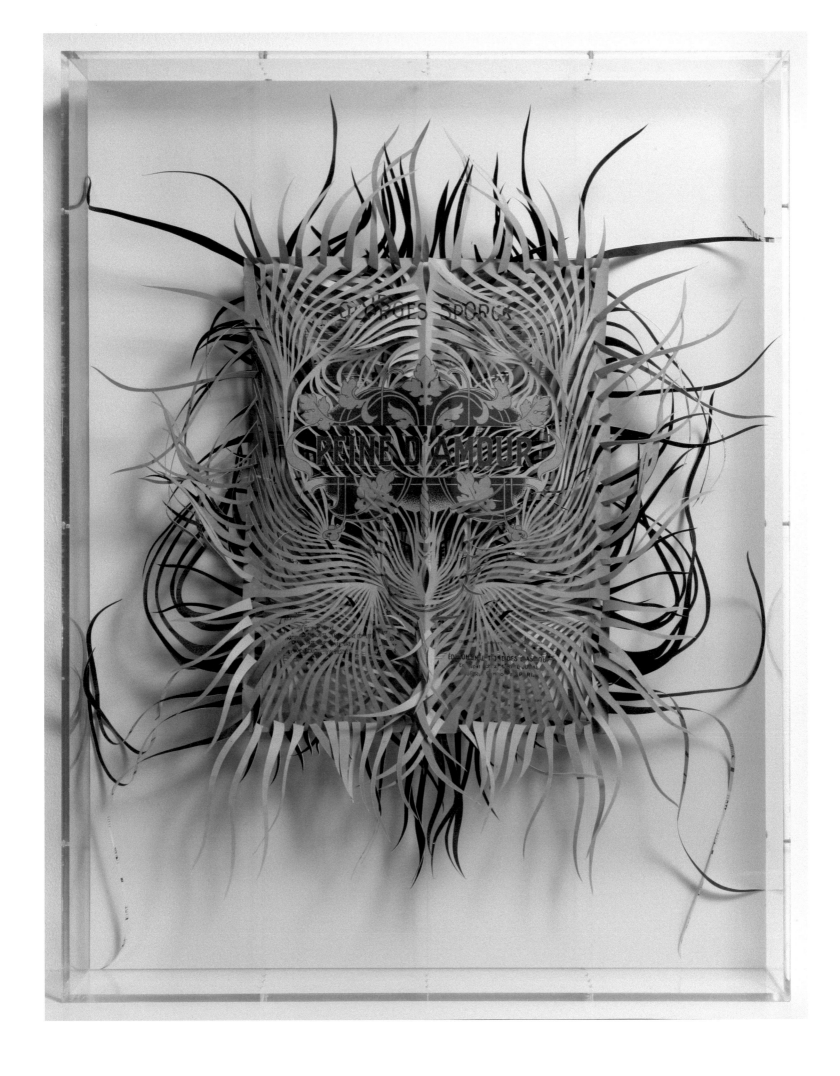

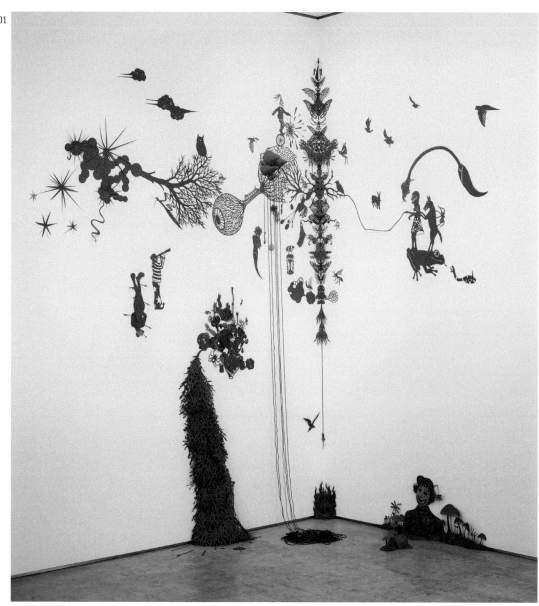

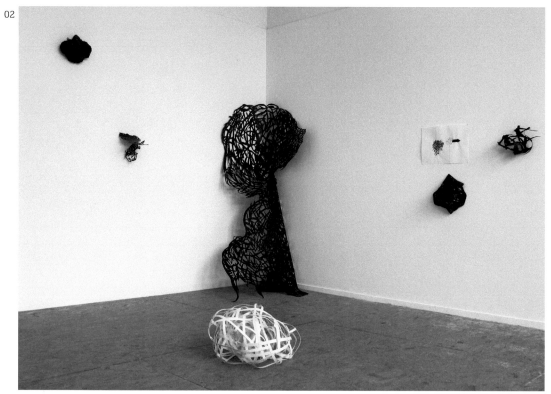

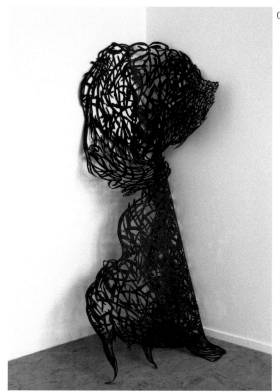

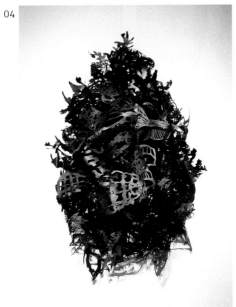

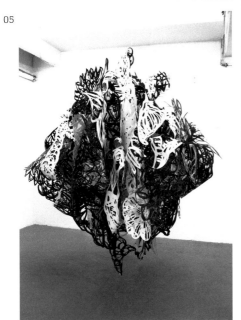

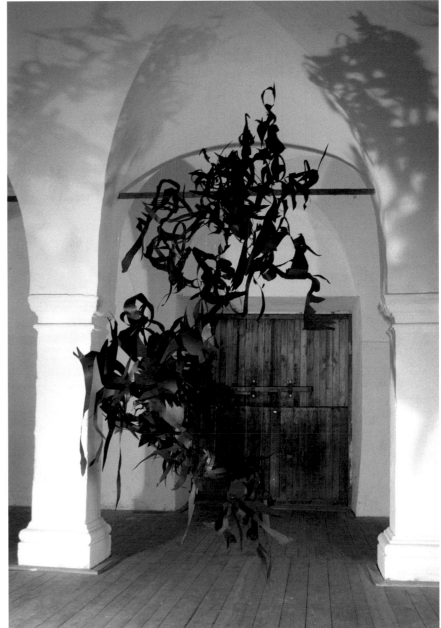

Birgit Knoechl

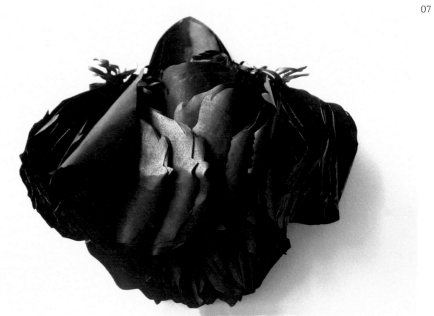

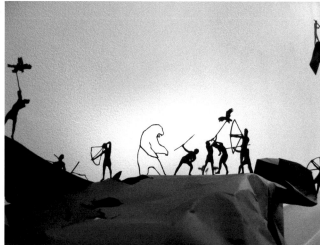

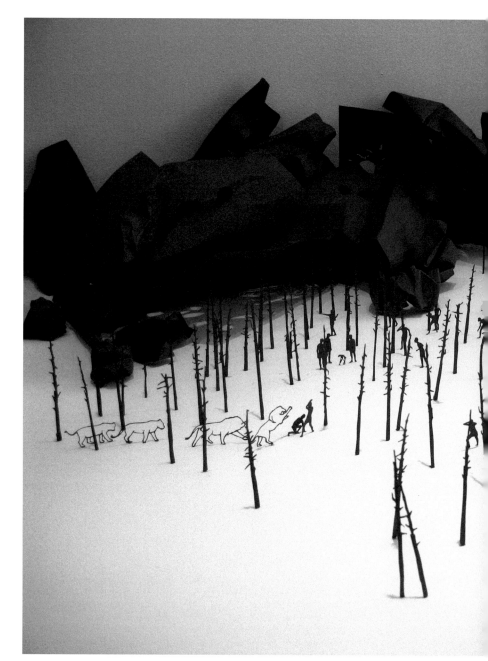

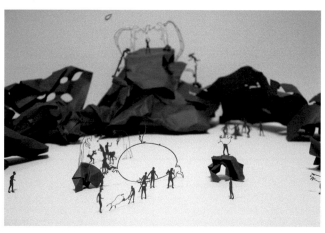

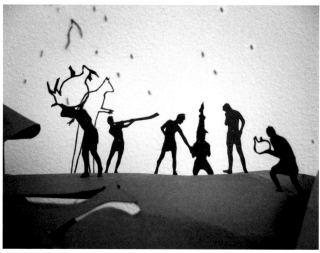

Andrew Scott Ross

01 <u>Rocks and Rocks and Caves and Dreams</u>
Installation using manipulated paper to explore the role of imagination in the early stages of human culture. 700 one inch paper figures represent a composite of primitive society, showing aspects of humanity ranging from physical presence to self-projection through art.

02 <u>Stones and Rocks and Stones and Bones</u>
Installation made from hand-cut office paper addressing the symbolism and rituals performed before the appearance of cities and the Agricultural Revolution. It made its debut at The Museum of Art and Design in New York City as a part of the exhibition "Slash: Paper Under the Knife."

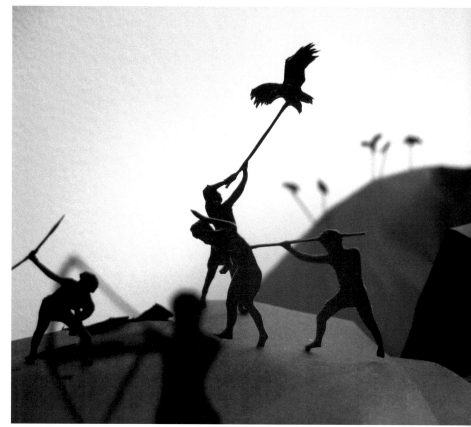

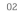

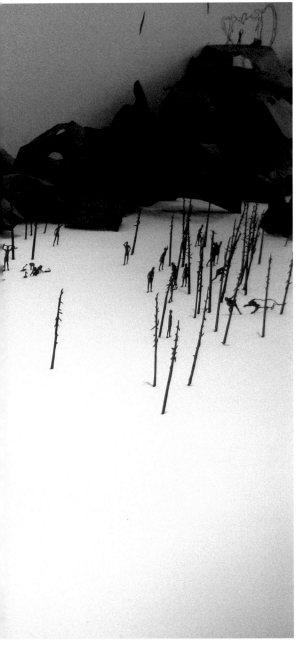

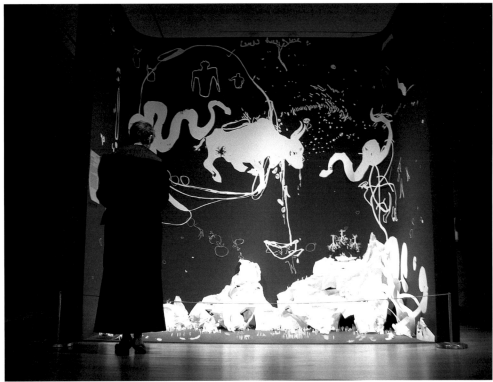

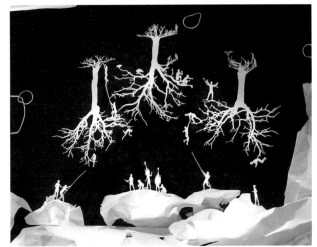

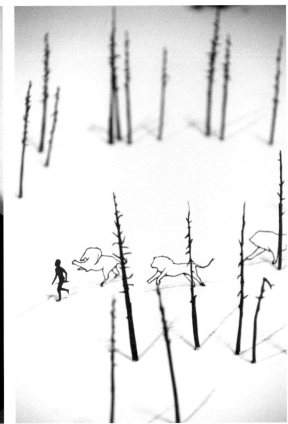

In his detailed explorations of pre-history, Andrew Scott Ross takes us all the way back to the early days of human existence—and mankind's hardships and heroic endeavors between hunt, tool use, predator scares and, most of all, collaboration.

By no means strictly scientific, linear, or factual, the artist's elaborate installations hint at a possible past, a cultural amalgamate that investigates society's origins in a range of stunningly detailed dioramas, set against stark, monochromatic landscapes.

Hidden among the caves and mountains formed by the crumpled sheets from which they were sliced, Ross's fictional ancestors simultaneously show up as actual figures, negative cutouts, sharp drop shadows, and light projections. In their sketched outlines, the resulting scenes play out like dynamic cave painting silhouettes in a powerfully immediate presentation of defining life-or-death scenarios.

Yet while *Rocks and Rocks and Caves and Dreams* aims for a relatively faithful depiction of the things that shape(d) us, its inverse twin, *Stones and Rocks and Stones and Bones,* not only turns the trees upside down, but also several facts of life. Modelled on the artist himself, the installation's protagonists re-enact rituals, warfare, and domestic activities in a cheeky and irreverent mix of ages and cultures, each highlighting a different possible origin or outcome of our species, historical or otherwise.

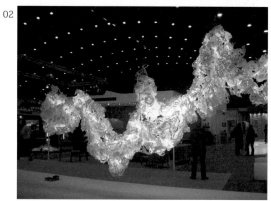

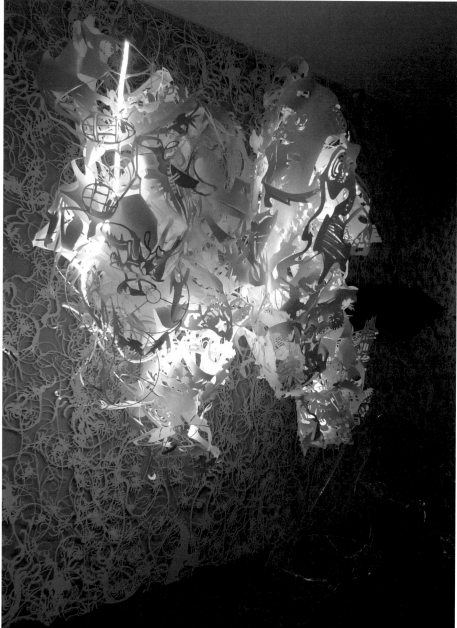

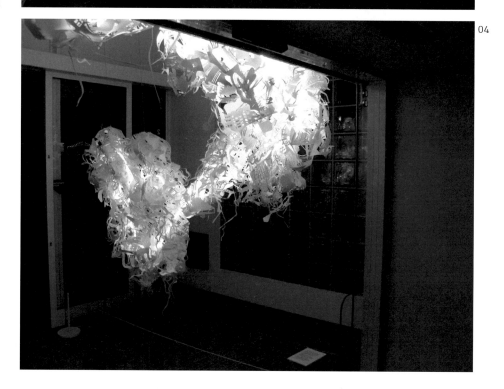

Yu Jordy Fu

01 Cloud Walk Typical Unit
Modular chandeliers inspired by the
spatial relationships between people
and the existing, proposed, and
imaginary London. Modular in form,
they can be installed and combined
vertically or horizontally in a variety
of shapes and sizes.

02 Cloud Walk
Horizontal chandelier, 13 meters long.

03 Cloud for Selfridges
Cloud Chandelier commissioned by
the Selfridges Department Store for
their rooftop restaurant.

04 Liquid Winter
Installation commissioned by the
London Design Museum. An inter-
play between the natural and built
environment, the installation is
made with a series of lightweight,
identical modular ripples that were
inspired by the views inside and
outside the museum.

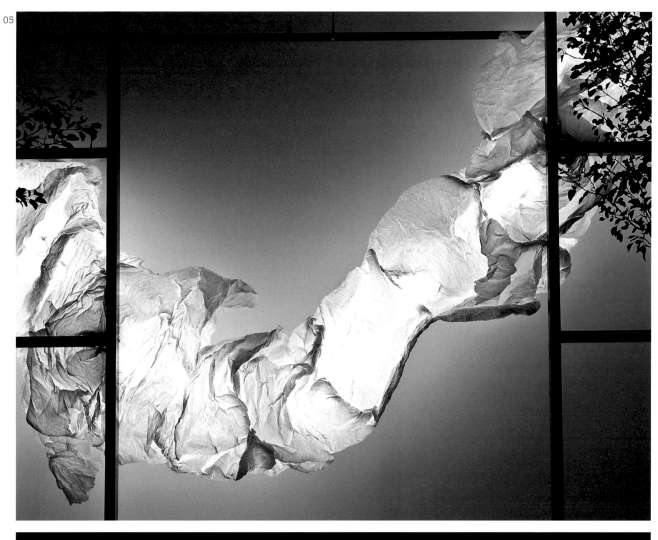

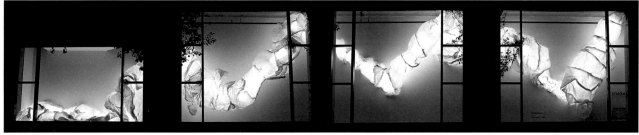

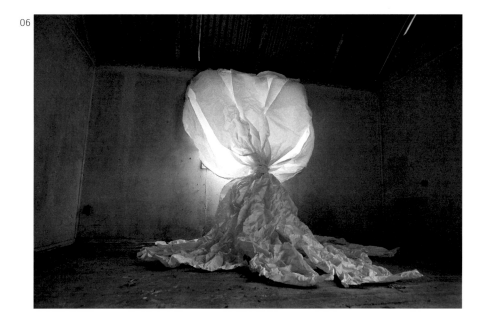

Christophe Piallat
05 Enfolded
Window display for the San
Francisco Museum of Modern Art.
06 Chapterhouse #6
Site-specific installation.

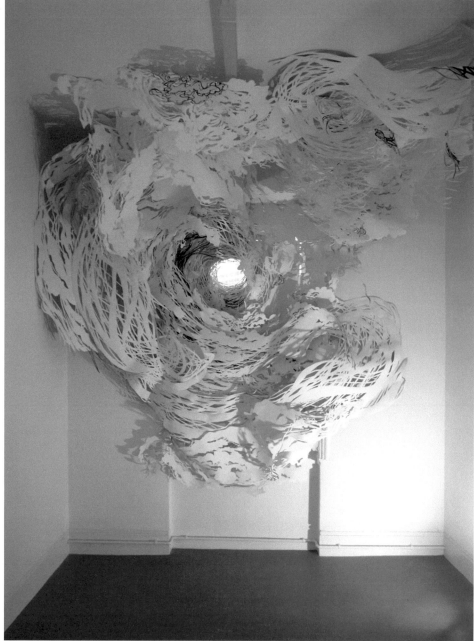

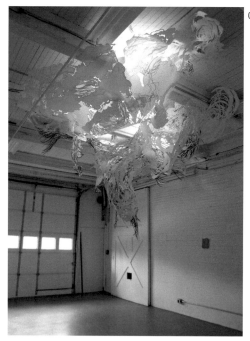

Mia Pearlman
03 Gyre (back view)
04 Gyre (front view)
Site-specific installation at the Islip
Art Museum on Long Island, New
York. The work appears to emerge
from the ceiling of the space.

Mia Pearlman

01 Eye
Site-specific installation at the
Centre for Recent Drawing in
London. The piece is a cloud vortex
that appears to be suspended
between the world inside the gal-
lery and an unknown world beyond
its walls.

02 Inrush
Site-specific installation at the
Museum of Arts and Design in New
York City. The natural light entering
through the building's window is
used to blur the boundary between
interior and exterior space.

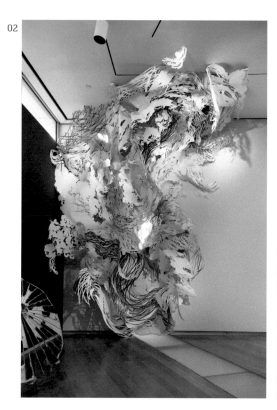

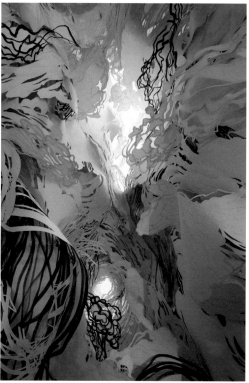

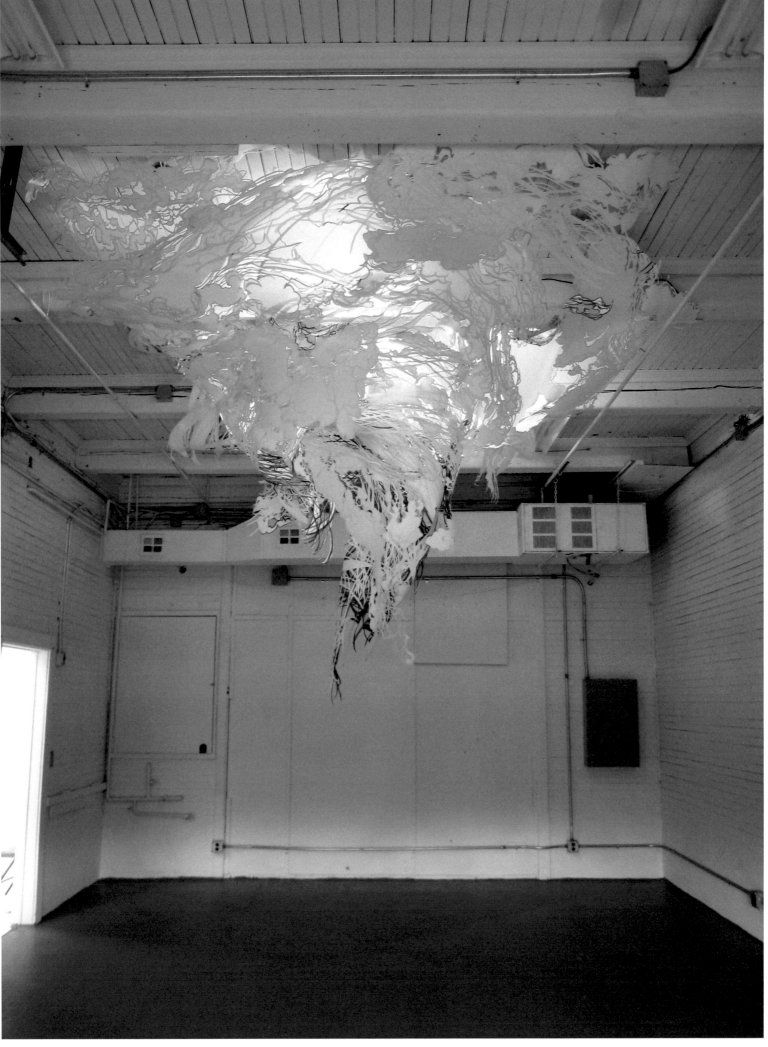

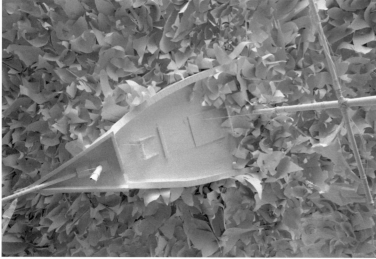

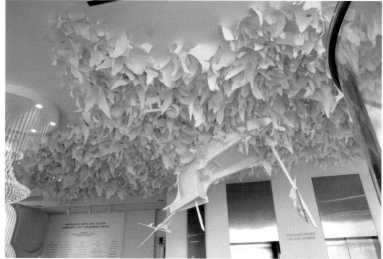

Andrea Mastrovito
Non Ci Resta Che Piangere /
There's Nothing Left to Do But Cry
Installation installed on the ceiling
depicting Christopher Columbus's
ship, the *Santa Maria*, sinking in
stormy waters before reaching the
Americas.

right page
Yuko Takada Keller
Wave
Installation created in 2009,
when the COP15 took place in
Copenhagen, Denmark. The piece
focuses on living in a convenient
society — one that fosters laziness
and global warming. Small pieces
of tracing paper were assembled to
form a dynamic wave.

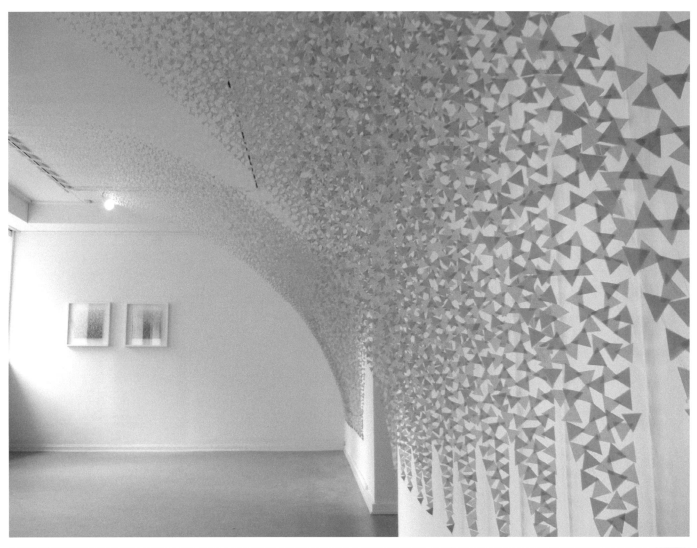

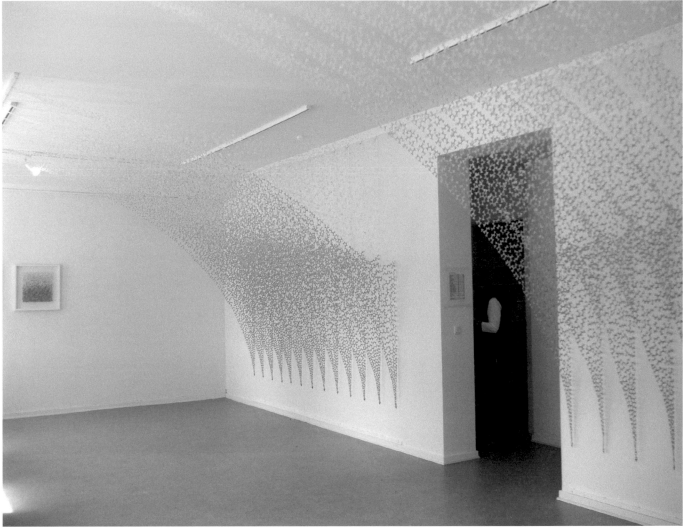

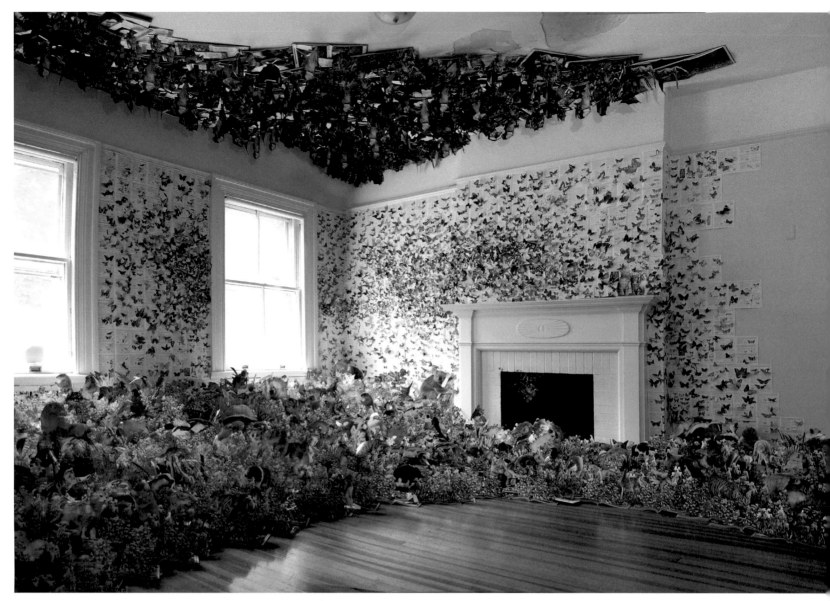

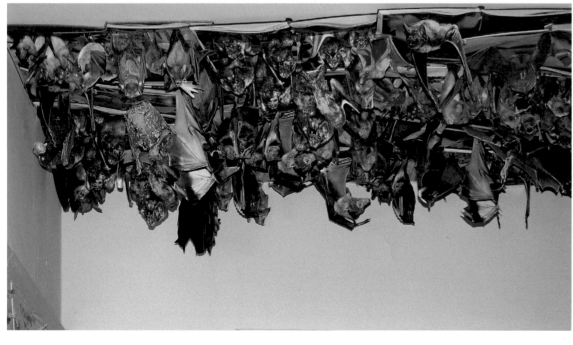

Andrea Mastrovito
The Island of Dr. Mastrovito
Installation created for the group
show "The Sixth Borough" using
1,300 hand-cut flower and animal
encyclopedias as well as a televi-
sion set and a DVD video.

Andrea Mastrovito
Love Is a Four-Letter Word
Installation cut from 100 flower
encyclopedias and two books
about cats.

01
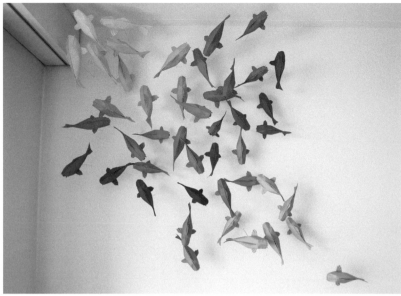

02
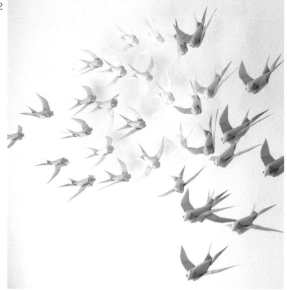

Sipho Mabona
01 Friendly Koi Pond
02 Pursuit of Happiness
Each piece is folded from one uncut
square of 160 gsm Aquarelle paper.

03
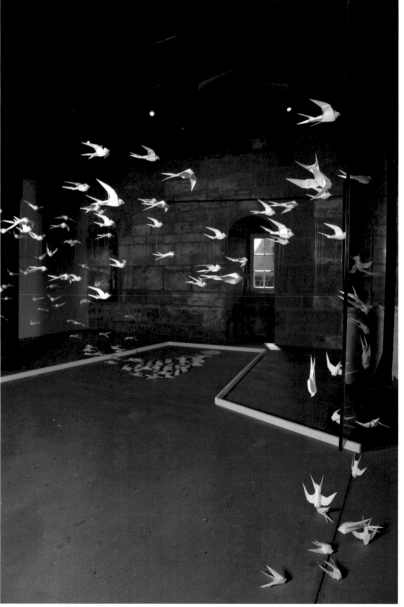

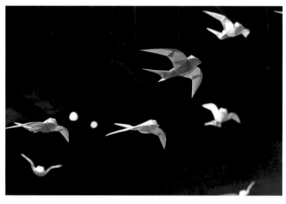

Sipho Mabona
03 Invisible Foe
Paper birds folded from one uncut
square of paper for the exhibition
"Invisible Foes" at the Gutenberg
Museum in Fribourg, Switzerland.

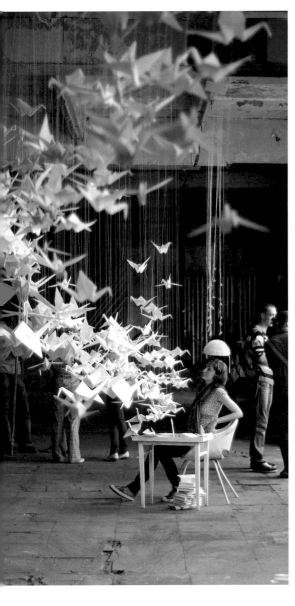

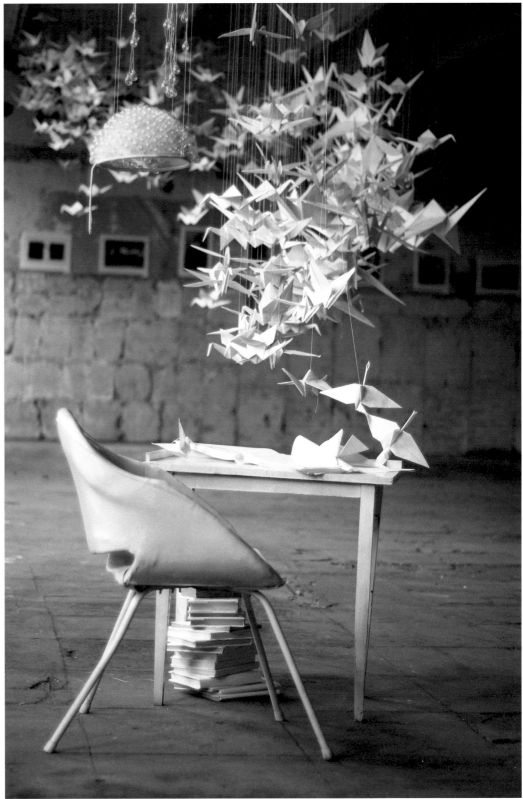

**Nataliya Kuzil, Ira Gumenchuk &
Lena Patsevych**

<u>Art Installation "Ideas Generator"</u>
An interactive art installation that
invited visitors to sit underneath a
helmet with lightbulbs in it, where
they could write or draw in a book.
Origami birds appear to emerge from
the book and fly about the space
while others disappear through a
hole in the wall. The piece, which
addresses the fleeting nature of
thoughts and ideas, attempts to
catch them and bring them to life.
Approximately 300 origami cranes
were mounted separately with
thread to the ceiling, reaching a
total length of 16 meters.

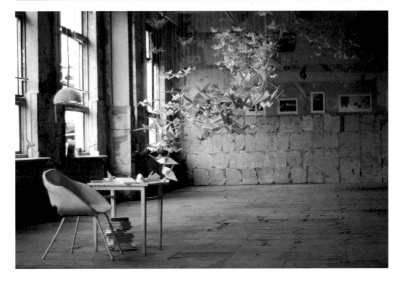

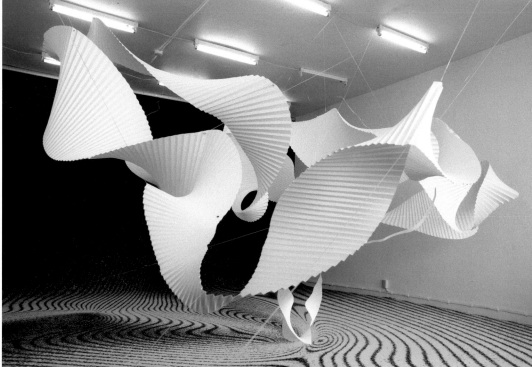

01

Richard Sweeney

01 <u>Beta II</u>
Installation comprised of several meters of continuous, hand-pleated paper, which seem to be writhing, fluid forms that trace the movement of line through space. Hundreds of individual folds change the property of the paper, giving it rigidity while still allowing it to flex and bend.

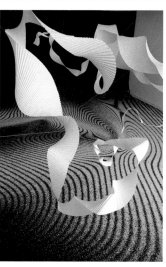

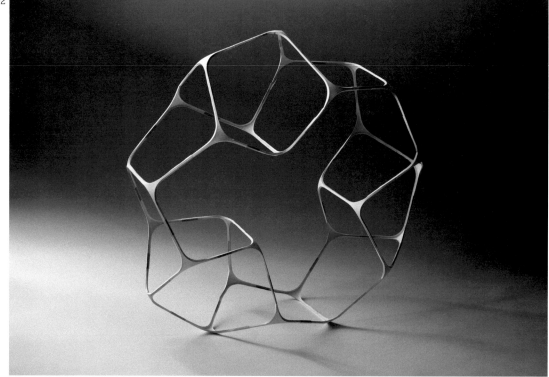

02

Richard Sweeney

02 <u>Bone</u>
Sculpture measuring 50 × 20 centimeters made from triangular modules of hand-cut and folded cartridge paper. The goal was to produce a modular work using the thinnest pieces possible while still maintaining the structure of the form.

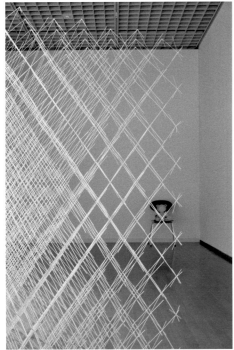

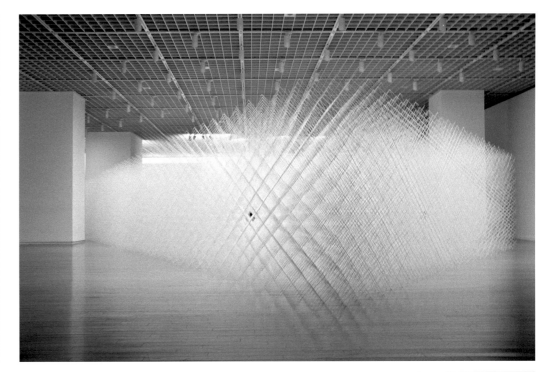

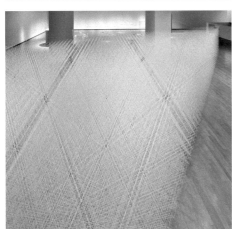

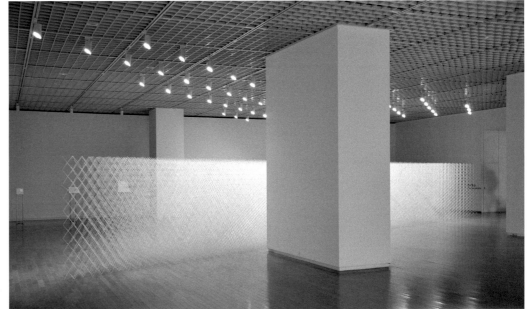

Ryuji Nakamura

<u>Cornfield</u>

Paper structure measuring 16 meters at its longest side, with a total volume of 100 cubic meters. When the viewer walks along the exterior, the structure visually shifts due to the many lines that are drawn one on top of the other in its uniform paper frames. Consisting of laser-cut vulcanized fiber paper and glue, the structure itself is visually subtle, blending in easily with the surrounding space.

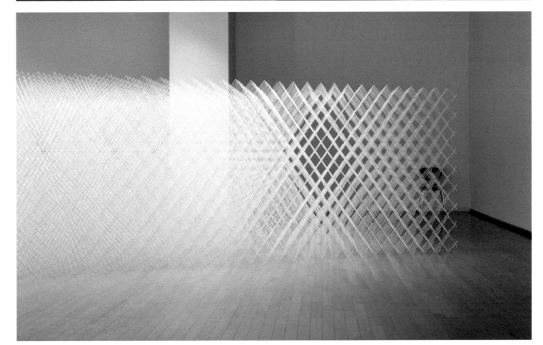

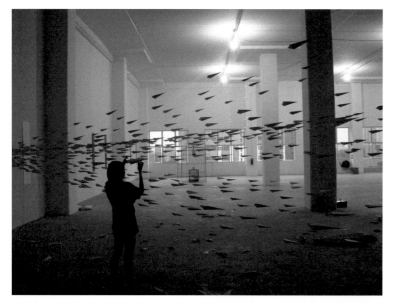

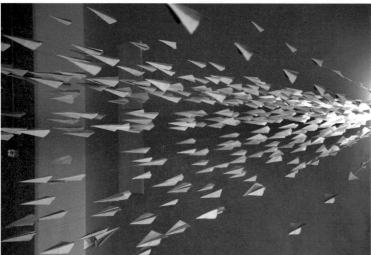

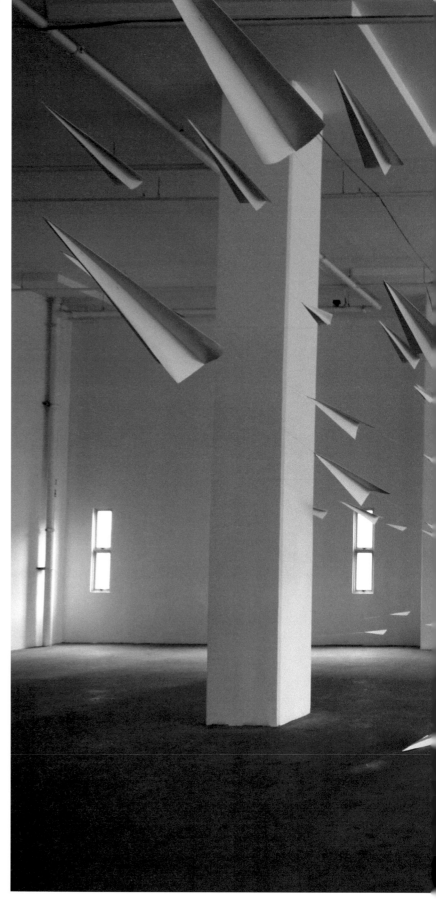

Dawn Ng

I Fly Like Paper Get High Like Planes
Sculptural installation composed
of hundreds of paper airplanes.
Each airplane explodes outward
from a single window. The sizes of
the planes vary from palm-sized to
person-sized.

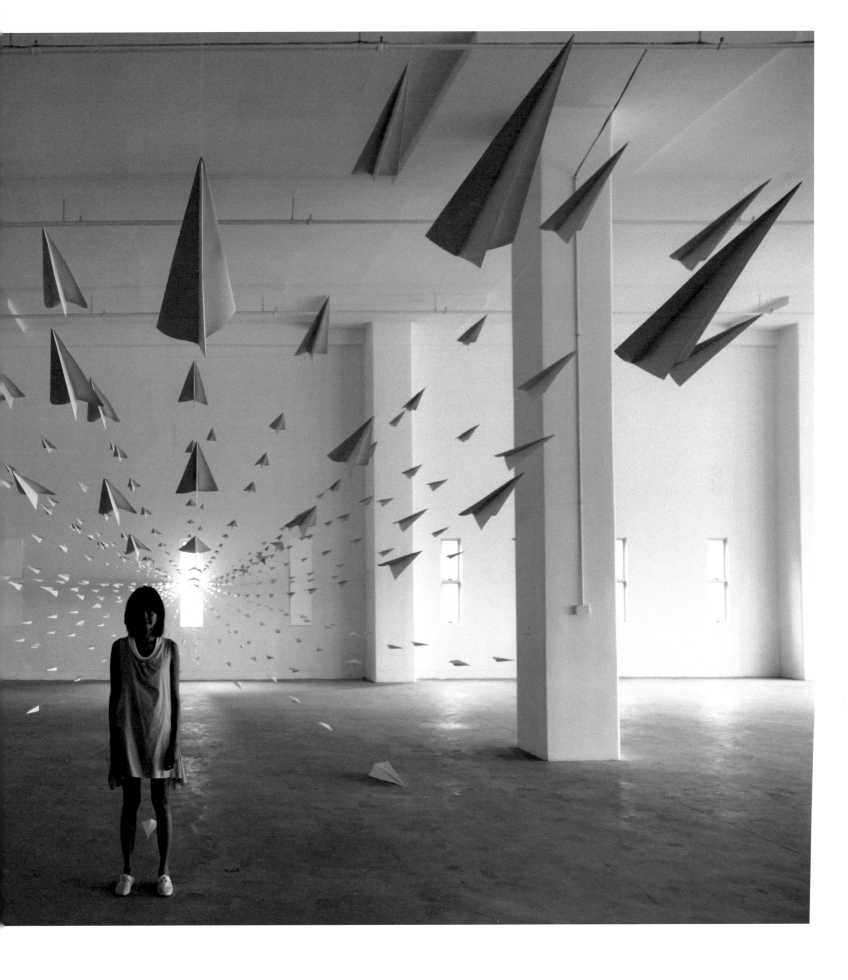

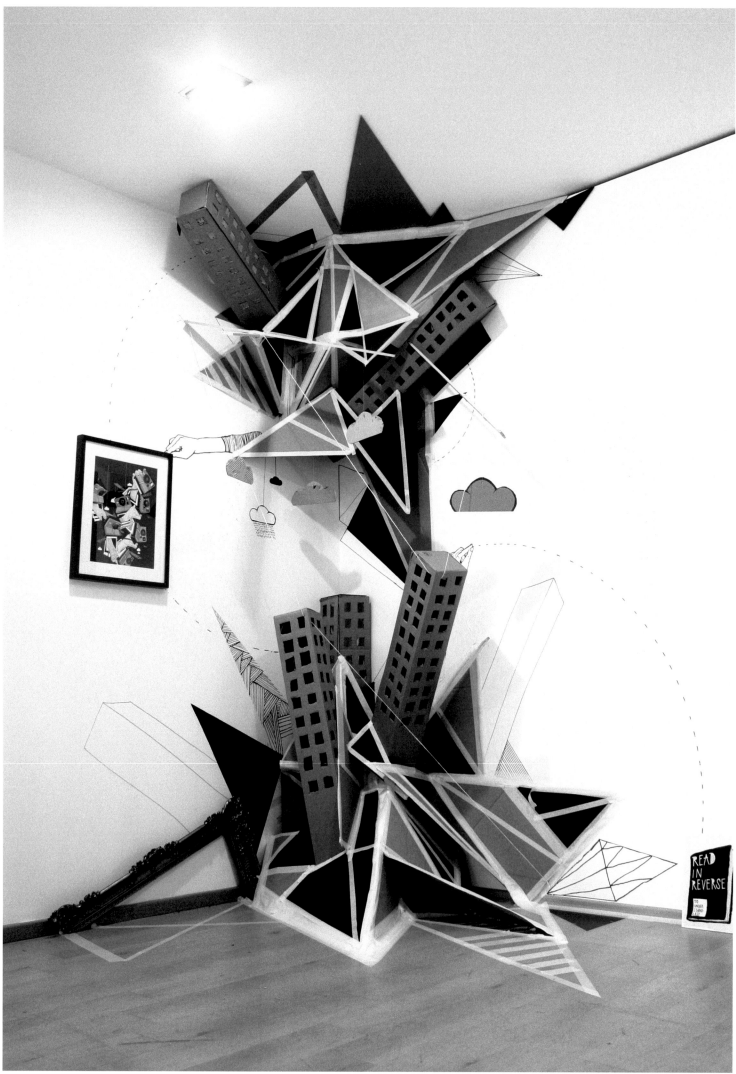

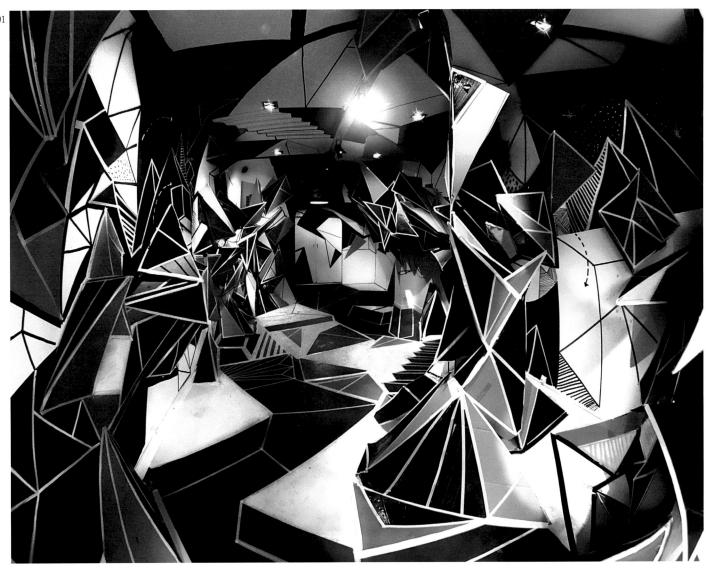

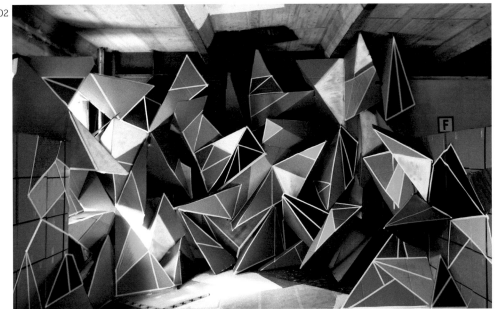

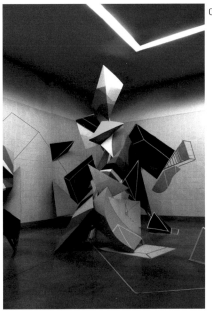

01
02
03

left page

Clemens Behr

No Control

Installation for an exhibition
at Heimatdesign in Dortmund,
Germany. Marionette-like strings
are attached to buildings, although
it is not clear which part controls
the other.

Clemens Behr

01 Seize
Installation built at Galerie Seize in
Marseille, France.

02 Get Set / Metro Station
Installation for the Get Set Art
Festival in Porto, Portugal. Built
in the main subway station with
pieces of cardboard prepared ac-
cording to the appearance of the
station.

Clemens Behr

03 Untitled
Two installations built at the
Mazine headquarters in Mülheim,
Germany, celebrating the fashion
brand's tenth anniversary.

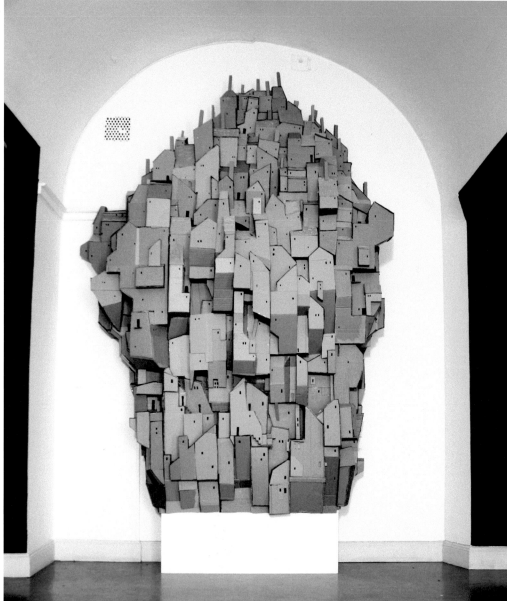

02

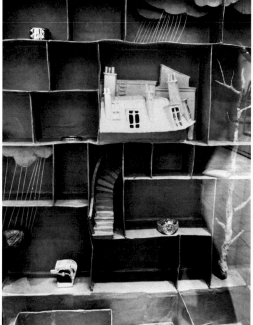

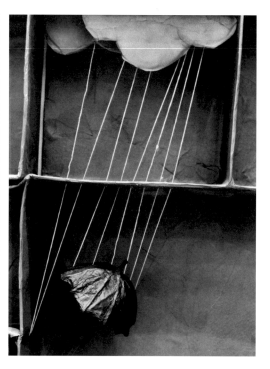

Nina Lindgren
01 Cardboard Heaven
Sculpture made of cardboard.

**ijm / Frank Visser,
Elsa Dray Farges**
02 Grey Archive Paris Style
Window display created for the
Hermès store in Amsterdam,
Netherlands.

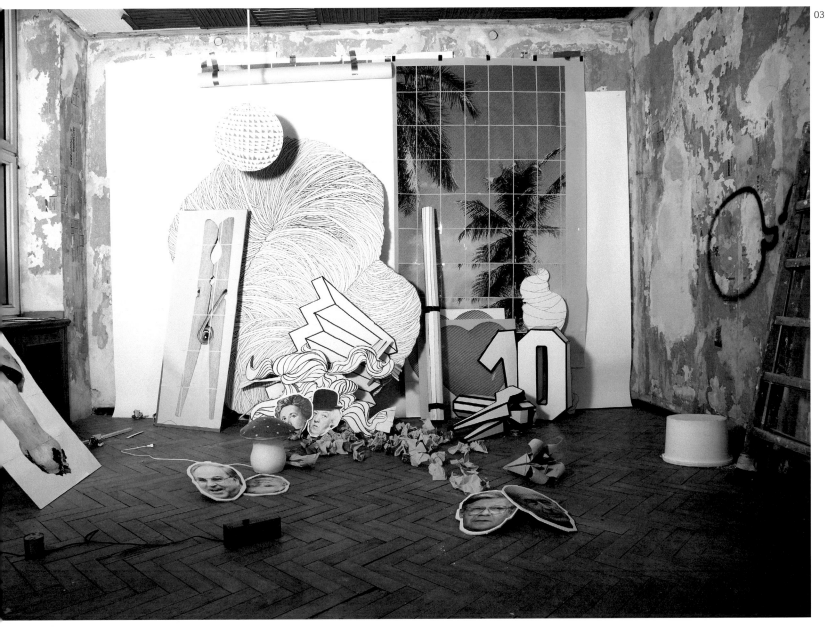

Ilka Helmig / Leitwerk
03 Friendship
Editorial illustration.

Luis Valdes (Don Lucho)
04 1/4 de Mi Casa

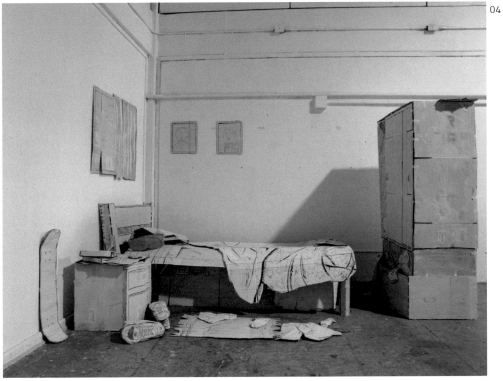

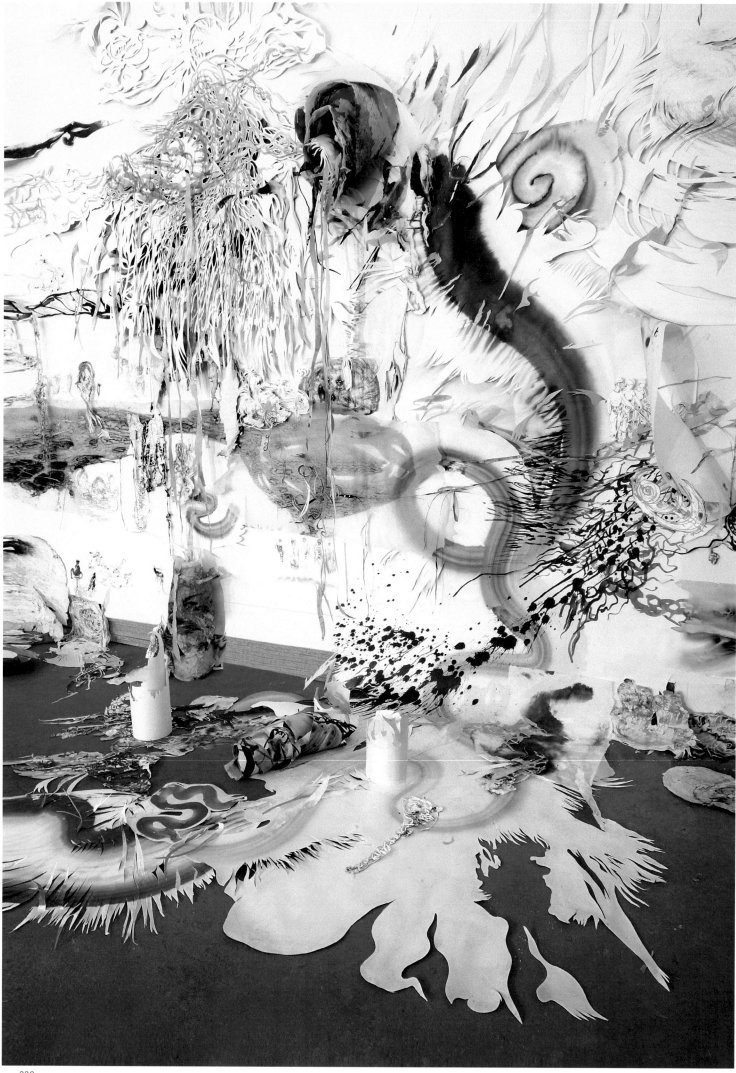

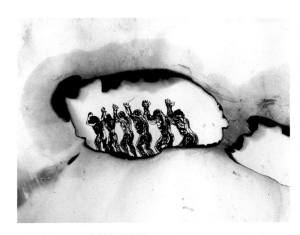

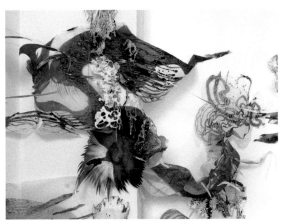

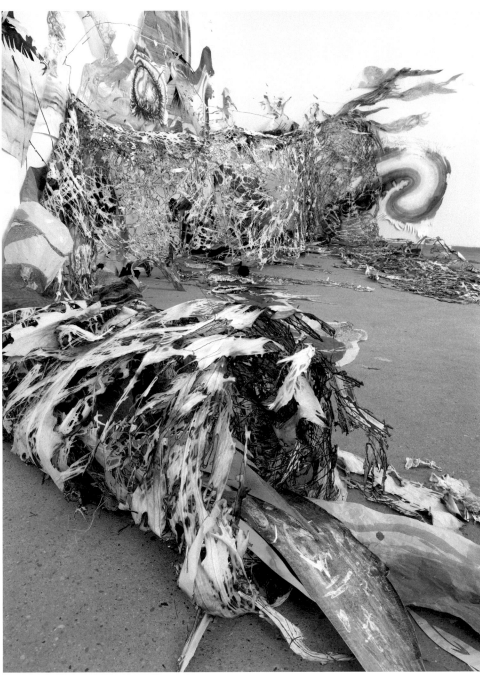

Nadja Schöllhammer

left page
Meteor
Detail of a wall installation in
a former train factory in Berlin,
Germany.

this page
Terra Incognita (installation view
and details)
Installation for a solo exhibition at
Galerie Alexandra Saheb in Berlin,
Germany.

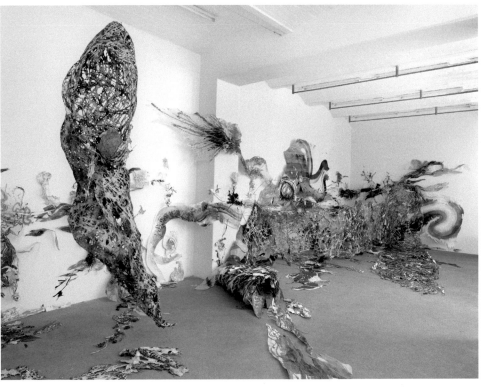

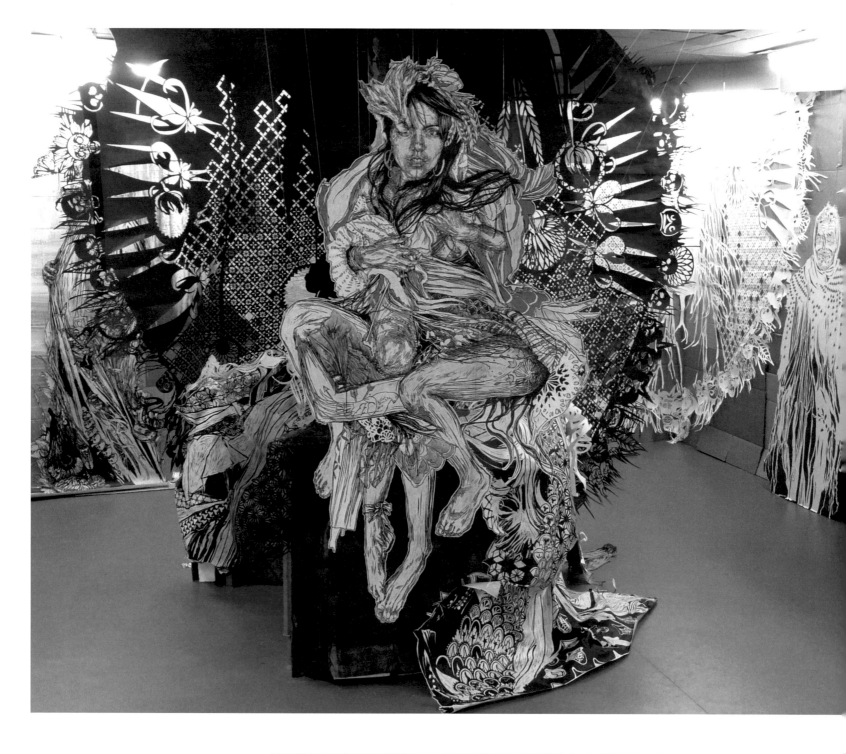

Swoon
Fata Morgana
Installation for the "Fata Morgana"
exhibition at Galerie LJ in Paris,
France.

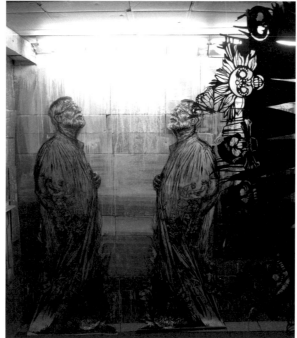

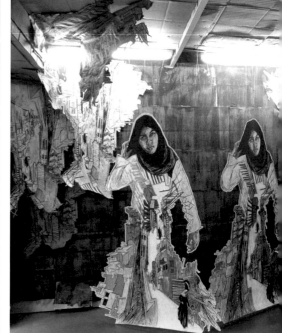

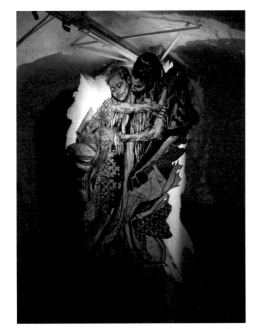

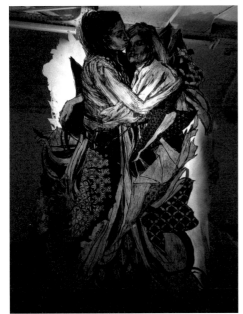

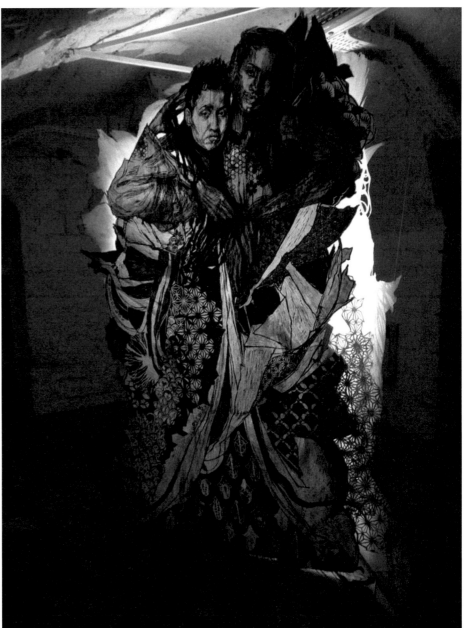

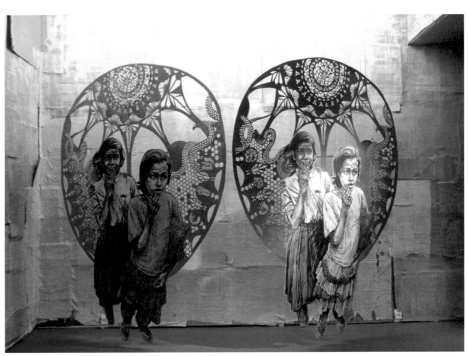

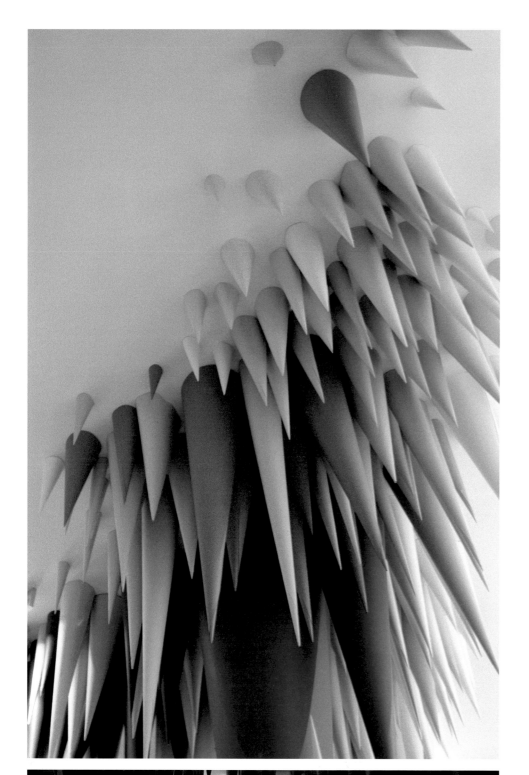

Wendy Plomp / Edhv
Paper Cave
Installation composed of paper
cones of various sizes and colors at
Spazio Verger in Milan, Italy. Color
is used to generate the experience
of light.

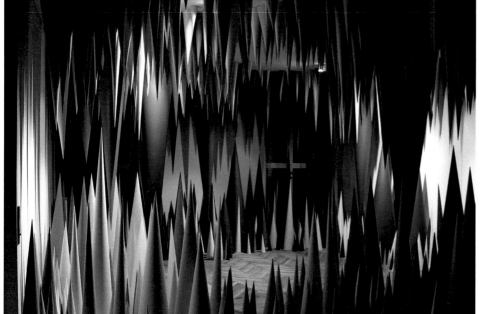

right page
**Robin Nas (ZenkOne), Marloes de
Laat, Paul van Barneveld, Gerco
Hiddink, Marga van de Heuvel,
Sophie van Kempen, Charlotte
van der Wiel, Marco Overkamp**
GreyTones "MyCity"
Installation attempting to answer
the question as to what makes
their city the best for a design
competition. Submissions were
exhibited during the 2010 Graphic
Design Festival in the Netherlands.

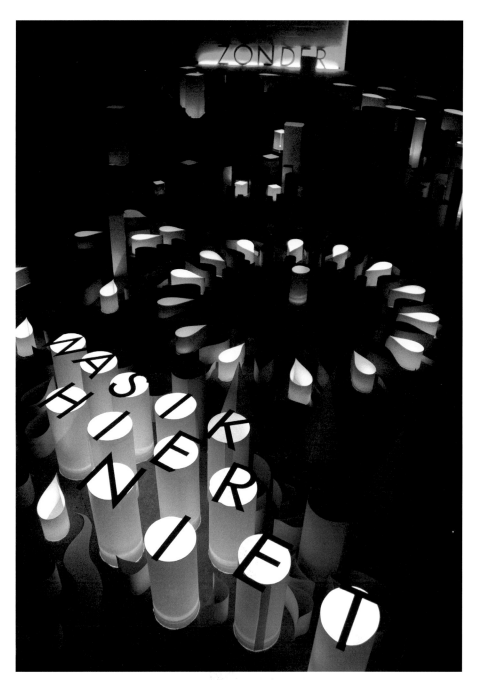

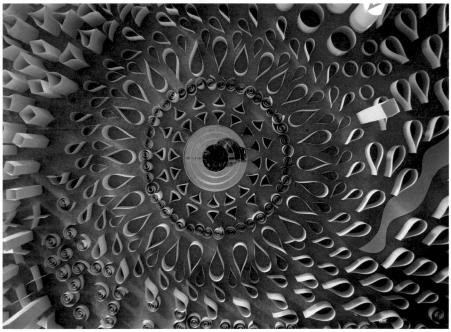

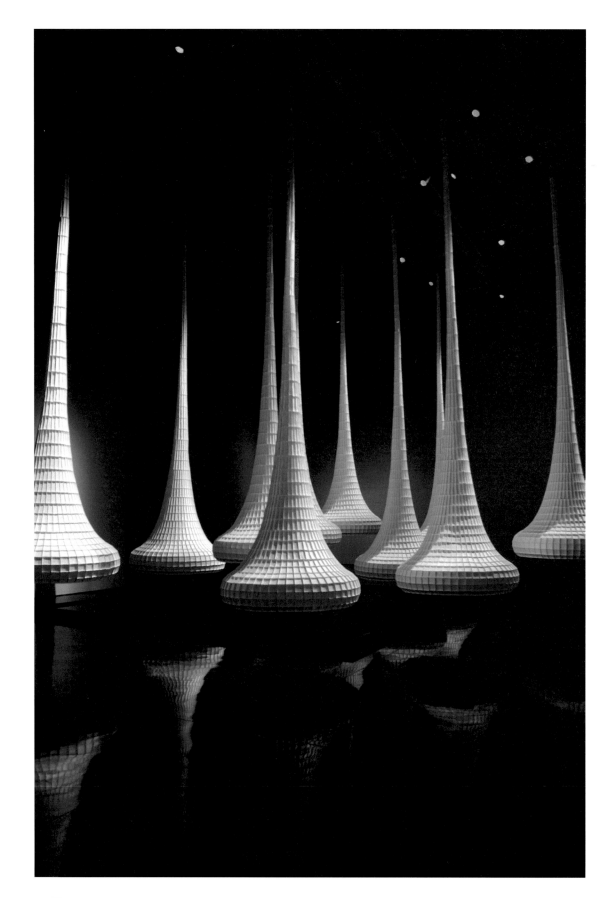

John Grade
The Elephant Bed

Installation exhibited at Fabrica in Brighton, England and at the Watcom Museum in Bellingham, Washington, U.S.A. Its twenty forms, each over seven meters tall, were made of materials designed to rapidly deteriorate when exposed to moisture. During the Fabrica exhibition, half of the forms were gradually lowered into pools of ink and the remaining forms carried into the English Channel, where they immediately disintegrated in the waves. Microscopic calcium shells that protect phytoplankton inspired the sculpture's fluted forms. When these protective shells fall to the ocean floor, they create deposits that geologists informally call the Elephant Bed. These deposits make up much of England's shoreline, including the White Cliffs of Dover.

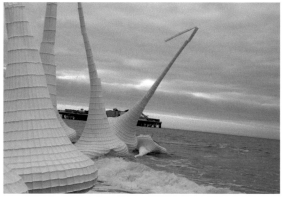

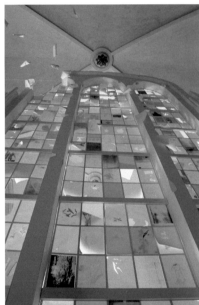

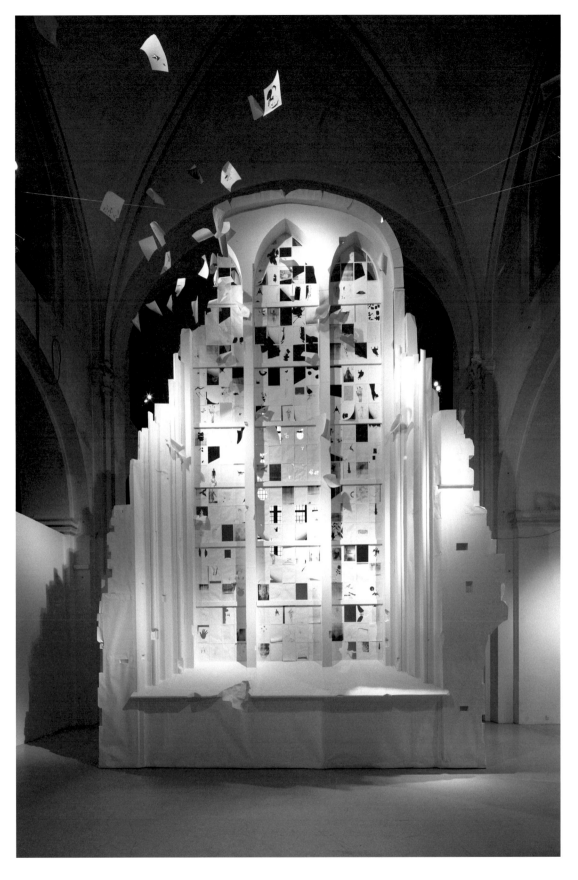

Peter Callesen
White Window
Paper installation using 264 sheets
of A4 paper including old sketches,
cuttings, and copies. Made spe-
cifically for Nikolaj's Church in
Copenhagen, Denmark, it is a 1:1
copy of a window in the church.

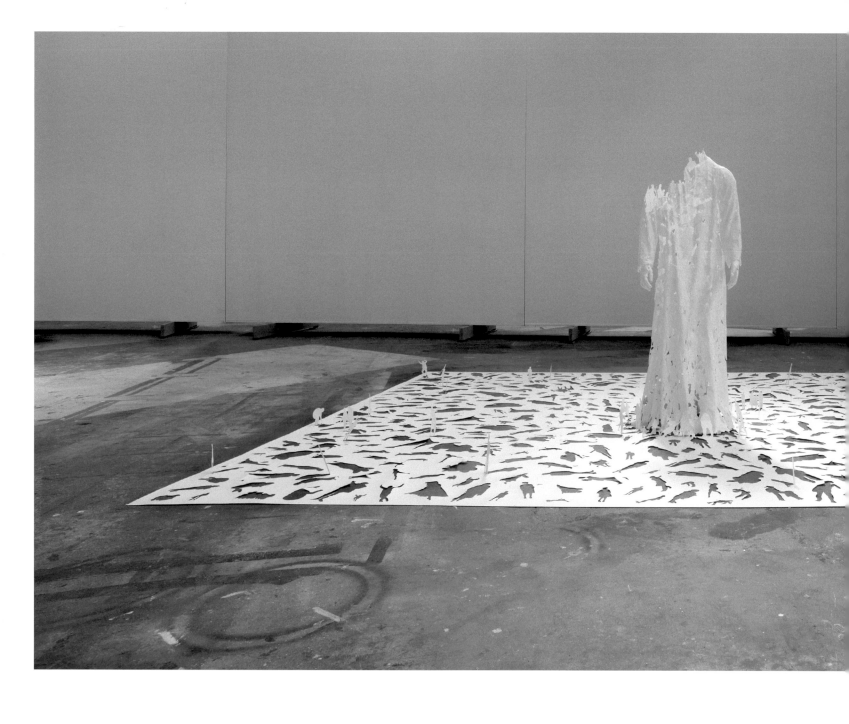

Peter Callesen
<u>Transparent God</u>

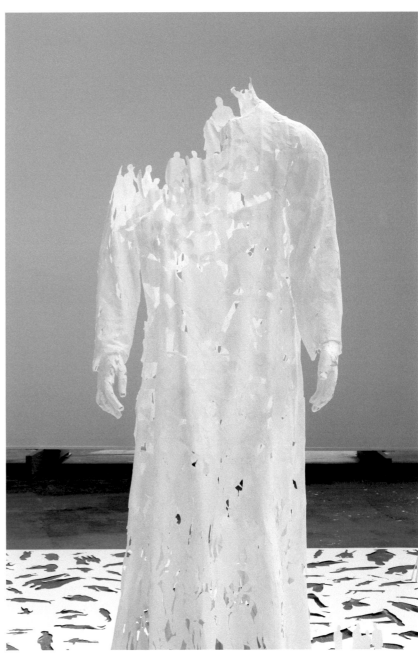

INDEX

INDEX

INDEX

VIDEO-DVD

Please refer to the book index for credits information

01

02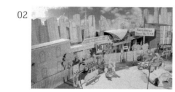

03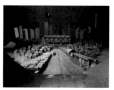

04

05

06

07

08

09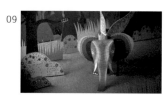

10

11

12

13

14

15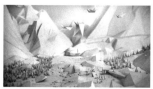

 16

 17

 18

 19

 20

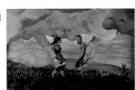 21

 22

 22

 23

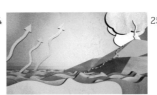 24

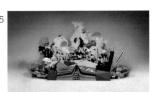 25

 26

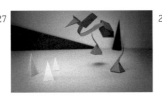 27

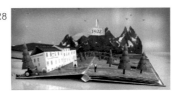 28

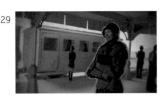 29

Papercraft 2

Design and Art with Paper

Edited by Robert Klanten and Birga Meyer
Preface, chapter introductions, and extended project descriptions
by Sonja Commentz
Project descriptions by Rebecca Silus

Layout by Birga Meyer for Gestalten
Cover image from short film *The Seed* by Johnny Kelly
Typeface: EngelNewSerif by Sofie Beier
Foundry: www.gestaltenfonts.com

Project management by Julian Sorge for Gestalten
Project management assistance by Rebekka Wangler for Gestalten
Production management by Vinzenz Geppert for Gestalten
Proofreading by Bettina Klein
Printed by SIA Livonia Print, Riga
Made in Europe

Published by Gestalten, Berlin 2011
ISBN 978-3-89955-333-8

Bibliographic information published by the Deutsche
Nationalbibliothek.
The Deutsche Nationalbibliothek lists this publication in the
Deutsche Nationalbibliografie; detailed bibliographic data is
available online at http://dnb.d-nb.de.

None of the content in this book was published in exchange
for payment by commercial parties or designers; Gestalten
selected all included work based solely on its artistic merit.

This book was printed according to the internationally ac-
cepted ISO 14001 standards for environmental protection,
which specify requirements for an environmental manage-
ment system.

This book was printed on paper certified by the FSC®.

Mixed Sources
Product group from well-managed
forests and other controlled sources
www.fsc.org Cert no. SW-COC-002883
© 1996 Forest Stewardship Council

Gestalten is a climate-neutral company and so are our
products. We collaborate with the non-profit carbon offset
provider myclimate (www.myclimate.org) to neutralize the
company's carbon footprint produced through our worldwide
business activities by investing in projects that reduce CO_2
emissions (www.gestalten.com/myclimate).

402730

402730